HISTORY OF ART

for Young People

H. W. JANSON

Professor of Fine Arts, New York University

WITH SAMUEL CAUMAN

History

of Art

for Young People

Harry N. Abrams, Inc., Publishers, New York

Third Printing

Standard Book Number: 8109–0188–9
Library of Congress Catalogue Card Number: 72–157517

3-81. 1642 B✝J

Copyright © 1971 by Harry N. Abrams N.V., The Netherlands

CONTENTS

PART FOUR *The Modern World*

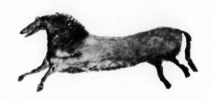

PART ONE

How Art Began

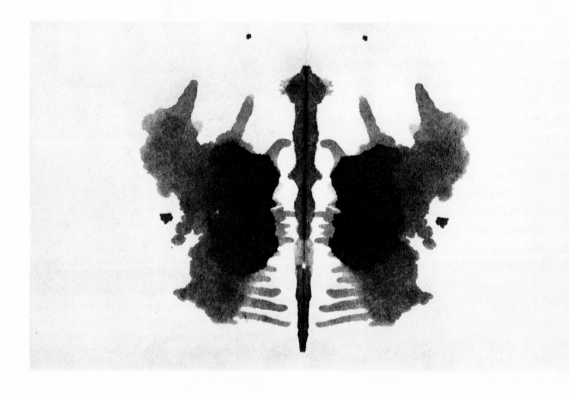

Images and Imagination

Everybody dreams. Even animals dream. A cat's ears and tail may twitch as he sleeps, and a sleeping dog may whine and growl and paw the air, just as if he were having a fight. Even when awake, animals "see" things. For no apparent reason a cat's fur may rise on his back as he peers into a dark closet. And you or I may get goose pimples from phantoms we neither see nor hear.

That is imagination at work. Human beings are not the only creatures who have imagination, although they are the only creatures who can tell one another about it. If we tell in words what we imagine, we have made a story. If we take a pencil and draw it, we have made a picture. To imagine means "to make an image"—a picture—in our minds.

There are many different ways for our imagination to get started. When we are ill in bed and have nothing to do, a ceiling crack on which we have kept our eye may begin to look like an animal or a tree. Our imagination adds the lines that were not there before. Again, an ink blot (see figure 1) will remind us of other things, although it was made by accident. Psychologists know this and have made up ink-blot tests to find out what is in our minds, for each of us, depending on the sort of person he is, sees a different picture in the same blot.

The *Bull's Head* by Picasso (figure 2) is

a striking example of how an artist saw something new and exciting in two very ordinary objects. Look closely. The bull's head is the seat and handle bars of an old bicycle. To put them together was ridiculously simple. But there was nothing simple about the leap of imagination that recognized a powerful hidden image. *That* was a master stroke. Where an ordinary person's eyes and brain would find no connection, Picasso's did. His hands finished the job and translated the image that had been in his head into something that could be seen and touched. When Picasso's inner vision had been given this outer physical form, ordinary people like you and me could understand what had come into his mind. We could share his discovery.

With their eyes, minds, and hands, artists create works of art. We could say "make" works of art, but "make" is the word we use for the production of the usual run of things with easily predictable results. Great artists constantly astonish us in the remarkable images they produce. They have the urge and the ability to look at the world and find something new and original, rich and intense. Such is the nature of the artistic imagination.

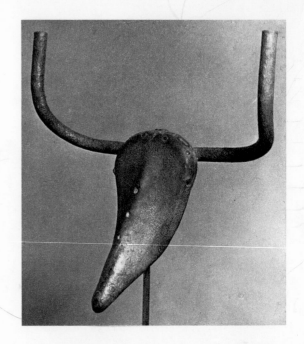

2. Pablo Picasso. *Bull's Head.* 1943. Handlebars and seat of a bicycle, height 16⅛″. Galerie Louise Leiris, Paris. It was easy in this case for the artist's hands to carry out the commands of his imagination and create this visual "pun." Usually the material with which an artist works has no shape of its own, and is changed into an interesting image only gradually and with difficulty through many operations, as the artist's hands respond to one leap of the imagination after another.

The Magic Art of Cavemen and Primitive Peoples

THE OLD STONE AGE

The first pictures and sculptures we know of were made in the Old Stone Age, some 20,000 years ago, by people who lived in caves. Their biggest worry was how to find enough to eat. They had not yet learned how to keep cattle or raise crops, so for their food supply they depended mainly on the hunting of wild animals. When the hunting was poor, they had to go hungry. There were, of course, various birds and fish and small animals they

could catch, and nuts and berries they could pick, but these were not enough to live on. They always hoped to kill something big— a deer, perhaps, or a buffalo—that would yield enough meat to last them for some time. They were eager to kill these animals; they were afraid of them too, for as yet they had only the simplest of weapons. In fact, they knew nothing of metal, so that whatever tools they had were made of wood, bone, or stone. And they had to hunt on foot because they had not yet learned how to tame horses.

No wonder, then, that the cavemen's minds were always full of the idea of hunting large animals for food, and of how dangerous this was. And because they thought so much about these things, it is not surprising to find that almost all of their paintings and sculptures are of these animals.

How did the cavemen learn to make such pictures? We don't know for sure. But since the pictures were done on the walls of caves, which are rough and bumpy, it is possible that the idea of making pictures came from these bumps, just as ink blots suggest ideas to us. Some hungry caveman, staring at the walls of his cave, imagined, perhaps, that a particular bump looked like an animal and drew an outline around it with a burned stick from the fire. He could then complete the picture by filling in the missing parts. He could finally have learned to make such a drawing all by himself, without the help of the bump on the cave wall.

Figure 3 shows a painted cave wall as it really looks. You will notice that the animals are all scrambled together without any kind of order. Once you get them sorted out, you can recognize each one easily. Why, then, did the cavemen spoil their pictures by doing one on top of another? Because they did *not* want them for decoration. Even if the pictures were not such a jumble, we could tell this from the fact that all the caves with pictures in them are very dark and difficult to get into.

If the cavemen artists had done their animal paintings merely for pleasure, they would have put them near the cave entrance, where everybody could have looked at them. As it is, they are often so well hidden that they were discovered only recently and by chance. The cave in figure 3 was, in fact, found in 1940 by some boys who had gone out hiking with their dog. Suddenly the dog was gone, and in looking for him they found the hole, overgrown with brambles and weeds, through which he had fallen into the cave.

But what were the pictures for, then? They must have been a kind of hunting magic, because some of the animals have spears sticking into them. The cavemen must have thought that if they made a painting that looked convincingly real and then "killed" it, they were doing something almost like killing the animal itself. Perhaps they threw stones at it, too, and jabbed it with real spears. This would have made them feel stronger and surer, so that when they finally went out to hunt their prey, they had a better chance of success because they were no longer afraid. Once they had "killed" the picture, they did not care about it any more. One cannot kill a real animal twice, and so they felt that one cannot kill a painted animal twice, either. The next

3. Cave painting. About 20,000 B.C. Lascaux (Dordogne), France. The animals shown here are stags, wild horses, and wild cattle. Except for a few done as a group, the images overlap without any kind of order. There are great differences in scale—the largest figures are lifesize.

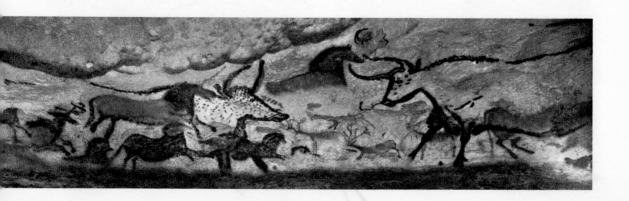

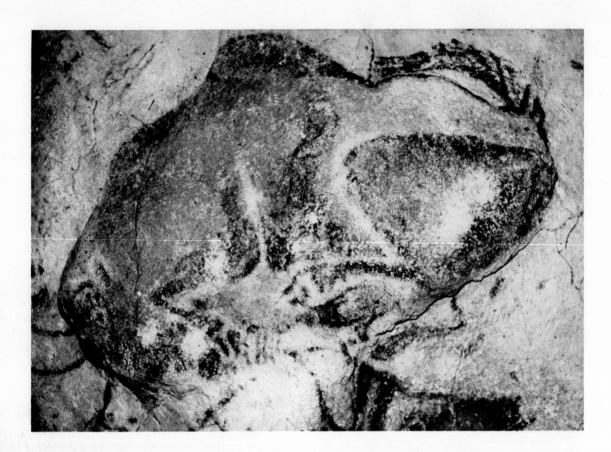

4. *Wounded Bison*. About 15,000–10,000 B.C. Cave painting. Altamira, Spain. Dignified and powerful, this dying animal lowers his head in his final agony. Strength is suggested by the vigorous, sure outlines; roundness, weight, and bulk are suggested by the shading inside. The artist's keen observation of nature makes the whole picture lifelike.

time they got ready to hunt, they had first to make a new picture to kill.

It is remarkable that the cavemen took so much trouble with their animal paintings. After all, they were going to use them only once. Perhaps they felt that the magic would work best if the animal looked as much like the real thing as possible. And they were probably right, since they used the pictures as targets that would help them to learn exactly where to hit the animal in order to bring it down.

In any case, it took a great deal of skill to make such convincing pictures. Some cavemen must have been better at this than the rest, men who had special talent for art. After a while they were probably allowed to stay at home and practice the making of pictures while the other men had to go out hunting. Even 20,000 years ago, then, it would appear that the artist was a special kind of person, although we might say that he was mainly supposed to be a magician.

In addition to making large cave paintings for magic purposes, the men of the Old Stone Age collected hand-sized "magic" pebbles, much as today we collect intriguing stones and shells along the seashore. To improve magic pebbles or magic pieces of horn or bone into drawings and carvings of people and animals was as natural to the magician-artist as to improve a bump on a cave wall into a painting of a bison. Thus sculpture in the round was born. The so-called *Venus of Willendorf* (figure 5) is round and bulbous, re-

minding us of an egg-shaped sacred pebble. And the masterful *Bison* (figure 6) owes its compactness to the shape of the piece of reindeer antler from which it was carved.

Today we no longer get mixed up between living things and the pictures of those things. But even now our feelings sometimes get confused, no matter what our reason tells us. For instance, it still happens that after a quarrel people will tear up the photograph of someone they used to love. They know well enough that they cannot actually hurt anybody by doing so, but it gives them emotional relief. We need hardly be surprised, therefore, that the men of the Old Stone Age, who understood very much less than we do about the difference between thinking and feeling, could get pictures confused with real things.

below:

5. *Venus of Willendorf*. About 15,000–10,000 B.C. Stone, height 4⅜″. Museum of Natural History, Vienna, Austria. Carved from an egg-shaped piece of limestone with a sharp flint tool. This tiny, bulbous female figurine was probably a mother symbol, whose magic would provide the tribe with offspring.

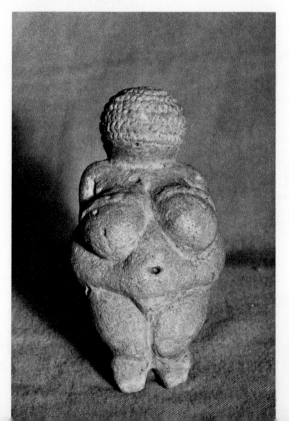

Art is always as much concerned with the way people feel about things as it is with the way things really are. Usually both knowing and feeling go to make up a picture, and so paintings are different from one another, depending on whether the artist was more interested in what he saw or knew, on the one hand, or in what he felt, on the other.

THE NEW STONE AGE

The cave pictures tell us a great deal about the way our imagination works as well as about life in the Old Stone Age. We say *our* imagination, because the minds of the cavemen were not really so very different from our own—otherwise we would not understand their pictures so well as we do. The difference between us and the cavemen is not in the kind of minds we have; it is in what we think about and feel. Because whatever is in people's

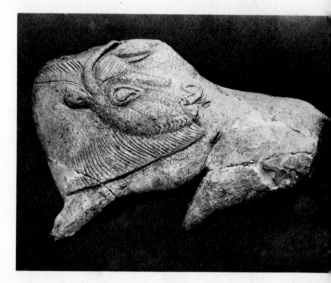

above:

6. *Bison Licking Its Flank*, from La Madeleine near Les Eyzies (Dordogne), France. About 15,000–10,000 B.C. Reindeer horn, length 4″. Museum of National Antiquities, St.-Germain-en-Laye, France. This tiny carving, skillfully cut by means of a razor-sharp flint knife, is a worthy companion to the splendid cave paintings of deer, horses, and bison.

minds finds its way into art, works of art will help us to understand how men managed to leave the life of the Old Stone Age behind, and how, over many thousands of years, they gradually changed into the kind of men that we are today.

Even though the cavemen may have been stronger than we, their life was much more dangerous than ours—and much less interesting. The big animals they hunted were really their masters, because the people depended on them so completely. When the animals moved away, the men had to move, too, so they never built houses for themselves, only rough shelters. If they could find no animals to hunt, they starved. In the Old Stone Age, men worked together only in hunting (the painters helped, too, with their magic), but today we cooperate in a thousand complicated ways. We depend on one another far more than the cavemen did.

Now, our modern way of living could come about only because we are very much more orderly than the people of the Old Stone Age.

We think ahead. We *plan* things, whereas the lives of the cavemen were just as disorderly as their paintings. When did people discover the need for order? Just as soon as they found that there were ways of controlling their food supply instead of letting their food supply control them. First they learned how to tame and keep some of the animals they had hunted before. They became herdsmen who moved about with their sheep, goats, cattle, or camels, always looking for grazing lands. Other people found a different and still better way to control their food supply. They tamed not only animals but plants, saving the seeds and growing their own crops.

Once they had made certain of a regular food supply, men were able to settle down permanently in villages. They no longer lived in little bands tied to the wanderings of big game. A stable way of life brought the construction of houses and tribal council chambers in wood and other materials. Thus architecture was born. There were other great inventions, too: basket making, cloth weav-

7, 8. *The Great Circle.* About 1800 B.C. Diameter of circle 97'. Height of boulders above ground 13½'. Stonehenge, England. In Northern Europe, the New Stone Age persisted for 2,000 years after historic civilization had begun in Egypt and the Near East.

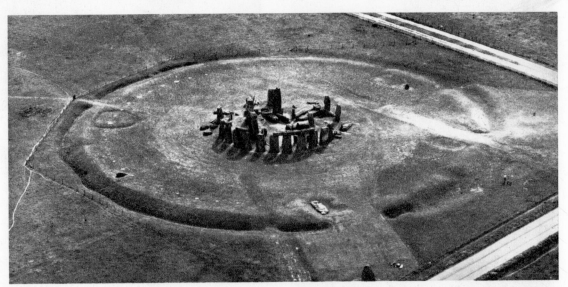

ing, pottery. Perhaps of the greatest significance was religious faith, which brought a new sense of order into people's thinking and feeling.

So tremendous a change as this in man's way of life we call a "revolution." The New Stone Age was a real revolution, even though it was thousands of years in the making, and though it was thousands of years more before metals replaced stone as the material for tools and weapons. In Europe, in fact, the New Stone Age way of life continued long after metals came to be used.

Figures 7 and 8, the Great Circle of Stonehenge, show you a structure built—that is, first planned and then put together—of huge, craggy boulders, some set upright and others laid across the uprights. All together, they form a large double circle with an altar-like stone in the center. They are so arranged that on the first day of summer, the sun's first rays strike precisely on the altar stone.

Each of these stones weighs many tons. What a difficult task it must have been to drag them by sheer muscle power across a long, empty plain and then erect them into this crude-looking but impressive structure. There seems something awe-inspiring and superhuman about the Great Circle. Indeed, not so many centuries ago, it was thought to have been built by a forgotten race of giants. It would be hard for us to build it today, with all our modern equipment. What inspired the sustained teamwork required for a creation so disciplined and imaginative? Nothing less than the powerful emotions aroused by religious belief.

The Great Circle must have been a setting for religious services connected with the sun. The men who built it must have wanted to make it different from such ordinary buildings as their houses, in view of its greater importance. Thus it was made to be impressive and to last indefinitely. Where our highest aspirations and purposes are involved, we always create the grandest monuments of which we are capable and constantly try to reach new heights of grandeur.

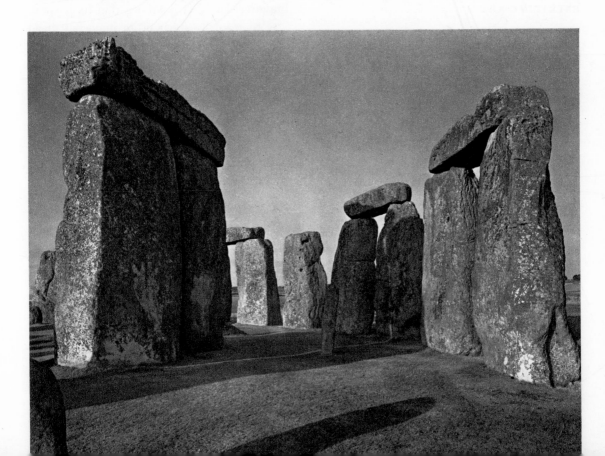

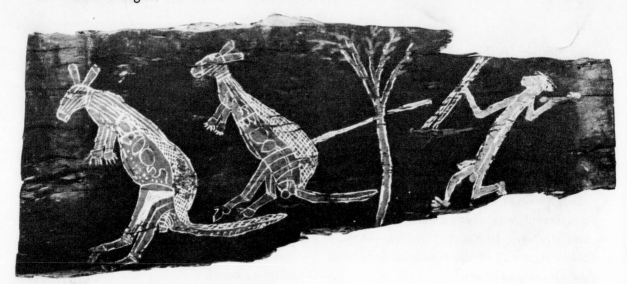

9. *A Spirit Man Spearing Kangaroos*. About 1900. Painting on tree bark. Western Arnhem Land, North Australia. The drawings of these natives are modern survivals of Old Stone Age art. Their magic purpose is evident; not only are they done on pieces of bark so that they could actually be taken along on the hunt, but they are "X-ray pictures" meaning that they show some of the bones and inner organs of particular importance to the hunter.

PRIMITIVE ART

A very few societies have kept their Old Stone Age way of life until the present day (see figure 9). Other societies—especially in tropical Africa, the islands of the South Pacific, and North and South America—passed through the New Stone Age revolution and stopped there, never going on to develop cities and states, writing and civilization. These societies we call "primitive."

The cave art of the Old Stone Age and the architecture of the Great Circle of Stonehenge have already shown us how closely art depends on the way people live and think. Therefore, it is reasonable to believe that primitive art has many similarities with the lost art of our own New Stone Age ancestors and can also tell us a great deal about their lives.

Figure 10 shows you a large primitive wood carving of a man with a bird rising above his shoulders. It is a "magic" piece of sculpture, but its magical purpose is not that of the Old Stone Age sculptures we have seen (figures 5 and 6). Those sculptors tried to create life —the purpose of the bison carved on reindeer horn was the creation of bison to be hunted; the purpose of the Venus of Willendorf was the creation of human beings to do the hunting. This primitive figure tries to perpetuate life after death. It is known that its purpose was to trap the spirit of an important dead person—a tribal chief or ancestor—and thereby to gain control over his power and ability, using these powers for the welfare of the tribe. The primitive sculptor believed that this spirit or soul was located in the head. For this reason, the head has been made all-important, with intensely staring eyes made of sea shell. It may not be a true portrait of the dead ancestor in the sense that it resembles him closely, but who it is has been made clear by the scratched and painted tattoo marks. The rest of the body has been reduced to a mere support for the head. The great sea bird with outstretched wings represents the ancestor's life force or spirit.

At first glance, you may find this ancestor figure odd and savage, and indeed it is. But a ferocious expression is appropriate to a guardian spirit who protects against enemies

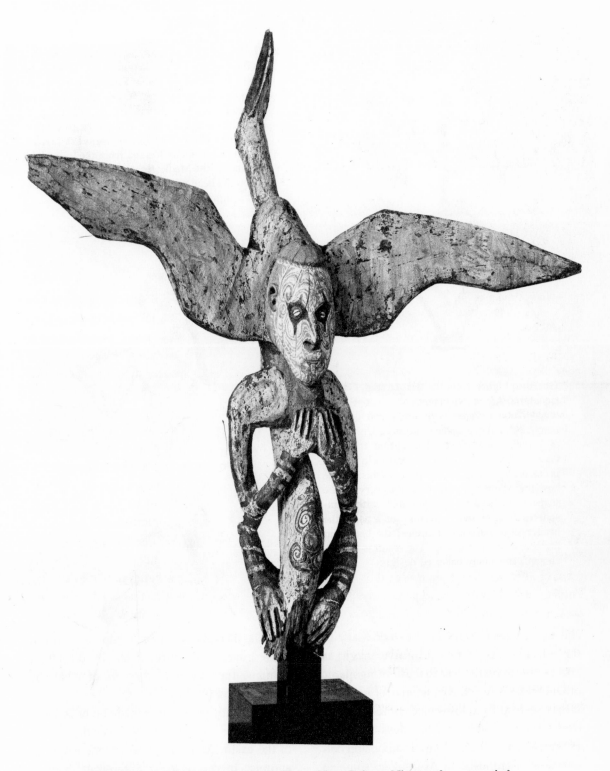

10. *Male Figure and Bird*, from the Sepik River, New Guinea. Nineteenth or twentieth
century. Wood, height 48″. Washington University Art Collection, St. Louis. The
soaring movement of the "soul bird," the contrasting rigidity of the human figure,
the intense stare, the boldness of the shapes, all combine to create a powerful and
arresting image.

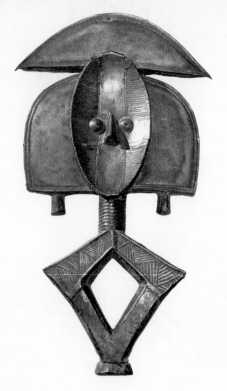

above:

11. Guardian Figure, from the Bakota area, Gabon, Equatorial Africa. Nineteenth or twentieth century. Wood covered with brass and copper, height 30". Ethnographic Collection, University of Zurich, Switzerland. The native tribes of Gabon collected the skulls of ancestors in baskets protected by such guardian figures as this. Notice how the whole figure is reduced to very simple shapes—the head to a hollow dish with hemispheres for eyes and a pyramid for a nose; the headdress to portions of circles; the body and limbs to an open diamond. The result is a calm, elegant, and finely balanced design.

below:

12. *Hornblower*, from Benin, Nigeria. About seventeenth century. Bronze, height 24⅞". The Museum of Primitive Art, New York. The artists of the kingdom of Benin produced, in addition to ancestor figures, many works that had nothing to do with the spirit world, but served to glorify the ruler and his court. These works are cast in bronze, a technique learned from the high civilizations of the Mediterranean. Here, the emphasis on the head reveals a kinship with tribal ancestor figures in wood.

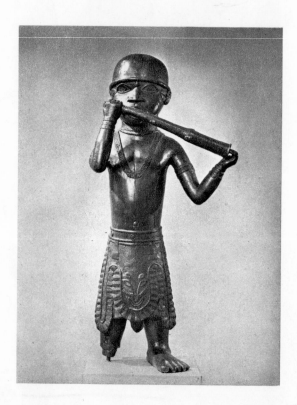

and evil demons. Ferocity is as necessary to the effectiveness of this primitive magic as faithfulness to reality was to the hunting magic of Old Stone Age art. Art, no matter how odd it may seem at first, loses much of its strangeness when we understand the ideas behind it. Primitive art is much admired today, and collected with enthusiasm. Moreover, some of our own ideas are not too different from those we find in primitive art. The Christian religion, too, has a "soul bird," the dove of the Holy Spirit. And in our public places, we set up portrait heads or busts of heroes and famous men as often as complete statues; these guard our future, if not by dispelling demons, then by reminding us of what the heroes stood for.

The primitive world is made up of isolated little groups widely scattered over the surface of the earth. Accordingly, from one group to another, there are great differences in manners and customs as well as tremendous artistic variety (see figures 11–16). But all have ancestor worship in common, and in all, the sculptured ancestor figure is an important type of art.

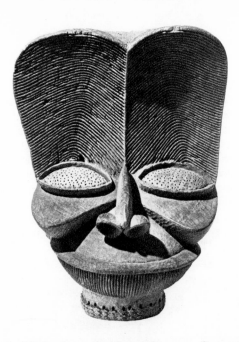

13. Mask, from the Bamenda area, Cameroons, Equatorial Africa. Nineteenth or twentieth century. Wood, height 26½″. Rietberg Museum, Zurich, Switzerland. E.v.d. Heydt Collection. African masks are noted for their symmetrical design and sharp, precise carving. Eyes, nose, chin, and mouth have been remade into an exciting pattern. The eyebrows, fantastically enlarged, loom over the face like a canopy.

14. Mask, from southwest Alaska. About 1900. Wood, height 22″. Museum of the American Indian, Heye Foundation, New York. All that we can recognize in this strange-looking Eskimo design is the single eye and the mouthful of teeth. To those who know how to "read" this set of shapes, however, it is a description of a tribal myth about a swan that drives white whales to the hunters.

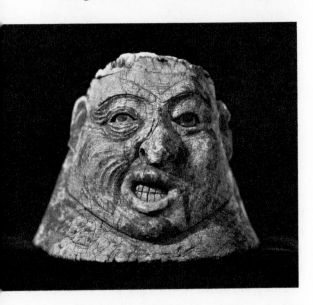

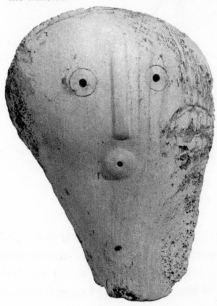

15. War Helmet (Tlingit), from southeast Alaska. Early nineteenth century. Wood, height 12″. The American Museum of Natural History, New York. Of Indian, not Eskimo, origin, this helmet is strongly realistic. It is very like a mask, for it is a second face intended to scare the enemy by its fierce expression.

16. Mask, from the Brakebill Mound, Tennessee. Probably between 1000 and 1600. Ocean shell, height 8⅝″. Peabody Museum, Harvard University. This fascinating mask comes from an American Indian burial mound. A little carving and drilling have changed the sea shell's outer surface into a face. Such masks provided the dead with a second, everlasting face in order to trap his spirit underground forever.

17. *Men, Boats, and Animals.* About 3500 B.C.
Wall painting. Hierakonpolis, southern Egypt.
Compared with the cavemen's paintings, this
picture has a flat, pattern-like effect. There is no
shading any more, and the simplified figures look
like a kind of shorthand. They are carefully
planned, however, to cover the surface without
crowding or overlapping. This sense of order is
a new, important achievement.

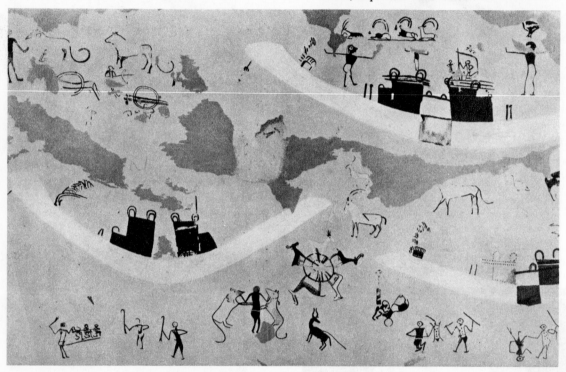

Art for the Dead—Egypt

THE OLD KINGDOM

In Egypt, Mesopotamia, India, and China, about five thousand years ago, a great development began to take place along the fertile banks of the Nile, Tigris, Euphrates, Indus, and Yellow rivers. Loosely organized tribal groups of herdsmen and farmers gave way to highly organized states ruled by kings who took charge over large populations and wide areas. There were new centers of population —cities. Some became as big as hundreds of villages. In the cities, life became richer and more complex: people were divided into social classes according to the work they did, becoming slaves, soldiers, priests, and craftsmen. The cities were also centers of power. They had fortification walls, military garrisons, and royal palaces.

This giant step forward from the New Stone Age is called "civilization." It did not take place by accident. The New Stone Age had decided once and for all whether men would be overwhelmed by nature. Could they survive on the surface of this planet? They could. But could they survive what came next: the disagreements and quarrels among themselves, the theft of their crops and herds by outsiders,

the thinning of numbers in wars and battles? Again, they could—but only by submitting to the rule of the sword and the rule of law.

There were great men in early historic civilizations, and great deeds—the first that have come down to us. They have come down because of the invention of writing. Indeed, the ability of the early Egyptians and Meso-potamians to keep records made their civiliza-tions "historic."

The changeover from the prehistoric to the historic way of life in Egypt took a surprisingly short time. We can follow it in works of art created only a few hundred years apart. The first of these works is the oldest painting in Egypt. Figure 17 shows a part of it. It was painted on the wall of a tomb in a place called Hierakonpolis, on the banks of the Nile, about 3500 B.C. There are some lively animals in it, and people fighting with them and with one another. The big white shapes are boats. At that time, then, the Egyptians still did a great deal of hunting, but they no longer depended on it as the cavemen had. They knew how to make and use all sorts of tools, for they built solid buildings with smooth walls of brick and stone, and boats for sailing up and down the river. Along the valley, there must have been many separate tribes that made war on one another. Notice the two figures in the lower right-hand corner; the man with the white, dotted body is beating the man with the black body, who belongs to another tribe.

If we compare this picture with cave paint-ings, we find that the figures in it do not look nearly so real. There is no shading; they seem flat, as if glued to the wall; and the artist has left out many details. He uses a kind of short-hand as some comic strips do today, so that a circle with a dot stands for a face, a crooked line for an arm, and so on.

There is something else that we notice about the Hierakonpolis painting. We cannot tell whether the figures in it are supposed to be connected in some way, for there is no setting, no indication of landscape or even of the ground they stand on. But there is no messy overlapping, either, and the figures are spread evenly over the whole surface. These animals were not painted to be "killed" for hunting magic.

Egyptian art is connected with another, more complicated form of magic. In order to understand it, we must know something of Egyptian ideas about religion, especially about life and death. These ideas the Egyp-tians expressed in their tombs at a very early time.

Figure 18 brings us squarely into the historic period, when life advanced rapidly and great kings called Pharaohs ruled with absolute power over a united kingdom. We are obviously in the historic era of Egyptian civilization, for we know the name of the king for whom this man-made "mountain" was built. His name—Zoser—has been preserved for us in hieroglyphics, the early Egyptian form of picture writing. The name of the architect is also known—Imhotep—the first recorded artist in all history. King Zoser's funerary district, of which the step pyramid was a part, is the earliest architectural monu-ment of solemnity and grandeur that we know. Even to us, it is tremendously impressive. To the early Egyptians, it was so amazing an achievement that its creator, Imhotep, was made a god.

King Zoser's funerary district included palaces, temples, courts, and burial cham-bers (figures 18, 19). The pyramid of steps, built of stone, took up only a small part of its area. It was absolutely solid and rose high above the plain to form a great landmark that would last forever.

"Forever" was a very important idea with the Egyptians. Like the men of the New Stone Age, they believed that a man had a vital

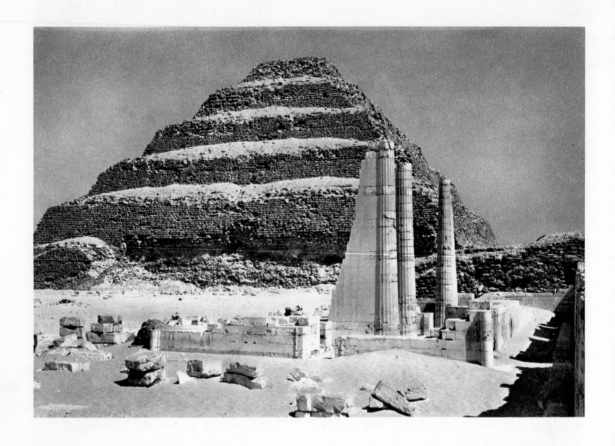

above:

18. Step Pyramid of King Zoser, Saqqara, Egypt. Old Kingdom. About 2750 B.C. In the foreground are the remains of the South Palace of Zoser's funerary district. Attached to the palace walls are tall, slender, tapering columns. These are not smooth and round, but have many vertical bevels.

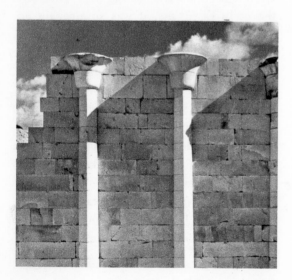

spirit, or soul, inside him. When a person died, his soul left his body and kept on living separately. They also thought that in this afterlife, the soul still needed a body to come back to. Because of this, they went to great trouble to preserve the bodies of the dead. They made mummies of them by drying them and wrapping them up, and then put them in strong tombs so that nobody would disturb them. Pharaohs and great nobles even had statues of themselves placed in their tombs as "replacements" if something should happen to the real body.

The Egyptians also believed that the spirit

left:

19. Papyrus Half-Columns, North Palace, Funerary District of King Zoser, Saqqara. Old Kingdom. About 2750 B.C. These slender, graceful half-columns were inspired by the shape of papyrus plants, which are found in the marshes of the Nile delta in northern Egypt—hence they enliven the fine masonry walls of the North Palace.

of the dead needed the same material things as a living person, so they furnished their tombs like regular households, except that everything was supposed to last forever. Of course, even the richest man could not take with him into the tomb all the things he owned, such as his land, his animals, and his servants. Instead, he had pictures of them made on the walls, where his spirit would find them.

Thus, in ancient Egypt, tombs almost monopolized architecture, sculpture, and painting—which were all truly an art for the dead.

The developed style of Egyptian tomb art can be seen in full beauty in a funerary portrait of the scribe Hesy-ra, one of Zoser's high officials (figure 20). This example is perhaps seven hundred years later than the Hierakonpolis mural, and is carved in wood in very low relief rather than painted on a wall. It obeys the rules for pictures and reliefs established in the Old Kingdom and maintained throughout Egyptian history. Note how the eye and shoulders are in front view; how head, waist, and legs are in side view. A walking pose is shown us, but Hesy-ra is utterly motionless. By contrast, the Hierakonpolis mural stick figures seem very lively—even though childishly done. There is nothing childish-looking about Hesy-ra, however. The modeling is subtle and delicate, the carved outline harmonious and pure. Details are rendered with extreme accuracy by a sculptor who knows appearances and has the ability to render what he knows.

Zoser's early successors had an equal passion for colossal funerary monuments that would last until the end of time. In Giza, in northern Egypt (near present-day Cairo), they created three great pyramids—true pyramids this time, rather than pyramids built of steps. The Pharaoh Cheops—who may have been Zoser's grandson—erected sixty million tons of stone into a solid, glass-smooth mountain nearly five hundred feet

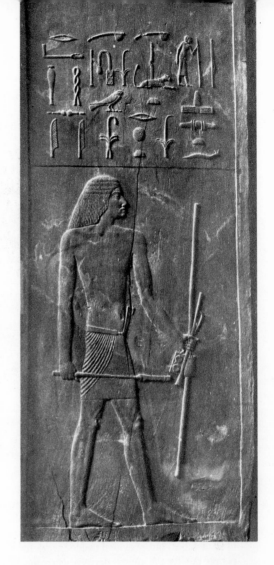

20. *Portrait Panel of Hesy-ra*, from Saqqara. About 2750 B.C. Wood, height 45″. Egyptian Museum, Cairo. This masterly relief portrait shows the dead man with the emblems of his rank. These include writing materials, for the position of scribe was highly honored.

high. This was the earliest and largest of the Great Pyramids. In figure 21 you see it on the extreme right. Originally, it had a stone casing so accurately fitted together that a knife blade could not be forced into the joints. The royal burial chambers were in the center of its mass.

Almost as large, but intended to be larger, was the second pyramid, erected by Cheops's brother Chefren. This is the middle pyramid in figure 21. Chefren was a greater builder than Cheops, for it was he who had hewn out of a rocky bluff the huge human-headed lion,

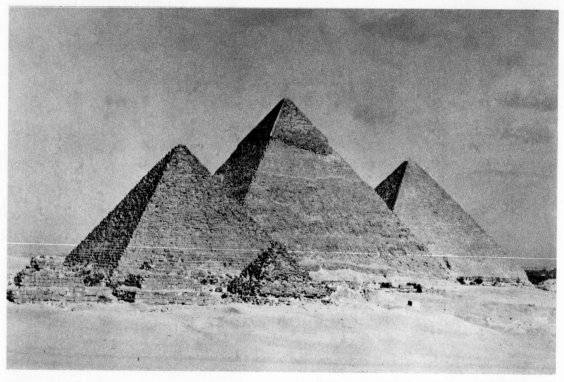

above:

21. Pyramids of Mycerinus (about 2500 B.C.), Chefren (about 2530 B.C.), and Cheops (about 2570 B.C.), Giza. The four corners of each pyramid face the four points of the compass with absolute precision. The pyramids were not built by gangs of slave labor, but provided needed work for the people during the annual periods when the Nile overflowed its banks and prevented the tilling of the land.

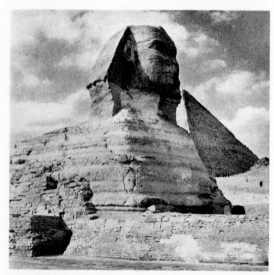

22. *The Great Sphinx*. Old Kingdom. About 2530 B.C. Giza. The colossal head rises to a height of sixty-five feet.

the Great Sphinx (figure 22). This embodiment of Pharaonic power and wealth bore the features, probably, of Chefren himself.

The statues unearthed near the Great Pyramids belong to the golden age of Egyptian sculpture. Figure 23 shows you a "replacement" statue of Mycerinus—builder of the third pyramid—and his wife. They are rigid-looking figures, congealed and motionless. The arms and hands are held stiffly. The faces point straight ahead. Notice here how the statues have no holes or openings, just like a stone block. The left foot is advanced, according to the rules set for statues shortly before the Old Kingdom began, but a sheet of stone connects it with the stone slab that backs up both figures.

It would seem that the block of stone out of which the sculptor carved Mycerinus and his queen has not only shaped the sculptor's ideas, but also set limits to them. This is how the sculptor worked. On each of the four main faces of the block he drew an outline view—a side view at the sides, a front view at the front. Then, following his outline, he

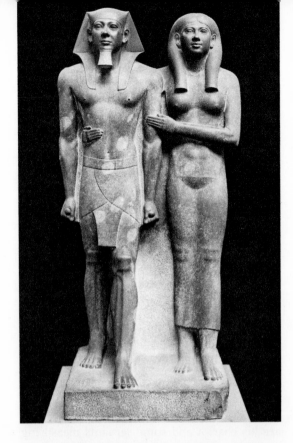

23. *Mycerinus and His Queen*, from Giza. Old Kingdom. About 2475 B.C. Slate, height 56″. Museum of Fine Arts, Boston. Here the artist takes pains to preserve, as much as possible, the block from which he chiseled these figures: he has left stone where a hole or opening might be expected. The "false beard" beneath the Pharaoh's chin is an emblem of divine kingship.

drilled at right angles to each face of the block. The figure was then roughed out. After that, he rounded it off, cut in details, and carefully polished the completed work. When all this was over, the onlooker still had some sense of the stone cube with which the sculptor had begun.

Let us note that the look of this pair is not entirely a matter of rules. There is direct study of nature here, in spite of the iron discipline which the sculptor had to follow. Both heads are clearly portraits. But accurately rendered though they are, they seem handsomer, nobler, more symmetrical than they would be in real life. We call such treatment idealization—a term we shall use rather often in this book, although in a different way for different types of art. Idealization was considered proper to such important subjects; the majesty and serenity that have resulted from its use here are symbolic of the grandeur of a god or a Pharaoh. The bodies have not been studied with anything like the care put into the heads. The heads are sufficient for identification; the rest is determined by the set rules.

Note how skillful this work is. There is nothing awkward or hard here. The sculptor's accomplished chisel knew how to make the surfaces rounded and supple. Even though the artist worked according to a rigid set of rules, there was room inside these rules to achieve both strength and refinement.

Colorplate 1 shows us another type of statue made according to the strict rules of the Old Kingdom: the seated pair. This pair owes its strikingly lifelike appearance to the vividly painted surface. Rahotep is shown darker than his wife—in Egyptian art men are always darker than women. The eyes have been inlaid with glittering stones. The faces, in keeping with this emphasis upon surface detail, are more individual than the highly idealized faces of Mycerinus and his queen, and therefore are more clearly portraits.

THE NEW KINGDOM

The Pharaohs of the Old Kingdom placed much power in the hands of great lords who ruled over the various provinces of Egypt. Eventually these lords became so powerful that they overthrew the Pharaoh, putting an end to central, unified government. Five unsettled centuries of political disturbance and changing fortunes followed, as provincial rulers struggled for supremacy over all Egypt.

The princes of Thebes, in the south, won out in this struggle. They became stronger than their competitors and established a flourishing local art and culture from about

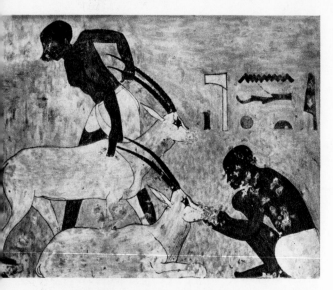

24. *Feeding the Oryxes*, from Tomb of Khnum-hotep, Beni Hasan. Middle Kingdom. About 1920 B.C. Southern Egypt. In the topsy-turvy life of the Middle Kingdom, painters did not feel so strictly bound by the Old Kingdom rules. This artist has boldly, if awkwardly, foreshortened the shoulders of the two servants who are attending to the needs of the dead prince's pet antelopes. The graceful outlines of the antelopes have been drawn with great skill and assurance.

2100 to 1800 B.C. This period of comparative stability and peace is called the Middle Kingdom. Egypt as a whole remained weak and divided, however, and was an easy prey to invasion by Asiatic tribesmen under the so-called Shepherd Kings.

The Shepherd Kings ruled Egypt harshly for 150 years. They made a genuine contribution to later Egyptian life, nevertheless, for they brought in the horse, the chariot, and new weapons of war. In particular, they did away with the local overlords, except for the princes of Thebes, whom they never managed to subdue completely. Thus they removed the greatest obstacle to the centralization of Egypt.

Around 1570 B.C., the princes of Thebes expelled the invaders and restored single rule over all Egypt. They became the new Pharaohs, richer and more powerful than those of the Old Kingdom. Egypt became an empire, extending its rule far beyond its own borders. This renewal of Egypt's golden age is known as the New Kingdom, and it lasted for five centuries.

New Kingdom art was tremendously varied. Mostly it adhered to the strict rules for painting and sculpture established two thousand years before, but sometimes it showed great freedom. It could be massive and overpowering or delicate and refined.

Figure 25 shows you a painting still done, for the most part, according to the prescribed rules laid down just before the Old Kingdom. It is a tomb painting of a harvest scene. At the top, the dead man's servants are measuring a wheat field with a rope. At the bottom, they are cutting the wheat with sickles, while the deceased himself sits under an awning that protects him from the sun. In the center are his chariot and some servants measuring a pile of grain. The figures are still put together in the same strange way that we saw in the low-relief carved panel from the tomb of Hesy-ra: heads, arms, and legs in side view, eyes and bodies in front view. They seem stiff and motionless. But look at the horse. Its dappled color, its prancing movement, make it gay and lively. Now, horses were unknown when the rules for painting were set up—so the painter was not bound by such strict rules when depicting a horse.

How much freer, by comparison, is the tomb painting of flute players and dancing girls (figure 26). Not only do the dancers seem alive and moving, but they are shown completely from the side; except for their eyes, they are not a combination of side and front views. The arms and faces of two of the flute players are shown from the front. Their eyes actually meet ours! The arm of the musician at the right of the group is foreshortened —in using this device that shows depth we see a radical departure from the absolute flatness of the traditional Egyptian style.

An even more radical departure from Egyptian tradition was the reign of the

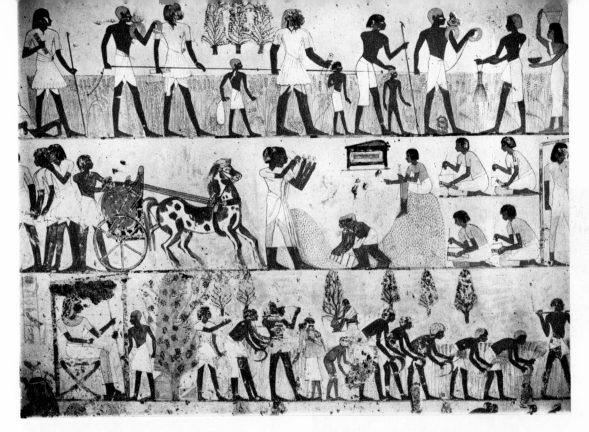

25. *Harvest Scenes*. New Kingdom. About 1400 B.C. Thebes, southern Egypt. Here the sense of order has congealed into a strict set of rules which the Egyptian painter respected for almost 3,000 years. Characteristically enough, the measuring of the fields (at the top) and the exact recording of the yield (in the center strip) were just as important to the Egyptians as the actual cutting of the grain (bottom right).

26. *Girl Dancers and Musicians*, from Thebes. New Kingdom. About 1400 B.C. British Museum, London. The well-to-do Egyptian was willing to forego few pleasures in the hereafter. The painter has captured the girls so well that we can almost hear the piercing music.

Pharaoh Akhenaten, who broke away from the grip of the most conservative force in Egyptian life, the powerful priesthood of the supreme god Amun. The priests of Amun were so rich and strong that they were a threat to royal authority. Akhenaten proclaimed belief in the one god, Aten, which means simply "Lord." Aten had no human form; his symbol was a sun disk. Akhenaten closed Amun's temples and moved his capital away from the centers of Amun worship. In his new capital, he encouraged the creation of the lively new style of art.

In figure 27 we see a tiny relief sculpture of Akhenaten himself. We see once more the attempt to show some depth: parts of this portrait—the nose, the lips, the chin, the ear —are in higher relief than other parts and suggest roundness. Moreover, there is noth-

27. *Akhenaten*. New Kingdom. About 1365 B.C. Limestone, height 3⅛″. State Museums, Berlin. This Pharaoh was originally Amenhotep IV. When he changed from Amun to Aten worship, he changed his name to "Akhenaten," which means "Aten is satisfied."

28. *Queen Nofretete*. New Kingdom. About 1365 B.C. Limestone, height about 20″. State Museums, Berlin. This portrait bust of Akhenaten's wife is fully colored and astonishingly lifelike.

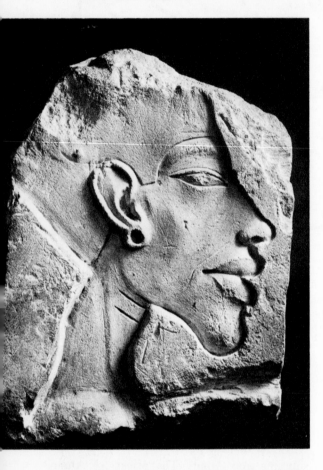

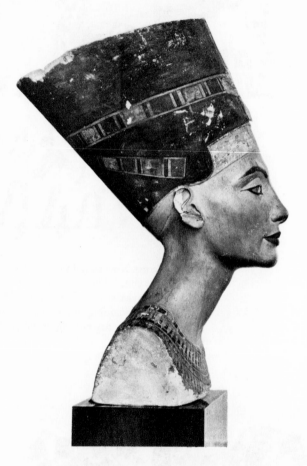

ing of the idealization that we saw in the Old Kingdom portrait of Mycerinus. Not only is Akhenaten almost caricatured—his head and face seem misshapen—but there is no godlike, expressionless serenity here. The sculptor tells us what kind of man Akhenaten was— sensitive, troubled, intellectual. This is a psychological portrait.

The masterpiece of the Akhenaten style is the famous colored bust of Akhenaten's queen, Nofretete (figure 28). What makes this sculpture seem so real to us? Not its accuracy of detail, nor its subtlety and refinement— these qualities are found in the conservative, frozen style too. Nofretete seems to live and

breathe; she is pliable and relaxed; she is a person, not a formula.

The Akhenaten style gradually faded after the Pharaoh's early death. The priests of Amun regained their authority, and the conservative style returned. But there is still a trace of the expressiveness of the Akhenaten style in the magnificent gold and jeweled coffin of Tutankhamen, the boy Pharaoh who succeeded Akhenaten and died only a few years later (see colorplate 2).

In the remaining four centuries of imperial power and priestly control, the Pharaohs continued to build temple-tombs. But the greatest architectural energies were devoted to huge

temples of Amun. The enormous temple of Amun at Luxor (figures 29 and 30) took more than a century to build. Its plan is characteristic of later Egyptian temples: many courts, halls, and rooms are balanced along a narrow passage that travels from the beginning of the temple all the way to the end. The face of this temple is a monumental gateway, or "pylon"—an entrance set between two broad oblong towers with sloping sides. Beyond is a walled and pillared court, its plan slanted to follow the direction of the river Nile. A covered pillared hall brings us to another pylon and court, which is followed by another hall. This was as far as the worshipers could go. Only priests and royalty could go on through the suites of rooms and halls—ever lower, darker, smaller—culminating in the holy of holies, which could be entered only by the Pharaoh and the high priest of Amun. The forest of columns that screened the worshipers from the deeper recesses of the temple made the onlookers feel almost crushed by sheer mass. The effect is overawing, but also coarse and ostentatious when compared with the early masterpieces of Egyptian architecture (see figure 19). Little of the genius of Imhotep survives at Luxor.

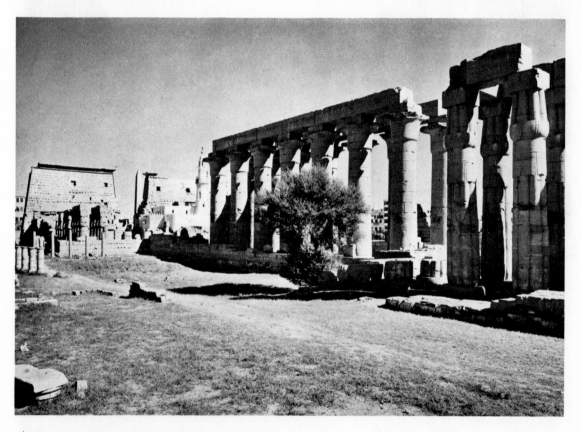

above:

29. Temple of Amun, Luxor. New Kingdom. The entrance pylon in the background was built by Ramesses II about 1260 B.C. The colonnade in the foreground was built by Amenhotep III about 1390 B.C.

right:

30. Plan of Temple of Amun, Luxor (after N. de Garis Davies)

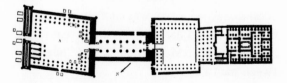

31. Interior of "White Temple," Uruk (Warka). Before 3000 B.C. This is the main room, a long hall with chambers to the left and right. Sacrifices were offered on the altar, which is shown in the middle of the picture.

Temples, Palaces, and Citadels—
The Ancient Near East and the Aegean

MESOPOTAMIA

It is astonishing that men should have emerged into the light of history at the same time in separate places. Between 3500 and 3000 B.C., when Egypt was being united under the rule of the Pharaohs, another great civilization arose in Mesopotamia, the "land between the two rivers."

Unlike the valley of the Nile, which is protected by desert and sea, the land between the Tigris and the Euphrates is exposed on all sides. It was hard to unite this area under a single monarch like the Pharaoh. Thus Mesopotamian history is a chronicle of rivalries between local city-states, of foreign invasions, of the sudden rise and equally sudden collapse of political and military power.

The founding fathers of Mesopotamian civilization were the Sumerians, a people of

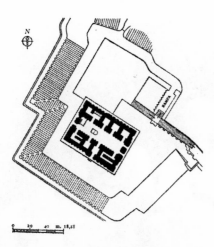

32. Plan of "White Temple" on its Ziggurat (after H. Frankfort). Religious processions in Mesopotamia did not follow a straight path, as in Egypt (compare figure 30). After ascending the stairs to the top of the ziggurat mound, they wound around the platform and temple, taking a long, spiral route.

mysterious origin and a language unlike any other that we know. They established a number of communities in the southern part of Mesopotamia, where the Tigris and Euphrates now come together but in ancient times flowed separately into the Persian Gulf.

In theory, each Sumerian city-state was owned and governed by its god; his commands were made known by his human steward, who therefore ruled as priest as well as a sort of king. All the people were subjects of the god, and lived in a kind of planned society of which the priesthood was in charge. The priests kept the records, stored and distributed much of the food, and administered such community projects as the building of dikes and irrigation ditches, which were necessary to keep the land fertile.

The remains of Sumerian civilization are few because, having no stone, the Sumerians made their buildings of mud brick, which does not last. Almost nothing is left of their architecture but foundations.

The layout of Sumerian cities shows us that the temple of the city god was the center

of existence, physical as well as spiritual. The houses clustered about a sacred area—a vast architectural array of workshops, storehouses, scribes' quarters, and shrines. In the midst of this area, on an immense, high platform, stood the temple. These sloping platforms soon became man-made mountains. They were like Egyptian pyramids, both in the effort that they required and in their effect as landmarks towering above the featureless plain. They are known as ziggurats.

The most famous ziggurat was the Biblical Tower of Babel—now destroyed. But an older ziggurat known as the White Temple, built before 3000 B.C. and thus earlier than the earliest of Egyptian pyramids, survives at Uruk (figures 31 and 32). Enough is left of the heavy walls, recessed at regular intervals, to suggest something of how it looked originally.

We are much better supplied with examples of Sumerian sculpture. Among these is a group of statuettes in stone, from the city now known as Tell Asmar (figure 33). The tallest is Abu, god of vegetation, and the second tallest is a mother goddess. The others are priests and worshipers. The two gods are made different from the other figures, not only by their greater size but by the proportionately larger pupils of their inlaid eyes—although the eyes of all the figures are enormous. The whole group stood in the sanctuary of the temple of Abu. The priests and worshipers faced the two deities and communicated with them through their insistently staring eyes, praying to them or sending messages. Thus, the eyes here are truly "windows of the soul." In order to avoid drawing attention away from the all-important eyes, the sculptor simplified both bodies and faces, making them geometric rather than living forms. If the Egyptian sculptor's sense of form was based on the cube, the Sumerian sculptor's sense of form was based on the cylinder and the cone. Arms and legs are as round and smooth as pipes; the long conical skirts

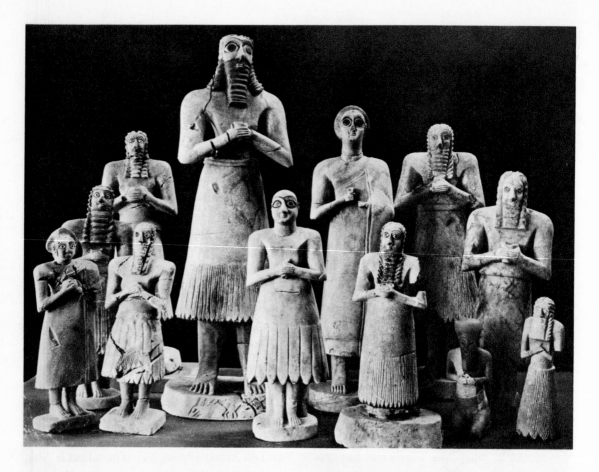

33. Statues, from the Temple of Abu, Tell Asmar. About 2700–2500 B.C. Marble, height of tallest figure about 30″. The Iraq Museum, Baghdad, and the Oriental Institute, University of Chicago. Abu and the mother goddess are larger than the worshipers and priests, to show their greater importance.

are smoothly curved. As a result, these statuettes look like stiff dolls.

Sumerian sculptors were softer and more flexible in handling forms and more realistic in describing things when they worked in wood and metal. An example is the sound box of a harp used in the temple at Ur (figure 34). The sound box is inlaid with fascinating scenes from sacred mythology. The top section shows a hero embracing two human-headed bulls. Below, a wolf and a lion carry food and wine to a banquet that we do not see. Then comes a scene in which an ass, a bear, and a deer provide musical entertainment—the harp shown

is the same type as that from which the inlaid panel comes. At the bottom we see a scorpion-man and a goat carrying objects they have taken from a large vase. The skillful artist who did this work was far less bound by rules than were artists working in Egypt at the same time.

The same realism can be seen in a sculpture in the round, also from the temple at Ur. This is a little offering stand made of wood covered with gold and inlaid with blue stones called lapis lazuli (colorplate 3). It is in the shape of a billy goat, sacred to the god Tammuz, rearing up against a flowering tree. The goat is marvelously alive and full of energy; it stares at us with almost demonic power.

Sumerian civilization was adopted by the Akkadians, a Semitic-speaking people who drifted into Sumer from the north. The Akkadians produced the first Mesopotamian rulers who openly called themselves kings and

proclaimed their ambition to conquer the whole earth.

After a few centuries of turmoil, the Babylonians became masters of all Mesopotamia around 1700 B.C. The founder of the Babylonian dynasty was Hammurabi. He was the greatest figure of the age, combining military ability with respect for Sumerian tradition: he saw himself as the "favorite shepherd" of the sun god, with the mission to "cause justice to

below:

34. Inlay on the sound box of a harp, from Ur. About 2600 B.C. The University Museum, Philadelphia. These scenes, inlaid with shell and lapis lazuli, strike us as delightfully humorous, but may have been done in deadly earnest. They are the earliest known ancestors of the animal fables that have flourished in the Western world from Aesop to James Thurber.

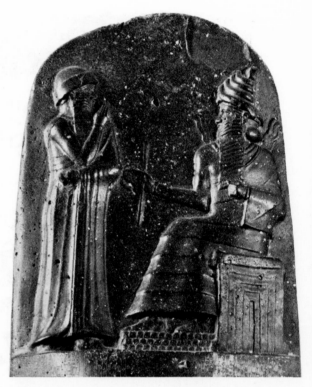

above:

35. Top of stone slab inscribed with the law code of Hammurabi. About 1760 B.C. Diorite, height of slab 7', height of relief 28". The Louvre, Paris. Hammurabi raises his right arm to the sun-god Shamash, who was also the god of justice, in a gesture that suggests he is making a report on his work of drawing up the code.

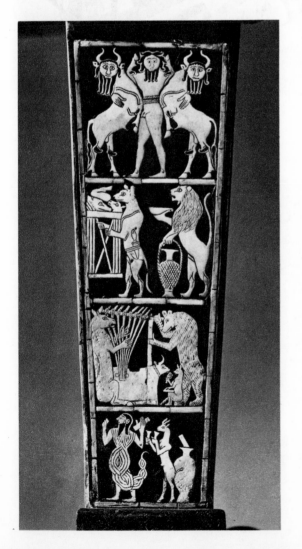

prevail in the land." His most memorable achievement was his law code, the earliest uniform written body of law in the world. Hammurabi's code was amazingly reasonable and humane. Under Hammurabi, Babylon became the cultural center of Mesopotamia, and was to remain so for more than a thousand years after its power had declined.

Hammurabi had his code engraved on a tall slab of hard stone: at the top (figure 35), in deeply carved relief against a flat background, he is shown standing before the enthroned sun god, who holds a scepter in his right hand. The stone has been worked to a high finish, inviting a wonderful play of light on the two imposing figures. The relief is so high that the

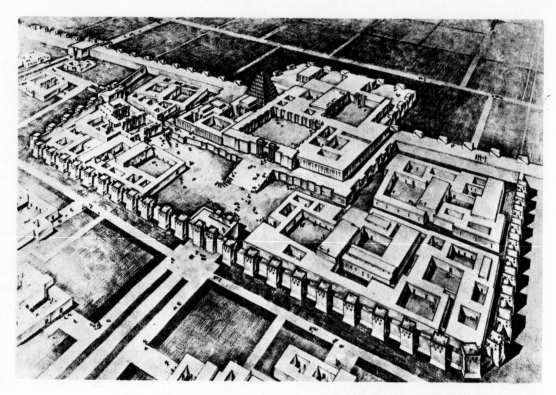

36. Citadel of Sargon II at Dur Sharrukin (Khorsabad). 742–706 B.C. (Reconstruction).
 This fortified city within a city was intended not only to furnish protection, but to
 overawe the spectator by a display of power. Late ziggurats (see top center) were
 not mere platforms with sloping sides; they were built up in stages and reached
 great heights.

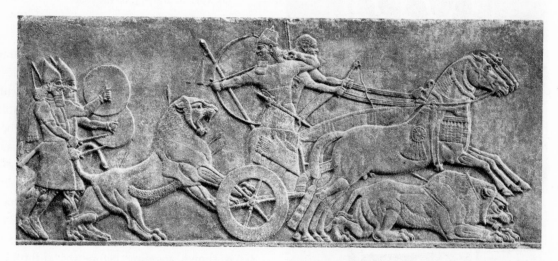

37. *Ashurnasirpal II Killing Lions*, relief from Palace at Nimrud. About 850 B.C. Lime-
 stone, 3′ 3″ × 8′ 4″. British Museum, London. Assyrian narrative art is often de-
 voted to such events as the burning of cities and the killing of men and animals.

sculptor was able to carve the eyes to their full depth, and Hammurabi and the sun god stare at each other with a force that reminds us of the early Sumerian statuettes from the temple of Abu, where the enormous eyes established a similar relation between gods and men.

Around 900 B.C., all Mesopotamia was taken over by the terrifying, powerful, and efficient Assyrians, who came from the northern part of the region. During the three centuries that followed, they created an empire that extended as far as Egypt. Then their subjects and neighbors, inflamed by the merciless conquests and harsh rule, joined together and defeated them.

The Assyrians took over the achievements of the south, changing them to fit their own needs. The palaces of Assyrian kings grew to unprecedented size and magnificence. Figure 36 shows us a reconstruction of the eighth-century palace of King Sargon II at ancient Khorsabad. The palace was on a high platform where there also stood a Sumerian-style ziggurat. About it was a citadel, a commanding fortress wall set with scores of heavily garrisoned towers.

Assyrian sculptors reached their greatest heights of achievement in low-relief sculptures of the royal lion hunts. These were not hunts out in the field: lions were let out of cages into areas closed off by troops with shields; standing in a horse-drawn chariot, the king shot them with bow and arrow. Figure 37 shows us King Ashurnasirpal II killing lions. How well the sculptor understood the anatomy of lions and horses, and how well he knew how to suggest weight and volume! He used very low relief, but skillfully created an effect of depth through minute differences in height of surface. The scene, charged with energy, fills us with a sense of life, drama, and emotion that we experience from no art of earlier times. Who is more determined and ferocious—Ashurnasirpal or the lions?

PERSIA

In 539 B.C., nomadic tribesmen from the mountain-fringed Iranian plateau east of Mesopotamia captured the city of Babylon and became the heirs of what had been the Assyrian empire. These were the Persians. The Persians rapidly expanded their empire, conquering Egypt and Asia Minor. They even got a toehold in Europe, taking the coastline of Macedonia and a narrow strip to its north. The Greek mainland, on the south, escaped the same fate by the narrowest of margins. The vast Persian empire endured for two centuries—it was toppled by Alexander the Great in 331 B.C.—during which it was ruled efficiently and humanely.

Within a single generation, drawing inspiration from all parts of their widespread territories, the Persians created a grand and imposing art of remarkable originality. They were not builders of temples, for their religious practices centered on fire altars in the open air. Their beliefs came from Zoroaster's prophecies, which pictured the world as a struggle between the rival principles of Good and Evil. In this struggle, a redeemer would come to lead the eventual victory of Good, embodied in Ahuramazda (Light), over Evil, embodied in Ahriman (Darkness). If the Persians were not builders of temples, they were builders of huge and impressive palaces. The most ambitious of these palaces was at Persepolis (figure 39) and was begun under Darius I in 518 B.C. The layout—a vast number of rooms, halls, and courts arranged on a raised platform—reminds us of the Assyrian palace of Sargon inside the citadel of Khorsabad (see figure 36). But the Audience Hall of Darius, a room 250 feet square, was supported by 36 columns 40 feet tall—a massing of columns that clearly reminds us of Egyptian architecture (compare figure 29). The columns, however, are not squat and heavy, as in Egypt. They are slender; and their shafts have long

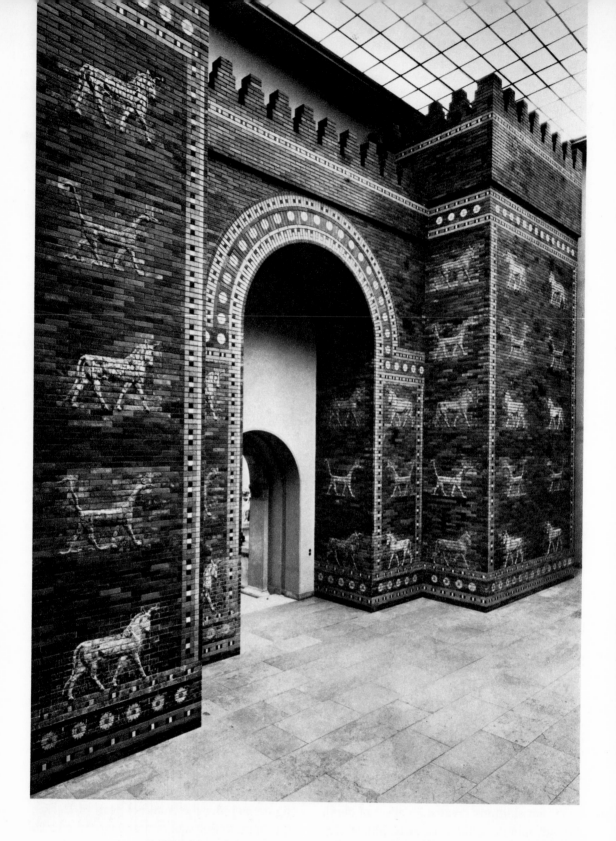

38. The Ishtar Gate (restored), from Babylon. About 575 B.C. State Museums, Berlin. Ancient Babylon took on new life after the Assyrians were destroyed; its kings built on an immense scale. The walls of these buildings were still of mud brick, but they were protected by baked and glazed bricks in bright colors. This gate shows us a gay and graceful procession of bulls, dragons, and other animals made of molded brick and framed by vividly colored bands of ornament.

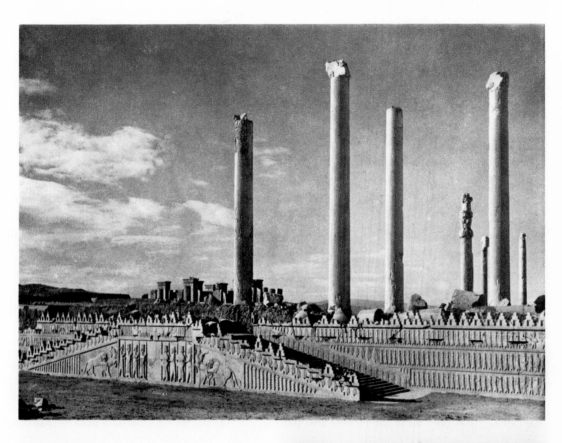

39. Audience Hall of Darius, Persepolis. About 500 B.C. The Persians built a world empire. Importing craftsmen from every corner, they created a distinctive architecture of their own.

vertical grooves that make them seem slenderer still. These characteristics are owed to the Ionian Greeks of Asia Minor, who, it is known, furnished artists to the Persian court. But all these separate elements are combined into one whole that is genuinely Persian.

Nomadic tribesmen have no use for architecture; their possessions must be easily portable, and they generally devote their artistic energies to the making of small, often precious ornamental objects. The Persians had a tradition of skills in such decorative art long before their conquests. Their remarkable goldsmith work can be seen in a drinking vessel in the shape of a winged lion (figure 40). It shows a blend of Assyrian and Greek influences, but the emphasis on texture and all-over pattern stems from the native Persian artistic heritage.

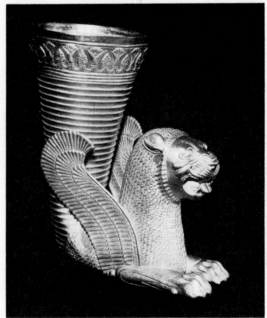

40. Gold Drinking Horn. Fifth to third century B.C. Archaeological Museum, Teheran. From its earliest beginnings to the present day, Persian art has shown a genius for elaborate ornamentation. Persian metalwork and textiles were strong influences on Europe during the Middle Ages.

AEGEAN ART

The Aegean Sea is an arm of the Mediterranean that stretches from the long, rocky island of Crete, about two hundred miles north of Egypt, to Asia Minor and the southern tip of mainland Greece. An astonishing nation of sailors, quite unlike the Egyptians or the peoples of Mesopotamia, developed a high civilization on Crete about 2000 B.C. and maintained it for a thousand years. We call this civilization Minoan, after the legendary Cretan king Minos. The Minoans were bold traders and pirates who made up for the poor soil of their homeland by bringing in food and other important items from every country that they could reach with their ships.

We have not yet learned to read their kind of writing very well, so that we do not know a great deal about them. But from the ruins of their palaces and from the pictures they made, we can see that they were the richest and the most adventurous of early Western nations. We can see that they were a luxurious and pleasure-loving people, too. Their palaces were comfortable and elegant, unlike Assyrian and Persian palaces (see figures 36 and 39), which in contrast were grand and imposing. Minoan palaces were not fortified—naval power protected them.

The so-called Palace of Minos, at Knossos, was the most ambitious. It covered a wide area and was composed of so many rooms that it survived in Greek legend as the labyrinth of the Minotaur. It was richly decorated and built of masonry, but its columns were made of wood. None of these columns have survived, but we know, from paintings and sculptures

41. Queen's Chamber, Palace of Minos, Knossos, Crete. About 1500 B.C. Light, airy, and open, the palaces of Crete suggest intimacy rather than grandeur. The columns in the air shaft beyond the chamber have been reconstructed.

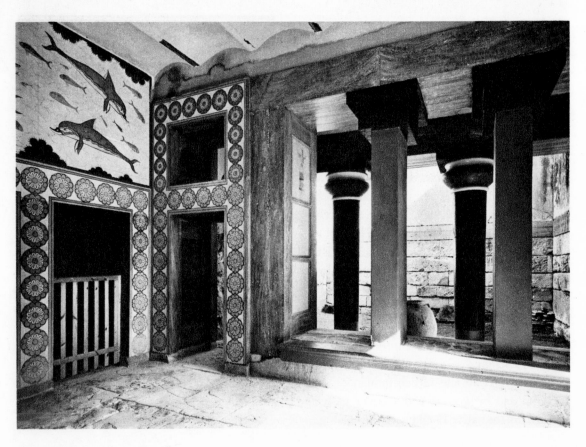

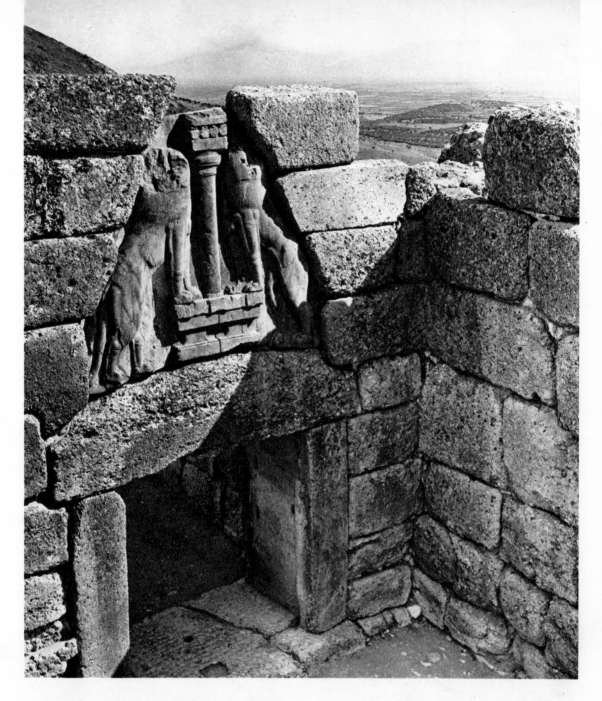

42. The Lion Gate, Mycenae. About 1250 B.C. The Greeks of later times thought that these rough, massive walls had been piled up by the Cyclopes, a mythical race of giants. Such masonry is still called Cyclopean.

that show them, that they had bulging cushion-shaped capitals and smooth shafts that tapered downward. In figure 41 we see a reconstructed corner of the palace, with columns of this kind and with characteristic Minoan decoration.

Colorplate 4, the so-called *Toreador Fresco*, shows us a wall painting from the Palace of Minos. Here, a youth and two girls—all wasp-waisted, in the Cretan manner—play a dangerous game. They seize the horns of a charging bull and somersault over his back. Actually this is a religious ritual, not a sport—but notice how the Minoan artist has stressed the harmonious, playful aspect of the ritual. Fluid, rhythmic, effortless movement was more important to him than accurate description—the bull is very, very long, indeed—or dramatic power.

Minoan civilization touched the coastline of southeastern mainland Greece. The inhabitants of this shore were not the same people as the Minoans but early Greek tribesmen who had entered Greece about 1800 B.C. Their most important settlement was Mycenae; and we have come to call their civilization Mycenaean. It flourished until about 1100 B.C.

43. *Boar Hunt*, from the Palace at Tiryns, Greece. About 1200 B.C. Wall painting. National Museum, Athens. This picture was done for pleasure, not for religious reasons. Hunting was a sport. These forms and their rapid movement tell us that the thrill of the chase and the love of nature were important in the lives of this earliest of Greek peoples.

As in Crete, the life of Mycenaean settlements centered on the palace. Basically, the palaces were very different from those of Crete, for they were hilltop fortresses with rough, massive walls of huge stone blocks. Nevertheless, the columns of the palaces were like those of Crete, and so were the wall paintings and most other decorative features. The Lion Gate at Mycenae (figure 42) not only is an impressive remnant of a rough Mycenaean fortress wall, but has a great stone relief over its doorway showing two lions flanking a Minoan column. The beasts of the vigorous *Boar Hunt* wall painting from the Palace at Tiryns (figure 43) are unmistakably similar in conception to the bull of the Minoan

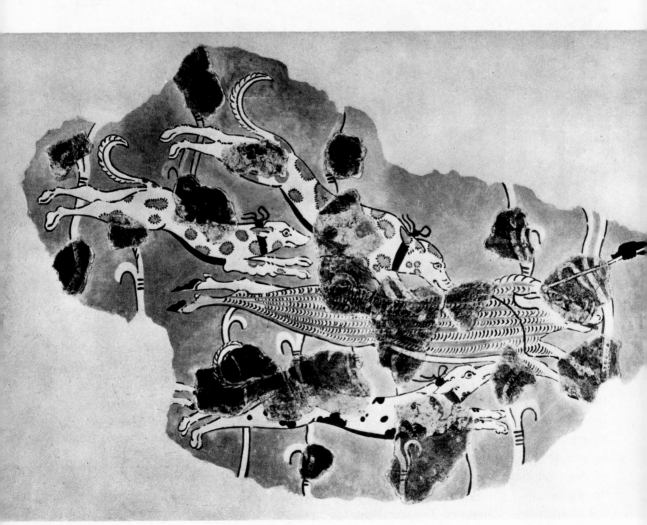

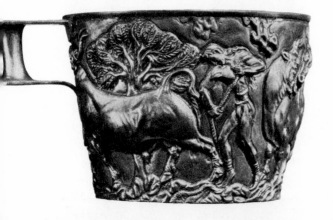

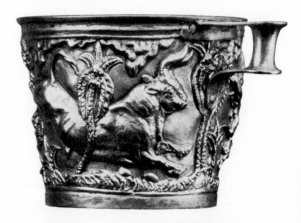

"Toreador Fresco." The two golden cups from Vaphio (figure 44) show us men—wasp-waisted, as in Crete—catching bulls with rope and net. The netting scene is very Minoan in its liveliness and sweep.

44. *The Vaphio Cups.* About 1500 B.C. Gold, height 3–3½". National Museum, Athens. Mycenaean metalworkers used much gold, which was probably acquired in trade with Egypt.

Greek Art

Mycenaean civilization was overrun and its palaces destroyed by a new wave of Greek tribesmen who came from the north around 1100 B.C. They mingled with the previous inhabitants, from whom they learned a great deal. They also learned from the Egyptians and from the nations of the Near East. Using the achievements of these older lands as a steppingstone, they eventually built a great civilization of their own—in some ways, the greatest the world has ever seen.

After their conquest of the Mycenaean centers, the invaders settled down and formed separate states, each named after its main city. Athens, in the region we call Attica, became the most important of these city-states. There, between the eighth and the third centuries B.C., the Greeks produced their keenest thinkers and finest artists.

Greece was a new kind of civilization. In Egypt and Mesopotamia, art, literature, and science were official and priestly. There was little place for individual initiative. But even the humblest Greek citizen took part in the life of his small city-state. He competed in its games, marched in its processions, and fought in its wars. Moreover, priests and officials were just ordinary men like himself. He was free.

Outstanding individual achievements were the center of the life of the Greek community. Artists, athletes, poets, and musicians were leaders. In serving the city-state, they felt that they were serving themselves and the gods.

Greek individualism is evident in Greek art. The Greek architect, when he built a temple, built something that he would start and he would finish. Moreover, it was complete—any major alteration or addition would destroy its fundamental character. As we have seen, the Egyptians kept building and building the great temple at Luxor (see figure 29) for

more than a hundred years. Additions and sub-
tractions did not really alter its character.
Greek individualism thus made for *unity* in a
temple. It also made for unity in statues and
paintings.

We do not contradict ourselves if we say
that the unity of Greek works of art also con-
tributed to *variety*. Respect for unity meant
avoiding monotonous repetition. Greek tem-
ples avoided monotony through subtle differ-
ences in parts of buildings. When sculptured
figures filled architectural spaces, an exact
balance was avoided.

The freedom of the Greeks to think for
themselves resulted in an intellectual revolu-
tion. Greeks were thinkers, not dreamers.
They invented science and philosophy, much
as we understand these today. The Greek
drama, the Greek philosophical dialogue, and
the Greek temple were orderly and clear. You
can look at a corner of a Greek temple and
easily predict the arrangement of the unseen
parts. The Greek work of art has *clarity*.

PAINTING

When we talk about the masterpieces of Greek
art, we usually think of temples and statues,
not of paintings. That is because a great many
famous temples and statues still exist; the
paintings that used to be on the walls of the
temples and houses have all been destroyed.
We can read about these pictures in ancient
writings, and we know that the Greeks were
as proud of their great painters as of their ar-
chitects and sculptors. Fortunately, we have
great quantities of Greek painted pottery (we
call them vases, although they were made to
hold wine, oil, or water rather than flowers).
These vase paintings are often very beautiful,
but, of course, they are much simpler than the
lost large pictures must have been. From
them, we can get at least an idea of what the
wall paintings were like.

In figure 45, we see a very early vase. It is
from the eighth century B.C. Most of the forms
are made up of triangles and squares, and
everything is fitted into so tight a pattern that
it takes us a while to realize that here is a
scene of mourning. In the middle, the dead
man is stretched out on a simple bed, and there
are long lines of people on both sides, wring-
ing their hands or tearing their hair in sorrow.
Here, at last, we find a picture of people not
only *doing* things but *feeling* things. This
shows us that the Greeks, from the very start,
were interested in life—not only the life out-
side people but the life inside. They felt that
life was a glorious adventure and the dead
only shadows whom nobody had to fear.

The vase in figure 46 and colorplate 5 was
made about 525 B.C.; its style is called Ar-
chaic to distinguish it from the earlier Geo-
metric style. It is painted in black and dark red
against the natural clay color of the vase. The
lines inside the figures are made by scratching
the paint away with a needle. This illustration
shows us the hero Hercules wrestling with a
lion. The energy and spirit of this picture are
very evident, and there are other things worth
mentioning besides. To begin with, we know
the name of the painter who did the picture, a
man named Psiax. That very fact tells us that
here is a work that is individual—a man could
become famous for his personal style. And
when men could become famous in this way,
great importance was placed on originality,
on trying to make art perfect or more ad-
vanced. We can certainly see advances over
the Geometric vase. We also see advances
over Egyptian and Aegean painting. The two
heavy bodies are locked in mortal combat—
something that the artist emphasizes by mak-
ing both one mass of black with very few red
lines scratched inside. What lines there are,
however, show us a knowledge of body struc-
ture and an ability to use foreshortening—
look at Hercules' abdomen and shoulders—
that are amazing when compared with any-

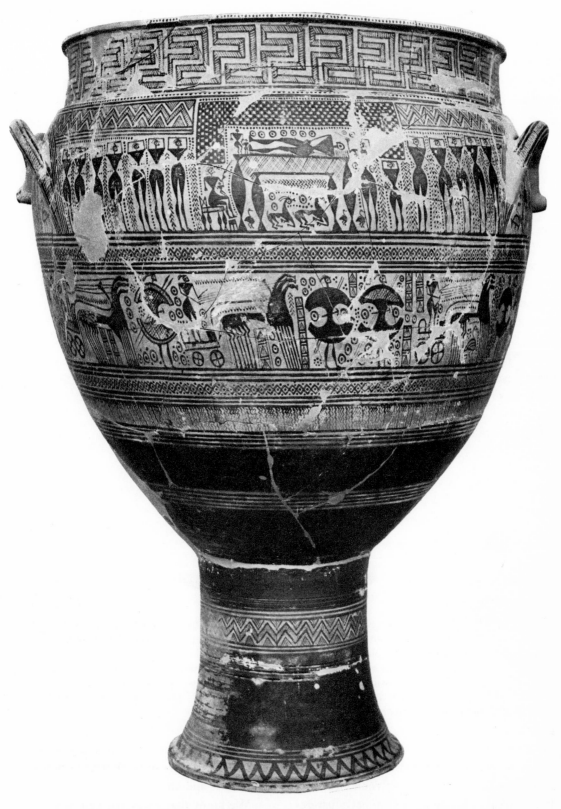

45. Funerary vase from Attica. Geometric Period. Eighth century B.C. Height 42 ½″. The Metropolitan Museum of Art, New York. Rogers Fund. Large vessels like this served as grave monuments. They have no bottom, so that offerings could be poured through them into the ground. The bands of decoration show the funeral itself.

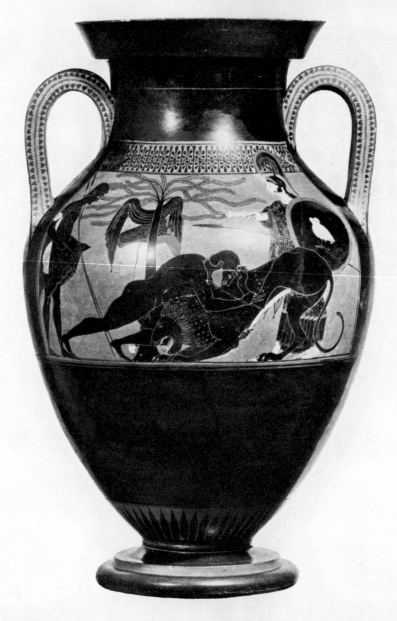

46. Psiax. *Hercules Strangling the Nemean Lion*. Attic black-figured amphora from Vulci. Archaic Period. About 525 B.C. Height 19″. Civic Museum, Brescia, Italy (see also colorplate 5). A revolution in style occurred as the Greeks absorbed the achievements of older civilizations and advanced beyond. Archaic art does not have the balance and perfection that Classic art will have later, but its freshness and vigor are particularly appealing to modern viewers. Many regard the Archaic period as the most vital phase in the development of Greek art.

thing we have seen hitherto. Only in the hero's eye do we still find the traditional front view. Amazing, too, is the effect of roundness that Psiax achieves by the means we have just described. And equally amazing is the unity of the whole composition: note how he has closed the scene on the left by a standing warrior and

on the right by the standing figure of the goddess Athena. The scene thus has a beginning, a middle, and an end.

We know that Psiax tried to move the art of painting forward, for in some of his vases, he changed the black-figure procedure that had been a tradition since the time of the

47. The Foundry Painter. *Lapith and Centaur*. Attic red-figured ware. Archaic Period. About 490–480 B.C. Diameter 15″. Staatliche Antikensammlungen, Munich. The artist is so fascinated by the new effects made possible by the red-figured technique that he has made the forms as big as possible. They almost burst the frame, and the top of the Lapith's helmet is actually cut off by it.

Geometric vases. He reversed it, in fact, leaving the figures in the red color of the pottery and brushing in a black background. In this way, it became possible to draw details freely with a brush rather than laboriously with a scratching tool. Thus it became possible to advance the study of foreshortening. After 500 B.C., the red-figured technique replaced the black-figured technique. The advantages of the new technique are clearly shown in the vase (figure 47) by an unknown artist nicknamed the Foundry Painter. Note how the foreshortening of the Lapith's shield, by giving us an inside and an outside view at the same time, suggests three dimensions. The three-quarter view of the Centaur's head, and the way his body has been flipped over, give us a convincing view of his underside—convincing because of the foreshortening of his legs and the overlapping of his limbs.

Painting of this kind suggests that shortly after 500 B.C. Greek painters were on the verge of a real breakthrough in art. In the hundred years that followed, they completely discarded the age-old painting rules which the Egyptians had worked out carefully and which had remained in the mind of everybody in the ancient world for three thousand years. The painting that resulted can no longer be called Archaic. It is in the Classic style.

There are a few examples of Greek vase painting that reflect the achievements of the Classic style in wall paintings and painted panels now lost to us. Figure 48 is an example of such a vase done around 440 or 430 B.C. At last, we have a figure that in its entirety—not just partly or mostly—reaches back into space instead of staying on the surface of the picture. The eye is in side view, now, and the body, which shows a little bit more than a side view, is foreshortened with exact knowledge of how things look. And we see another characteristic of Classic Greek art—of sculpture as well as of painting. The artist was not

48. The Achilles Painter. Attic white-ground vase (detail). Classic Period. About 440–430 B.C. Private collection. Classic art abandons the agitation and descriptive detail of Archaic painting for simplicity and quiet grandeur.

interested in portraying a particular person with individual features and personal imperfections. He idealized his subject, making her as beautiful as he knew how. He tried to make her perfect in other ways, too, that the Athenians of the Classic era regarded as ideal or proper. For example, it was felt to be beneath the dignity of a Greek or a god to exert himself violently or give way to emotion: self-control was a virtue of the highest order. The woman is completely poised, completely graceful, completely calm. The major principles of Classic art have been summarized in the phrase "noble simplicity and quiet grandeur."

Violent movement and vigorous action, pushed aside by the Classic ideal in the fifth century, returned in the fourth. But simplicity and grandeur remained ideals that the Greeks and their Roman successors never abandoned.

above:

49. Alexandros of Athens. *The Knucklebone Players.* First century B.C. Marble panel. National Museum, Naples, Italy. This small picture imitates a Classic painting of the late fifth century B.C., but lacks the strength we find in the vases of the Classic period.

below:

50. *The Battle of Issus*, from Pompeii. Mosaic copy (about 100 B.C.) of a Hellenistic Greek painting. Width of this portion about 10½'. National Museum, Naples, Italy. Mosaic, an ancient method of making designs out of small cubes of colored marble set in plaster, was brought to such perfection in later Greek and Roman art that it could be used to copy paintings. The painting copied here was a famous Greek example of about 315 B.C. showing the defeat of the Persian king Darius by Alexander the Great. The Hellenistic period retained the natural appearance of things and the suggestions of depth that are seen in the Classic style, but added motion and excitement.

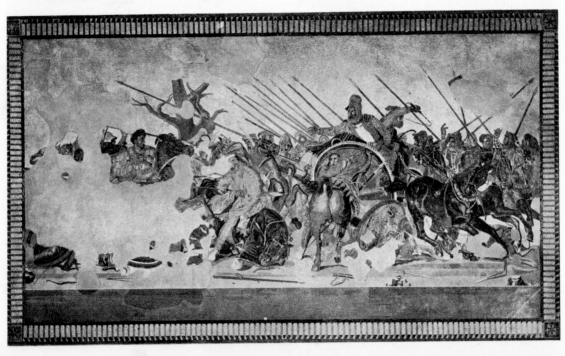

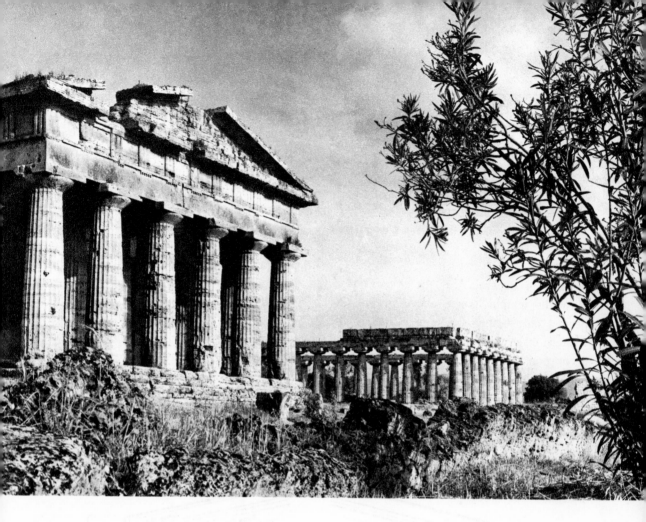

TEMPLES

Even the most advanced buildings in Egypt and Mesopotamia, in comparison with Greek temples, were like great blocks of material enclosing small pockets of interior space. They seem to have been carved out of a solid mass. Greek temples were not carved out; they were built up. The thickness and weight of Egyptian and Mesopotamian buildings create the impression of great stability. Greek temples were stable, too, but their stability did not depend on excess mass. It depended on mass governed by logic—structural logic.

The Paestum temples (figure 51), the Parthenon at Athens (figure 54), and the little nearby Temple of Athena Nike (figure 55) are stable and look stable because of their precise arrangement of parts—the placing, balancing, and logical combination of columns, beams, and blocks of stone. Each

51. The "Temple of Poseidon" (foreground; about 460 B.C.) and the "Basilica" (background; about 550 B.C.), Paestum, Italy. By the middle of the sixth century B.C., the northern Mediterranean coast was dotted with Greek colonies as far west as France and Spain. Poseidonia—"Paestum" in Latin—was an important settlement south of Rome.

of these temples was put together like a fine watch.

The simplest form of Greek temple was a mere chamber, with a porch in front held up by two columns between the side walls, and the whole building covered by a gently sloping gabled roof. The typical large temple (see the temple plan, figure 52) was formed by adding a back porch to the chamber and surrounding the chamber and porches with a row of columns—the colonnade. The whole temple rested on a stepped platform setting it off from the ground.

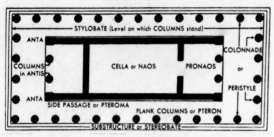

52. Ground plan of a typical Greek temple (after Grinnell)

This, in general, was the ground plan. How the temple looked above ground depended on whether the temple was of the western or eastern order of construction and decoration, whether it was of the Doric order or the Ionic (see figure 53).

The orders—we call them that rather than the "Greek orders" because there have never really been any others—have fascinated the world for more than 2500 years. From Roman times to ours, European civilizations have altered them, but they have never produced another order. For much of this time the orders have been looked upon as the only basis for beautiful architecture. But the importance of the orders does not end there. They are a more remarkable human accomplishment than, say, mass production, computer technique, or space travel (all of which, in a very direct way, their creation made possible). The principle underlying the orders is not simple, but an effort will be made here to state it simply.

The Greeks tried to regulate their temples in accordance with nature's harmony—the harmony among men, the gods, and the world common to both. They believed that precisely the same harmony regulated the human body

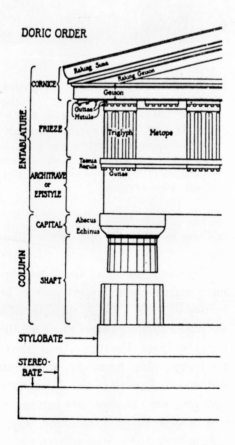

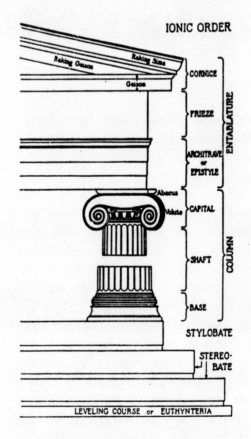

53. The Doric and Ionic orders (after Grinnell)

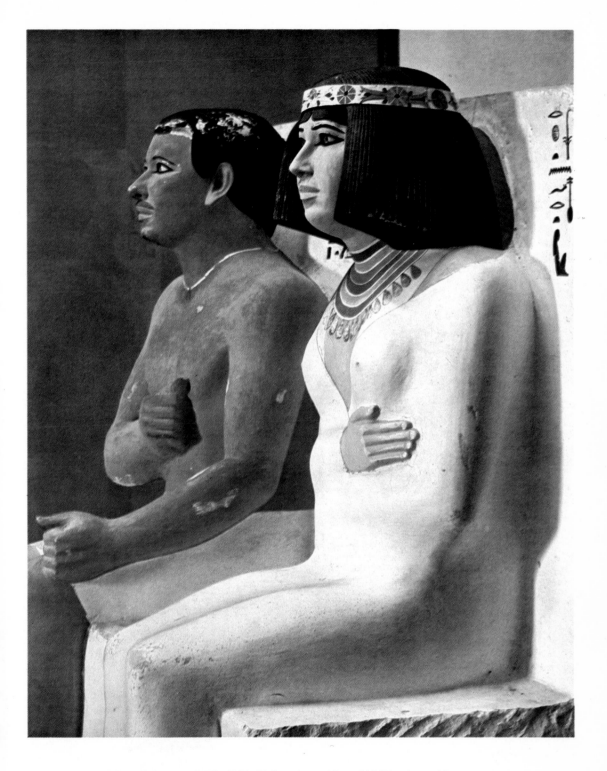

Colorplate 1. *Prince Rahotep and His Wife Nofret*, from Giza. Old Kingdom. About 2610 B.C.
Painted limestone, height 47¼″. Egyptian Museum, Cairo. This piece of Egyptian
statuary has retained its vivid color.

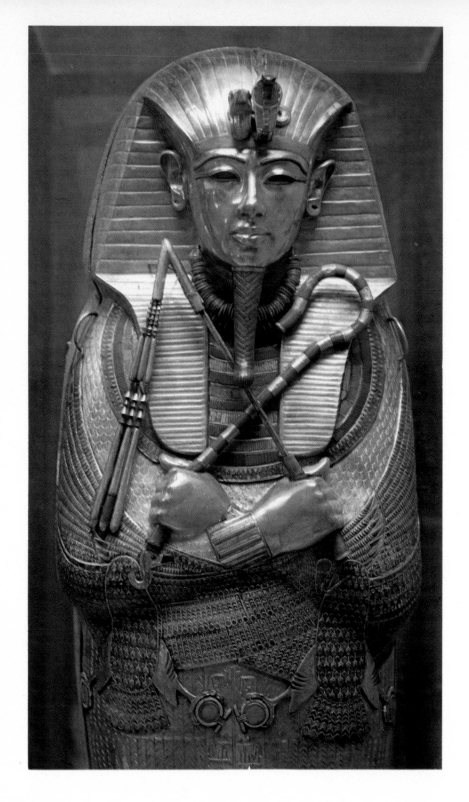

Colorplate 2. Upper portion of cover of Tutankhamen's coffin. New Kingdom. About 1350 B.C. Gold inlaid with enamel and precious stones, height of whole 72⅞". Egyptian Museum, Cairo. Here we see the false beard again and other emblems of divine kingship. Tutankhamen's is the only Pharaonic tomb that has come down to us with most of its contents undisturbed by grave robbers. The gold coffin weighs two hundred and fifty pounds, and its sheer money value tells us why, ever since the Old Kingdom, such tombs were robbed.

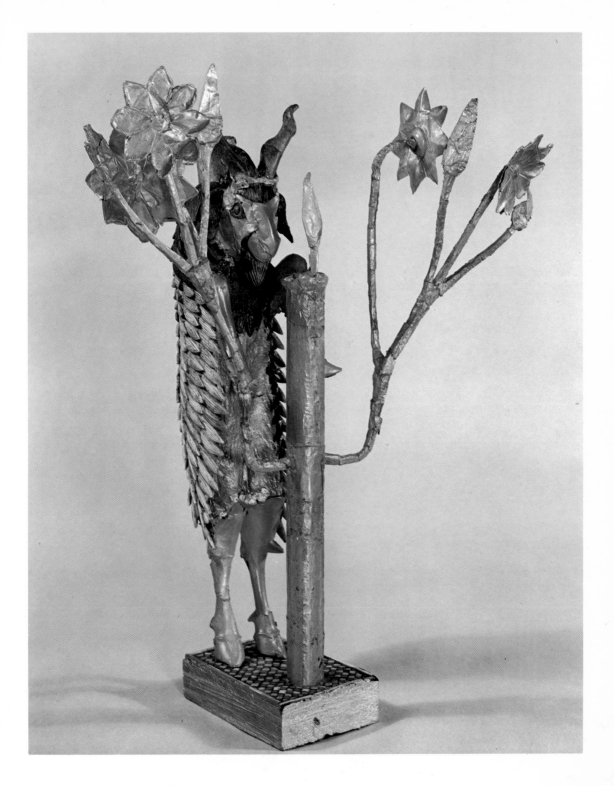

Colorplate 3. *Billy Goat and Tree*, offering stand from Ur. About 2600 B.C. Wood, gold, and lapis
lazuli, height 20″. The University Museum, Philadelphia. The goat and the tree are
both symbols of the god Tammuz, who died every winter and came to life every spring
along with all vegetation.

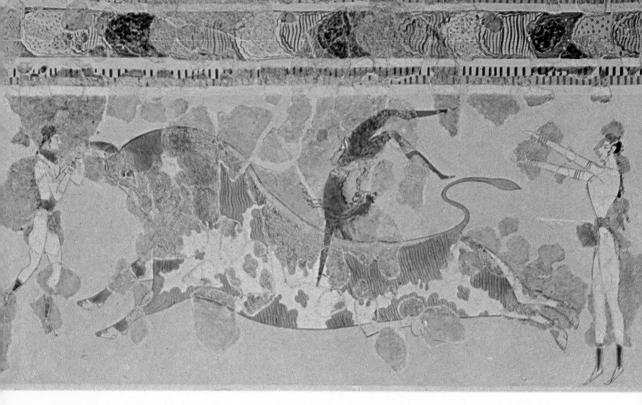

Colorplate 4. *"Toreador Fresco,"* from the Palace of Minos, Knossos, Crete. About 1500 B.C. Height about 24½". Archaeological Museum, Candia, Crete. As in Egypt, men are shown darker than women. Memories of Cretan bull-leaping long survived the Minoan civilization in the Greek legend of the Minotaur and in the bullfights of today in Spain and Mexico.

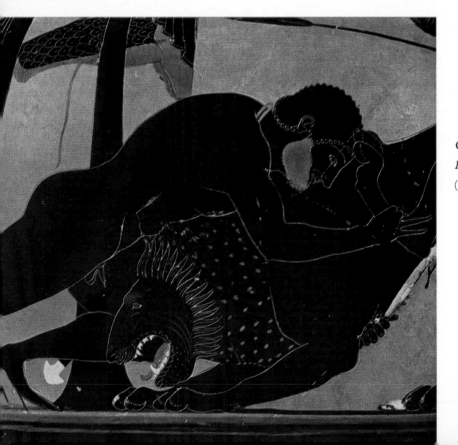

Colorplate 5. Psiax.
Hercules Strangling the Nemean Lion
(detail of figure 46)

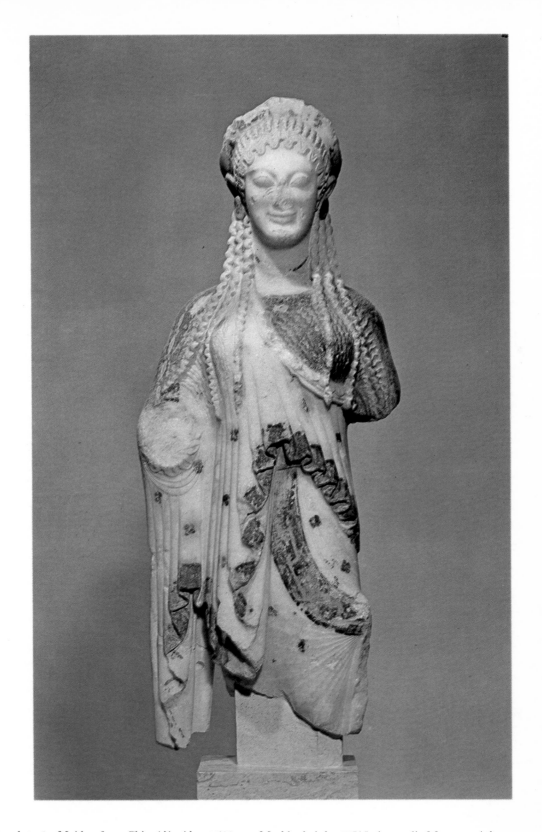

Colorplate 6. *Maiden*, from Chios(?). About 520 B.C. Marble, height 21⅞″. Acropolis Museum, Athens

Colorplate 7. *Portrait Head*, from Delos. About 80 B.C. Bronze, height 12¾". National Museum, Athens. Portraiture, which began in the late fifth century, flourished in Hellenistic times. This head of an unknown man was not made as a bust but, in accordance with Greek as opposed to Roman practice, as part of a full-length statue. The emphasis on personal traits of character would have been impossible in the fifth or fourth century B.C., when portraits were idealized and heroic.

Colorplate 8. *Two Dancers* (detail of wall painting). About 480–470 B.C. Tomb of the Lionesses, Tarquinia. The style of Etruscan wall paintings gives us some idea of what the lost Archaic wall paintings of the Greeks must have been like. The Etruscans had great admiration for the artistic genius of Greece, and imported Greek works of art enthusiastically. This scene represents a vision of the Etruscan paradise, where energetic dancing seems to have been the order of the day.

Colorplate 9. *Lady Musician and Young Girl*, wall painting from a villa at Boscoreale, near Pompeii. First century B.C. The Metropolitan Museum of Art, New York

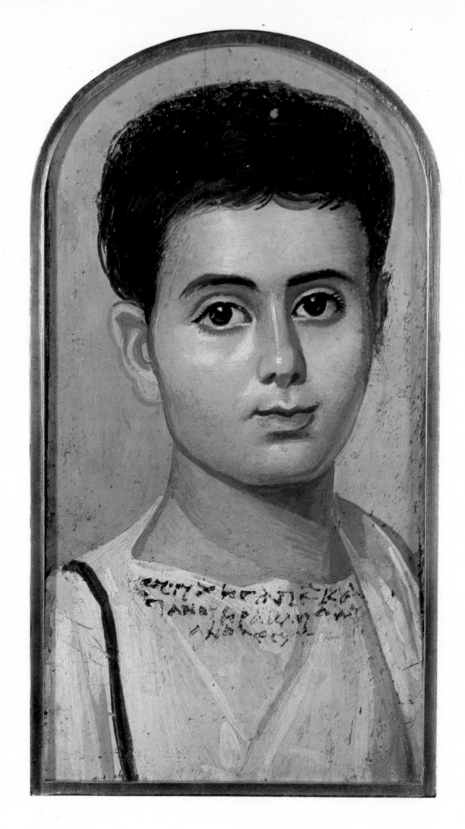

Colorplate 10. *Portrait of a Boy*, from the Faiyum, Upper Egypt. Second century A.D. Encaustic on panel, 13 × 7¼″. The Metropolitan Museum of Art, New York. Gift of Edward S. Harkness, 1918

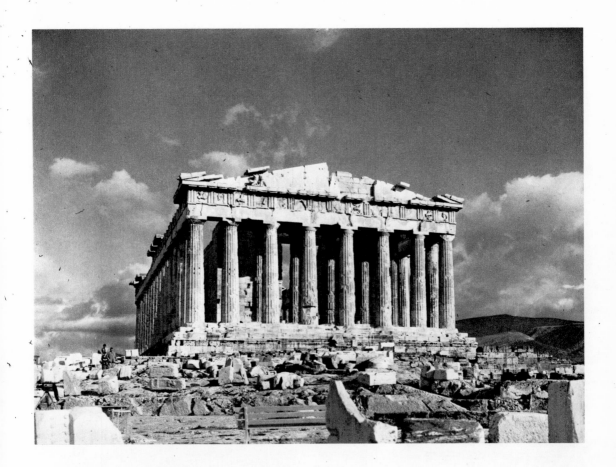

54. Ictinus and Callicrates. The Parthenon. 448–432
B.C. The Acropolis, Athens. After the final de-
feat of the Persian invasion of Greece in 479 B.C.,
the Athenians focused their creative energies on
the rebuilding of their ruined Acropolis, trying
to create a civic and religious center that would
be the greatest achievement of Greek civiliza-
tion. The Parthenon has been looked upon for
more than 2,000 years as the finest monument of
Greek architecture and sculpture.

itself—its heights, widths, depths, and shapes,
and the way the shapes are put together.
And the temple was thought of as something
almost alive, its structure analogous to our
body structure. It was composed of clearly
marked major divisions, and each division had
its own shape and its own work to do. Like
the legs, trunk, and head of the human body,
the temple was made up of base members,
supporting members, and crowning members.
The column, of course, was the chief support-

ing member. But the Ionic column is itself
composed of a base member, a supporting
member, and a crowning member (the Doric
is a little simpler). And the column's crowning
member—the capital—has a base member, a
supporting member, and a crowning member.
We could go on and on.

A Greek temple was composed of measured
units. The basic unit, of which all others were
fractions or multiples, was the bottom radius
of the column. Small units built up to bigger
units, and bigger units were contained in still
bigger units, producing the unity of the whole
temple. Each unit, small or big, was so pro-
portioned that all would be in perfect agree-
ment. ("Perfect" was as significant an idea
to the Greeks as "forever" was to the
Egyptians.)

And what has all that to do with space
travel? Simply this. Greek architects, in
mastering the part-whole relation, gave the

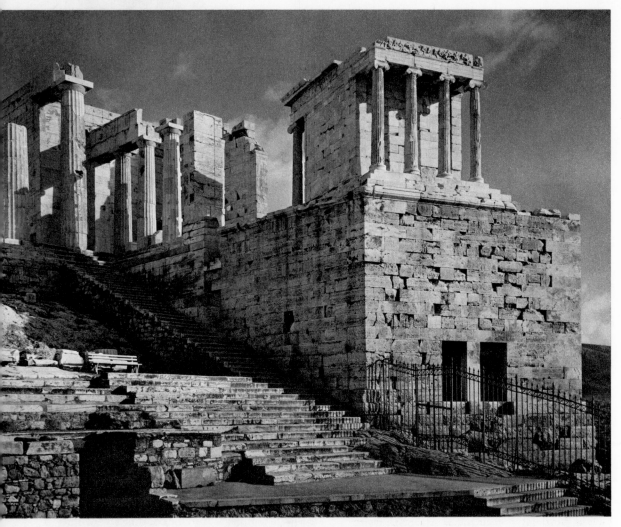

55. A corner of the Acropolis in Athens. The remains of the Propylaea (437–432 B.C.), the monumental gateway to the sacred area, are in the rear. The little Temple of Athena Nike (427–424 B.C.) in front shows us the Ionic order at its purest.

world one of its most powerful tools of understanding. As a result, men could make the most elaborate things imaginable and keep them intelligible and coherent. Hitherto, such miracles of organization had never occurred in man-made things. In what the gods made, yes—in such natural masterpieces as plants, animals, and men themselves, or in music, or the poetry of Homer, through the inspiration of a god. But now men could also create such organic unities, not by copying nature, not by divine inspiration, but by design. The Greeks themselves never went in for hugeness or elaboration; in their architecture, at least, they remained content for centuries with the balanced harmonies developed between 625 and 400 B.C. The Romans, those apt pupils of the Greeks, made fuller use of organic design. We make ever fuller use of it today.

Both the Doric and the Ionic order use the basic construction principle of any ordinary barn—the post-and-beam principle characteristic of simple wood construction. The very earliest Greek temples were actually of timber. In them, as in a barn, upright posts—or timber columns—carried horizontal beams. Lying across the beams and slanting up to the ridge of the roof, rafters carried the roofing.

Greek temples of both orders are built in just this way—but in stone, not wood. They are translations from wood into stone.

In the Doric order, the shaft of the column rests squarely on the topmost step. It tapers upward, not in a straight line but in a gently swelling curve. This curve is pronounced in the Temple of Poseidon and almost unnoticeable in the Parthenon.

The curving shaft ends at the capital, which consists of a round, cushion-like molding with a square block on top of it. The superstructure above the column consists of three members: architrave, frieze, and cornice. The architrave is the beam that stretches horizontally above the columns. The frieze above it consists of oblong panels (metopes) alternating with oblong channeled blocks (triglyphs). The crowning member of the superstructure is the cornice, whose chief feature is an overhanging wide, flat band that casts a strong shadow on the frieze below.

The Ionic order is much lighter than the Doric. The chief differences are in the frieze and the column. In the Temple of Athena Nike (figure 55), the frieze is a continuous sculptured band, not alternating blocks and panels. The Ionic column, unlike the Doric, has a base, and its shaft is tall and slender. The most prominent feature of the capital— and of the whole order—is the graceful bolster-like member with two projecting ends that curl into spirals. The Ionic superstructure is not nearly as heavy as the Doric.

Since Doric and Ionic temples were gabled, the gable ends were given special treatment. Sloping cornices met the horizontal cornice of the superstructure to form a low triangle, the pediment.

Now that we have identified and located the divisions of the orders and some of their more important parts, we can take a look at another important aspect of Greek temples. In devising architectural unities that in some ways are like living things, Greek architects did more than create superlatively organized designs. They made their temples seem actually to live. They achieved this triumph chiefly by expressing the structural forces that hold buildings up and keep them together.

Look at figures 53 and 54 again. The flutes (the vertical channels scooped out of the column shafts) of both orders convey the impression of upward lift. The flutes are neither functional nor primarily decorative in purpose; they are expressive of the column's function of supporting the superstructure. The capital of the column makes a transition between shaft and superstructure, spreading out the upward lift of the shaft, drawing in the downward pressure of the superstructure. Inside the Doric superstructure, the V-cut vertical channels of the frieze blocks (triglyphs) continue the upward rhythm of the fluted shafts and, seemingly, hold up the heavy cornice. In the Classic period, expressions of force and counterforce in both Doric and Ionic temples were proportioned so exactly that their opposition produced an effect of perfect equilibrium. A Classic Greek temple was not only a balanced harmony of sizes and shapes; it was also an image of harmoniously balanced forces.

As we have seen, Greek architecture was not all straight lines and flat surfaces. Greek architects avoided a look of hardness and rigidity and introduced curves and tapers into their forms. Although made of unyielding stone, those forms suggest, very subtly, the suppleness and elasticity of a firm, compact human body made of flesh and blood. In its expression of life, the Doric order, which is unornamented, seems completely muscular and athletic, stripped for action. Its forms are big and simple and deliver their structural messages boldly. The Ionic order is not only slighter in build and feature, but, to a limited extent, is clothed in ornament. Its expression of action is, thus, far less forceful. And so, down the centuries, men have used such words

as "sturdy," "powerful," and "masculine" to describe the Doric order, and such words as "delicate," "graceful," and "feminine" to describe the Ionic.

Archaic Doric temples, like the Archaic Greek paintings that we have seen, are lively and powerful but lack the elegance and perfection of the Classic art of the fifth century. The individual features of the "Basilica" (the farther building in figure 51), built about 550 B.C. in the southern Italian Greek colony of Paestum, are very boldly marked and express their functions vigorously. So vigorously, in fact, that the forms struggle with one another. The shafts taper sharply, and their upward curve is something of a bulge. The transition from shaft to superstructure is not easy: the capital flares out and the curve of its round cushion is very bold. Even in the nearer Temple of Poseidon (figure 51), built almost a century later, the superstructure is so heavy and bears down on the column with such an expression of force that great opposite energy has to be expressed by the columns below. Only a few years later the architects of the Parthenon (figure 54) in Athens harmonized these oppositions and produced a smoothly integrated building. The Classic style was already mature in Athens while Archaic temples were still going up in southern Italy.

This concern with harmonious proportion we shall also see in Greek sculpture. It shows us how closely Greek art was connected with Greek thought. The Greeks were great mathematicians; concern with geometry and number was at the center of their intellectual life.

Greek architecture reached its greatest heights in the rebuilding of the Acropolis of Athens, the sacred hill above the city, after the destruction of its temples and statues by the Persians in 480 B.C. The rebuilding took place in the second half of the fifth century, the Age of Pericles, which saw the development of Classic Greek art at its purest and most elegant.

The chief building of the Acropolis was the Parthenon, a great Doric temple constructed entirely of fine marble. The suggestion of strength, grace, and balance achieved here is extraordinary. The architects, Ictinus and Callicrates, went to extraordinary lengths to bring about this effect. Not only did they proportion the parts of the building with the utmost care, but they introduced a set of departures from strict regularity of size and strict regularity of verticals and horizontals. The columns slant back, and the columns at the corners are closer together than are all the others. The floor is not flat but very slightly convex. The superstructure is not horizontal but curves slightly upward toward the center. These so-called refinements play a major role in making the Parthenon the supreme achievement of Greek architecture.

SCULPTURE

The Greeks learned how to make large statues from the older peoples of the Mediterranean, especially from the Egyptians, and, to some extent, from the Mesopotamians, too. As we have seen, such pieces were not made in Greece during Mycenaean times.

The earliest examples known were done toward the end of the seventh century B.C. They were of stone and like later Greek statues, were originally embellished by color. (Many persons think of ancient sculpture as pure white because they are familiar with it through plaster-cast reproductions. Actually, Greek sculptors applied gold and color rather freely.)

The types of statue in the Archaic period were few, at first. The standing nude male (the *kouros*, or "youth") and the standing clothed female figure (the *kore*, or "maiden") were the two most important.

The marble *Standing Youth* (figure 56) is a very early example and immediately reminds us of its Egyptian models (compare figure 23). The body is broad-shouldered and slim;

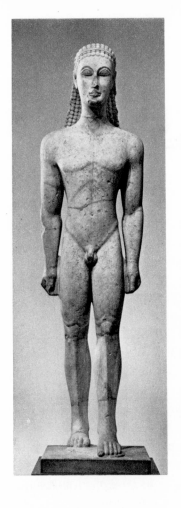

the hair falls to the shoulders in a blocky mass;
the arms are close to the sides; the kneecaps
are sharply carved; and the left foot is ad-
vanced. There are also characteristics that
seem Mesopotamian: the snail-shell curls of
the hair and the enormous, staring eyes. Com-
pared with the Egyptian statue, this youth
seems remote from nature and rather awk-
wardly done. But it embodies an idea too bold
for an Egyptian even to think of. The figure
stands free. Except at the fists, where a tiny
bridge protects the arms from breaking off,
there is no dead material—no stone screen
attaching to the extended leg, no block from
which the figure emerges. Whereas Egyptian
statues seem cradled in a bed of stone for all
time, this Greek youth appears tense and full
of life.

We can assume that the youth is not a por-
trait of someone, for neither his head nor his
body has been individualized. Nor is he a "re-

placement" body for the spirit of the dead to
come back to; Greek notions of an afterlife
were too vague and shadowy for that. Who,
then, is being represented? A god? A hero?
A champion in athletic games? It is not easy
to say, but the very lack of individuality seems
part of the youth's essential character. Neither
a god nor a man, exactly, he is something in
between: an ideal of physical vitality and
perfection shared by gods and men alike. In
the Greek religious myths, mortals and im-
mortals shared a common world and mingled
their lives. Great men and the gods were not
very different. The gods were almost human,
and heroes were almost gods.

The impressive maiden statue in figure 57
is also early, done perhaps fifty years later
than the youth. It was found in the Temple of
Hera on the island of Samos, and may well
have been an image of the goddess. The maid-
en is rather like a column come to life. Almost

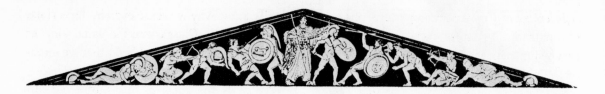

58. Reconstruction drawing of the east pediment of the Temple at Aegina (after Furtwängler). The pediments of Late Archaic temples were filled with statues grouped into a design. Here a battle between Greeks and Trojans rages around the goddess Athena. The left-hand corner shows us how the *Dying Warrior* of figure 59 fits into the composition of the battle scene.

a cylinder at the bottom, a cylinder enlivened by the closely spaced long vertical grooves of her undergarment, she grows and swells into a soft human form wrapped in two more layers of clothing. The drapery, almost architecture below, above turns into a kind of second skin, revealing her arms, torso, and hips. If in figures of youths very early Greek sculptors show interest in the ideal structure of the male body, in figures of maidens they show equally strong interest in the structure of drapery shaped by an ideal female form beneath.

Both types, youth and maiden, continued

to be produced through the Archaic period and beyond. We find here the same thread of stylistic development that we have already traced in Greek vase painting. The maiden of color-plate 6, for example, is a stylistic counterpart of the late Archaic red-figured vase of figure 47, especially in the treatment of drapery. The architectural grandeur of the *Hera of Samos* has now given way to ornate, refined grace. The garments still loop around the body in spiraling curves, but the intricate play of folds and pleats has become almost an end in itself. The maiden's hair has been given a similar treatment, and her face wears a soft, almost natural expression—the so-called "Archaic smile." This statue still has much of its original color, and shows us how important color actually was in Greek sculpture.

Our next example is neither a youth nor a maiden, but a type of statue developed at the very end of the Archaic period, about 490 B.C.

59. *Dying Warrior*, from the east pediment of the Temple at Aegina. About 490 B.C. Marble, length 72″. Glyptothek, Munich. Originally, certain details—for example, the curls of the warrior's beard—were not carved but painted. Now that the paint has vanished, the beard appears to be a solid mass.

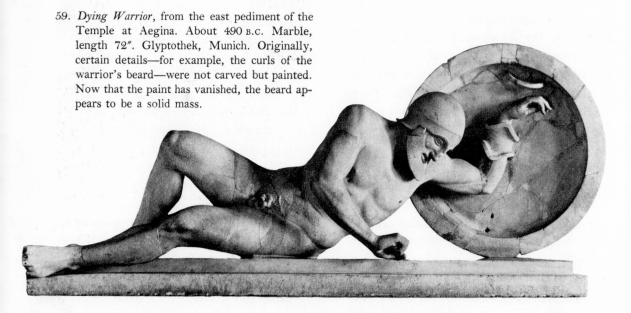

It is a piece of architectural sculpture, one part of a narrative group of statues placed in the east pediment of the Temple at Aegina (figure 58). This *Dying Warrior* (figure 59) is only a century or so later than the *Standing Youth*. With what astonishing speed have Greek sculptors gained proficiency in understanding the structure and workings of bones and muscles! How intent they must have been on acquiring this skill and knowledge! Here the artist shows a great command of the human form in action. Only the eyes, mouth, and beard have been determined by applying preset rules more than by describing natural form.

We are moved by this figure. Not so much by its technical skill—although skill is a quality that often and justifiably gains our admiration—as by its high dignity. In the agony of dying, the warrior suffers fate's decree with tremendous fortitude and resolve. Nobility of spirit is communicated to us by the figure as a whole and in detail, by the very shapes—firm and clear, yet organic rather than geometrical—of which this magnificent body is composed.

The *Dying Warrior*, like the vase painting of its time (see colorplate 5 and figure 46), shows that late Archaic Greek art was ready to part company with the great tradition that had its birth in Egypt and Sumer. That tradition denied time and space. Its goals were immobility and permanence. In Greece, the new ferment—vitality—dissolved that tradition in a few generations, and a different kind of artistic intention began to emerge. Thenceforward, Greek sculptors would seek to represent a natural form moving in space at a moment in time.

No more than a decade elapsed between the last phase of Archaic sculpture and the Classic breakthrough. The differences between statues made just before this turning point and just afterward are subtle. They are so subtle, in fact, that, unless we look closely, we do not really know why we sense even in the earliest statues of the Classic era the same kind of live working of limbs and body that we experience in ourselves. But sense it we do.

What is the basis of this subtle but all-important difference? We can discern it in two great statues of the early Classic era, each a nude male figure, each done around 460 B.C. One is the marble *Apollo* (figure 60) from the west pediment of the Temple of Zeus at Olympia, the other the bronze *Poseidon* (figure 61) recovered from the sea near the coast of Greece a few decades ago.

The west pediment of the Temple of Zeus at Olympia tells the story of the defeat of the Centaurs at the wedding feast of the king of the Lapiths. Apollo is the center of the composition. The shapes of his body are simpler

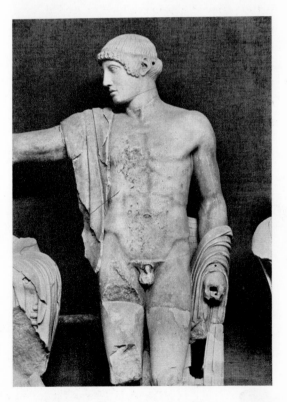

60. *Apollo* (detail), from the west pediment of the Temple of Zeus at Olympia. About 460 B.C. Marble, over lifesize. Museum, Olympia. This Early Classic figure of a god, although motionless, is full of life. His face radiates an awesome authority.

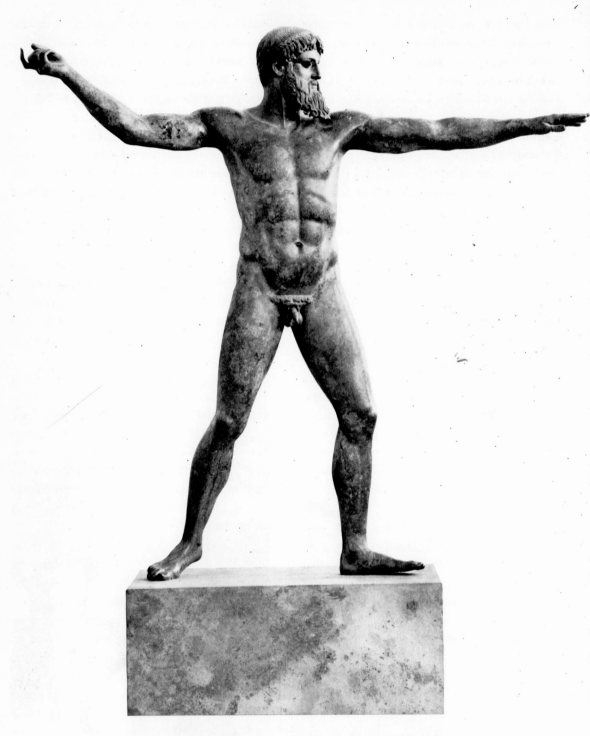

61. *Poseidon (Zeus?)*. About 460 B.C. Bronze, height 6'10". National Museum, Athens. Large freestanding statues showing movement were among the most important achievements of the Early Classic style.

than those of the *Dying Warrior*, yet softer, and each blends easily into its neighboring shape. Apollo's commanding figure is part of the drama, yet above it. The turn of his head and the stretch of his arm show his intervention in the battle: he *wills* the victory of the Lapiths but, as befits a god, does not join the fighting. The other statues of the group are not illustrated in this book, yet we can see their struggle mirrored in Apollo's face as he looks upon it. The feeling his face reflects, doubly impressive because he is outwardly so calm and controlled, transmits itself to us with great directness. This inner "illumination" of the head marks a basic departure from Archaic style. It is a major achievement of Classic sculpture.

Another major achievement of Classic sculpture that can be discerned in the statue of Apollo is seen more clearly in the bronze figure of Poseidon (figure 61). Note how Poseidon's forward leg supports his body's weight. His other leg is an elastic prop that serves to balance him. And as our eyes travel up his body toward his head, we can follow the expressed play of weight and support as it is carried through every limb. The axis of his frame is not a vertical line but a faint S-curve, because, left and right, his knees, hips, and chest thrust down on one side and swing up on the other. By these means the Classic sculptor "illuminates" the body, which is now shown in process of moving. Here, the god is hurling a weapon (now missing); it is an emblem of his divinity rather than an instrument of actual violence, yet he throws it like an athlete.

A technical term is used for the means whereby motion has been conveyed here. We call it counterpoise; the leg that carries the body's main weight is the engaged leg, the other the free leg. The invention of counterpoise meant that sculptors now had a key to the representing of free movement, no matter how strenuous.

Was there no motion in Archaic art? We have seen that there was motion, and strenuous action, too. But we only read these things from poses and gestures. The motion of a Classic work is something that we feel in our bones.

The second half of the fifth century B.C. was the era of the mature Classic style, a style that we associate with the name of Phidias. Phidias was the overseer of all the artistic works in Athens sponsored by Pericles, the city's political leader. We do not know whether he was a great artistic genius or merely an unusually able and successful co-ordinator, but the marvelous sculptures of the Parthenon (see figure 54), done under his direction, are the largest body of Classic works that we possess, and the most masterful. We shall look at two of these sculptures.

The first is the *Dionysus* (figure 62), a corner figure from the east pediment. It is battered and weather-worn, but even so, we marvel at its proportioned grace, its ease of movement, its thorough envelopment in deep space. There is no extreme movement or emotional excitement, indeed no specific action of any kind, only a deep sense of the poetry of being.

The second is not a statue but a relief (figure 63), part of a 525-foot-long continuous frieze at the top of the wall behind the Parthenon's outer colonnade. The frieze represented the procession from a festival in honor of the goddess Athena. It is carved in a manner typical of Greek reliefs: that is, the details closest to us are most nearly in the round, and details in a second and third layer are shallower, though completely set off from the flat, neutral background. In this way there is achieved a somewhat limited but still extremely convincing suggestion of space and depth. The most remarkable quality of the Parthenon frieze is its rhythmic grace, particularly striking in the spirited movement of this group of horsemen.

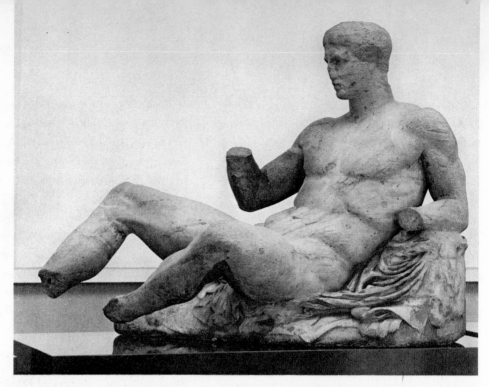

62. *Dionysus*, from the east pediment of the Parthenon. About 435 B.C. Marble, over lifesize. British Museum, London. This magnificent statue is in the "style of Phidias," although we do not know who actually carved it. The qualities of Classic Greek art have been summed up in the phrase "noble simplicity and quiet grandeur."

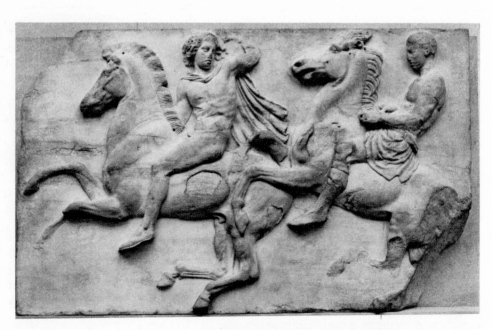

63. *Horsemen*, from the west frieze of the Parthenon. About 440 B.C. Marble, height 43". British Museum, London. The subject is the procession of the Greater Panathenaea, a festival held every four years in honor of the goddess Athena.

The brief enchanted springtime of the Classic era evaporated in the heat of the Peloponnesian War, an exhausting struggle between Athens and Sparta for supremacy in Greece. The war came to an end a little before 400 B.C., and in the next century, Greek art took a new turn.

The Classic spirit still rests upon the *Hermes* (figure 64) of Praxiteles, the most famous sculptor of the fourth century. This group shows the god playing with another god, the infant Dionysus, and is of such high quality that it is widely believed to be from Praxiteles' own chisel. We have no other piece of sculpture that can claim to be an original work by the hand of one of the very famous sculptors of Greece whose names have come down to us. The Classic properties that linger here are the quiet, relaxed mood and the ideal beauty of masculine form. But the changes are decisive: the playfulness that replaces the high seriousness of the fifth century; the caressingly soft, silky modeling of skin and hair; the deep cutting of the drapery folds; the slender proportions. The Parthenon sculptures, in their sobriety and reserve, had been a kind of public testimony to the Athenians' belief in themselves, their city, and their gods. The new art of Praxiteles is, by comparison, thoroughly intimate and personal.

Other sculptors of the fourth century emphasized emotional excitement, violent movement, and strenuous action. These aims, along with Praxiteles' ideal of sensuous beauty, persisted during the rest of Greek history. They were not diminished by the conquests of Alexander the Great, but were pursued even more diligently. Although the political picture changed, and Greek civilization was spread throughout such non-Greek lands as Egypt, Syria, and Mesopotamia, the thread of stylistic development remained unbroken during the new period. The Hellenistic Age, as we call that new period, lasted from about 325 to

about 100 B.C., when the Romans took over almost the entire known world.

The *Dying Gaul* (figure 65) is an ancient copy in marble of one of a number of bronze statues dedicated by Attalus I of Pergamum (a city in northwestern Asia Minor) shortly before 200 B.C. These statues celebrated his victory over invading Gauls, whom he forced to settle down as obedient subjects of the Pergamene kingdom. The Hellenistic sculptor who conceived this figure must have known the Gauls well, as we may see in the figure's

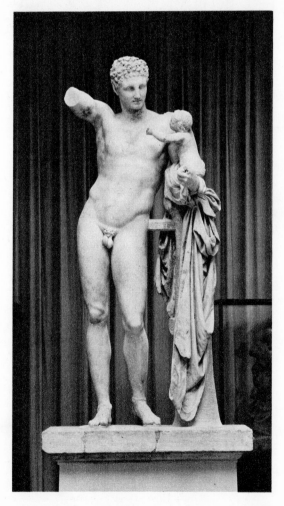

64. Praxiteles. *Hermes.* About 325 B.C. Marble, height 7' 1". Museum, Olympia. Fourth-century figures are lighter in build than those of the Classic era. Praxiteles was famous for the subtlety of his modeling and the sensuous "feel" of his surfaces.

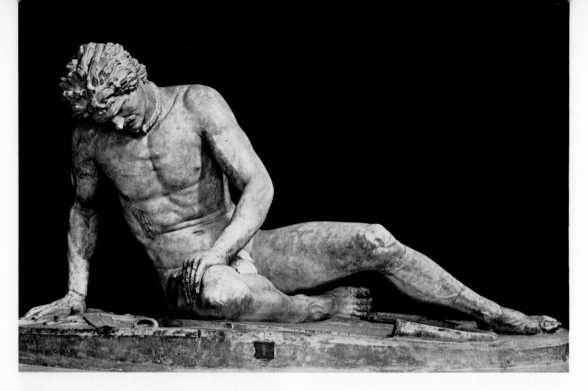

65. *Dying Gaul*. Roman copy after a bronze original of about 225 B.C. from Pergamum. Marble, lifesize. Capitoline Museum, Rome. Part of a group celebrating the victory of a Hellenistic kingdom in a desperate war against invading Gauls. The enemy is shown sympathetically in this close study of the agony of death.

66. *Nike of Samothrace*. About 190 B.C. Marble, height 8′. The Louvre, Paris. The greatest masterpiece of Hellenistic sculpture. The goddess, still airborne, is descending on the prow of a ship. The driving force of the wind, which we sense but do not see, balances her advancing figure and whips the drapery around it. This statue commemorates a naval victory.

bristly shock of hair, his broad head, and the characteristic Gaulish collar around his neck. Otherwise, the Gaul shares the heroic nudity of Greek warriors (see figure 59), and his death is not undignified. "They knew how to die, barbarians though they were," is the message carried by this statue. But there is something else, too, an animal quality opposite to the earlier Greek conceptions of man. This man is only a man—strong and well-built, but in no way like a god. He cannot control the physical responses of his body as his life slips away. No longer able to move his legs, he puts all his remaining strength into his arms, as if struggling to prevent some tremendous invisible weight from flattening him against the ground. Even more dramatic than the *Dying Gaul* is the famous *Laocoön*, a marble group created a century later (figure 67). It is all violence and strain: the bodies writhe

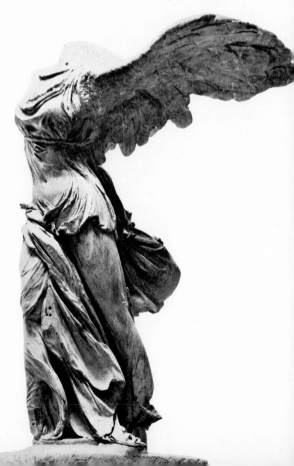

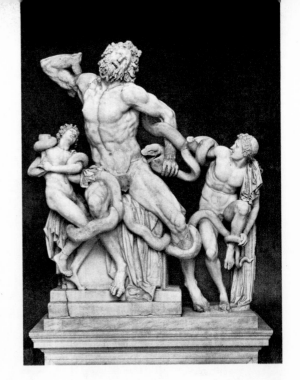

67. Agesander, Athenodorus, and Polydorus of Rhodes. *The Laocoön Group*. About 125 B.C. Marble, height 7'. Vatican Museums, Rome. Discovered in 1506, this work made a tremendous impression on Michelangelo and countless others. Today, we tend to find its expression of suffering too calculated, the surface finish too meticulous.

in the serpents' grip; the faces cannot hold back a show of agonizing pain; the muscles bulge; the elaborate detail and the high finish trumpet the sculptors' remarkable technical skill. As theater, the *Laocoön* could hardly be improved upon, but such a work was possible only when the prime impulse of Greek art was coming to an end.

Roman Art

Around 500 B.C., a little huddle of villages on the Tiber River threw off the rule of the long-established Etruscan civilization and became the Republic of Rome. By the beginning of the third century B.C., the tiny republic had grown into an important military and political power that contended with Carthage and the Hellenistic countries for domination of southern Italy. During this century, Roman literature and art began to take definite shape. In the second century, both Carthage and the major part of the Hellenistic world were conquered and taken over as Roman provinces. Now Greek influence, already present, became a flood. The Romans' unqualified admiration for Greek art brought the importation of thousands upon thousands of Greek originals —Archaic, Classic, and Hellenistic. The Romans had copies made of Greek works in even greater numbers. Many of Rome's artists were now Greek in origin. We need not be surprised, therefore, to find that Roman and Greek art bear a family resemblance. Yet the Romans altered Greek forms in order to meet their own requirements, so that their art has an unmistakable Roman stamp. That art became international as Rome became an empire that stretched three thousand miles across Europe, northern Africa, and western Asia, leaving impressive remains in staggering profusion from England and Spain in the west, to the Persian Gulf and the Caspian Sea in the east.

ARCHITECTURE

Roman architecture was a creative achievement of the highest order. The buildings put up by the Romans were more varied and complex than those of the Greeks, and far more enterprising in construction and planning. The Romans were inspired engineers. They covered their world from one end to the other with roads, bridges, aqueducts, theaters, arenas, immense bathing establishments, and great civic centers enclosing large public spaces. In order to give their buildings wide

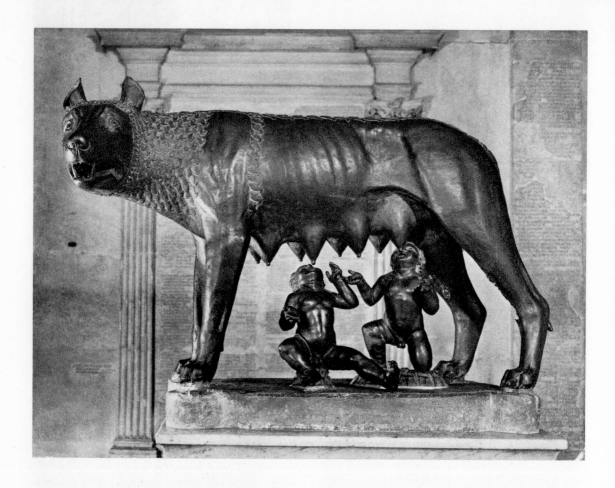

68. *She-Wolf.* About 500 B.C. Bronze, height 33½".
Capitoline Museums, Rome. The Etruscans were
a people of mysterious origin who ruled over
Rome in the seventh century B.C. In the sixth
century, the Romans won independence from
Etruscan rule; in the next two centuries they
took over Etruscan cities one after the other. The
Etruscans had great admiration for Greek civi-
lization, and their own art was strongly in-
fluenced by the Archaic art of Greece. The she-
wolf, according to early Roman mythology,
nourished Romulus and Remus, the twin
brothers who founded the city. The two babes
shown here were added 2,000 years after this
wonderfully ferocious beast was cast.

cially—that enabled them to execute their
ambitious building projects with speed and
economy. The brick and concrete cores of
Roman buildings had handsome outer skins of
stone and marble displaying Greek-inspired
decoration. It was not mere decoration, how-
ever. It was a visual language that Roman
architects used with eloquence to scale their
buildings to the human form and make com-
plex structures intelligible and clear.

The Etruscans had a tradition of rectan-
gular temples and passed this form on to the
Romans. But the Romans had their own, even
older, tradition of round temples, whose cir-
cular shape had been revered as the form of the
sky. During the Republic and the subsequent
Empire, they built round temples when
moved to renew their oldest and most sacred
ties. In its roundness, the "Temple of the
Sibyl" at Tivoli (figure 69) shows us how

openings and big, unobstructed interiors,
they used the arch, the vault, and the dome—
the Greeks had been content with the limita-
tions of the post-and-beam system. And the
Romans, who were nothing if not practical,
employed materials—brick and concrete espe-

stubbornly the Romans clung to their traditional past, even when the pulse of Greek influence beat strongly. The graceful exterior of the "Temple of the Sibyl" is Corinthian (a

69. "Temple of the Sibyl," Tivoli. Early first century B.C. The ancestor of this round temple of the Republican period was a round structure in the center of Rome in which the sacred flame of the city was kept.

variation of Ionic loved by the Romans for its richly decorative bell-shaped capitals) and thoroughly Greek in inspiration. But its substructure is a high footing—Etrusco-Roman in origin—rather than a low platform surrounded by steps, as in Greece. And if we look between the columns to the outer surface of the temple chamber, our gaze is halted by a thick wall of Roman concrete. Roman tem-

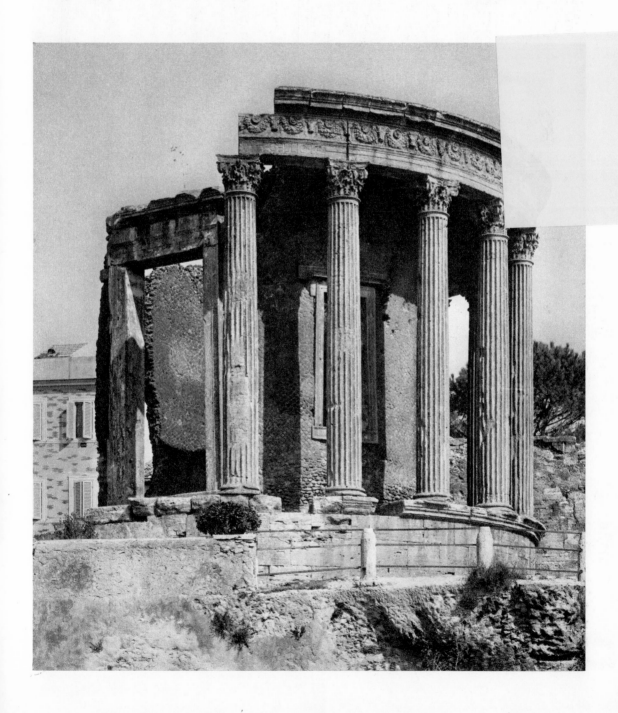

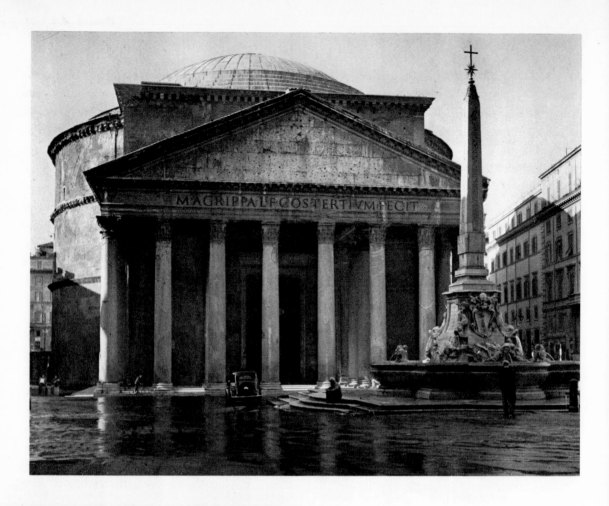

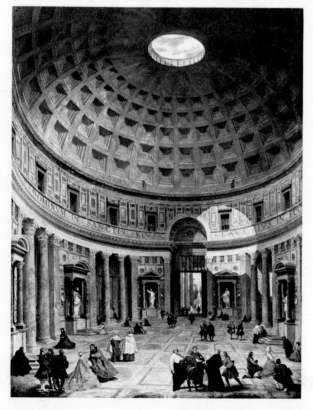

above:

70. The Pantheon, Rome. A.D. 118–25

left:

71. *The Interior of the Pantheon*. Painting by Giovanni Pannini, about 1750. National Gallery of Art, Washington, D.C. Kress Collection

The Romans were the first to build large-scale interior spaces in which a great many persons could congregate. Thus they originated architecture as we usually think of it today. Vaults and domes, which permit large spans uninterrupted by interior supports, were used for utilitarian structures at an early time. During the Empire, they were taken over for monumental civic and religious buildings.

ples, thus, were not imitations of Greek temples; they were something new.

The greatest Roman temple was the Pantheon (figures 70 and 71), built on the grand scale of the Empire at its height. One of the best preserved and the most impressive of all surviving Roman structures, the Pantheon is

a landmark in architecture: the world's first vast interior space.

From the outside, the Pantheon is a combination of a round and a rectangular temple. A deep porch, fronted by eight lofty Corinthian columns and crowned by a steep pediment, stands before a huge, bare brick-and-concrete drum (originally faced with a marble skin) that rises high to a gently curving dome. The stark exterior, although impressive, hardly prepares us for the stirring drama of the great domed space that opens before us as we step through the doorway. Inside, the dome is a complete hemisphere filled with a wonderfully even light from the circular opening at its summit. The distance from the "eye" of the dome to the patterned marble

72. Pont du Gard, Nîmes. Early first century A.D. The water supply for this ancient Roman city in southern France ran in a channel carried by the top tier of arches. Built for efficiency, this utilitarian structure achieves beauty through expressing permanence, strength, and rhythmic order.

floor below is 140 feet, and the inside diameter of the drum is also 140 feet. Accordingly, the dome and the drum it rests upon have the same height; they are in exact balance.

As its name suggests, the Pantheon was dedicated to "all the gods." More precisely, it was dedicated to the gods of the seven planets. This solemn, splendid structure, like its modest hutlike ancestor of many centuries before, represents the Dome of Heaven.

The great span and boldly molded space of the Pantheon were made possible by the Roman genius for engineering. That genius was shown as early as the fourth century B.C., when well-constructed arches and vaults were used in Rome's sewage system. Only a few of these early examples exist today, but many later arched and vaulted structures designed for utility rather than beauty still survive—bridges, aqueducts, and other major public works. One of the most famous is the Pont du Gard (figure 72), an exceptionally well-preserved stone aqueduct that spans a wide

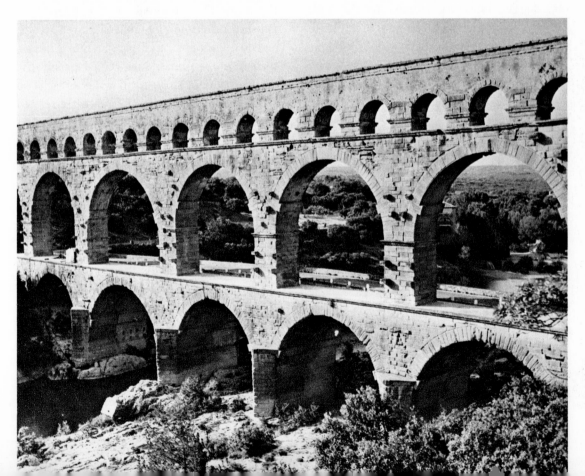

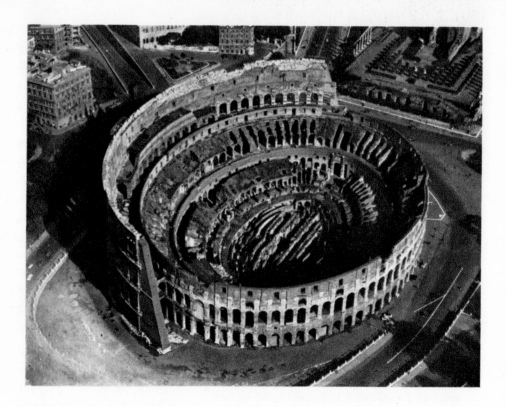

valley at Nîmes, in southern France. Its simple, rugged lines are witness to the high quality of Roman engineering and to the sense of practicality, permanence, and order that inspired an undertaking requiring so much work and planning.

The qualities that we admire in the Pont du Gard impress us also in the Colosseum (figures 73 and 74), the enormous amphitheater for gladiatorial spectacles built in the center of Rome in Imperial times. Its great mass makes it one of the largest buildings anywhere; when intact, it held more than fifty thousand spectators. The concrete core of the structure, with its miles of vaulted corridors and stairways, is a masterpiece of engineering efficiency; its design ensured a smooth flow of traffic to and from the arena. The exterior —dignified, strong, and faced with cut stone— is two-thirds of a mile around, and consists of an unending series of arches in three tiers. The arches are framed by Roman versions of the orders, here unfluted: Doric on the bottom tier, Ionic on the next, and Corinthian on the top. The columns are "engaged" in (pushed into) the piers that carry the arches, and do not support anything. They are, nevertheless, of the utmost importance artistically. Through them, this enormous exterior is so proportioned that it becomes directly related to the scale of human beings.

SCULPTURE

The Romans are often said to have been mere imitators of the Greeks in sculpture. There is a kernel of truth in this accusation: they decorated palatial homes with imitative works produced wholesale for the purpose, as well as importing and copying large numbers of Greek originals. But they had another kind of sculpture, too, with serious and important uses in Roman society. In portraiture and narrative relief they had a vital and interesting tradition of their own.

A sculptured-portrait style, unmistakably,

at left:
73. Colosseum (aerial view), Rome. A.D. 72–80

above:
74. Part of Outer Wall of the Colosseum

This vast honeycomb made of concrete faced with stone is an engineering masterpiece. It is an artistic masterpiece as well—the foremost example of how the Romans combined the Greek orders with the arch and gave coherence to a huge, complicated mass.

Roman, came into existence in the first century B.C., during the last six or seven decades of the Republic. We see that style in figure 75, which shows us the portrait head of an unknown Roman patrician. It was done at just about the same time as the fine Hellenistic Greek portrait in colorplate 7. Look at those two heads and see how different they are, even though both are extremely convincing likenesses. The Hellenistic head is a subtle psychological study; it tells us about the sitter's doubts and anxieties. The Roman head, when we first look at it, seems to be an extremely detailed description of an old man's face rather than an attempt to interpret character. It is not only that, however; the wrinkles are, no doubt, true to life, but the carver has treated them expressively. He has brought out a specifically Roman per-

sonality—stern, iron-willed, and with deep devotion to duty. The head is a "father image" of almost terrifying authority.

By old Roman custom, when the head of a family died, an image of wax was made of his face. The image was carried in his funeral procession and then kept in a special family shrine; ancestor worship of that kind may still be found in primitive societies (compare figure 10). In the first century B.C., these waxen images were translated into heads of enduring marble. And as they became transformed into portraits, they ceased to be mere visual documents—but their essential documentary quality still persisted.

We see a very different kind of artistic intention in the splendid statue of Augustus (figure 76), Rome's first emperor. If, at first, we cannot decide whether it represents a human being or a god, our indecision is wholly reasonable. This statue was meant to

75. *Portrait of a Roman.* About 80 B.C. Marble, life-size. Palazzo Torlonia, Rome. It was the custom of patrician families of ancient Rome to preserve "father images"—portrait busts that recorded the face of the head of the family with great faithfulness.

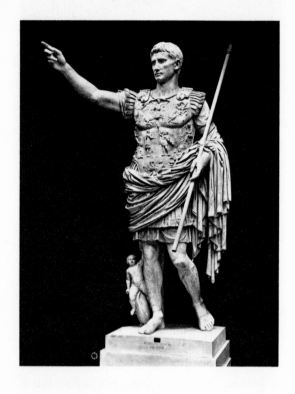

be both. As early as the time of Julius Caesar, before he was an emperor, there had arrived on Roman soil an idea from Egypt and the ancient Near East: the divine ruler, who is worshiped as well as feared and obeyed. Augustus is shown with a heroic, idealized body. The minute facial details that characterized the Republican head have been smoothed away, leaving an expression of godlike serenity. The Emperor's face seems to be a likeness, just the same; although it is the face of an exalted personage, it is clearly individual. Actually, it is beyond question a faithful likeness of Augustus—we know that face from many coins and other representations of the Emperor. A marriage of Greek idealization and Roman documentation has produced something distinctive and new.

In figure 77, which shows a narrative relief

above:

76. *Augustus of Primaporta*. About 20 B.C. Marble, height 6′ 8″. Vatican Museums, Rome. The Roman Emperor had superhuman status to dramatize the authority of the state. This statue of the first Roman emperor shows him in his capacity as divine ruler. The dolphin near his right leg is an emblem of Venus, from whom Augustus claimed descent.

below:

77. *Spoils from the Temple in Jerusalem*, relief on the Arch of Titus, Rome. A.D. 81. Marble, height 7′ 10″. This relief records the triumphal procession celebrating the Roman conquest of Judaea in A.D. 70. The illusion of space is far greater than in any Greek sculpture. On the right is one device that furthers this illusion: an archway that melts into the background of the relief.

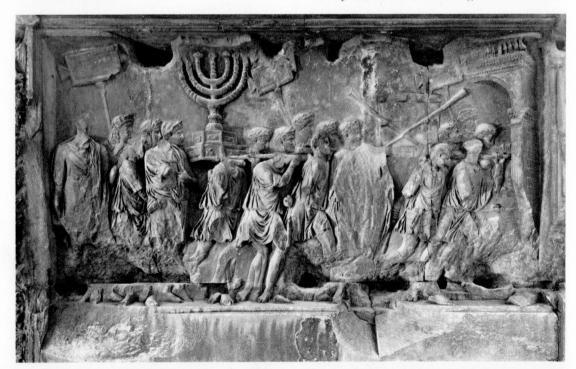

from the Arch of Titus, we see another type of sculpture used by Roman emperors to glorify their rule: representation of a great historic achievement. In the third century B.C., when the Republic became an important military power, the Romans had paintings made of the exploits of victorious generals. The paintings were carried like banners in triumphal processions. Sometime during the later years of the Republic, marble reliefs were made instead of paintings, and were attached to important monuments.

The Arch of Titus relief shows part of the triumphal procession of A.D. 71 that celebrated the Roman conquest of Judaea. The booty displayed includes the seven-branched gold candlestick and other sacred objects from the Temple at Jerusalem. The surface of the relief is damaged; nevertheless, the impression of a crowd of people moving in deep space is most successful. We see the blank background very

78. *Equestrian Statue of Marcus Aurelius.* A.D. 161–80. Bronze, over lifesize. Piazza del Campidoglio, Rome. The Romans had a tradition of showing the Emperor on horseback as the all-conquering lord of the earth. But Marcus Aurelius, a philosopher as well as an emperor, appears without arms or armor—a bringer of peace rather than a military hero, even though a small figure of a bound barbarian chieftain once crouched beneath his spirited and powerful horse. No other equestrian statue of an emperor has survived.

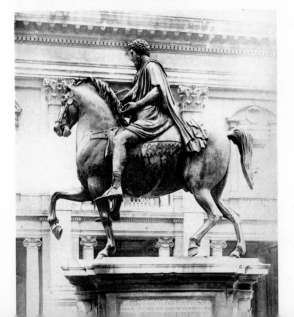

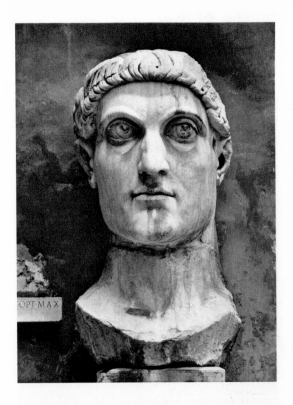

79. *Constantine the Great.* Early fourth century A.D. Marble, height 8′. Capitoline Museums, Rome. This enormous head of the first Christian emperor was part of a colossal statue. It marks the end of the Roman portrait tradition, for the sculptor is no longer trying to give us a physical likeness. The huge, radiant eyes and massive, immobile features tell us about Constantine's exalted office instead.

clearly as sky. The figures nearest us are in relief so high that they are almost in the round, and the figures farthest away in relief so low that they are almost shadows. On the right-hand side, the procession moves away to the left and disappears through a triumphal arch that is turned at an angle away from us and loses half its form in the background. This device is new, adventurous, and highly effective. The illusion of space is far greater than anything to be seen in any Greek sculpture. If we compare this procession with the procession from the Parthenon frieze (see figure 63), we are impressed by the difference between the two points of view, the Classic Greek and the Imperial Roman. The subject of the Parthenon frieze is an event that recurred every four years; the scene took place at no particular

right:

80. *Architectural View*, wall painting from the bed-
room of a villa at Boscoreale, near Pompeii,
Italy. First century B.C. The Metropolitan Mu-
seum of Art, New York. Rogers Fund, 1903.
By means of such elaborate vistas of buildings
or gardens Roman painters "opened" walls and
made small rooms seem spacious.

below:

81. *View of a Garden*, wall painting from the villa of
Livia, wife of Augustus, at Primaporta. About
20 B.C. Height of wall 9' 10½". Museo delle
Terme, Rome. The range of Roman painting is
astonishing. Here we see a painstakingly faith-
ful view of a garden. The artist's pleasure in the
beauty of flowers, fruit, and leaves was not to be
equaled for 1,400 years.

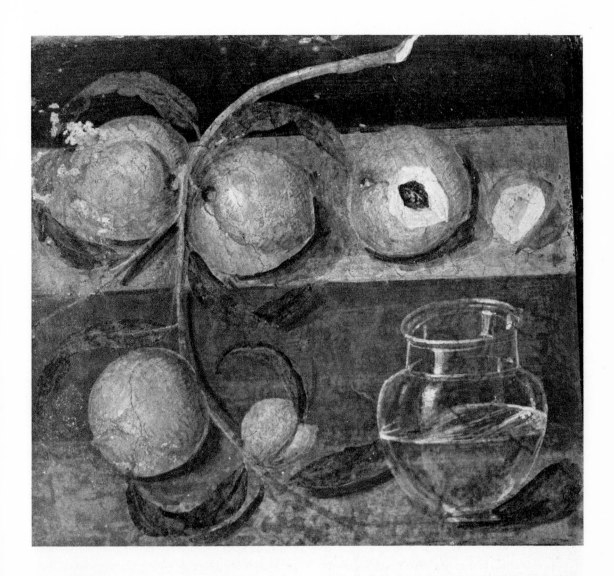

time. This is not one such procession—it is all of them. What holds the Greek relief together is its almost musical rhythm. The Arch of Titus does not deal with triumphal processions in general. Its subject is an event that occurred just once, and the scene is full of the particulars of that event. We see again that it was the artistic intention of Roman sculptors to be documentary.

PAINTING

Painted portraits served the ancestor cult of Republican Rome in much the same way as the portrait busts discussed in the previous section. Unfortunately, those portrait paintings

82. *Peaches and Glass Jar*, wall painting from Herculaneum. About A.D. 50. National Museum, Naples, Italy. Still lifes were another way for the Roman painter to break down the solid surface of a wall.

no longer exist. We do have a large number of realistic, highly individual painted portraits from Roman-dominated Egypt, where the ancient practice of attaching an image of the deceased to his mummified body lasted into Roman times. The *Portrait of a Boy* (colorplate 10) is as bright and strong in color as on the day it was painted. Its freshness is owed to a durable technique called encaustic, in which the pigments were mixed with hot wax.

83. *Girl Athlete* (detail of a pavement). About A.D. 400. Mosaic. Piazza Armerina, Sicily. The villa in which this strangely modern-looking maiden was recently found must have been one of the last outposts of the pagan way of life after Christianity had become the official religion of the Roman state.

In our example, the paint has been applied with great sureness of touch. The boy's face is firmly modeled by light and shade; it is as solid and lifelike as anyone could wish. The highlights on forehead, nose, eyelids, and cheekbones give sparkle to the painting, and the pinpoints of light in the large dark eyes make the boy appear to be looking right at us.

Encaustic could be used on the inside walls of houses as well as on small wooden panels. The favored method of working on walls, however, was fresco, in which the artist worked with watercolors on freshly applied wet plaster. Most of the Roman wall paintings that we still have today are from Pompeii and the other towns near Naples buried by the eruption of the volcano Vesuvius in A.D. 79.

The *Lady Musician and Girl* (colorplate 9) from a villa near Pompeii looks like colored sculpture. The accomplished foreshortening and skillful modeling in light and shade make the figures, chair, and musical instrument look convincingly real and solid. The flat red background reinforces the resemblance to sculpture, for it reminds us of the flat background plane from which the forms of Greek and Roman reliefs come forward.

In the richly imaginative *Architectural View* (figure 80) from the same villa, the artist has created a remarkable illusion of differently textured solid forms—note particularly the mask and the ornate columns that frame the scene—existing in deep space. He has an inkling of the principles of perspective—the forms diminish as they recede, and near and distant elements are different in scale. The suggestion of space opens the wall and makes the room seem larger.

We can be sure that Roman wall paintings preserve many properties of Greek painting. We know that the Romans imported Greek paintings and painters. But since no Classic or Hellenistic Greek wall paintings have survived, it is hard to sort out what is Greek about the works we have just seen, and what is Roman. Our musical Roman lady, for example, has something of the idealized beauty of the seated woman painted on the Classic Greek vase (figure 48). But it is easy to see that she belongs within a realm of space and light never described on a Greek vase. If we could put our Roman wall paintings together with the decorations on the Greek vases discussed on pages 42–46, we would get a better notion of the lost masterpieces of Greek wall painting.

PART TWO

The Middle Ages

Early Christian Art

The Roman Empire, with its many different lands and peoples, held together for five full centuries only because the Romans had a genius for government. They were too wise to rely on military force alone, even though they had the most powerful armies on earth. After conquering a country, they turned its people into Romans of a sort by teaching them Roman ways and allowing them to become Roman citizens. They did not try to give the Empire a common religious faith, never insisting that everyone had to accept the official Roman religion. All they required was an annual sacrifice to the emperor, who, like Egyptian and Oriental rulers before him, was a god as well as a ruler. For the rest, the Roman gods, Greek gods, Egyptian gods, and the local gods of all the provinces were allowed to compete with one another. The general tendency was to believe that no religion had all of the truth but that every religion had some of it.

No one religion could win primacy over all the others while the Empire was stable and peaceful. But when the economy sagged and powerful neighbors began to press against the frontiers, people felt a great need for a strong faith that could provide assurance and comfort. Then they turned to the religions that offered the world such a faith, the Christian religion among them. The followers of Jesus Christ were zealous in spreading their beliefs. By the time the Empire was verging on collapse, Christianity had won out over all other religions and the Christian Church was well established.

Jesus of Nazareth was born among the Jews, who had long believed in one God while their neighbors worshiped many gods. God, as conceived by the Jews, was all-powerful and ruled over the entire universe, which He had created. All men were His children, but He had a special concern for His chosen people, the Jews, to whom He had made his will known through His laws and commandments. Those laws, written down in the Old Testament, told men exactly how they had to behave toward the Lord and one another in order to lead good lives. That God was just, and that obeying His commandments was the only way to please Him, was a great and new concept. The laws of the Old Testament were accepted by Jesus. But Jesus said that to observe them was less important than to love God, who had love and mercy for all mankind, even for the people who broke His laws. And He also said that God commanded men to be loving and forgiving toward one another. Jesus' own life, as told in the Gospels of the New Testament, was an example of how men should live. To His followers, He was the Son of God, the Saviour whose coming had been predicted in the Old Testament. Those who put their trust in Christ, they believed, would be raised after death to live eternally in Paradise; and God held out this hope to all races and nations, to Jews and gentiles, to rich and poor.

The followers of Jesus were eager to carry their message everywhere. They traveled to remote parts of the Roman Empire to teach the new religion and establish Christian communities. In Italy, the most important such community was in Rome, where we find some of the earliest pictures by Christian artists. The pictures were painted on the walls and

84. *The Good Shepherd, the Story of Jonah, and Praying Figures.* Early fourth century A.D. Painted ceiling of the Catacomb of Saints Peter and Marcellinus, Rome. To Early Christians, the Biblical story of the miraculous rescue of Jonah was a promise that they, too, would rise from the grave through the power and mercy of the Lord. The image of the Good Shepherd, who gives his life for his sheep, stands for Christ. The design forms a cross, the basic symbol of the new faith.

ceilings of catacombs, the long underground passages where the Early Christians buried their dead.

What is left of a painted ceiling from such a catacomb is shown in figure 84. Its style, clearly enough, is borrowed from pagan Roman painting, although the figures, by comparison with the pagan examples we have seen, appear immobile, stiff, and rather flat—almost as though pasted against the white background. Our artist, obviously, was not too interested in such matters as modeling and foreshortening.

We can tell from this painting that the Early Christians had a new outlook on life. Their thoughts were centered on the Saviour and on the life hereafter, rather than on them-selves and on the pleasures of this earth. Thus the physical beauty and strength of the human body—which had been supremely important in Greek and Roman art—ceased to hold much meaning for them. They wanted their pictures, instead, to show the power and glory of Christ and tell about His mission on earth.

Early Christian painters could not do that directly. Instead they hinted at it by using symbols—that is, figures or signs that stand for something else, something we cannot see. The frame that separates and connects the scenes at one and the same time is a complex symbolic structure, and each scene within it has a symbolic meaning. Let us see the significance of these messages.

The outer edge of the frame is a circle that is intended to suggest the Dome of Heaven. The hub of the frame encloses a picture of a shepherd and his flock. He stands for Christ, the Good Shepherd, who gives up His life for His sheep; and His central position in the scheme of the ceiling proclaims Christ's central position in the universal scheme. The compartments arrayed like the spokes of a wheel form a big cross. The cross, a sweep-

ingly comprehensive symbol of the new faith, stands for Christ himself, for the Christian Church, for the salvation of mankind. The upright figures lifting their hands symbolize the members of the Church, who pray to God for help and salvation. Inside the semicircular compartments are scenes from the Old Testament story of the prophet Jonah. Jonah, after taking passage on a ship contrary to God's command, was thrown by the sailors into the sea, where a whale swallowed him. While inside the whale he prayed to God to be let out, and the whale released him on dry land. In the scene on the left we see the ship, Jonah dropping into the water, and the waiting whale. In the scene on the right we see the whale disgorging him. The bottom scene shows Jonah back on land and lying in the shadow of a vine. This story signified to the Early Christians that God would deliver them from the grip of death into eternal life, just as he had delivered Jonah from the whale.

At first the Christians were an illegal sect. But even though they were despised and persecuted, their message turned out to have an irresistible appeal. More and more people joined them as time went on. In the fourth century, the Emperor Constantine became a Christian, and Christianity became the state religion of the Roman Empire. Constantine recruited master architects to create an impressive setting for the new Imperial religion. In a short time, an astonishing number of large churches arose in Rome, in the Holy Land, and in the newly established Imperial capital of Constantinople. These churches were a new type of structure, the Christian basilica.

Early Christian basilicas were rather lightly built, with timber roofs; over the centuries, many of them have been so remodeled as to lose much of their original appearance. For these reasons, no Constantinian basilica survives in its true form. Constantine's greatest church, Old St. Peter's in Rome, was torn down more than four hundred years ago to make way for the present St. Peter's. There are records, however, that can help us form an idea of what it was like.

One such record is the ground plan of Old St. Peter's, which is shown in figure 85. The elements of the plan—an open court surrounded by columns, an entrance hall formed by the far end of the court, and the five-aisled church proper—are something like those of the Egyptian temples of many centuries before, and, as in Egyptian temples, are laid out on a single long axis. The central aisle, the nave, is twice as wide as the others; all of them end at a separate compartment, the transept, placed at right angles to it. Beyond, centered on the transept, is the final and easternmost element, the semicircular apse.

Another record is a picture of the interior of St. Paul's Outside the Walls, a basilica much like Old St. Peter's in size and arrangement and only slightly later in date. St. Paul's Outside the Walls, until wrecked by fire in the early 1800s, retained its original form, which is shown in the picture (figure 86). If we could go through the door of the entrance hall, we should come upon this impressive view. The nave rises high above the side aisles in a clerestory lit by windows at the top. The steady rhythm of the nave columns pulls us toward the great triumphal arch that frames the altar and the half-domed apse beyond. As we move forward we realize that the altar stands at the point where the axis of the nave bisects the axis of the transept. The altar, the focal point of worship, is the architectural focal point as well.

Inside, Early Christian basilicas were filled with the shimmering light and color of precious marble surfaces and wall mosaics in gold and colored glass. Outside, they were unadorned brick. The opposition of interior splendor and exterior drabness was intended to symbolize the difference between things of the spirit and things of this earth. The King-

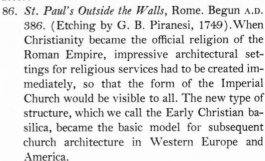

above:
86. *St. Paul's Outside the Walls*, Rome. Begun A.D. 386. (Etching by G. B. Piranesi, 1749).When Christianity became the official religion of the Roman Empire, impressive architectural settings for religious services had to be created immediately, so that the form of the Imperial Church would be visible to all. The new type of structure, which we call the Early Christian basilica, became the basic model for subsequent church architecture in Western Europe and America.

right:
85. Plan of Old St. Peter's, Rome. Begun about A.D. 333. Old St. Peter's, Constantine's greatest basilica, was torn down during the Renaissance to make way for the structure we know today.

dom of God was within—a spiritual realm completely separate from the scorned world of nature and everyday life outside. Our two views of the well-preserved sixth-century church of Sant' Apollinare in Classe, near Ravenna, Italy (figure 87 and colorplate 11), show this contrast in a striking way.

The triumph of Christianity in the fourth century was revolutionary for pictorial art as well as for architecture. All of a sudden there were huge wall surfaces—apse, triumphal arch, the walls carried by the nave columns—that had to be covered with images worthy of their monumental setting. Who was equal to this challenge? Certainly not the humble artists who had decorated the catacombs with their limited stock of types and subjects. They were supplanted by artists of much greater ability, recruited, like the architects of the new basilicas, by the Imperial authorities. Drawing upon earlier sources, these men created a great new art form, the Early Christian wall mosaic. The Romans, in pagan times, had made pictorial floor mosaics out of pieces of colored stone (see figures 50 and

83). The material of the Christian mosaics was glass. The bits of glass were unsuitable for imitating painted pictures, for they could not provide the necessary gradations of tone, but they were used to make decorations and pictures of a new sort. For, unlike the bits of marble, they had rich, intense colors, including gold. Moreover, they acted as tiny reflectors that broke up the uniform, continuous wall surfaces, turning them into glowing, glittering screens composed, seemingly, of the light they reflected rather than of solid stone. In Early Christian architecture, every effort was made to suppress the suggestion that walls were thick and bore down upon columns. The walls gave shape to poised and weightless volumes of interior space, and glass mosaic was a true partner to the architecture in this aesthetic task.

The Parting of Lot and Abraham (figure 88) is a scene from a series of narrative mosaics along the nave walls of the church of Santa Maria Maggiore in Rome. The mosaicist, faced with the problem of showing complex action so simply that an observer who stands

below and some distance away can read it clearly, has used shorthand abbreviations for "house," "tree," and "city" (we use a similar shorthand in stage properties and scenery today). In another bit of visual shorthand, he suggests a crowd of people by a cluster of heads behind a foreground figure. Having to resort to such tricks gave him no distress. There were precedents for them in pagan Roman art, and furthermore—unlike his Roman predecessors—he was not interested in suggesting palpable three-dimensional physical reality. Nor was he interested in dramatic movements and the little details that would develop the narrative—the observer was expected to be acquainted with the story already. The scene has a deep meaning. It is a sermon, a lesson in the workings of God's will. Glances and gestures are the prime means by which the artist has put his message across. One half of the composition is occupied by Abraham and his family;

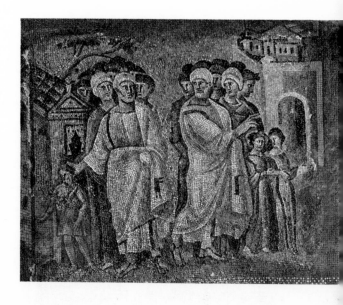

88. *The Parting of Lot and Abraham*. About A.D. 430. Mosaic. Santa Maria Maggiore, Rome. Classical Roman mural paintings created an illusion of an earthly reality beyond the flatness of the wall surface. Early Christian mosaicists continued to use some of the old devices, but showed a supernatural, heavenly realm very different from the world of ordinary experience.

Abraham points to his family as he turns to the left. The other half is occupied by Lot and his family, who turn away from Abraham and toward the city of Sodom, which is on the extreme right. The significance of this parting is clear: Abraham's way is that of righteousness and the Covenant; Lot's is that of sin and disobedience, destined to be punished by God.

Where did the designers of narrative mosaic sequences get the inspiration for their compositions? For some subjects, they could have found models among the catacomb murals. The chief source, however, seems to have been picture books illustrated, page after page, with scenes from the Bible. Christianity was a scriptural, or written, religion. The sacred texts were duplicated in vast numbers, and, since books were vessels for the deepest feelings and the highest aspirations of the age, each copy was treated with reverence, and many copies became works of pictorial art. Book illustration—illumination, we usually

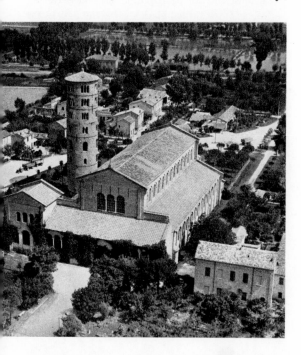

87. Sant' Apollinare in Classe, Ravenna, Italy. A.D. 533–49. The exteriors of Early Christian basilicas were plain in contrast with the richly decorated interiors.

89. Illustration from the *Vatican Vergil*. Early fifth century A.D. Miniature. Vatican Library, Rome. This scene, separated from the text by a heavy frame, looks like a window cut into the page of the book. Its style recalls Roman wall paintings of an earlier day (see figure 81).

say—in rich colors, including gold, became the small-scale counterpart of murals, mosaics, and painted panels.

We do not know exactly when Early Christian book illumination began, nor can we trace its earliest developments. But classical as well as Biblical subjects were depicted; and the style of the earliest illuminations was influenced by Greek and Roman painting (see figures 80–82). The *Vatican Vergil*, done about the same time as the mosaics of Santa Maria Maggiore, is one of the oldest illuminated manuscript books still preserved, and reflects the Roman tradition; a page is shown in figure 89. The Greek-language *Vienna Genesis* is a far more impressive work than

below:

90. *Jacob Wrestling with the Angel*, from the *Vienna Genesis*. Early sixth century A.D. Miniature. National Library, Vienna. The pages of this manuscript are deep purple and the lettering silver (now turned black). Here the figures are no longer inside a "window"; the page itself now serves as the sky.

the rather lame *Vatican Vergil*. Written in silver (now turned black) on purple-dyed vellum (thin, bleached calfskin) and adorned with brilliantly colored miniatures, it attains a splendor like that of the mosaics we have just examined. Figure 90 tells a part of the Old Testament story of Jacob. Here, rather than a single event, we are shown a whole sequence of events strung along a U-shaped path. At the bottom center, for example, Jacob wrestles with the angel and then, to the left, without any separation, receives the angel's blessing. This method of continuous narration is extremely economical; it enables the painter to pack a maximum of storytelling into a limited area. Our artist, apparently, thought of his picture as a running account to be read like a text, rather than—as in the *Vatican Vergil*—a window demanding a frame. Until late in Hellenistic times, when our present type of bound book was developed, books had the form of continuous scrolls that were unwound and rewound as the reader went along. The organization of the *Vienna Genesis* picture may very well reflect such earlier scrolls.

Christian art, in the fourth and fifth centuries of our era, was a shared development of the Latin Roman Empire in the West and the Greek Roman Empire in the East. In the sixth century, Constantinople (now called Istanbul) and the East became supreme, and the artistic contribution of the West faded away. There was no longer a western Roman emperor or an Imperial government. The eastern Emperor Justinian ruled over the West through his governor in Ravenna; but he ruled only in name, for the Roman Pope and the barbarian kings were in fact independent. Early Christian art thus arrived at its culmination in Constantinople, the capital of the East; the sixth century is called the First Golden Age of Byzantine art, after Byzantium, the ancient name for Constantinople.

Justinian built on a truly imperial scale. The masterpiece of his reign was the domed church of Hagia Sophia (Holy Wisdom) in Constantinople—in the East the dome was preferred to the open timber ceilings of the West. Hagia Sophia is illustrated in figures 91–93. The central feature of its nave is a square compartment that is changed to a circle at the top by four spherical triangles. Above their circular rim, the triumphant dome—"like the radiant heavens," said a writer of the time—floats on a glowing ring of light let in by the windows in its base. Light plays a key role in the interior. It seems to expand and fill the dome, the spherical triangles, and the half-domed recesses beyond. Standing on the patterned marble floor, we lose all sense of weight, as though nothing above us and around us were solid and material. The architectural aesthetic that we saw taking shape in Early Christian basilicas has here reached a new dimension. The golden glitter of the original mosaics must have intensified the illusion of a heavenly realm divorced from everyday reality.

The still surviving mosaics of the First Golden Age are found in the Byzantine Empire's Italian outpost of Ravenna rather than in Constantinople itself. The most famous are the pair flanking the altar of the church of San Vitale (figure 94 and colorplate 12). Here, the Emperor Justinian and the Empress Theodora, accompanied by officials, clergy, and ladies-in-waiting, attend the service. They reveal a new ideal of human beauty: extraordinarily tall, slim figures; small, almond-shaped faces with huge staring eyes; bodies that disappear under magnificently patterned costumes; and tiny feet that make no contact with the ground. Every hint of movement or change is carefully excluded. These solemn, frontal figures, heads all in a row like notes of music, seem to present a celestial rather than an earthly and secular court, a fusion of spiritual and political authority. We are in

above:

91. Anthemius of Tralles and Isidorus of Miletus. Hagia Sophia, Istanbul. A.D. 532–37. We must imagine this structure without the four minarets, which are a Turkish addition. Byzantine construction methods enabled Justinian's architects to place the dome of Hagia Sophia over a square base instead of the cylindrical drum used in the Pantheon (figure 70). The dome, moreover, was lighter, and could be higher and more prominent than in classical Roman structures.

left:

92. Interior of Hagia Sophia. Beneath the windows that ring the base of the dome, note the spherical triangles that convert the square compartment of the nave into a circle for the dome to rest upon.

below:

93. Section of Hagia Sophia (after Gurlitt)

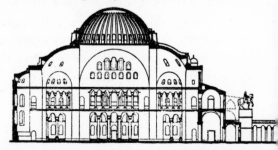

fact invited to see Justinian and Theodora as counterparts of Christ and the Virgin: they both wear halos, and Justinian's twelve companions (there are six soldiers behind the shield bearing the monogram of Christ) are counterparts of the twelve apostles.

The development of Byzantine painting and mosaic was disrupted by the century-long Iconoclastic Controversy, which began in 726 with an Imperial edict forbidding religious images. Recovery was rapid in the Second Golden Age (roughly 850 to 1200). The finest works of the Second Golden Age show a classicism that lives in harmony with the spiritualized ideal of human beauty that we saw in the Justinian mosaics. Among those works, the eleventh-century *Crucifixion* mosaic at Daphnē (figure 95) is especially famous. The most profound aspect of its classicism is its

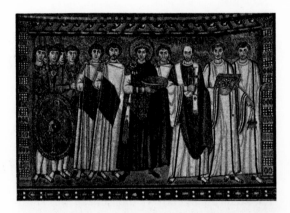

top right:
94. *Justinian and Attendants.* About A.D. 547. Mosaic. San Vitale, Ravenna, Italy (see also colorplate 12). Under Justinian, the Byzantine Empire reached the height of its political power, and Byzantine artists produced some of their finest work. Mosaics such as this differ from Roman examples (compare figure 83) not only in style but also in technique; composed of small cubes of glass rather than of marble, they dazzle the beholder with their rainbow-bright colors.

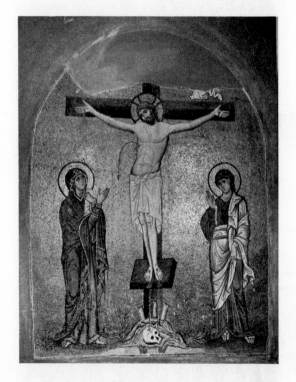

middle right:
95. *The Crucifixion.* Eleventh century. Mosaic. Monastery Church, Daphnē, Greece. The Second Golden Age of Byzantine art added something of the human emotion and bodily grace of classical art to the eternal and divine qualities stressed in the mosaics of the First Golden Age.

bottom right:
96. *Christ in Majesty.* About 1148. Mosaic. Cathedral, Cefalù, Sicily. Southern Italy and Sicily, until about 1100 when the Normans took over, belonged to the Eastern Roman Empire. Byzantine influence persisted after 1100. This awesome Christ, who gazes at us with hypnotic intensity, is the equal of the finest Second Golden Age works in Greece itself. Note that the lefthand page of the book is in Greek, the righthand page in Latin.

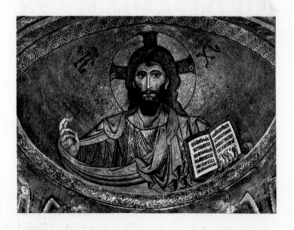

quality of human emotion, a restrained and noble suffering of the kind we first met in Greek art of the fifth century B.C. (see pages 62–65). Early Christian art had been completely dispassionate and formal; in representing Christ it had stressed his eternal and divine rather than his human qualities, his wisdom and power rather than his sufferings on earth and sacrificial death on the cross. The *Daphnē Crucifixion* harks back to classical antiquity in its balance and clarity, too, and in the statuesque dignity of its three figures. Although slim and graceful, they have more substance than the ethereal forms of the Justinian mosaics.

Icons—pictures painted on panels—were produced in considerable number during the Second Golden Age and were held in great veneration. Little is known about their origins, for examples earlier than the Iconoclastic Controversy are very scarce. Among the most important is a *Madonna* recently discovered in Rome (figure 99). Its encaustic technique and its modeling by light and shade

98. *The Archangel Michael*. Leaf of a diptych. Early sixth century A.D. Ivory, $17 \times 5\frac{1}{2}''$. British Museum, London. This small but majestic archangel is a descendant of the winged Victories of Greek and Roman art. But the power he displays is not of this world, nor does he occupy an earthly space. He seems to hover weightlessly rather than to stand (note the position of his feet on the steps). The architectural niche behind him has lost all of its depth.

97. Sarcophagus of Junius Bassus. About A.D. 359. Marble, $3' \ 10\frac{1}{2}'' \times 8'$. Vatican Grottoes, Rome. Sculpture was much less important in Early Christian art than painting and architecture. Lifesize sculptured figures were avoided as "idols." The most important sculptures were marble sarcophagi. This example shows a mixture of Old and New Testament scenes. Like manuscripts and wall mosaics, they convey their own story and also a higher, symbolic meaning.

show a connection with Roman portraits (see pages 79, 80). The forms themselves, however—heart-shaped face, tiny mouth, long, narrow nose, enormous eyes—reflect an ideal of beauty as formal and celestial as that of the San Vitale mosaics, and far more sculptural. The impressiveness of this image is owed to its severe geometric design, which lends the features a grandeur never to be seen again in Early Christian or Byzantine art. When and where was it painted? In the sixth or seventh century perhaps, but whether in Italy or the East we cannot say.

Most icons were meticulously craftsmanlike rather than artistically inventive; the painters repeated fixed patterns over and over. The *Madonna Enthroned* (colorplate 13) is such a work. As a result of endless repetition,

the drapery highlights have been stylized into ornamental sunbursts, and the throne, although foreshortened, does not work as a description of a three-dimensional object. But the graceful pose, the rich play of drapery folds, and the tender melancholy of the Virgin's face all breathe the classicism of the Second Golden Age. The total effect is neither flat nor spatial: the painting, rather, has something of the transparency of stained glass; the shapes look as if they were lit from behind. In a sense they are, for they have been painted as a thin film on the reflecting gold surface that forms the highlights, the halos, and the background, so that even the shadows never seem wholly opaque. This pervasive celestial radiance is a quality that we first saw in Early Christian mosaics.

Together with the Orthodox Christian faith, the style of the Second Golden Age was taken over by the newly converted Russians and Bulgarians almost at the time it began, and it has lived on in Eastern Europe down to our own times.

99. *Madonna and Child* (detail). Sixth or seventh century A.D. Encaustic on wood. Santa Francesca Romana, Rome. This image is painted in the same hot-wax technique as the portrait of a boy in colorplate 9, but the ideal of beauty represented here is far removed from classical art.

The Earlier Middle Ages in the West

THE DARK AGES

Between the fifth century and the seventh, wave after wave of Germanic tribesmen penetrated the Roman world of western Europe. They defeated the Roman armies and, mixing with the local populations, created independent local kingdoms. They became Christians and absorbed what was left of Roman civilization. The present nations of western Europe —Spain, France, Italy, Germany, England— were born in this process. In the eighth century, the Church in Rome separated from the Orthodox Church and broke its ties with the East Roman Empire. It turned for protection to the north, where the Frankish kingdom had extended its power over France, Germany, and part of Italy. On Christmas, 800, the Pope solemnized the new order of things by conferring the title of emperor on the Frankish king Charlemagne. The Europe that we know today was now beginning to take shape.

The two hundred years between the death of Justinian and the reign of Charlemagne are known as the Dark Ages. They were by no means wholly dark, for in these centuries the people of western Europe were painfully creating the social and political framework of the Middle Ages. And we shall see that they also created important works of art.

100. Purse Cover from the Sutton Hoo Ship-Burial. Before A.D. 655. Gold and enamel. British Museum, London. The fighting monsters at the top center combine the animal style of barbarian nomads with the interlace pattern of the civilized Mediterranean world.

The Germanic tribes carried into Europe, in the form of harness trappings and other gear, an ancient and widespread artistic tradition, the so-called "animal style." Characteristic of this style (see figure 100) are the four ornamental designs arranged symmetrically along the bottom of a seventh-century gold-and-enamel purse cover once buried with a petty Anglo-Saxon king—two motifs, each repeated. One motif is a man between two facing beasts, the other an eagle pouncing on a duck. Both motifs had a long history; we saw one of them on a Sumerian object of 2600 B.C. (figure 34). The design in the top center of the purse cover, however, just above the eagle-and-duck motifs, was of recent origin. Moreover, this upper design is not in the animal style exactly, although obviously related to it. It consists, we notice, of fighting monsters whose tails, legs, and jaws are extended into ribbonlike bands that form a complex interlacing pattern. Now, the interlace motif happens to be Mediterranean in origin. It came to be added to animal-style beast shapes in the Dark Ages, not before. The combined shape seen here is worth attention

for its high degree of control and its imaginative freedom—it is disciplined, abstract, and, at the same time, organic and full of life.

When the barbarians settled down—thereby creating the Dark Ages—the forms of the animal style, which had originated in metalwork during the period of their wanderings, were transferred to stone and wood. One of the rare surviving examples in wood is the splendid head of a beast (figure 101) found in a ninth-century Viking ship-burial. The ba-

101. *Animal Head*, from the Oseberg Ship-Burial. About A.D. 825. Wood, height about 5". University Museum of Antiquities, Oslo, Norway. This head is spun over with geometric and interlacing patterns derived from metalwork.

sic shape of the head is convincingly realistic, and so are such details as nostrils, fangs, and gums, but the surface has been spun over with interlacing and geometric patterns clearly derived from metalwork. Snarling monsters such as this were used as figureheads on Viking ships, which thereby took on the look of mythical sea dragons.

The pagan animal style made its way into the earliest Christian works of art produced north of the Alps. These works were manuscripts written and illuminated by Irish monks. The Irish, during the Dark Ages, were the standard-bearers of civilization. Irish missionary monks not only speeded the conversion to Christianity of northern Britain, northern France, the Low Countries, Scandinavia, and Germany, but, through the monasteries they founded in those countries, set a pattern that the early medieval Church would follow. Until the twelfth century, all Europe north of the Alps remained rural, with low populations and no large cities. The monasteries were the most important religious and cultural centers. Their monks were not only Europe's priests and teachers but also its artists, craftsmen, and agricultural experts.

Nothing at first glance seems Christian about the eighth-century Irish manuscript page (figure 102) from the *Book of Durrow*. This manuscript tells the story of the life of Christ as written by the Evangelists Matthew, Mark, Luke, and John; it is, in other words, a gospel book. But we see that the artist has not tried to illustrate the sacred story. Instead, he has brightened it up with a wonderful piece of ornament in the pagan animal style. Working with a jeweler's precision, he has poured into the outer compartments of his geometric frame an animal interlace so dense and yet so full of controlled movement that the fighting beasts of the Sutton Hoo purse seem simple by comparison. The compartments surround an empty square, inside which is another island of ornament, a circle made up of a geometric

102. Page from the *Book of Durrow*. About A.D. 700. Manuscript illumination. Trinity College Library, Dublin. The monk who decorated this page borrowed his interlacing bands and fighting animals from the art of his pagan ancestors. The tiny cross is the only Christian element here.

interlace without animals. And in the center of this circle is the Christian core of the whole design: a tiny cross inscribed in a tiny circle. In the symbolic language to which we were introduced when we first looked at Early Christian art, the artist is telling us that there are two different worlds: the outer frame, with its fighting monsters, suggests the dark and cruel world of paganism; the central circle stands for the peaceful, stable world under Christ.

Let us look at a page from another gospel book of the same time, a *Crucifixion* (figure 103). Here the artist of the Dark Ages, so

103. *Crucifixion*, from a gospel book. About A.D. 750. Manuscript illumination. Stiftsbibliothek, St. Gall, Switzerland

104. *St. Matthew*, from the *Gospel Book of Charlemagne*. About A.D. 800. Manuscript illumination. Schatzkammer, Kunsthistorisches Museum, Vienna, Austria

masterly within his own inherited tradition of ornament, was out of his depth when obliged to make the image of man. In his attempt to reproduce an Early Christian composition, our miniaturist has struggled with the problem of how to represent the human body as a connected whole with a characteristic structure. He deals with this challenge by using the means that have come down to him, and he turns Christ's body into a knot of interlacing bands out of which emerge head, hands, and feet. In trying to do something that he does not fully understand, he has produced a picture that seems childish and crude. But we can see in it, also, a triumph of man's adventurous spirit, for the artist is making a conscious effort toward bridging the gap between Northern barbarism and the traditions of Mediterranean lands.

CAROLINGIAN ART

Charlemagne's empire did not endure, but the effects of his cultural revolution can be felt even today. Preserving the classics was part of Charlemagne's great dream of restoring Roman civilization. To a remarkable extent, he succeeded in inoculating the minds of his semibarbarous subjects with the majestic traditions of the Roman past. The art of the Carolingian Revival was a thoroughgoing blend of Mediterranean culture and Celtic-Germanic spirit. Thus, it was the first that we can truly call European.

This very page you are reading, for example, looks the way it does because of the Roman letters of which it has been composed. The shapes of those letters are actually a Carolingian invention, and the monks devel-

halo, might almost be mistaken for an ancient Roman portrait. Everything about him—powerful body, bold head, shading and foreshortening, the suggestion that he is being seen through a window—reminds us of Roman painting. The artist—was he Byzantine? Italian? a Frank?—has mastered the Roman tradition, down to the leaf-ornamented frame that suggests a window opening.

Our next miniature, *St. Mark*, was painted twenty or thirty years later for the *Gospel Book of Archbishop Ebbo of Reims* (figure 105). Its close connection with the St. Matthew that we just saw is unmistakable. But it is much less classical in feeling. St. Mark's gaze is not fixed on the book that he is writing but on his symbol, the winged lion carrying a scroll of the sacred text down from heaven. The picture, then, expresses obedience to God's command—a medieval rather than a classical conception. And the dynamic line that distinguishes the *Gospel Book of Ebbo* from the *Gospel Book of Charlemagne* recalls the passionate expressive movement we found in Christian Irish ornament during the Dark Ages. St. Mark's toga swirls around him; the plants and shrubs seem tossed by a whirlwind; even the leaf pattern on the frame is agitated and flamelike. Everything is in motion; the entire picture is charged with energy. The two living traditions of Western Europe have now blended in a single, integrated new style.

Charlemagne, through his visits to Italy, was familiar with the architectural monuments of Constantine's reign in Rome and Justinian's reign in Ravenna. He wished his own capital of Aachen to convey the majesty of empire through buildings as impressive as those of his great predecessors south of the Alps. His famous Palace Chapel was directly inspired by the church of San Vitale in Ravenna, whose mosaics we saw in the previous chapter. To erect such a structure on Northern European soil, where the art of grand-scale building had disappeared with the

105. *St. Mark*, from the *Gospel Book of Archbishop Ebbo of Reims*. A.D. 816–35. Manuscript illumination. Municipal Library, Épernay, France

During the "Roman revival" under Charlemagne, Northern European artists learned to master the images of Early Christian art. The crucified Christ in figure 103 is still a knot of interlacing bands, but the *St. Matthew* (figure 104) could almost be mistaken for a Roman author. The *St. Mark* is clearly derived from Roman models, but every line has the energy of the interlacing bands of figure 103.

oped them to use in Charlemagne's project of collecting and copying ancient Roman literary works. The oldest existing texts for many classical Latin authors are Carolingian manuscripts that, for a long time, were mistakenly thought to be Roman. Hence the word "Roman" for their letter shapes.

Let us look at figure 104, a miniature of *St. Matthew* from a gospel book said to have been found in Charlemagne's tomb. It is an astonishing work to have been executed in Northern Europe around the year 800. The Evangelist, if it were not for his large golden

106. Interior of the Palace Chapel of Charlemagne. A.D. 792–805. Aachen, Germany. After the fall of the western Roman Empire, monumental architecture disappeared in western Europe. Charlemagne's dreams of restoring Roman civilization can be seen in this chapel, a training ground for the architects of the Middle Ages.

decline of the western Roman Empire, was an ambitious undertaking Expert stonemasons must have been extremely difficult to find. Columns and bronze gratings had to be imported from Italy, where artisans still knew how to make them. But the problems were resolutely overcome, and the church was built. Its design was no mere echo of the architecture of the First Golden Age, but a vigorous new statement of architectural form, as we see in figure 106. The surfaces are not covered with glittering immaterial screens of mosaic defining volumes of fluid space. Instead, piers and vaults of Roman massiveness dominate the interior and break it up into clearly defined blocks of space surrounding the octagonal central hall.

Charlemagne's empire, after his death, was divided among his heirs, whose rule was feeble and incompetent. Actual power fell into the hands of nobles who could offer strong local resistance to new penetrations by fierce barbarian invaders, the Northmen, who struck savagely at every exposed point. The decline of central government and the disruption of life by the Northmen brought Northern Europe to a condition approaching anarchy. In the tenth century, the kings of Saxony restored central government to what is now Germany. The greatest Saxon king, Otto I, also revived Charlemagne's dream of restoring Imperial Rome. He extended his rule over most of Italy and had himself crowned emperor by the Pope in 962. Until 1806, the Holy Roman Empire—so called—was to be a German institution.

During the Ottonian age—from the mid-tenth to the mid-eleventh century—Germany was the leading nation in Europe. The Carolingian tradition was reasserted and underwent further development. The foremost patron of the arts was Bishop Bernward of Hildesheim. His chief monument was the solid and massive abbey church of St. Michael's (destroyed in World War II), whose interior is shown in figure 107. Its system of nave supports did not consist of uniform columns, as in the Early Christian basilicas of St. Paul's Outside the Walls and Sant' Apollinare in Classe (see figures 86 and 87), but of square piers alternating with pairs of columns. This arrangement was more like that of the Palace Chapel at Aachen, and went back to Byzantine antecedents. The heavy piers were the basic supports; the columns, with their richly carved capitals, were accented beats in the rhythm of the arcade. The nave, with its high expanse of wall between arcade and clerestory, was majestic and spacious. Columns, arches, piers, clerestory windows, horizontal bands, and vertical strips divided the nave walls into compartments and subcompartments. St. Michael's, then, compared with the Early

Christian basilicas from which it ultimately derived, was both more complex and more unified—in other words, more organic in design.

The two sculptured bronze doors ordered for St. Michael's by Bishop Bernward represent an extraordinary technical achievement, for they were cast whole. Each is made up of Biblical scenes in high relief; here (figure 108) we see *Adam and Eve Reproached by the Lord After the Fall*. The composition must have come straight from a medieval manuscript: the oddly stylized trees and plants have a good deal of the twisting, turning motion we saw in Irish miniatures. The story is told forcefully and directly. The focus of the drama is the Lord's accusing finger. Sharply outlined

108. *Adam and Eve Reproached by the Lord*, from the Bronze Doors of Bishop Bernward for St. Michael's. 1015. This portion about 23 × 43″. Hildesheim Cathedral. These figures seem smaller than they are, and could be mistaken for goldsmith's work. The composition must have been derived from an illuminated manuscript. The dramatic force of this work recalls such manuscript paintings as the *Gospel Book of Otto III* (see colorplate 15).

against blankness, it points at a cringing Adam, who passes the blame to his mate, who, in turn, passes it to the serpent at her feet.

The same intensity of glance and gesture is seen in Ottonian manuscript painting, which blends Carolingian and Byzantine elements into a new style. Among its greatest achievements was the *Gospel Book of Otto III*, one of the glories of medieval art. The scene of *Christ Washing the Feet of Peter* (colorplate 15) is full of memories of ancient painting, transmitted through Byzantine manuscripts: the soft, pastel hues of the background echo Pompeian landscapes; the architectural frame behind Christ is a late descendant of such architectural perspectives as the mural from Boscoreale (see figure 80). The Ottonian artist, no longer understanding these perspective views, has put them to a new use of his own. He has produced a vision of a world outside our gross human experience. What was once an architectural vista is now the Heavenly City, the House of the Lord. It is filled with a golden celestial space; ordinary

107. Interior (view toward the west, before World War II), St. Michael's, Hildesheim. 1001–33. This interior not only sums up previous church architecture—the general arrangement is like that of an Early Christian basilica, and the carving of the capitals and the structural system of square piers alternating with columns is Byzantine—but, in its breadth, scale, and majesty, tells us that by the year 1000 a new architectural spirit was well-established north of the Alps.

atmospheric space is outside. The figures, too, no longer signify what they once did. In ancient art, this composition was used to represent a doctor treating a patient; now St. Peter has taken the sufferer's place, and Christ the physician's. In consequence, emphasis has shifted from physical to spiritual action. This new kind of action not only is conveyed through glances and gestures, but also governs the scale of things: Christ and St. Peter, the most active figures, are larger than all the others; Christ's "active" arm is longer than his "passive" arm; eight watching disciples have been squeezed into the smallest of areas, so that we see hardly more than their eyes and hands.

ROMANESQUE ART

Romanesque art sprang up all over Europe in the latter half of the eleventh century. Christianity had triumphed everywhere. The Vikings, still pagans when terrorizing the British Isles and the Continent in the ninth century and the tenth, had now entered the fold, not only in the French province of Normandy but in Scandinavia as well. Religious devotion became a tremendous driving force, gripping whole populations, covering Europe with a "white mantle of churches," and launching pilgrims on the roads toward the holy sites. The swelling stream of pilgrims crested, after 1095, in the armed crusades unleashed against the Moslem world to recapture the Holy Land for Christendom. Manufacturing outgrew the bounds of the monasteries, and commerce revived. In consequence, the cities and towns, depopulated or deserted since the end of the Roman Empire in the West, began to fill with people. A new urban middle class of craftsmen and merchants took its place beside the medieval peasantry and landed nobility. Europe grew economically and militarily strong, and it recaptured patterns of high civilization lost since the time of the Roman Empire. There was no central secular authority—although, to a limited extent, there was the central spiritual authority of the Pope and the widespread Cluniac Order of Benedictine monks. Political authority was exercised over regions and localities by great feudal overlords and semi-independent abbots and nobles. Romanesque art, accordingly, consisted not of one central style but of a variety of regional and provincial styles, one distinct from another, yet all related. Incorporating the artistic and intellectual impulses of its Late Classical, Early Christian, Byzantine, Celto-Germanic, and Carolingian-Ottonian inheritances, it was a God-intoxicated flowering throughout the rural, feudal, and monastic society that existed in Europe after the fall of Rome and before the rise of the cities.

ARCHITECTURE. In the eleventh century, Catholic Europe exploded from one end to the other with new churches bigger than their Early Christian, Carolingian, and Ottonian predecessors and more Roman-looking, too, for their exteriors were resplendent with sculpture and ornament, and their interiors were covered with heavy stone vaults instead of light wooden ceilings. The greatest inventiveness, structural daring, and diversity of style were to be found in France.

Among the largest French Romanesque churches was St.-Sernin, in the southern French town of Toulouse. It was one of many great churches built along the roads leading to the shrine of the Apostle James in Compostela, Spain, the most visited place of pilgrimage in Europe. If we look at the plan of St.-Sernin (figure 109), we note that, like Old St. Peter's (compare figure 85), it was designed to accommodate large crowds of lay worshipers rather than a small monastic community, like St. Michael's (figure 107). But there the resemblance ends. St.-Sernin is an emphatic cross, with boldly projecting arms.

The nave is flanked by two aisles on either side, and one aisle continues around the transept and the apse as well. Small chapels radiate from the apse and continue along the eastern face of the transept. The aisles are made up of square bays; these bays are basic units for the other plan elements—one nave or transept bay, for example, equals two such units; the crossing of nave and transept equals four units, and so does each of the two towers at the western front. The plan, then, tells us that St.-Sernin is far more interrelated than any church we have seen hitherto, and far more complex.

On the exterior (see figure 110), the rich articulation produces a dramatic climax at the eastern end of St.-Sernin; the radiating chapels and the mounting roof levels of apse and transept build up to the tower that soars above the crossing. Another, lesser, concentration was intended at the western front, but, sadly, the two towers beside the entrance porch were never completed and remain stumps to this day.

The interior of St.-Sernin is also dramatic. As we enter the nave (figure 111), we are impressed by the tall proportions, the dim light, and the elaborate nave walls. The architec-

below:
109. Plan of St.-Sernin, Toulouse (after Conant) About 1080–1120

bottom left:
110. St.-Sernin, Toulouse. Aerial view

bottom right:
111. St.-Sernin, Toulouse. Nave and choir

Romanesque churches were not only more numerous than those of the early Middle Ages; they were also generally larger, more richly articulated, and more "Roman-looking," for their naves now had stone vaults instead of wooden roofs and their exteriors were enriched with both architectural ornament and sculpture. St.-Sernin is one of a group of great churches built along the roads that led to the pilgrimage center of Santiago de Compostela in northwestern Spain.

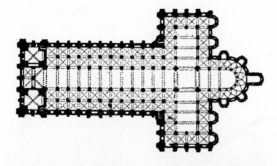

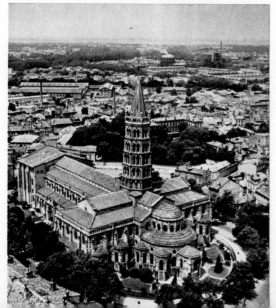

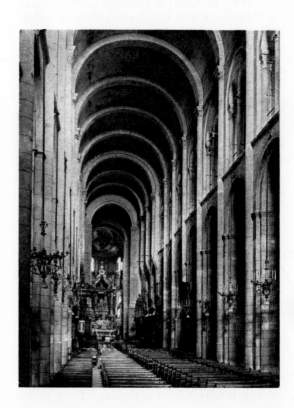

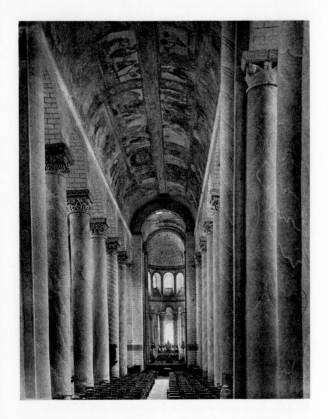

above:

112. Choir (about 1060–75) and Nave (about 1095–1115), St.-Savin-sur-Gartempe. Romanesque style varied from region to region, even within the same country. This church in the west of France has a simpler structural system than St.-Sernin. There is no nave wall, and the vault—unribbed—rests directly on the arcade, which is carried by columns, not piers. The aisles are nearly as high as the nave, and the nave is accordingly well lit by the aisle windows.

tural aesthetic here is very different from that of St. Michael's or the Early Christian basilicas we have seen. The nave walls of St.-Sernin show greater kinship with Roman structures like the Colosseum (see figure 74), where tiers of arches framed by engaged columns and their superstructures are firmly knit together in a coherent order. But St.-Sernin's Roman-like structural system of arches, piers, wall strips, and vault is used to create a most un-Roman mood: the half-columns that rise the entire height of the wall would have looked unnaturally tall to a Roman. They seem

driven by some tremendous unseen pressure as they hasten to meet the arches that subdivide the barrel vault flung across the nave. Their insistent rhythm propels us eastward toward the light-filled crossing and its canopied altar. Instead of ancient Roman architecture's physical and muscular expressiveness, the aims of this architect are spiritualized and antimaterial. To achieve them he put up the highest vault he dared, pitting his knowledge and intuition against the physical forces that threatened to bring it crashing to the ground. He did not dare to leave the vault unbraced

below:

113. West Façade, St.-Étienne, Caen. Begun about 1068. This Norman church was founded by William the Conqueror after his invasion of England. The type of facade that we see here became the model for the façades of the great Gothic cathedrals. Four huge wall strips divide it into three vertical sections, each having three stories, with a large entrance portal in the center. Norman façades were unsculptured.

114. Nave, looking east, Durham Cathedral. 1093–
1130. The structural daring of Anglo-Norman
Romanesque architects at the end of the eleventh
century reached a peak in Durham Cathedral,
which represents a marked advance over St.-Ser-
nin. Now light is brought into the nave through
clerestory windows placed over the gallery. The
clerestory was made possible by use of a ribbed
groin vault over the nave—Europe's earliest.
On alternate piers the ribs are carried all the way
down to the floor.

anywhere; consequently St.-Sernin has no
windowed clerestory above its nave gallery.

The builders of St.-Sernin would have been
the first to admit that their answer to the prob-
lem of the nave vault was not final. Anglo-
Norman architects on both sides of the English
Channel arrived at a more elegant solution.
Their most ambitious structure was the Ca-
thedral of Durham, England (figure 114), one
of the noblest churches in all Christendom.
Durham has a clerestory, and its nave is a
third wider than St.-Sernin's; its architects
thus set themselves a far more difficult engi-
neering problem in conceiving its majestic
vault. A barrel vault like St.-Sernin's would

have required continuous bracing to offset its
outward push; and if they had used such a vault
they could not have had a clerestory. Accord-
ingly, they channeled the thrust of the vault
so that it was no longer continuous but was
concentrated at certain points. The structure
could then be braced at those points, and win-
dows inserted between them. It took the com-
plex form of a groined vault carried on ribs
and divided into sections (or bays) by arches.
Every bay of vaulting was made up of a num-
ber of compartments, each a concave gore
with a surface like a bellying sail. The nave
wall system was also more complex than St.-
Sernin's—it had to be to contend with the play
of forces exerted by so complex a vault. Sim-
ple piers were alternated with compound
piers, which is to say piers with bundles of
shafts and engaged columns around a central
core. Aesthetically, the nave of Durham has no
superior; the wonderful sturdiness of the al-
ternating piers makes a splendid contrast with
the dramatically lit, sail-like surfaces above.
Structurally, it reaches the point at which
Romanesque trembles on the verge of turning
into Gothic.

SCULPTURE. The revival of large-scale stone
sculpture, which had disappeared with the
collapse of Imperial Rome, was linked with
the eleventh-century revival of popular re-
ligion. This art is public and popular in its
very nature, meant to appeal to lay worshipers
rather than to members of closed monastic
communities. It made its reappearance before
1100 on the walls of French and Spanish pil-
grimage churches on the roads leading to
Compostela, and its subsequent development
was extremely rapid.

The *Apostle* of figure 117 is an early exam-
ple, having been carved around 1090. A little
over half lifesize, it was not intended for
close-range viewing only, for it has bulk and
weight enough to be read easily from a con-
siderable distance. Where have we seen its

Alinari P.' I.' N.' 1807. a. FIRENZE - Il Battistero. (Del VII e VIII secolo, restaurato e rivestito di marmi da Arnolfo di Ca

above:

115. Pisa Cathedral, with Baptistery and Bell Tower.
1053–1272. The wealth and pride of the city re-
public of Pisa received ambitious expression in
this remarkable group of Tuscan Romanesque
buildings on a spacious open site. Throughout
the Middle Ages, Tuscany clung to memories
of its classical heritage. This Cathedral scheme is
still close to the plan of the Early Christian basil-
ica, although the transepts project more, and the
crossing of nave and transept is crowned by a
dome. Instead of built-in western towers forming
part of the façade, Pisa Cathedral has a detached
bell tower just to the south and east—the famous
Leaning Tower. Cathedral and tower both—like
classical temples and unlike Early Christian ba-
silicas—are richly decorated on the exterior in
characteristic Tuscan galleries and arcades.

116. Baptistery, Florence. About 1060–1150. This
octagonal Tuscan Romanesque building is dec-
orated with colored marble paneling and ar-
cades so classical in proportion and detail that,
a few hundred years after it had been built, people
thought it had originally been a Roman temple
of Mars.

left:

117. *Apostle.* About 1090. St.-Sernin, Toulouse

below left:

118. Detail of south portal, St.-Pierre, Moissac. Early twelfth century

below:

119. *Last Judgment* (detail), from west tympanum, Autun Cathedral. About 1130–35

Large-scale stone sculpture was an achievement even more astonishing than Romanesque church architecture, for it had disappeared from Western art after the fifth century and was not revived by Carolingian or Ottonian artists. Its reappearance was linked with the growth of towns and the greater popular appeal of religion during the eleventh century.

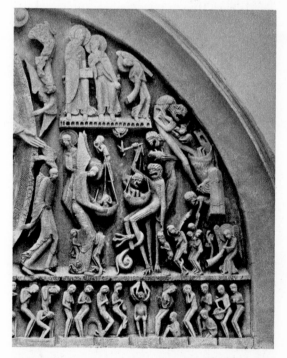

like before? Its classical solidity of form suggests that the artist has taken a good look at late Roman sculpture, of which a great quantity remained in southern France. The design as a whole, however—its frontality, its placement within an architectural frame—indicates a Byzantine source, some tiny ivory panel descended from the *Archangel Michael* of figure 98. In enlarging such a miniature form,

our artist made sculpture spatial once again: the apostle's body is blocklike; his hair is a round, close-fitting cap; the niche that surrounds him is a real cavity. And the whole work has much the same dignity and directness as the sculpture of Archaic Greece.

In the south portal of the abbey church of Moissac, carved a generation later, we see fully developed French Romanesque sculpture. Figure 118 illustrates the magnificent center post and door jamb. They are both scalloped, as if squeezed from a gigantic pastry tube. The carved forms are handled with such incredible flexibility that the spidery prophet on the side of the post fits into the scalloped contours with complete assurance. He is even free to turn his head as he unfolds his scroll and to cross his legs in a dancelike movement. The crossed lions on the face of the post are descendants of the interlaced beasts of Irish miniatures. They belong to a vast family of savage or monstrous creatures used in Romanesque art to symbolize the function of support. Their purpose is as much expressive as decorative; they are images of dark forces domesticated into guardian figures or held in restraint, through all eternity, snarl as they will.

The space above the doors of the main portal of Romanesque churches is given over to an awesome scene of Christian art, usually the Christ Enthroned of the Apocalyptic Vision, or the Last Judgment. Figure 119 shows the weighing of the souls in the *Last Judgment* at Autun Cathedral. At the bottom, the dead rise from their graves in fear and trembling. Some are already beset by snakes or gripped by huge, clawlike hands. Above, their fate literally hangs in the balance, as devils yank at one end of the scales and angels support the other. The saved souls cling like children to the hem of the angel's garment while the condemned are seized by grinning demons and cast into the mouth of Hell. The demons reveal the same nightmare imagina-

tion that created Romanesque animals and monsters; they are basically human, but with spidery legs, furry thighs, pointed ears, and enormous, savage mouths. Their violence, unlike the violence of the animal monsters, knows no restraint; they abandon themselves fully to their grim amusement. Having "read in the marble" here (to quote St. Bernard of Clairvaux), no visitor could fail to enter the cathedral in a chastened mood.

PAINTING. Romanesque painters took no such revolutionary departure from earlier styles. The floral patterns in the border frame of the wonderful miniature of *St. John the Evangelist* (colorplate 16) are derived from classical Roman ornamental motifs. The human figures are based on Carolingian and Byzantine models. The animal-style monsters and interlacing patterns of the Dark Ages (see figure 102) have contributed greatly to the energetic movement and disciplined control of the floral patterns and the folds of drapery. What is new here is the interweaving of the forms of the frame with the forms of the figure to create a remarkable unity, a unity reinforced and heightened by the content. The Evangelist, for example, has been so placed within his frame that to separate them would be to cut off his ink supply (proffered by Abbot Wedricus, who commissioned the manuscript), his source of inspiration (the dove of the Holy Spirit in the hand of God), and his identifying symbol (the eagle). The medallions showing small-scale scenes from the life of John the Evangelist are less directly linked with the central figure.

But this painter did not merely take a store of treasured images and combine them in a well-knit design. His starting point, rather, was a grand governing unitary plan. He reached into his memory for the images he needed and unhesitatingly worked them over into exactly the forms required for the design already in his head. For example, barely a

120. *The Building of the Tower of Babel.* Detail of painting on the nave vault. Early twelfth century. St.-Savin-sur-Gartempe. The walls and vaults of Romanesque churches provided ample space for murals such as this, but few have survived to the present day.

trace remains here of the emphatic modeling, fluid brushstrokes, and suggested light and space of the *Gospel Book of Archbishop Ebbo* (see figure 105). They have been ironed out in order to create a uniformity of line character and surface texture in human and animal figures, frame, throne, floral patterns, and even the half-dozen letters of the alphabet beside Wedricus' head. Ornament, text, and illustration, thus, are fused into an unprecedented unity of design.

Our Romanesque artist has also developed considerable expressive power. This is evident in another picture (figure 120), a scene from one of the large-scale twelfth-century wall paintings in the church of St.-Savin in western France. The subject here is the Old Testament story of the building of the Tower of Babel. The Lord Himself, on the far left, takes part as He addresses the workmen. Balancing Him on the right is the giant Nimrod, the leader of the enterprise, who frantically hands blocks of stone to the masons at the top of the tower. The entire scene, then, is a great test of strength between God and Man. The heavy, dark contours and emphatic play of gesture make the composition readable and impressive from a distance.

Towns, Cathedrals, and Gothic Art

ARCHITECTURE

In the twelfth and thirteenth centuries, the growing towns dethroned the monastic communities as centers of medieval life. Cathedrals—that is to say, large town churches presided over by a bishop—took the foreground in religion. Cathedral schools and universities —institutions that came into being with the rise of the towns—became the important centers of learning. Townspeople became the most important artists, craftsmen, and traders. And at the same time, with the freer and more stimulating life in the cities, people opened

themselves to new ideas. Great advances were made in thought and in technical knowledge.

Out of this ferment came an exultant new style in art called Gothic. Its early course was set by the genius of one man, Suger, the bold and energetic head of the royal abbey of St.-Denis, just outside Paris. An adviser of kings, the regent of France while Louis VII was off crusading, Abbot Suger was France's foremost political and religious power. He was a fierce national patriot at a time when other Frenchmen thought of themselves as Gascons, Normans, or Burgundians. He worked hard and successfully at expanding the authority of the crown and the power of the towns at the expense of the landed nobles and the great monasteries. He wanted St.-Denis, the shrine of the Apostle to the Gauls, the crowning and burial place of Frankish kings, to be the holiest and most popular of pilgrimage centers for all the French, an inspiring symbol of national unity under a divinely appointed king.

In seven brief years, 1137 to 1144, Suger made over the small Carolingian church of St.-Denis into a great structure that would serve his large purposes. The new church was designed not only to take in an army of worshipers but also to exalt man's handiwork into a mirror of God's perfection. Suger's own account of the exciting work of rebuilding is a remarkable document, full of poetry and philosophizing, in which eloquent stress is laid on mathematical planning and the central importance of light. Harmony of proportion, he wrote, was the source of all beauty, and gave outer, physical form to the laws by which divine reason had constructed the universe. (Compare the Greek conception of harmony, pages 48, 57.) The "miraculous" light flooding the eastern end of the church through the "most sacred" windows was an image of the Light Divine, a mystic revelation of the spirit of God.

In rebuilding St.-Denis, Suger and the architects who worked hand in hand with him

and carried out his ideas so changed earlier medieval architecture that every visitor was overwhelmed. The new style was used immediately in building the Cathedral of Chartres and, a decade or two later, in other new cathedrals of the Paris region (the royal domain). Thereafter, it swept into the rest of France and then into England, Germany, Italy, and Spain.

St.-Denis itself has been drastically altered from its original appearance, and in any case, French Gothic culminated in the great cathedrals that succeeded it; therefore, we shall examine Gothic style through other monuments than St.-Denis. One of those monuments, Notre-Dame de Paris—begun in 1163, still building in 1250, and, like almost all Gothic cathedrals, never finished—we shall look at in some detail.

The plan of Notre-Dame (figure 122) is extremely compact and far more unified than that of any Romanesque church. The double aisles flanking the nave continue beyond the transept and around the apse. The transept, hardly wider than the west façade, is so placed as to cross the nave almost at the exact center of the cathedral's long axis. More than half the floor area, therefore, is occupied by the choir (the transept plus everything to the east). This proportioning of floor space was in keeping with Suger's conception of the choir as a church building's most important part. The size and complexity of Notre-Dame's choir was in keeping, too, with a trend toward increasingly impressive and elaborate ritual. To the strongly marked rhythms of the music composed by Perotinus, Notre-Dame's famous choirmaster of the later twelfth century, ceremonial processions of chanting priests and choristers wove in and out of the choir's passages and openings.

The interior of Notre-Dame (figure 121) shows us the use of a characteristic feature of Gothic architecture, the pointed arch. We may see this type of arch in the ground-floor

arcade, in the gallery above it, in the big windows of the clerestory, and in the eight strong, supple arches that mark the transverse boundaries of the bays of groin vaulting over the nave. Certainly, here, the pointed Gothic arch is put to satisfying decorative use. But has it profounder purposes than mere decoration? It has.

In Notre-Dame, the pointed arch is used to make way for light. It is used to increase open space and cut down on solid wall. A semicircular arch is half as high as it is wide, neither more nor less. A pointed arch can have any degree of sharpness we want; we can choose its height whatever its width. Notre-Dame's pointed windows reach up to the base of the vault, where round-headed windows just as wide could not; the underside of the vault is therefore lit, not shadowed. A pointed arch can be fashioned to enclose more area than a semicircular arch; there is as much glass and as little stone in Notre-Dame's clerestory as seems at all possible. Throughout its length, the clerestory is a window wall.

But how could the architect have dared to place all that window area beneath all that vault? The outward push of the great vault must be nothing less than tremendous, yet we see no masonry to hold it in. What uncanny power keeps the vault in place?

Let us go back a moment to figure 122, the plan of Notre-Dame. At the edge of the ground-level plan—the top half of the drawing—is a row of black bars linked together by compartments that represent little chapels. Each black bar represents a mass of masonry twenty-four feet long and six feet thick, most of it concealed by the chapel roof. The similar black bars projecting from the bottom half of the drawing—the plan of the cathedral at the next higher level—correspond (take a brief look at figure 123, a rear view of the exterior) to bridgelike elements that soar above the aisle roofs. These elements carry the vault thrusts to the hidden stone anchors below,

which are big and heavy enough to absorb them. We now realize that the vault has been stabilized by a set of braces—flying buttresses, as we call them—as imaginative and graceful as they are energetic and strong. But even though we may know this in our minds, it is almost impossible to stand inside Notre-Dame's great nave and, seeing the huge vault above suspended, as it were, over nothing, believe what we see.

The interior of this great Gothic cathedral amazes us in many ways: the airiness of the space and the lightness, grace, and weightlessness of the stone forms, which are lean and trim, with little excess material. Everything soars.

The sense of levitation that we receive does not depend too much on the actual proportions of the nave—some Romanesque naves are equally tall with respect to their width. It depends much more on the constant accenting of verticals and on the apparent ease with which height is suggested. By contrast, Romanesque interiors (compare figure 111) emphasize the tremendous counterforce required in supporting the vault's weight and bracing against its outward push.

The most monumental aspect of Notre-Dame's exterior is the west façade (figure 124). Tall buttresses (reinforcement strips) define the tower corners and divide the façade vertically into three main parts. Other members divide it horizontally into three stories. Lacelike arcades, huge windows, vast portals, and rich sculptural decoration break up and dissolve the wall surface, so that the façade as a whole suggests an openwork screen. Its foremost quality, perhaps, is the way in which all details have been reconciled with one another and integrated into a wonderfully balanced and coherent whole. The meaning of Suger's message of harmony, geometric order, and proportion is evidenced as strikingly here as in the magnificent ground plan and the soaring interior. The façade's discipline and order

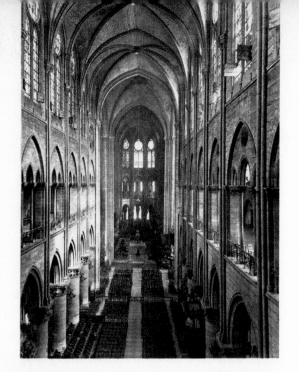

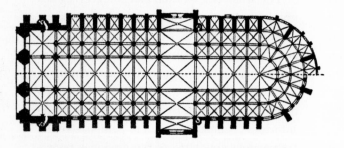

left:
121. Nave and Choir, Notre-Dame, Paris. 1163–about 1200

below left:
122. Plan of Notre-Dame, Paris

bottom:
123. Notre-Dame, Paris. View from the southeast

at right:
124. West Façade, Notre-Dame, Paris

The origin of no previous architectural style can be pinpointed as exactly as that of Gothic. It was about 1140 in the region of Paris, and its early development was closely linked with the growing power of the king. Most of its elements—the pointed arch, the ribbed groin vault, the choir with ambulatory and radiating chapels—had existed separately in Romanesque churches; their combination in great cathedrals such as Notre-Dame yielded a new whole, impressive by virtue of its huge scale and the loftiness of its interior spaces. That forms so light and slender could sustain so vast a structure still strikes the beholder as a kind of architectural miracle.

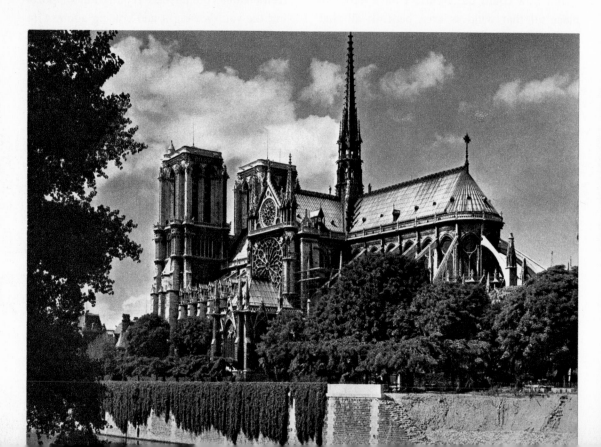

embrace the sculpture, which is no longer allowed the free growth so characteristic of Romanesque, but has been assigned a precisely defined role within the architectural framework.

In describing Notre-Dame de Paris, we have also described the essentials of Gothic architecture. But one element of the style—an element of major importance—has not been touched upon. The windows of Gothic cathedrals were made of small pieces of colored glass bound together by lead strips and assembled into huge pictures. Casting their "Light Divine"—to use Suger's own words—they "direct[ed] thought by material means toward that which is immaterial." The spiritualizing effect of the stained-glass windows upon the interior space cannot be seen at Notre-Dame, which has lost almost all its glass.

Another major Gothic cathedral, Chartres, still retains its original stained glass. The magic of its interior space, unforgettable to anyone who has experienced it, cannot be suggested by a black-and-white photograph; inevitably, windows are shown as blazing holes rather than the glowing walls they really are. In truth, even when the outside world is brightest, and the windows, seen from inside, sparkle like brilliant jewels, the light that filters through is not intense. It has been softened, harmonized, and enriched. It fills the whole cathedral and lies upon the floor in pools of color, constantly changing as the light outside dims or brightens and glass of different hue comes into play. And it changes and enriches whatever it falls upon. Colorplate 18 shows the nave, transept, and apse variously illuminated by stained-glass windows. Something of the tonal play is conveyed here, a hint of the warmth and vibrancy created when stone is washed in this bath of light and color.

The nave of Chartres was begun a generation later than the nave of Notre-Dame, and was the first masterpiece of the fully developed

125. Choir Vault, Amiens Cathedral. Begun 1220. In the developed High Gothic style, the clerestory becomes nothing but a wall of glass. We cannot see from the inside how the heavy flying buttresses take up the push of the huge vaults, and thus they seem—incredibly—suspended over nothing.

High Gothic architectural style. High Gothic reached its climax of development a little later still, in the interior of the Cathedral of Amiens (figure 125). Here breathtaking height has become the dominant aim, both in aesthetics and in engineering: skeletal construction is carried to its precarious limit. The openings of the ground-floor arcade have become very tall and narrow. The vaults are simple in shape, and as taut and thin as membranes. The clerestory is extremely high, with a greatly increased window area, and windows have now been placed behind the gallery (the gallery is blind in Notre-Dame and Chartres). From the top of the arcade to the bottom of the vault, Amiens is all window.

The High Gothic cathedrals of France represent a concentrated expenditure of effort

left:

126. Salisbury Cathedral. 1220–70. Begun the same year as Amiens, Salisbury shows us that English Gothic architecture was different from French. This cathedral is long and low, with no straining after height except in the great crossing tower, which is a characteristic English feature. The west façade is a screen wall covered with bands of ornament and statuary; and its towers are no more than stubby turrets.

bottom left:

127. Choir, Gloucester Cathedral. 1332-57. In the fourteenth century, English Gothic churches acquired the verticality that is missing in the thirteenth: bundles of ribs, for example, are carried from the vault all the way to the floor in an unbroken line. In this later style, the vaults are spun over with a web of decorative ribs in a dazzling display of architectural pageantry.

below:

128. Florence Cathedral. Begun by Arnolfo di Cambio in 1296. Dome by Filippo Brunelleschi, 1420–36. Italian Gothic architecture stands apart from the Gothic of the rest of Europe: windows are small; the architectural lines are horizontal; and the walls retain the solidity of the Romanesque. Florence Cathedral was planned as a monumental landmark towering above the city. Its most striking feature is the enormous octagonal dome, not completed until the fifteenth century. The marble paneling on the exterior is a perfect match for the Romanesque Baptistery across the way (see figure 116).

such as the world has rarely seen. They are truly national monuments, whose immense cost was borne by willing donations from all over the country and from all classes of society. But an entire nation cannot sustain itself at a white heat forever. By the middle of the thirteenth century, the pace of work had slackened on the vast structures begun in earlier times, and new projects became smaller and fewer. A quarter-century later, the heroic age of French Gothic had passed into history.

SCULPTURE 1150–1420

The sculpture that once graced the abbey church of St.-Denis is now terribly battered. It would be useless to scrutinize those mutilated stones for clues to Suger's ideas about the part to be played by sculpture in the great drama of the Gothic cathedral. But the west portals of Chartres, which are in rather good condition, were begun in 1145 and reflect Suger's ideas very closely. They show us Gothic sculpture in its infancy.

The key works here are the unnaturally tall figures attached to the columns of the door jambs (figure 129). In what way are they different from Romanesque figures? The figure we saw on a Romanesque portal (compare figure 118) had much this kind of drastic elongation. It was a relief carved into the masonry, however, and the jamb figures at Chartres—look closely—are statues. Each has its own sloping pedestal, from which, presumably, we could detach it.

We are witnessing a development of revolutionary importance: the first step toward the reconquest of sculpture in the round. We have not seen large sculpture in the round since the end of classical antiquity. Apparently, this first step could not be taken without borrowing the rigid cylinder of the column itself. As a result, our jamb figures, curiously, seem even more frozen into a pattern than their Romanesque predecessors.

129. Jamb Statues, from west portals, Chartres Cathedral. Begun 1145. These cylindrical-looking figures seem to follow the lines of the columns to which they are attached. They are statues, nevertheless, each with its own pedestal. Thus they represent the first step in the reconquest of sculpture in the round.

We can also discern another and equally revolutionary development. The heads have a gentle, human quality. They are calm and rather solemn. Where is the Romanesque sculptors' anti-natural world—their fascination with the wild, fantastic, and demoniacal? The Early Gothic sculptors of Chartres turned away from unearthly visions and back toward the world of nature and ordinary existence.

This great turning was closely connected with Suger's thought and writings, in which ordinary things were viewed as a reflection of God who had created them, and earthly beauty as a reflection of God's perfection. We cannot truthfully say that the Chartres jamb figures look very natural (it is hard to perceive something that is barely beginning), but their realism—if we may call it that—is nevertheless there.

A third important quality of these sculptures is rationality. Standing in a row, submitting to the demands of their architectural setting, they are disciplined and ordered. And in their symbolic significance—as we already know, medieval art is symbolic from start to finish—they belong to a rational scheme that underlies their whole arrangement and makes them a consistent part of the order of the cathedral as a whole. Our detail, for example, shows us crowned figures, male and female. The jamb figures of all three portals together are a single sequence representing Biblical prophets, kings, and queens. The onlooker is to understand that the French kings are the spiritual descendants of Old Testament kings, and that the secular rule of royalty is the harmonious twin of the spiritual rule of the medieval hierarchy.

Gothic statues were not to remain immobile for long, nor unnatural in their forms and proportions. Let us move seventy-five years ahead to the High Gothic west portals of the Cathedral of Reims and its famous *Visitation* group (figure 130, right). See how free these two jamb figures are; the columns are now little more than background. The pose has changed to an easy stance, and each figure describes an S-curve. The proportions are completely natural, and the forms, both of body and of drapery, seem convincingly real. There is a strong suggestion of substance and weight; the robes reveal bodily form underneath as each figure pulls a fold of drapery across her middle; the pedestals have ceased

to be slopes upon which the feet seem to float, and have become level platforms on which the feet rest firmly. The Virgin clearly embodies an ideal of youthful feminine beauty, here sharply contrasted with the age-lined and careworn face of St. Anne. There is a deeply felt tenderness and warmth in their relationship as they turn toward each other. The suggestion of balanced weight and support reminds us strongly of classical counterpoise (see page 65), and indeed, for a brief moment in the first half of the thirteenth century, High Gothic sculpture went through a classical phase.

The sculptural program at Reims was so vast that one workshop could not handle it all, and several were called upon to help. For this reason we meet several separate and distinct

130. *Annunciation* and *Visitation*, from west portals, Reims Cathedral. About 1225-45. The left pair of statues represents one narrative scene, and the right pair, another. The four statues are in three distinct styles, although all were done at about the same time: the sculptural program at Reims was so vast that masters and workshops had to be called in from a number of locations. The "elegant" style of the angel of the *Annunciation* became the basis for later Gothic sculpture throughout Europe.

131. *Virgin of Paris*. Early fourteenth century. Notre-Dame, Paris. We saw the beginnings of this style in the angel of the *Annunciation* at Reims. Realistic description has now given way to an unearthly grace.

spicuously graceful: we note the tiny, round face framed by curly locks; the emphatic smile; the strong S-curve of the slender body; the ample drapery, deep-cut and richly accented with shadow. Here we see the so-called "elegant style," which had originated in the royal court in Paris. The elegant style became the standard formula for Gothic sculpture in the later thirteenth century.

Let us move ahead another seventy-five years to about the year 1300 and the famous *Virgin of Paris* (figure 131). Now, we can see, the High Gothic era has been left behind. Every trace of the classicism of the Reims *Visitation* has disappeared. There is no suggestion that this figure exerts weight upon the ground. On the contrary, the Virgin's upper part and the Child on her arm seem supported by the upward flow of her ample drapery. For the rest, she is quite literally disembodied—there is no body inside the cavern of that robe! The prominences of the form into which the stone has been worked are so deeply undercut that we see them not as rounded surfaces but as sharply projecting curved edges. The linear play of the projecting curves underlines and emphasizes the spiraling S-curve that the figure describes. In addition, as a result of this way of cutting stone, the statue is otherwise largely made up of concave shapes; and a striking play of light and shadow adds its own dimension to the play of lines. The artistic intention of this sculptor is obviously not realistic description. Once again, pattern has gained the upper hand in its incessant war with realistic description, and the Virgin, in her swaying stance, has been made an abstract form of unearthly grace. Compared with this figure, the angel of the Reims *Annunciation* seems thoroughly solid and tangible. Its every aspect, just the same, contained a germ of the style so strikingly developed in the *Virgin of Paris*.

The retreat from realism around 1300 was not a headlong flight. Gothic realism was at

styles in the Reims jamb statues. Two of the styles—neither showing the classicism of the *Visitation*—appear in the *Annunciation* group (figure 130, left), one in each figure. The Virgin is severe in style, slender and vertical; the folds of her drapery are straight and tubular. The angel, on the other hand, is con-

no time a realism of general structure; it was not systematic and all-embracing. It was always a realism of particulars; it focused on individual forms and specific details. Side by side with the abstract patterning of the *Virgin of Paris*, realism survived in the detail of the Infant Christ. He is not a miniature Saviour, facing us solemnly in sternness and grandeur. He is a thoroughly human baby who turns to his mother and plays with her veil. Here we are reminded of the Reims *Visitation*, where, in a like manner, we were made to sense the intimate human relationship of two figures. The classical echoes in High Gothic may have died away by the time the *Virgin of Paris* was made, and fidelity to natural appearance may have lost importance for its sculptor, but there is still a firm link with the Reims *Visitation*. The link is the appeal to human feeling. Whatever the sculptor of the *Virgin of Paris* has surrendered, he has held fast to intimate human emotion. Appeal to human feeling was

the core of Gothic realism, the force that generated it and set its limits.

Gothic sculpture was tardy in spreading beyond France. After it was transplanted, however, it developed rapidly. Its English development cannot be traced, for most of English Gothic sculpture, unfortunately, was destroyed during the Reformation. Germany, then, next to France, is Europe's greatest treasure house of Gothic sculpture. Around 1225, German sculptors trained in the sculpture workshops of the great French cathedrals brought the new style back to their homeland. This was appreciably sooner than Gothic architecture was transplanted there. Accordingly, German sculptors, unlike their French teachers, were not strongly governed by overall architectural and sculptural programs. They focused less on the exteriors of churches than on the interiors, where sculpture had less need of being made part of its architectural setting. For these reasons, German sculptors

132. *The Kiss of Judas*, from the choir screen, Naumburg Cathedral. About 1250–60. Gothic sculpture in Germany began while architecture was still in the Romanesque style. For this reason, it tended to be less dependent on the architecture and thus developed greater expressive freedom than its French models. Intense feeling dominates this scene, with its strong contrast between Christ's meekness and St. Peter's violence.

133. *Pietà*. Early fourteenth century. Wood, height 34½". Provinzialmuseum, Bonn. New types of religious images arose around 1300. The most important such image was the Pietà, a representation of the Virgin grieving over the dead Christ. Its purpose was to arouse overwhelming emotional response.

had more liberty than French sculptors to work out individual style and expressive freedom. The Naumburg Master, a mid-thirteenth-century artist of unusual genius, took full advantage of this opportunity. His solid figure types and unrelenting drive to give religious themes strong emotional appeal can be seen in his dramatic *Kiss of Judas* relief (figure 132). The figures here are brought squarely down to earth, both physically and emotionally, through the artist's emphasis on

weight and volume and his eloquence in conveying human passion. The contrast between Christ's meekness and St. Peter's sword-wielding fury is unforgettable.

At the turn of the fourteenth century, there was a mounting desire in all Europe for the most intense emotionalism in religious art. New themes and images arose; and German sculptors played a leading part in their development. The most important such theme was the *Pietà*, the Virgin grieving over the dead

Christ. The *Pietà* illustrated in figure 133 is of wood and is vividly painted. Within this very abstract work, realism has been employed only as a tool of expression: the faces are all agony; Christ's bloody wounds are grotesquely elaborated and enlarged, his body utterly emaciated, his arms and legs made as thin and sticklike as those of puppets. The purpose here, clearly, is to arouse in the be-

134. Giovanni Pisano. *Madonna*. About 1315. Marble, height 27". Prato Cathedral. Giovanni Pisano adopts the "disembodied" style of the *Virgin of Paris*, but keeps the firm modeling and heavy drapery of the more classical native Italian tradition.

holder a sense of horror and pity so overwhelming that he will sense, through his own feelings, those of the grief-stricken Mother of God.

Gothic sculpture appeared in Italy halfway through the thirteenth century, but was not really very Gothic-looking. It was so bound by ancient classical tradition—so Roman in feeling, so full of Roman borrowings—that close study would be needed to detect the Gothic elements. On the other hand, the *Madonna* (figure 134) carved soon after 1300 by the gifted Giovanni Pisano is quite obviously Gothic. We are immediately reminded of the *Virgin of Paris* by the way in which the Infant Christ plays with his mother's crown, and by the swaying stance and elegant flow of drapery of the Madonna herself. We cannot doubt that we are seeing strong French influence. The native Italian memories of classical antiquity have not been erased, however; we can see them in the firm, solid modeling and in the heavy folds that anchor the figure to its base.

In the later fourteenth century, Italy continued to be hospitable to French influence. At the same time, northern European artists renewed their interest in suggesting weight and volume and describing nature. Toward 1400, the two trends merged in the so-called International Style, which dominated all western Europe for twenty years.

We shall look at two works of sculpture in the International Style. The first was made north of the Alps by its greatest master, Claus Sluter. His *Moses Well* (figure 135) is an impressive work. The majestic figure of Moses, on the right, is heavy-bodied. Soft, lavishly draped garments envelop him like an ample shell. The swelling forms reach out into the surrounding space and take up as much of it as they can. Those qualities of style are less pronounced in the Isaiah, on the left. What strikes us in this figure is the artist's mastery of realistic detail; he has carefully described

135. Claus Sluter. *The Moses Well*. 1395–1406. Stone, height of figures about 6′. Chartreuse de Champmol, Dijon, France. After 1350, interest in sculptural weight and volume increased, and there was a renewed impulse toward the exploration of observed nature. The climax of this trend occurred around 1400 in the International Style. Claus Sluter was the greatest master of International Style sculpture.

the texture of the costume, and his chisel has dwelt lovingly on every wrinkle of Isaiah's skin. Isaiah's head, unlike that of Moses, is as individual as though it were an actual portrait. Sluter's love of minute, specific detail distinguishes his realistic vision from the broader, simpler descriptive realism of the thirteenth century.

Our second example of International Style sculpture was made south of the Alps by Lorenzo Ghiberti, who in his youth must have had close contact with French art. *The Sacrifice of Isaac* (figure 136) strikes us first of all by the utter perfection of its craftsmanship. The surfaces of this small bronze relief panel shimmer like silk, and the wealth of realistic detail is beautifully articulated. If drama and emotion seem lacking—even when engaged in acts of violence, the softly draped figures retain an air of courtly elegance—the International Style taste for realism did not extend to the emotional realm. No matter how much Ghiberti owed to French influence, in one respect he was thoroughly Italian: he greatly admired ancient sculpture. The evidence is the beautiful nude torso of the boy Isaac. And for the first time since classical antiquity, we have been made to sense the background of a relief not as flat surface but as empty space from which the sculptured forms—note particularly the angel in the upper right-hand corner— come forward toward us. This sculpture is as spatial as a painting. An advanced artist but no revolutionary, Ghiberti prepared the way for the impending revolution we call the Renaissance.

PAINTING 1200–1400

The birth of Gothic architecture had a telling effect upon pictorial art. Manuscript illumination, hitherto the most important branch of medieval painting, now lost pride of place to stained glass. Stained-glass designers were called upon to do things they had never done before—to make their windows large and to develop an elaborate repertory of sacred subjects. The townspeople loved the brilliant stained glass of the new cathedrals and the miraculous light it cast. But unlike sculpture, which underwent radical change and became a new art of roundness and realism, stained glass at first kept to its old Romanesque style.

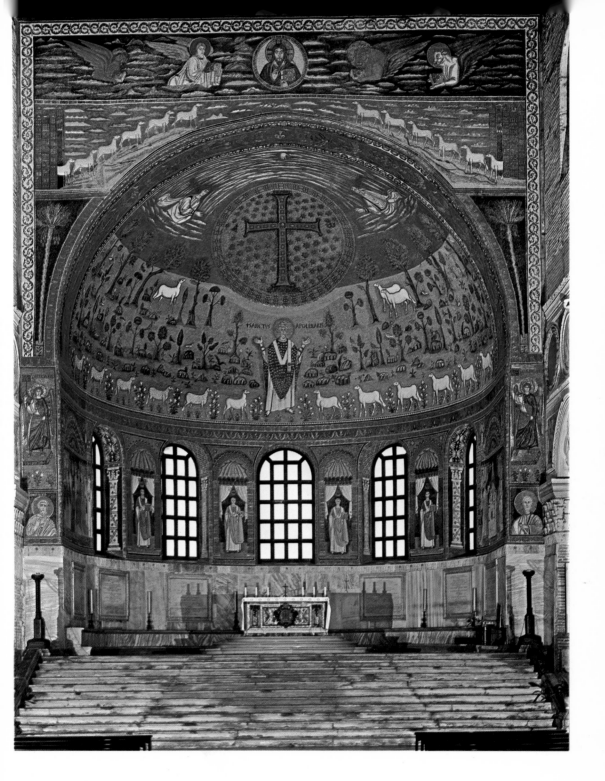

Colorplate 11. Interior (view toward the apse). Sant' Apollinare in Classe, Ravenna. A.D. 533–49.
The columns and wall mosaics are in the Byzantine style of the First Golden Age.

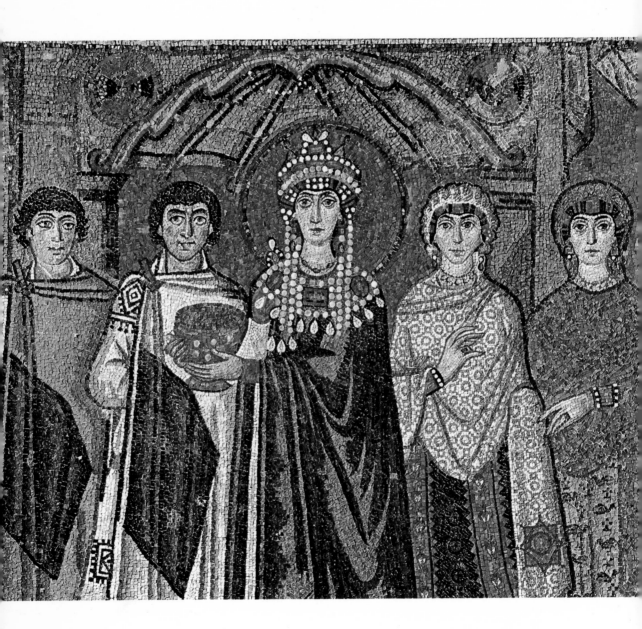

Colorplate 12. *Empress Theodora and Attendants* (portion). About A.D. 547. Mosaic. San Vitale, Ravenna

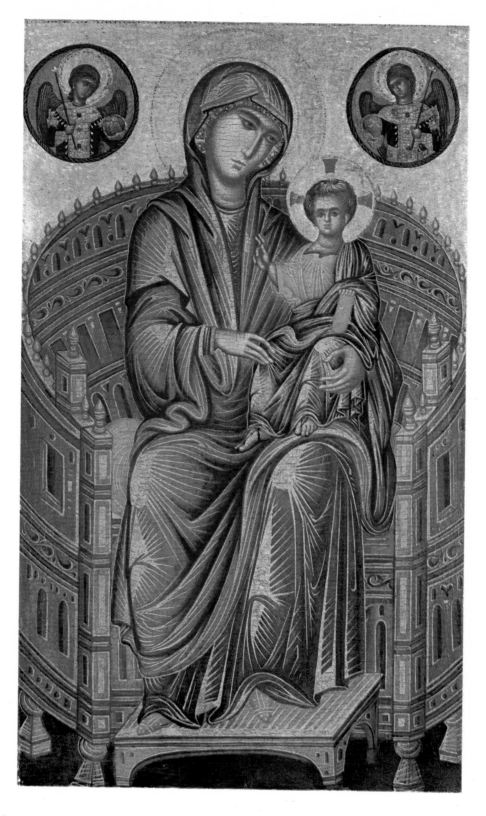

Colorplate 13. *Madonna Enthroned*. Late thirteenth century. Tempera on panel, $32 \times 19\frac{1}{2}''$.
National Gallery of Art, Washington, D.C. Mellon Collection

Colorplate 14. *Symbol of St. Mark*, from the *Echternach Gospels*. About A.D. 700. Bibliothèque Nationale, Paris

Colorplate 15. *Christ Washing the Feet of Peter*, from the *Gospel Book of Otto III*. About 1000. Bavarian State Library, Munich

Colorplate 16. *St. John the Evangelist*, from the *Gospel Book of Abbot Wedricus*. Shortly before 1147. Société Archéologique, Avesnes, France

Colorplate 17. *The Virgin with Apostles* (detail). About 1150. Stained glass. Cathedral, Le Mans.
The style of these figures, on the threshold of the Gothic era, still has the expressive
energy of Romanesque painting, now intensified by glowing color.

Colorplate 18. View of the Nave, Chartres Cathedral. 1194–1220

Colorplate 19. Giotto. *Lamentation over Christ*. About 1305–6. Fresco. Arena Chapel, Padua

Colorplate 20. Simone Martini. *Christ Carrying the Cross*. About 1340. Tempera on panel, 9⅞ × 6⅛″. The Louvre, Paris

Colorplate 21. Bohemian Master. *Death of the Virgin*. 1350–60. Tempera on panel, $39 \times 27\frac{3}{4}''$.
Museum of Fine Arts, Boston. The Italian style of painting was brought to Prague
in the middle of the fourteenth century, and from Prague spread to the western part
of Germany.

Colorplate 22. The Limbourg Brothers. *October*, from the *Very Rich Book of Hours of the Duke of Berry*. 1413–16. Musée Condé, Chantilly, France

136. Lorenzo Ghiberti. *The Sacrifice of Isaac.* 1401–2. Gilt bronze, 21 × 17″. National Museum, Florence. The foremost representative of the International Style in Italy, Ghiberti was a metalworker of unsurpassed skill. This panel was the winning entry in the competition of 1401–2 for a pair of sculptured bronze doors for the Baptistery in Florence.

Stained glass, basically, was an abstract art of flat, ornamental pattern, and had a built-in resistance to three-dimensional effects. Romanesque style, with its flatness and its linear energy, was appropriate to the stained-glass medium. Gradually, however, stained-glass designers absorbed influences from the sculptors with whom they rubbed shoulders in cathedral workshops, and by 1200 had their own version of High Gothic style. The next fifty years were the golden age of stained glass. The majestic *Habakkuk* window (figure 137) of the Cathedral of Bourges is a Gothic jamb statue translated into the two-dimensional forms of stained-glass design.

The demand for stained glass slackened as

137. *Habakkuk.* About 1220. Stained-glass window, height about 14′. Bourges Cathedral. Stained glass became the leading form of painting with the development of Gothic architecture. The stained-glass windows of Gothic cathedrals were assembled like jigsaw puzzles out of hundreds of odd-shaped bits of colored glass, which were cut to fit the contours of the represented forms and held in place by strips of lead.

cathedral building declined. After 1250, manuscript illumination once again became the most important branch of French painting. No longer a monastic specialty, it was mostly produced in city workshops set up by laymen. Its style, through the formative influence of the stone sculpture and stained glass of the earlier thirteenth century, was now Gothic. A layman, Master Honoré of Paris, painted the refined and graceful *David and Goliath* scene (figure 138) in a book made for the king of France in 1295. This little picture reminds us of Gothic narrative relief sculptures: it has an ornamental frame; a shallow, boxlike space ending at a patterned flat background; and soft, natural-looking forms giving a suggestion of roundness and relief through smooth, skillful shading.

Painting took a very different course in Italy, where, toward the end of the thirteenth century, there was an explosion of creative energy as spectacular and far-reaching as the rise of the French Gothic cathedral 150 years before. One look at Giotto's *Lamentation over Christ* (colorplate 19) and we know we are seeing a revolution. How could a contemporary of Master Honoré conceive a work of such overwhelming power?

Italy was not quite like the nations north of the Alps. The Italians were the heirs of the Romans and Early Christians and had never forgotten it. They had always been in close contact with Byzantine civilization. Their churches had never abandoned walls of solid stone for walls of glass. Mural painting, wall mosaic, and panel painting—none of which had taken firm root north of the Alps—all stayed alive and vigorous on Italian soil. In the thirteenth century a fresh wave of Byzantine influence swept over Italian painting. It washed away the lingering traces of Romanesque style and mingled with the current of Gothic influence then spilling over from sculpture into pictorial art. The single, united stream that resulted was the revolutionary

138. Master Honoré. *David and Goliath*, from the *Prayer Book of Philip the Fair*. 1295. Manuscript illumination, miniature. Bibliothèque Nationale, Paris. The modeling here is so vigorous that the figures look as if they were carved in relief. Note how well the artist has observed oak and maple leaves.

new style of which Giotto was the leading spirit.

Giotto, who was born near the wealthy and powerful medieval city of Florence in 1266, was a landmark in the history of art. He is the first painter who is admired as much in our day as he was in his own. The *Lamentation over the Dead Christ* is one of a series of murals he painted in a private chapel in Padua soon after 1300. It was done in fresco, a technique in which watercolors are applied to fresh plaster. From our colorplate 19 we can guess at once that the *Lamentation* is a large picture and not a small illustration on a manuscript page. This has little to do with actual size— which we cannot tell from a small-scale printed reproduction—but much to do with the painting's monumentality, the bigness of its shapes. There is no fussiness of detail. The forms are simple and strong, and their weight and solidity make them look like great rocks. Yet Giotto's figures are charged with feeling.

The weeping angels in the sky and the mourners on earth below speak to us so clearly and simply through their gestures and facial expressions that we become part of the scene and share their sorrow over Christ's death. Still another aspect of the *Lamentation* has great importance in making it so intensely powerful: its composition, by which we mean the arrangement of forms within the picture. In looking at such storytelling pictures as Romanesque murals (see figure 120) or Master Honoré's *David and Goliath*, the eye runs along from one detail to the next; the *Lamentation* invites us to see the whole scene at once. Not only has Giotto made the forms large and simple and joined the figures in strong groupings, but he has organized the scene as a great stage director would in the theater. The space before the landscape setting, which looks very much like scenery on a stage, is no deeper than it need be to contain the figures. In this way Giotto has brought the important action up close, so that we feel that we are looking right at it. The background is flat; if we let our eyes follow the foreshortened right arm of St. John, the haloed figure in the center, we have a sense of measuring the picture's actual depth.

A painter of Siena, a town not far from Giotto's Florence, took a different path in realizing aims similar to Giotto's. He thawed out Byzantine art, breathing life and warmth into its rigid forms, enriching its frozen subject matter with such familiar images as the trees, buildings, and people of his own fourteenth-century surroundings, and reopening its locked-up space.

Our Sienese painter was Duccio, who was born ten or fifteen years before Giotto. Duccio's *Christ Entering Jerusalem* (figure 139) is a scene from the back of a large wooden altarpiece, and was done in tempera on a gold ground. In tempera, a technique used for both miniatures and panels, colors are mixed with egg yolk and water to make a thin, smooth paint that dries to a hard, tough surface. With their fine detail and brilliant color, tempera paintings are jewel-like in comparison with frescoes, which are limited in their range of tones and brightness of color.

The most novel thing about this work is its depth and clarity of space. The low walls, slanting upward to the city gateway on the right, frame a roadway that recedes into depth. Various locations in the picture are given to us by details of landscape and bits of architecture. Duccio thus has created a kind of perspective space by architectural means, and, furthermore, has placed figures inside it. Christ and his followers, on the bottom left, seem farther away from us than the youth who welcomes them by spreading a coat on the road, and nearer to us than the people just under the archway of the city gate. A bit of byplay that enriches and humanizes the scene with a touch of everyday life is used, in addition, to emphasize the picture's continuity of spatial depth. This secondary action takes place behind the city wall: a youth has climbed a tree; others turn toward him or lean their elbows on the city wall as they look over; one or two more view the spectacle from more distant points.

The architecturally created depth of Roman wall paintings, deep-frozen and stored away in Early Christian and Byzantine mosaics and murals, has been "unfrozen" and restored to real use. Not only that, but in the process it has become more coherent and systematic: it is now a perspective of architecture and figures together. Roman painters, we saw, had no continuity in their perspective vistas. Unable to relate any figure to the depths of those vistas, they tended to put all their figures in the foreground.

Apart from recapturing classical space and making it more systematic, Duccio thawed out the frozen Byzantine figure style. In his hands, the angular drapery of Byzantine icons (compare colorplate 13) became soft and flowing,

139. Duccio. *Christ Entering Jerusalem*. Panel from the back of the
Maestà Altar. 1308–11. Tempera. Cathedral Museum, Siena.
Duccio, like Giotto (see colorplate 19), wanted to lead Italian
art back to more natural forms. He went about doing so in a
different way, unfreezing the Byzantine style of painting so
that it became livelier and more realistic.

in the Gothic manner brought to Siena by the
sculptor Giovanni Pisano shortly before 1300.
He outlined limbs and features in smooth,
harmonious curves, and made facial expres-
sions human and gentle. And if he lacked
Giotto's great solidity and force, he had a
singing, poetic quality of his own.

The next generation of Italian Gothic
painters kept no more than traces of the
Byzantine style, and turned toward the newer
elements in both Giotto and Duccio. Giotto's
grandeur could not be rivaled, but Duccio's
touch of familiar reality and clarity of space
could be exceeded.

The dramatic gestures and strong facial
expressions of Simone Martini's *Christ Carry-
ing the Cross* (colorplate 20) proclaim Giotto's
influence, and so do the vigorously modeled

140. Pietro Lorenzetti. *The Birth of the Virgin*. 1342. Tempera on panel, 6′ 1½″ × 5′ 11½″. Cathedral Museum, Siena. The picture surface has now become a window into a fairly deep space.

and rather bulky forms. The sparkling colors, architectural background, and general scheme remind us even more of Duccio. Simone, on his own, had a wonderfully observant eye for the little details that bring a scene like this to life. His great variety of costume and physical type and his wealth of human incident bring us a new sense of down-to-earth reality.

Simone's tiny panel was painted around 1340. As he worked, the brothers Lorenzetti were advancing boldly into uncharted realms of space.

In Pietro Lorenzetti's *Birth of the Virgin* (figure 140), the architecture painted on the picture surface is joined to the real architecture of the triple frame to create a single system. The painting's two right-hand panels are seen as a single space—the room in which the newborn Virgin is being bathed—that continues unbroken behind a column of the frame. The picture surface has become a window through which—not on which—we perceive the same kind of space we know from daily experience. What an astonishing breakthrough!

Ambrogio Lorenzetti too was in love with space and familiar reality. On the walls of the Siena city hall he unfolded a view of the entire town (figure 141). Here we are not shown an imaginary city, like Duccio's Jerusalem, but

above:

141. Ambrogio Lorenzetti. *Good Government* (portion). 1338–40. Fresco. Palazzo Pubblico, Siena

left:

142. Ambrogio Lorenzetti. *Good Government* (detail)

This "portrait" of the town of Siena and the nearby countryside is a daring thrust into unknown territory—the first realistic landscape since ancient Roman times.

a well-described "portrait" of the Siena of 1340. The gay, busy crowd in the streets and houses gives this architectural vista the animation of life and the convincing reality of human scale. Only part of the long fresco is shown in this book; the Sienese countryside and mountains beyond were portrayed also. Figure 142 is a detail of that part of the fresco. Here is a true landscape, the first since ancient Rome. And it is not only a landscape but an authentic human environment. That characteristic scene of vineyards, valleys, fields, pastures, farm buildings, and peasants at their labors can still be seen in Italy today.

For most of the fourteenth century, the southern French town of Avignon replaced the city of Rome as the official residence of Popes. Avignon thus became a gateway for Italian influence on France. Simone Martini spent his last few years in Avignon, and his his little *Christ Carrying the Cross* was probably painted there. By the end of the fourteenth century, the merging of the French and Italian Gothic traditions had given rise to the International Style, which dominated all Europe until 1420. The International Style was not confined to painting—we have used the term for the sculpture of the time—but painters were the main contributors to its development.

The panel in figure 143 was painted in the 1390s by Melchior Broederlam for the Duke of Burgundy. It is one of the two shutters of an altar shrine—hence its odd shape. On the left we see the Christ Child being presented

to the High Priest in the Temple. Broederlam's picture space is not Pietro and Ambrogio Lorenzetti's—his architecture is rather like a doll's house—but no previous Northern painting ever gave us such a sense of depth. And the softly rounded shapes and dark, velvety shadows evoke a sense of light and air that more than compensates for any shortcomings in perspective or scale. The loose, ample, flowing garments remind us of the sculptured drapery of Sluter and Ghiberti (see figures 135 and 136). On the right we see the Holy Family—Mary, Joseph, and the Infant Christ —on its flight to Egypt. The softly shaded rocky slopes and lovingly detailed trees and flowers tell us that landscape has now become important in the North. For Broederlam, every detail of the natural world was worth

143. Melchior Broederlam. *Presentation in the Temple and Flight into Egypt*. 1394–99. Tempera on panel, 64 × 51″. Museum of Fine Arts, Dijon, France. This Northern European painting of the International Style clearly shows the influence of Italian painting.

looking at—its plants, animals, and people. His charming donkey was certainly painted from life; and his Joseph makes us think of a rough, simple farmer.

Although panels were taking on importance in the North around 1400, book illumination remained the leading form of painting. The International Style reached its peak in the *Very Rich Book of Hours*, a sumptuous prayerbook painted around 1415 by Pol de Limbourg and his two brothers for the Duke of Berry, brother of the king of France. This book is remarkable for its calendar pages, which, in keeping with a medieval tradition by no means dead today, depict the life cycle of man and nature through the twelve months of the year.

Colorplate 22 shows us the calendar for October and the sowing of winter grain on a clear, bright day. Figures—for the first time since classical antiquity—cast visible shadows on the ground. Once again we marvel at the wealth of realistic detail: the scarecrow in the middle distance, the footprints left by the sower in the soil of the freshly plowed field. The sower, ragged and miserable, is more than merely described. The artist meant to contrast the wretched life of the medieval peasants with the splendid life of the great aristocracy, as symbolized by the lavish castle on the far side of the river. The castle, we may note, is more than a symbol; it is a "portrait" of the Louvre as it was in Gothic times. The February miniature (figure 144) is among the earliest snow scenes in European art. And what a delightful picture it is! Here is country life in the dead of winter: sheep huddling in the fold, birds hungrily scratching in the barnyard, a maid blowing on her frostbitten hands as she runs to the cottage (the front wall of which has been omitted for our convenience) where her companions warm themselves before the fire; in the middle distance one man cuts wood and another drives a laden donkey toward the village in the hills. What

144. The Limbourg Brothers. *February*, from the *Very Rich Book of Hours of the Duke of Berry*. 1413–16. Condé Museum, Chantilly, France. One of the earliest snow landscapes in European art, this picture shows the sharp-eyed observation of nature and everyday life fostered by the International Style.

145. Gentile da Fabriano. *The Nativity*. 1423. Tempera on panel, 12¼ × 29½". Uffizi Gallery, Florence. This panel is on the base of the large altarpiece illustrated in colorplate 23. Gentile must have had the habit of sketching animals directly from life. The ox and the ass in this picture are far more keenly observed than the human figures, whose softly flowing draperies are characteristic of the International Style.

was attempted in the Broederlam panel has here been achieved: exterior architecture, interior architecture, and landscape are smoothly united in deep, atmospheric space. Even forms so unsubstantial as clouds, smoke, and frozen breath have now become paintable.

The foremost Italian painter of the International Style was Gentile da Fabriano, who must have known the work of such Northern painters as Broederlam and the Limbourg brothers. His *Nativity* (figure 145), done in 1423, is part of the great altarpiece illustrated in colorplate 23. The soft shading, the flowing drapery, the carefully studied plants and animals—these are all familiar to us by now. What is not familiar about this panel is the lighting. In the pictures we have seen before now we could never tell the time of day, nor could we tell what kind of light an artist had in mind. Now we have a true night scene, one of the first ever painted; and we know where the light comes from. Its chief source is the Christ Child himself. He had long been called the "light of the world," but no one had ever painted that divine light as a warm little campfire. Around 1400, it would seem, artists began to realize that light was separate from form and color and, perhaps, was more significant, for how things look depends on how light strikes them. This poetic night scene opened up a whole world of possibilities. Two centuries were to go by before artists would explore those possibilities fully.

PART THREE

The Renaissance

The "New Age"

The sequence of illustrations in Part Two of this book traced the course of the spiritual outlook of the people of Western Europe over a thousand-year span. For the first four-fifths of the Middle Ages, that outlook was salvation-centered and full of an overwhelming sense of man's inferiority in the great scheme of things. The outlook then began to change. A new interest in nature and humanity took hold and grew. With the fourteenth century, men looked at the world around them, finding new beauties and wonders in their natural surroundings and taking a new pride in the richness of their common life and the magnitude of their own achievements. Precarious though their world was, there was much to give them such self-awareness and self-confidence: a rapidly developing technology of eyeglasses, clocks, and cannon, roads, bridges, and canals, seaworthy ships and navigation instruments; a flourishing visual art full of discovery, and such daring artists as Duccio, Giotto, and the brothers Lorenzetti; a flourishing literature, and such poets and men of letters as the Italians Dante, Petrarch, and Boccaccio, and the Englishman Chaucer. Some men even came to look on their own times as a new dawn, the threshold of a new age, and on themselves as the first of a new breed of men. This bold idea, which had a powerful effect on subsequent history, had its start in the 1330s in the mind of one person, Petrarch. "Here stand I as though on a frontier between two peoples," he wrote, "looking both to the past and to the future."

The past to which Petrarch looked was not the recent past. It was an ideal vision of classical antiquity. In Greece and Rome, he thought, man had stood his tallest and reached the peak of his creative powers. The future was a reflection of that first era of enlightenment, the enlightened "New Age" of his own enlightened new breed. But the vast interval between classical antiquity and the new age being born was a "time-in-between," a "Middle Age" of darkness and small accomplishment.

The movement launched by Petrarch—humanism—was thus secular by deliberate intention. It focused upon "humane letters," that is, literature, history, and philosophy pursued for their own sake (we still call these "the humanities"), as against "divine letters"—in other words, scriptural study and theology. High literary standards and responsible scholarship were sought for human self-realization rather than for the greater glory of God.

Within fifty years after Petrarch's death in 1374, his envisioned new age had appeared on Italian soil and was following patterns he had set. Its own label for itself was *rinascità*, "rebirth," or, as we say, since the word has come to us through the French, *renaissance*.

The Renaissance brought a revival of antiquity far beyond anything that Petrarch had attempted himself: he had merely tried to purify his medieval Latin through studying ancient models, and had never learned Greek. During the fifteenth and sixteenth centuries, however, the revival of antiquity came to embrace Greek as well as Latin scholarship, and the entire range of creative endeavor, the visual arts most of all. But the men of the

Renaissance remained Christian through and through. They tried to reconcile their classical heritage with Christianity (not always successfully) and to equal or surpass their classical models, not duplicate them. In their striving, they became like the sorcerer's apprentice who set out to emulate his master and in the attempt released energies far greater than he had bargained for. Rejecting the Middle Ages, they brought about not the rebirth of antiquity but the birth of Modern Man.

Late Gothic Painting North of the Alps

Around 1420, Northern painters and Italian painters marched boldly beyond the International Style, keeping in perfect step but nevertheless parting company—for the Northerners went straight ahead and the Italians in a new direction. Thus two painting styles emerged, not one; and although the two had much in common, we call the Italian style Early Renaissance and the Northern style Late Gothic.

The Italian revolution broke with its recent past and brought sweeping changes to architecture, sculpture, learning, and manners as well as to painting. North of the Alps, there were scattered revolutionary developments in the 1400s, but no thoroughgoing revolution. Music and painting changed radically in Flanders (or Belgium, as we say today). Northern architecture did not undergo important change, and life, for the most part, went on as it had before. The Middle Ages ended gradually in Northern Europe and, in many places, lingered well into the sixteenth century.

The Italians of the Early Renaissance, it must be said, did not regard Late Gothic painting as "Gothic," which was their dirty word for an imported style they now considered un-Italian and barbarous. (The Goths were one of the invading Germanic tribes who had destroyed the Roman Empire.) Most Italians admired Flemish painting for its highly successful imitation of nature, which they associated with "the return to the clas-

sics." Should early Flemish painting, then, also be called Renaissance? There are those who think so.

We still use the words "Gothic" and "Middle Ages" today, and would be hard put to find substitutes for them. We do not use them in the old way, however, as terms of abuse, for we no longer despise Gothic architecture or the Middle Ages. Visual art in the Renaissance bore the stamp of the revival of antiquity, to which the early Flemish painters paid no heed. We do not underestimate their genius or suggest that they were out of date when we regard their work as Gothic painting's final phase.

The first great early Flemish painter was a man whose name we do not know for certain; we call him the Master of Flémalle. One of his finest works is the *Annunciation* (colorplate 24) painted in 1425 or a little after. We recognize a family resemblance to the International Style (compare figures 143 and 144 and colorplate 22). But what a different experience it gives us! This panel is like a window into the real world. Unlike International Style painters, who created enchanting tales and a toy world, the Master of Flémalle has undertaken to tell us the truth, the whole truth, and nothing but the truth. He has not found this very easy to do: the perspective seems odd, and the forms rather jostle one another in space. But he painstakingly gives extraordinary reality to every detail. He makes it look tangible and solid. He defines its shape and

size, its material substance, its color and texture, its degree of rigidity, and its response to light. He has even distinguished between the direct light from the two round windows and the indirect, diffused light elsewhere in the room. The direct light casts strong, hard-edged shadows against the walls and bounces highlights off the candlestick and the hanging brass pot. The more diffused light produces soft shadows and many different levels of brightness.

Effects so realistic would never have developed if artists had continued to rely on tempera technique, which limited their choice of tones—rich, clean darks were particularly hard to achieve—and would not allow them to join tones smoothly. This *Annunciation* is a pioneer work in a technique that offered painters a wider range of possibilities. On top of an underpainting in grayish tempera—a drawing, really—the Master of Flémalle placed thin, transparent layers of oil color. By this means he could produce a variety of tones, soft shades, and smooth harmonious blending.

Another innovation to be seen here will show us that this artist's passion for exact imitation of nature had deep spiritual roots. When we were looking at religious paintings of the International Style (see figures 143 and 145 and colorplate 23), we found ourselves in a very elegant and aristocratic world. The very different world into which the Master of Flémalle has ushered us so abruptly is the household of a Flemish burgher. Never before had the Queen of Heaven been made to appear in a setting so domestic and humble. This very fact posed a problem that no previous artist had ever faced. How does an artist transfer a lofty supernatural event from a symbolic setting to a very common, ordinary setting without making it seem preposterous? The Master of Flémalle met this challenge by resorting to *hidden* symbolism. The lilies in the pitcher, for example, signify the Virgin's purity. The shiny pot with water in it and the towel hanging on the rack are also tributes to the Virgin, who was "the vessel most clean" and "the well of living waters." Now we can understand why objects that might be thought unimportant were described with such insistent realism: this artist believed that everything in the physical world was holy, a mirror of divine truth.

Jan van Eyck was a little younger than the Master of Flémalle and much more famous. He was another early user of the exciting new oil technique, and discovered many of the almost limitless effects possible with it. He used it with great refinement, achieving a soft radiance of tone that has never been equaled.

The two pictures of colorplate 25 were painted before 1425 either by Jan van Eyck or by his brother Hubert. The tall, narrow shape of the panels suggests that they are the wings of a small altar; they may once have flanked a larger center panel.

The left panel is a *Crucifixion* scene. The style reminds us strongly of the Master of Flémalle's *Annunciation*. The drapery has the same sharply breaking angular folds, and we find a similar devotion to the physical world and its details. There are many differences, however. One difference is more apparent than real: we felt that we were looking straight ahead at the Annunciation scene, but that we are looking down on the Crucifixion from a point high in the air. If the Van Eycks had placed us on the ground, they would not have been telling this story clearly, for the foreground figures would then have blocked our view of the figures behind them. But there are genuine differences, too. Not only are the Van Eycks far less interested than the Master of Flémalle in making all details look firm and solid, and far more skillful in relating figures to one another—any number of figures—but they have observed and recorded a whole new dimension of spatial reality. How

completely they have mastered the natural world's light and air, its continuous and unlimited space!

The colors of this panel pale with distance, till we are no longer sure where the earth leaves off and the sky begins. The sweeping sense of spatial depth we receive comes less from the way things get smaller with distance than from those subtle changes of light and color.

We all know that in fog or mist we can see only a few feet ahead. Actually, our atmosphere always contains moisture or dust; it is never completely clear. Gradually, as objects recede, they lose sharpness of contour, strength of color, contrast of light and dark. They become dimmer and grayer, and eventually are dissolved. The Van Eycks were the first artists who understood this principle so clearly that they could make every detail fall into position in space. An order of nature was involved, the strict order of human perception that we call atmospheric perspective. It works only when the artist is faithful to it in every detail. If he makes any exceptions, he distorts the natural world into which he has cut a window.

The panel on the right shows us *The Last Judgment*. Here the Van Eycks had to call on their own imagination to provide the setting, for the story is placed at the end of time, when the dead rise from their graves and are judged. In the middle of the picture we see the resurrected dead come up from the earth and the ocean. Above them is the Lord, surrounded by saints and patriarchs. Below, the damned are being tormented by hellish monsters. Hell here has the awful reality of a nightmare. There was little action in the *Crucifixion*, and the display of grief was dignified and restrained. In the lower part of *The Last Judgment*, however, the Van Eycks have poured out all the violence and all the expressiveness they avoided in the other panel. The new rules of painting, it would seem, could

be applied even to an "unnatural" subject. Far from stifling the artistic imagination, they helped it. Fantastic monsters could be made believable, and the anguish of the damned overwhelming.

The Ghent Altarpiece (figures 146–148), begun by Hubert van Eyck in 1425, the year before he died, and finished by his brother Jan seven years later, is the greatest monument of early Flemish painting. It is also one of the greatest puzzles ever inflicted upon professional art historians. Their tenacity in reconstructing the history of this "super-altar" and determining each brother's share has made the evolution of Late Gothic art much clearer. We can now watch the next phase of Flemish painting emerge, and, with it, the mature individual style of a giant of world art.

The altarpiece is more than eleven feet high and made in three sections: a wide center section painted on the front only and two narrower wings painted front and back. When the wings fold in, the altar is closed; when the wings fold out, the altar is open. Whether it is open or closed, however, we see such a combination of panels of different shapes and sizes that the basic structure is not immediately plain to our eyes. The twelve panels of the altarpiece in its open state (figure 146) do not even hang together as a unified design. As we look, we begin to see that they comprise more than one system of pictures—perhaps several. The bottom tier of five panels must be all one system: it tells one story, the *Adoration of the Lamb*, and reveals a continuous and consistent world. But what about the upper tier and its seven panels? The three center panels showing the Lord between the Virgin Mary and St. John the Baptist certainly go together; perhaps they were planned as a separate three-panel altar. The musical-angel panels to their left and right go with each other, but with no other panels here. And the two end panels with nude figures of Adam and

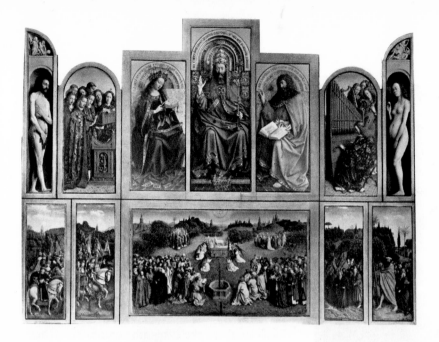

above left:
146. Hubert and Jan van Eyck. *The Ghent Altarpiece* (open). Completed 1432. Oil on panel, 11′ 3″ × 14′ 5″. St. Bavo, Ghent

above right:
147. *Adam* and *Eve* (detail of *The Ghent Altarpiece*)

left:
148. *The Ghent Altarpiece* (closed)

> This huge altarpiece presents every aspect of the new painting style created by the Van Eycks: splendid landscape vistas filled with light and air; realistic interiors inhabited by tangible figures, some "live," others carved in stone; the faithful observation of every detail of the real world, from blades of grass to sparkling jewels; a new mastery of the nude. That Adam and Eve occupy so conspicuous a place here is perhaps the most striking aspect of this work.

Eve must be still another pair. There are four systems in all.

Now let us fold the wings in. At this point we see the altar in its closed state (figure 148). The eight outer panels now displayed are definitely read by our eyes as one coherent design. They must have been planned that way, even though the inner panels of the same wings could not have been planned originally as we just saw them.

What happened?

Apparently Jan took a number of panels left unfinished by Hubert, completed them, added some of his own, and assembled them as the present altarpiece. Presumably he did this to the order of wealthy townspeople, who donated the altarpiece to their cathedral; the donors are portrayed on the two end panels of the bottom tier in figure 148.

The twelve inside panels, except for two subjects, are in a style that reminds us of the

149. Jan van Eyck. *Man in a Red Turban (Self-Portrait?*). 1433. Oil on panel, 10¼ × 7⅛". The National Gallery, London (Reproduced by courtesy of the Trustees). There were no true portraits in medieval art. Now painters learned how to record the features that made one person look different from another.

Crucifixion, although in its gentleness there is no suggestion of grief. Hubert painted these, probably, and Jan touched them up. But the two panels in a different style—the pictures of Adam and Eve—are very different. Jan must have painted them and completed the inside of the altar by adding them to Hubert's left-over stock. Jan must also have both planned and painted the eight outer panels, which are in the same style as the pictures of Adam and Eve.

The *Adam* and *Eve* (figure 147) are a landmark in Western art. Almost lifesize—the first monumental nudes of Northern painting —they are quiet, dignified, magnificently observed, and bathed by a most delicate play of light and shade. The way in which they were designed for their location was a masterstroke of spatial realism. The shallow ledges on which they stand are a little above eye level, and they have been described accordingly, that is, exactly the way that we would see flesh-and-blood figures from the same vantage point. Since they are painted images and not flesh and blood, picture space and real space are shown here in a new relationship. An imaginative, resourceful, and skilled artist has seen an opportunity here to make each kind of space the continuation of the other.

The portraits of the donors are splendidly individual. In the fifteenth century, Northern painters gained command over the human face seen from three-quarter view and at close range. There had been no true portraiture in medieval painting before the fourteenth century; now people wanted portraits they could recognize. In addition to donor's portraits, artists began to produce small, independent likenesses. These were so intimate and personal that they must have been treasured keepsakes, substitutes, as it were, for the real presence of a real person. One of the finest is Jan van Eyck's *Man in a Red Turban* (figure 149), painted in 1433. The sitter may well have been Jan himself, for there is a slight strain about the eyes, as though he were gazing into a mirror. Here again we marvel at the rich play of light and shade, which shows up every detail of the surfaces with great precision, from the stubble on the sitter's chin to the crinkly fabric of his turban. The face is strangely calm, as in all of Jan's portraits. The *Crucifixion* and *Last Judgment* showed us that Jan was thoroughly capable of expressing any emotion, so that the composure we see here surely represents his personal ideal of human character.

Jan van Eyck's most remarkable portrait, and a major masterpiece of the period, was his *Giovanni Arnolfini and His Bride* (colorplate 26). We are shown a young couple solemnly exchanging vows in their bridal chamber.

150. Jan van Eyck. *Giovanni Arnolfini and His Bride* (detail of colorplate 26). One of the two
men in the mirror is the artist (his signature reads, in Latin, "Jan van Eyck was here").
He thus attests the fact that he has witnessed the ceremony, and the picture becomes a
kind of marriage certificate.

151. Roger van der Weyden. *Francesco d'Este*. About 1455. Oil on panel, 11¾ × 8″. The Metropolitan Museum of Art, New York. The Michael Friedsam Collection, 1931. Unlike Jan van Eyck, Roger stresses the main outlines of the face instead of exact detail. His portrait tells more about the sitter's personality, but less about the way the sitter actually looked.

They seem alone, but the reflection in the mirror behind them (figure 150) reveals two other persons. One is the artist, for above the mirror in florid legal lettering are the words "Johannes de eyck fuit hic" (Jan van Eyck was here) and the date 1434. Jan, then, is a witness; the picture is not only a portrait but a marriage certificate. It is also a whole world of hidden meaning. The homelike setting and the realistic forms organized so flawlessly in the depth of the light-filled space contain symbolic messages of the sacredness of marriage. The single candle in the chandelier, burning in daylight, stands for Christ, who sees all. The bridegroom has removed his shoes because he stands on "holy ground." Even the little dog is a symbol of faithfulness. Like the Master of Flémalle before him, Jan van Eyck has so filled the world of nature with the world of the spirit that the two have actually become one.

Jan van Eyck's exploration of light and color attained a level to which his successors could not aspire. His detachment, moreover, was not in tune with their inherited attitudes. They turned to Roger van der Weyden, the third great master of early Flemish painting. Roger took on a task as important as Jan van Eyck's. His explorations, however, were not in the world around us but in the world within us. Using the realistic style, he reclaimed the Gothic heritage of drama and emotion.

Roger's greatest masterpiece is *The Descent from the Cross* (colorplate 27), painted around 1435. The angular drapery folds and the precisely modeled, very sculptural forms remind us of the Master of Flémalle. The soft half-shadows and rich, glowing colors show knowledge of Jan van Eyck. But a different world of feeling is revealed. The mood is tragic: every face is desolate, and every gesture weighted with grief. The artistic ancestry of the faces and gestures can be found in sculpture—the Bonn *Pietà* (figure 133), for example, or Sluter's *Moses Well* (figure 135)—rather than in painting. It is not strange, then, that Roger has staged the scene in a boxlike shrine instead of a landscape, nor that the figures look like colored sculpture. This device enabled him to mold the figures into a strong group and to focus all our attention on the foreground.

Roger's art set an example for countless other artists. When he died in 1464, after a long reign as the foremost artist of Flanders, his influence was supreme in every country north of the Alps. Among the artists from neighboring countries who felt his influence was a Frenchman whose name has been forgotten. He left us a large work, one of the most famous in all Late Gothic painting (fig-

above:

152. Hugo van der Goes. *The Portinari Altarpiece*
(center). About 1476. Oil on panel, 8' 3½" ×
10'. Uffizi Gallery, Florence. The altar of which
this is the center panel was done for Tommaso
Portinari, a Florentine businessman, by the
boldest and most dramatic Flemish painter of
the late fifteenth century. Not since Roger van
der Weyden's *Descent from the Cross* (colorplate
27) had a painter achieved such expressive
power. Note especially the wonderful group of
shepherds staring in breathless, wide-eyed ado-
ration at the newborn child. The work arrived in
Florence around 1480 and exerted a great in-
fluence on Florentine painting toward the end of
the century.

left:

153. Geertgen tot Sint Jans. *The Nativity*. About
1490. Oil on panel, 13½ × 10". The National
Gallery, London (Reproduced by courtesy of
the Trustees). Toward the end of the fifteenth
century the most original Northern painters
were Dutchmen. This wonderfully gentle night-
time scene by Geertgen recalls the discovery of
painted light in the International Style of around
1400 (compare figure 145).

154. Southern French Master. *The Avignon Pietà*.
About 1470. Oil on panel, 64 × 86″. The Louvre,
Paris. "Pietà," the Italian word for pity, also
means the image of the dead Christ in His
mother's lap. Such pictures are intended to make
us share the Virgin's grief by reminding us of the
happier days when the Madonna held the Infant
Christ in her lap. Although this work is entirely
Late Gothic in feeling, it has a monumentality
more Italian than Flemish.

ure 154). We call it *The Avignon Pietà*, since
it was found near Avignon, in the south of
France. The figure types and tragic mood
could come from no source other than Roger.
The design, however, is much simpler, and
has a bigness about it that makes us think of
Giotto. This master must have been touched
by Italian art, no matter how Late Gothic his
figure style and depth of feeling.

The most extraordinary painter in North-
ern Europe at the end of the fifteenth century
was the Dutch master Hieronymus Bosch. He
used the new visual techniques and the new
language of symbols to make the unreal seem
real. His paintings are fanciful worlds full of
weird images, puzzling symbols, and airy
landscapes that recall the Van Eycks. The
richest and most puzzling of his works is the
strangely poetic *Garden of Delights* (figure
155). This work is so packed with detail that
it must be read slowly, the way we read a long
religious poem—for example, Dante's *Divine
Comedy*, which also is in three parts (like the
Trinity) and also is full of beauty, imaginative
power, and striking symbols.

The left panel is the *Garden of Eden*, a
dreamlike landscape with exotic animals; in
the foreground, the Lord introduces Adam to
the newly created Eve.

The right panel (figure 156) is a nightmare
landscape of blazing ruins and fantastic tor-
tures. It is surely Hell, the *Garden of Satan*.

155. Hieronymus Bosch. *The Garden of Delights.*
About 1500. Oil on panel, center 86½ × 76¾″;
wings 86½ × 38″ each. The Prado, Madrid (see
also colorplate 28)

156. *Hell* (right panel of figure 155)

These panels are so densely filled with detail that
their full beauty and imaginative power can be under-
stood only at close range. The whole demands to be
"read" slowly for its meaning is very complex.
Bosch's theme here is the vice of lust.

But what of the center, the *Garden of
Earthly Delights*? Here, as we are shown in
colorplate 28, nude men and women inno-
cently parade on the backs of beasts, sit on
giant birds, eat colorful giant fruits, and play
in a stream; a few make love. Every bird,
fruit, animal, and diversion is a symbol of
temptation, of an earthly pleasure. The artist
is telling us that we are the prisoners of our
earthly appetites. Like Adam and Eve before
us, we succumb to temptation. We sin and
are doomed to keep on sinning, and we will
never stop. We can end nowhere but in Hell.

Bosch, then, is a stern moralist, and this
work is a visual sermon. We are meant to
find it, not a true garden of delights, but a
rebuke and a warning. This panorama of our
sinfulness, however, although born of deepest
pessimism, develops so much poetic charm
and sensuous appeal as it unfolds that we tend
to admire it for what the artist meant to
condemn.

157. Conrad Witz. *Christ Walking on the Water*. 1444. Oil on panel, 51 × 61″. Museum, Geneva. The most remarkable part of this altar panel by a Flemish-trained Swiss painter is the background, a faithful "portrait" of Lake Geneva. Such a realistic setting makes the miracle, too, seem very real.

right:

158. *St. Dorothy*. About 1420. Woodcut. Staatliche Graphische Sammlung, Munich. The idea of printing pictorial designs from wood blocks onto paper originated in Northern Europe at the very end of the fourteenth century, and led to printing books from movable type fifty years later. Early woodcuts are flat and ornamental: their forms are defined by simple, heavy lines. Wood-block printing was a popular art; prints were inexpensive and widely distributed.

159. Martin Schongauer. *The Temptation of St. Anthony*. About 1480–90. Engraving. The Metropolitan Museum of Art, New York. Rogers Fund, 1920. Engravings on metal plates appeared a little later than woodcuts. Capable of more refined treatment than woodcuts, they appealed to a more sophisticated public and were created by more distinguished artists. The finest Late Gothic engraver was the German artist Martin Schongauer. This print is a masterful combination of savage expressiveness and formal precision, of violent movement and stable design. The longer we look at it the more we marvel at its range of tonal values and the artist's ability to render every conceivable surface and texture—spiky, scaly, leathery, furry—merely by controlling the attack of his tool upon the metal printing plate.

The Early Renaissance in Italy

In the closing years of the fourteenth century, the city republic of Florence became engaged in a struggle to prevent the powerful dukes of Milan from helping themselves to all of Italy. The issue was contested as strongly in the public realm of ideas as in secret diplomacy and military action. Led by the Medici family of bankers and wool merchants (see page 163), Florence eventually rallied Venice and Naples to her support. The crushing defeat of the Milanese forces in 1429 ended the crisis. Meanwhile, Florence had become the undisputed political and intellectual leader among Italian cities.

Why did Florence alone come forward to defy superior might? Because she was the "new Athens," the Florentine humanist writers of 1400 told the Italians—descended from the city-states of ancient Etruria, indomitable in spirit, free in her institutions, and supreme in cultural achievement. The Florentines plainly felt they had been called to greatness; for in 1401, when Milanese power was threatening to engulf them, they embarked on an ambitious long-range campaign to complete the prodigious civic artistic enterprises begun in Giotto's time. During the next thirty-five years, they produced two pairs of sculptured bronze doors for the Baptistery, continued the sculptural decoration of the Cathedral and the church of Or San Michele, and—their biggest and most difficult project—built the Cathedral dome. The huge investment was comparable to the cost of building the Acropolis in Athens (see page 60). The effort created new practical opportunities and a stirring mental climate for the development of new talents and a style worthy of the "new Athens."

Among the many revolutionary Florentine developments of this period was a changed conception of the place of art and artists. In the Middle Ages, architecture, sculpture, and painting had been put among the crafts, or "mechanical arts," for they lacked a theoretical basis. In the Early Renaissance, they were promoted to the select company of the "liberal arts," which, by classical tradition, were the intellectual disciplines of a gentleman's education—mathematics (including music), dialectics, grammar, rhetoric, and philosophy. Now artists came to be seen as men of ideas, and a work of art as the visible record of a highly creative mind—something beyond judgment by the fixed standards of craftsmanship. The outlook of artists, too, underwent changes. The companions and the equals of poets and philosophers, artists frequently became theoreticians and biographers themselves. They began to fall into two repeating types of personality: the polished and educated man of the world, at ease in aristocratic society; and the solitary genius, withdrawn, moody, ready to quarrel with his patrons. This very modern view of art and artists took hold quickly in Early Renaissance Florence.

SCULPTURE

Donatello, the greatest sculptor of the fifteenth century and one of the greatest who ever lived, was a founding father of the Renaissance. We have clearly entered a new epoch when we look at his *St. George* (figure 160), carved in marble for a niche of the church of Or San Michele around 1415. Here is the first statue we have seen since ancient times that can stand by itself, or, put another way, the first to recapture the full meaning of Classic counterpoise (for a discussion of counterpoise turn to page 65). The artist has mastered at one stroke the central achievement of ancient sculpture: he has treated the human body as an articulated *structure* capable

160. Donatello. *St. George*. About 1415–17. Marble, height 6′ 10″. Or San Michele, Florence (statue now in the National Museum, replaced here by a bronze copy). In this revolutionary work the artist announces the arrival of a new era. Once again, as in classical sculpture, the body is a fully articulated working structure capable of movement.

of movement. Its armor and its drapery are a secondary structure shaped by the body underneath; unlike any Gothic statue, St. George can take off his clothes. And, also unlike any Gothic statue, he can be taken away from his architectural setting and lose none of his immense authority. His stance, with his weight placed on the forward leg, conveys the idea of readiness for combat (the right hand originally held a weapon). The controlled energy of his body is echoed in his eyes, which seem to scan the horizon for the approaching enemy. For this St. George, slayer of dragons, is a proud and heroic defender of the "new Athens."

The unidentified prophet (figure 161) nicknamed *Zuccone* ("Pumpkinhead"), for a reason that should be obvious, was carved some eight years later for the bell tower of the Cathedral. Unquestionably, it is more realistic, more like a real person, than any other statue we have seen so far. But what kind of realism do we have here? The artist has not given us a bearded old man holding a scroll—the traditional Christian image of a prophet. Nor has he given us a fellow townsman in the costume of the day. Why not? Why was it not enough for Donatello to be like Sluter and reinterpret the traditional type from a contemporary realistic point of view?

Donatello, the first solitary genius of the Renaissance, was compelled from within to create a new type on the basis of his own thinking and feeling. From his reading of the Old Testament he had formed a mental picture of the Biblical prophets, an impression of divinely inspired orators haranguing the multitude; and this, in turn, he had connected with the Roman orators he had seen in ancient sculpture. Hence the classical costume of the *Zuccone*, whose mantle falls from one shoulder and whose head is lined and ugly, yet noble (compare the toga–clad patrician of figure 75). To shape these elements into a coherent image was a revolutionary feat and required an almost visible struggle. Donatello looked upon this achievement as particularly hard-won; and the *Zuccone* is his earliest known work to carry his signature. He swore "by the Zuccone," it is said, when he wished to speak

emphatically; and he shouted at it as he worked, "Speak! speak! or the plague take you!"

Medieval nudes lacked sensuous appeal—a quality we take for granted in every nude of classical antiquity. Such appeal was avoided purposely, for to the medieval mind the physical beauty of ancient "idols" was paganism

161. Donatello. *Prophet (Zuccone)*, from the Bell Tower, Florence Cathedral. 1423–25. Marble, height 6′ 5″. Cathedral Museum, Florence. The artist has pushed tradition aside and shows us a prophet based on his own personal conception.

at its most insidious. The rediscovery of the beauty of the unclothed human body in the fifteenth century took different paths in Flanders and Italy; the two paths were to come together in the Venetian painting of the following century. Jan van Eyck's *Adam* and *Eve* (figure 147) and Bosch's unclothed figures in *The Garden of Delights* (colorplate 28) were unlike the nudes of ancient or, indeed, medieval art. Rather than "nude," they were "naked"—people who, normally, were fully dressed but who, for some particular reason, had their clothes off. Italian artists, however, created "nudes" in the full classical sense. Donatello's bronze *David* (figure 162) of around 1430 was such a nude—the first life-size, free-standing nude statue since ancient times, and a truly revolutionary achievement. Donatello's contemporaries must have felt uneasy about it, for it remained the only work of its kind for many years. David is, in a sense, partly dressed, for he wears rather ornate military boots and a hat; but we tend to wonder why he wears these rather than what has happened to the rest of his clothes. Nudity is his natural state. Otherwise, he resembles a classical statue mainly in his marvelous counterpoise. Donatello shows us a wiry stripling rather than a full-grown athlete with crisply articulated body masses and swelling muscles, like the gods and heroes of Classic Greece. The spirit of the David is profoundly classical, nevertheless, for, as in ancient statues, the body speaks to us more eloquently than the face, which is impassive by Donatello's standards.

Donatello was called to Padua in 1443 to create a monument to Gattamelata, the commander of the Venetian armies, who had just died. This equestrian statue (figure 163) was Donatello's largest free-standing work. We have already seen its major source, the equestrian statue of the Roman emperor Marcus Aurelius (figure 78). The *Gattamelata*, without imitating the *Marcus Aurelius* directly,

shares its bronze material, its impressive scale, and its great balance and dignity. The horse is a tremendous animal, fit to carry a man in full armor. Yet the man dominates him completely, not by physical strength but by force of character. In the new Renaissance fashion, the statue's purpose was to pay official honor to a great soldier who had served the Venetian Republic well. To this purpose, Donatello created an image that fuses the real and the ideal in a perfect union. The general's armor combines fifteenth-century construction with classical detail. His head is powerfully individual, yet truly Roman in its expression of nobility.

Two important sculptors were left in Florence after Donatello's departure: Lorenzo Ghiberti and Luca della Robbia.

Ghiberti, in his middle and late years, was a convert to the new style, although his

above:

162. Donatello. *David*. About 1430–32. Bronze, height 5′ 2¼″. National Museum, Florence. The first lifesize free-standing nude statue since classical antiquity, the *David* remained the only work of its kind until well after the middle of the century.

right:

163. Donatello. *Equestrian Monument of Gattamelata*. 1445–50. Bronze, over lifesize. Piazza del Santo, Padua. The rider dominates his large and powerful horse by force of character rather than by physical force. Realistic and strongly individualized, the *Gattamelata* is nevertheless a heroic image.

164. Lorenzo Ghiberti. *The Story of Jacob and Esau,* panel from the "Gates of Paradise." About 1435. Gilt bronze, 31¼" square. Baptistery, Florence. Ghiberti's second set of bronze doors for the Baptistery shows him converted to the Renaissance point of view, through the influence of Brunelleschi, Donatello, Alberti, and other pioneers of the new style (compare figure 136).

figures continued to hark back to the International Style in their flow of drapery and their gentle grace (see page 120 and figure 136). *The Story of Jacob and Esau* relief (figure 164) from his second pair of bronze doors for the Baptistery—the "Gates of Paradise," as the Florentines named them because of their great beauty—belongs to the Early Renaissance. The spacious architectural setting, with its airy arcades and tall Corinthian order, is in the style launched by Filippo Brunelleschi (see pages 163–64). The perspective (also learned from Brunelleschi) is deep, clear, and mathematically precise. An image of objects in space has been mapped onto the bronze surface much as, today, a spatial

image is recorded on film by the lens of a camera. In the perspective system employed here (and generally in Early Renaissance paintings and pictorial reliefs), parallel lines converge at a single vanishing point located at the observer's eye level. Ghiberti has handled both Early Renaissance architectural design and scientific perspective with seemingly effortless ease and assurance.

Luca della Robbia, a gifted sculptor who did not share Donatello's passion for experimentation and growth, never made a freestanding statue and, in the 1440s, gave up carving in marble—at which he was a master —for the cheaper and less demanding medium of glazed terra cotta (baked clay). His semi-

165. Luca della Robbia. *Madonna and Angels*. About 1460. Glazed terra cotta, 63 × 87½″. National Museum, Florence. Luca was a fine sculptor in marble, but his work in the terra-cotta process that he invented proved so popular that he gathered his relatives together and organized a workshop to produce it in quantity. Even so, he could not keep up with the demand.

circular *Madonna and Angels* in this medium (figure 165) shows us the appealing combination of sweetness and solemnity that has made Luca so popular a sculptor. The color combination here is characteristic of Luca. Except in the border wreath of flowers, where several colors are used, it is restricted to blue and white—a deep blue for the background, a smooth, lustrous white for the figures.

Luca's withdrawal into terra cotta gave younger Florentine marble carvers freedom to develop into artists of importance. These men produced Florence's marble tombs, church furniture, and Madonna reliefs during the later fifteenth century, and, besides, originated a new form of large-scale sculpture: the Renaissance portrait bust. One of the earliest and best is Antonio Rossellino's bust of Giovanni Chellini (figure 166), carved around 1455. The sitter's personality, at once ironical and kindly, has been observed with great penetration: his head is far more individual than any Roman's (see figures 76, 78, and 79). Although it is as documentary as a Roman head—not one wrinkle has been ignored—Antonio has not permitted detailed realism to obscure the sitter's qualities as a human being.

The popularity of portrait busts after 1450 can be explained by the growing demand for works of art to be placed in private homes rather than churches and civic buildings. Decades earlier, artists and humanists had begun to collect ancient Roman busts and small bronzes. The vogue for collecting spread, and soon sculptors were being called upon for busts and bronzes "in the manner of the ancients."

Antonio del Pollaiuolo's *Hercules and Antaeus* (figure 167) is a particularly fine bronze "in the manner of the ancients." The way the limbs are flung out in every direction is even more extraordinary than we see it in our illustration, for the complexity of the action is fully revealed only when we look at the

above:

166. Antonio Rossellino. *Giovanni Chellini.* 1456. Marble, height 20". Victoria and Albert Museum, London. The Renaissance portrait bust originated among the younger sculptors working in Florence around 1450. The idea of the portrait bust was of Roman origin (compare figure 75), but the style of this attractive work owes very little to Rome.

below:

167. Antonio del Pollaiuolo. *Hercules and Antaeus.* About 1475. Bronze, height 18". National Museum, Florence. To create a free-standing group of two figures in violent struggle was a new idea in sculpture. Here Pollaiuolo, who was also a painter and printmaker, took his inspiration from the painting style originated by Andrea del Castagno (see figure 177).

bronze from every angle. No matter how we shift our viewpoint, the statuette remains in balance all around the point where Antonio has attached the two adversaries to each other.

If this kind of design had no predecessors in sculpture, it did have them in painting, for example, Castagno's *David* (figure 177). Antonio del Pollaiuolo took a composition from drawing and painting and put it in the round; he was a painter and engraver as well as a sculptor (see figure 178). Of all the masters of his time, he contributed most to the solution of the difficult problem of anatomy in action. He was as passionately devoted to the scientific study of anatomy as Piero della Francesca and Paolo Uccello (see pages 168, 169 and colorplate 30) were to the scientific study of perspective, and it is said that he was the first artist to dissect the human body in order to learn its structure and workings at first hand. He must have developed deep understanding, for he shows us living anatomy, the anatomy of bones and muscles in use and under strain, not the anatomy of lifeless forms on a dissecting table. His study of anatomy in action extended to the facial expressions that went with the strained and struggling nude bodies that he described. Artists before him had described contorted features, but none had so united the show of motion and emotion to create a single, fused expression.

Pollaiuolo, although he did large-scale tombs in bronze, never had the opportunity to create a lifesize free-standing statue. For such works we turn to his younger contemporary Andrea del Verrocchio, the greatest sculptor of his day. Verrocchio's most popular work in Florence is his *Putto with Dolphin* (figure 168). The Early Renaissance reintroduced the putto—which in Roman art was a winged child as the embodiment of a spirit; see the putto with dolphin of figure 76—both in its original sense and as a child angel. Our putto is the centerpiece of a fountain—the dolphin spouts because the putto hugs. In

168. Andrea del Verrocchio. *Putto with Dolphin.*
About 1470. Bronze, height 27″ without base.
Palazzo Vecchio, Florence. The greatest sculp-
tor of the later fifteenth century, Verrocchio was
the only one to share something of Donatello's
range and high ambition. He was also a respected
painter, and Leonardo da Vinci's teacher.

spite of his larger scale, ampler volume, and
more playful spirit, this putto is close to
Pollaiuolo's *Hercules and Antaeus.* Again the
limbs swing out in all directions from a central
axis. But here the movement is graceful and
continuous, not jagged and broken. The out-
stretched leg, dolphin, arms, and wings de-
scribe an ascending spiral; the statue seems to
revolve before our eyes.

ARCHITECTURE

The towering genius of Filippo Brunelleschi
ushered the new architecture into history.
Goldsmith and sculptor as well as architect,
skilled in mechanics and military engineering,
builder of clocks and scientific apparatus, the
correspondent of mathematicians, and the in-
ventor of mathematical perspective, he was
the first great representative of the "universal
man" for whom the Early Renaissance is
famous.

Brunelleschi was twenty-five years old
when he lost out to Ghiberti in the 1401–2
competition for the the bronze doors of the
Florence Baptistery. Shortly thereafter, he
went to Rome. He was the first, it seems, to
take careful measurements of ancient Roman
buildings. He was back in Florence between
1417 and 1419, and competing with Ghiberti
again. The competition was for the job of
building the Cathedral dome. This time he
won.

The vastness of the projected dome pre-
sented a construction problem of frightening
dimensions. Built solid in the traditional way,
it would have had an outward push so great
as to defy bracing. Its cost, assuming it could
be put up at all, threatened to bankrupt the
Republic. But Brunelleschi had a solution. He
envisioned a dome that would be light in
weight and almost thrustless: a tall double
shell. He proposed to build it without the
mountain-high web of scaffolding required by
the older construction method. Both the man
and his ideas so impressed the authorities that
they awarded him the job. Construction began
in 1420 and was completed sixteen years later
(see figure 128).

There was nothing new about the basic
shape of the dome: an older, Gothic design
was being carried out. As an achievement of a
different kind, however, it had enormous sig-
nificance, for it marked the transformation of
architecture from craft to learned profession.
Brunelleschi's dome freed his successors from
the tyranny of traditions and gave them a new
foundation for their work: the scientific point
of view. Thereafter, when faced with tech-
nical challenges, they would submit their prob-
lems to scientific analysis in order to come up
with workable solutions. Brunelleschi's quest-
ing spirit brought architecture, which is a

marriage of engineering and art, squarely into a new era.

Brunelleschi's ideas were equally bold and new in architectural design. In 1419, while working on the final plans for the Cathedral dome, he received his first opportunity to carry out a design of his own. The Medici commissioned him to build an addition to the Romanesque church of San Lorenzo. The new part of the church was to be both a sacristy and burial chapel for the Medici family. Brunelleschi's plans were so impressive that he was asked to develop a design for a whole new church (figures 169 and 170) to replace the old structure.

The ground plan of the new church of San Lorenzo may not seem novel at first glance. What distinguishes it from previous churches is its new emphasis on regularity. The design as a whole is made up of square units: four large units for choir, crossing, and transept arms; four more combined into the nave; smaller squares, each one-fourth the size of the larger, for aisle compartments and transept chapels (the oblong chapels off the aisles should be ignored; they were not part of the original design). There are actually small deviations from the scheme of squares: the tran-

sept arms are each a little wider than long, and the nave is a little longer than four squares. A few simple measurements, however, explain these discrepancies: lines drawn from center to center of columns and walls do indeed create a pattern of consistently square areas. In other words, Brunelleschi conceived his design mathematically as a set of abstract geometric forms, the larger forms being simple multiples of the standard unit cube. Once we grasp his conception we realize how revolutionary it was, for his clearly defined, separate compartments represent a major change from Gothic thinking.

The view of the interior reinforces the impression given us by the ground plan. Cool, static order has replaced the warmth and the flow of movement we saw in Gothic interiors. San Lorenzo does not sweep us off our feet. It

below left:
169. Filippo Brunelleschi. San Lorenzo. 1421–69. Florence. This church represents the earliest full statement of the architectural aims of the first great genius of the Italian Renaissance.

below right:
170. Filippo Brunelleschi. Plan of San Lorenzo

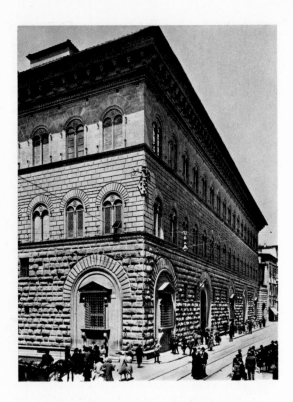

171. Michelozzo. Palazzo Medici-Riccardi, Florence. Begun 1444. Michelozzo has transformed the traditional Florentine fortress-palace according to Brunelleschi's principles. The three stories diminish in height from bottom to top. As they grow smaller they grow smoother: the bottom story is encased by rough stones, the second story by smooth stones grooved at the edges, the top story by unbroken masonry. The large, strongly projecting cornice at the very top was inspired by the entablatures of ancient Roman temples. The ground-floor windows were added much later by Michelangelo.

does not even draw us forward after we have entered. We are content to remain at the door, for we can take in everything from that point, as though seeing a particularly convincing demonstration of scientific perspective (compare figure 164). We may be reminded—and rightly so—of Early Christian basilicas (see figure 86), which to Brunelleschi were examples of classical architecture. They inspired his return to round arches and classical columns in the nave arcade.

Brunelleschi revived the classical orders for more reasons than mere enthusiasm for antiquity. He was drawn by their inherent discipline. Without the aid of a standardized vocabulary and strict rules, he would have had difficulty in defining his spatial shapes so cleanly. He has been able to emphasize the boundaries between these shapes without interrupting their rhythmic sequence. The scheme is carried through to the last detail, down to the stone floor, where the patterning of dark bands and lighter square areas completes the articulation of the interior into self-contained units.

Brunelleschi's death in 1446 brought another "universal man" into the forefront. Leone Battista Alberti was a scholar, poet, playwright, musician, mathematician, philosopher, painter, architect, and man of the world. As a theoretician, he wrote treatises on painting, sculpture, and architecture. At first an amateur artist, later a practicing architect of outstanding ability, he went beyond Brunelleschi in reviving classical antiquity. In his majestic façade for the church of Sant' Andrea, Mantua (figure 172), we see an extremely imaginative combination of a classical pedimented temple front and an arch of triumph. The architect, clearly, had a conception of a "Christian temple"; he was putting ancient Roman clothing on the religion of his own day.

The church behind the façade of Sant' Andrea was not the ideal shape that Alberti had glorified in his treatise on architecture. The plan of a sacred building, he had written, ought to be a circle or a shape derived from a circle—a square, a hexagon, an octagon, and so forth—for the circle is the perfect as well as the most natural figure, and therefore a direct image of Divine Reason. The structure should stand alone, raised above its everyday surroundings. Openings to the outside should be placed high, for only God's sky should be seen through them.

Alberti never received an opportunity to make his dream of the ideal church come true. But after his death, his treatise began to be widely known, and the central-plan church gained acceptance. It reigned supreme in the first quarter of the sixteenth century. Giuliano da Sangallo's church of Santa Maria delle Carceri (figure 173) in the town of Prato was an early and distinguished example of this trend. Essentially it is a cube, broken at the corners to form an equal-armed cross, with a dome above. Windows in the upper stories and the drum of the dome give an outlook on the sky. In all probability, it was no accident that the foundation of this church was laid in 1485, the year in which Alberti's treatise was first printed.

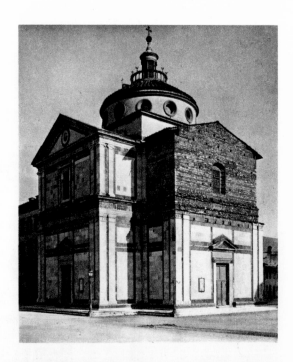

173. Giuliano da Sangallo. Santa Maria delle Carceri. 1485. Prato. Alberti's ideal of the central-plan church gained general acceptance toward the end of the fifteenth century.

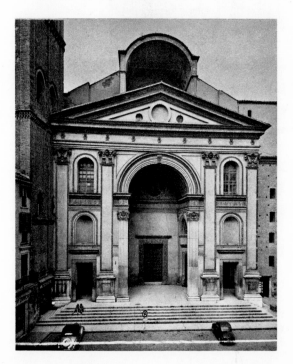

172. Leone Battista Alberti. Sant' Andrea, Mantua. Designed 1470. Earlier in the century, Brunelleschi had used elements of Roman architecture in his own way, without attempting to design buildings that looked Roman. With this façade based on a triumphal arch, Alberti is coming closer to classical models, although he interprets the details very freely.

PAINTING

In the early 1420s, a decade later than in sculpture, the new style sprang up in painting. A twenty-one-year-old genius, Masaccio, created it singlehanded. Only twenty-seven when he died, he left us a mere handful of pictures. But these represent a stupendous achievement.

The fresco of *The Holy Trinity with the Virgin and St. John* (figure 174) shows us that Masaccio was a bolder explorer even than Jan van Eyck. He was trained in the International Style, but we could never tell it from this painting. The massiveness of the figures and the simplicity and bigness of the design show us unmistakably that he was looking back a hundred years to the art of Giotto (see colorplate 19), whom he fully equaled in grandeur. There are major differences, however. Medieval painters had not been con-

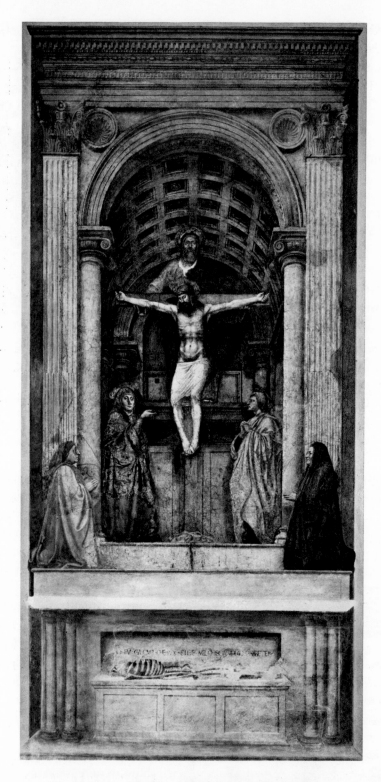

174. Masaccio. *The Holy Trinity with the Virgin and St. John.* 1425. Fresco. Santa Maria Novella, Florence. Note how the artist has adjusted the perspective to a viewer whose eyes are about five feet above the floor of the church.

cerned with the structure of the human body. Giotto's bodies and drapery seem made of the same substance. Masaccio, like Donatello, thought in the Renaissance way: first the bodies, then the clothes. To do this, he had to find out how cloth drapes when a cloak is pulled over the shoulders, bunched over an arm, or let fall to the floor. And—still more difficult—he had to find out how bodies worked. Again, like Donatello, he had to re-learn what the ancients had discovered about the body and the Middle Ages had forgotten. A look at his Christ crucified tells us that he succeeded in this effort. Not only is every bone and muscle in the right place, but all fit to-gether and work together. A late Gothic fig-ure never seems able to do something on its own; an Early Renaissance figure always does, even when standing, or hanging from a cross.

The setting of the *Trinity* shows a complete command of Brunelleschi's classical architec-ture and scientific perspective. This barrel-vaulted chamber is a deep space, and not only a deep space but a space of utter clarity; the rules of perspective have been applied so sys-tematically that we can calculate with great precision the location of every form within the depth of the picture.

Masaccio's untimely death left a gap that took a dozen years to fill. Among his younger contemporaries were painters of ability and charm, but no one whose work rose to any-thing like his level of self-assurance. Then, in 1439, Domenico Veneziano—which is to say, Domenico the Venetian—came to Florence. He became a thoroughgoing Florentine and a very important master of the Early Renais-sance. His *Madonna and Child with Saints* (colorplate 29) shows us that he studied Masaccio's *Trinity* very carefully, for his St. John the Baptist looks at us while pointing to the Madonna and Child, repeating the glance and gesture of Masaccio's Virgin. The saints also turn toward one another, as though in conversation. The figures, thus, are linked

with us and with one another by a thoroughly human awareness. But, even though admitted to their presence, we do not join them; like theatergoers, we are not allowed on stage. For the world to which St. John the Baptist calls our attention, despite its utter clarity of architecture and of the space the architecture defines, is not our earthly world but a place far more elevated and solemn.

Domenico's figures are less massive than Masaccio's; their slim bodies and expressive faces remind us more of Donatello (see figure 161). But in the use of color, he was his own man: this altar is quite as remarkable for its color scheme as for the skill with which the artist has grouped the figures and placed them within their setting. The blond tonality, with its harmonious combination of pink, light green, and white set off by carefully placed spots of red, blue, and yellow, combines the decorative brightness of Gothic panels with the new qualities given by perspective space and natural-looking light. The scene is set in an outdoor loggia flooded with sunlight streaming from the upper right (notice the cast shadow behind the Madonna). The archi-tectural surfaces reflect light so strongly that even the shadowed areas glow with color. The influence of Domenico's remarkable color sense was to be felt in Florentine painting for the next half-century.

Domenico's pupil Piero della Francesca be-came one of the truly great artists of the Early Renaissance. His major work was a series of frescoes telling the legendary history of the True Cross—the cross used for Christ's cruci-fixion. The section seen in figure 175 shows the discovery of the True Cross by St. Helena, mother of Emperor Constantine the Great. On the left, three crosses are dug out of the ground, the True Cross and the crosses of the thieves who died beside Christ. On the right, the True Cross is distinguished from the other two by its power to bring a dead youth back to life. The early morning light enters the

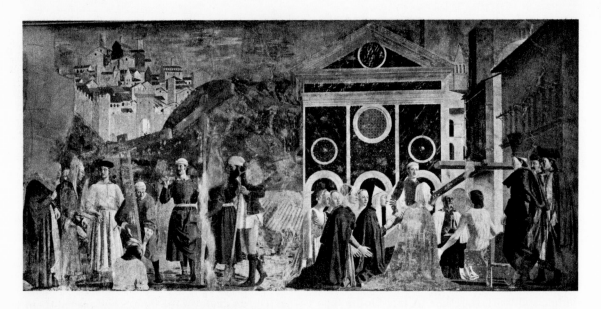

above:

175. Piero della Francesca. *The Discovery and Proving of the True Cross*. About 1455. Fresco. San Francesco, Arezzo. At a time when other Florentine painters were turning toward lightness, movement, and grace, Piero della Francesca pursued Masaccio's aims of deep space, monumentality, and an austere calm.

right:

176. Piero della Francesca. Illustrations from the treatise *De Prospectiva Pingendi* (*Of Perspective in Painting*). About 1480. Biblioteca Palatina, Parma. View of a cube with foreshortened sides and the head of a man seen in profile, from above, and from below.

scene at a low angle, defining every solid shape finely and clearly. Piero's link with Domenico Veneziano is apparent in this dramatic light. But the figures have a harsh grandeur that reminds us much more of Masaccio. These men and women seem to belong to a lost heroic race, beautiful, strong, and silent. What goes on inside them is conveyed by glances and gestures, not by facial expression; in their gravity and poise, they seem the kin of Greek sculptures of the Severe style (see pages 63, 65). How did Piero come to these memorable images?

More than any other artist of his day, Piero believed in scientific perspective as the basis of great painting. He wrote a famous book that demonstrated how the rules of perspective apply to shapes of solid geometry, architectural shapes, and the human form. Figure 176 shows us some illustrations from this book: at the top is a cube with foreshortened surfaces; aligned below are three views of a man's head—from the side, from above, and from below. The last two of these drawings show the odd contours that would be produced if the head were sliced through at various levels; corresponding points in the three views are connected by an array of parallel lines. Piero's geometrical outlook pervaded all his

work. When he drew a head, an arm, or a fold of drapery, he saw it as a combination of sphere, cylinder, cone, cube, and pyramid. He saw the world as a great realm of geometric form; and to explore that realm and reveal its clarity and permanence was a gripping adventure. Piero was the spiritual ancestor of the abstract artists of our time; they, too, systematically simplify natural forms.

Piero della Francesca stayed in Florence no more than a few years. He had to go elsewhere to work and live, for the Florentines of 1450 were beginning to find solidity of form and hushed grandeur rather old-fashioned. Their admiration went out to artists who were moving into the new horizon of grace and action. The earliest representative of this trend was the very gifted painter Andrea del Castagno, whose *David* is illustrated in figure 177. This picture is on a leather shield—a shield used for display, not combat—and tells us that the owner will be as brave as the Biblical hero when he does confront an enemy in battle. David is a slim young athlete, tense and energetic as a coiled spring. As he bestrides the head of the fallen giant, his hair and drapery are blown by the wind, and he flings up his arm in a proud gesture of challenge. Outline, not solid volume, defines the forms of which he is made; and the outlines are nervous and agitated, not smooth and harmonious. The modeling is flatter than Masaccio's or Piero della Francesca's, so that Castagno's forms look as if they were in relief, rather than in the round.

Florentine painting continued with excited movement and rippling outline for the rest of the fifteenth century. At the same time, borrowings from classical antiquity became more frequent and more pronounced. We have already seen this development in sculpture through two works (figures 167 and 168). Both of these had mythological subjects; both were nudes; one was a reworking of a borrowed classical form. We now see it in pic-

177. Andrea del Castagno. *David*. About 1450–57. Leather, height 45½". National Gallery of Art, Washington, D. C. Widener Collection. This lean, energetic young hero has been translated from an ancient statue. Castagno's interest in movement and action marks an important new trend in Early Renaissance painting and sculpture.

torial art, through Pollaiuolo's one surviving engraving, the *Battle of Ten Naked Men* (figure 178). His devotion to the scientific study of anatomy is even plainer here, for the play of muscles is shown as though the ten men had no covering of skin.

During the last quarter of the century, Florentine art and literature tended toward puzzling allegories and myths. These emanated from the circle of intellectuals around Lorenzo the Magnificent, poet, head of the

178. Antonio del Pollaiuolo. *Battle of Ten Naked Men*. About 1465–70. Engraving. The Metroplitan Museum of Art, New York. Joseph Pulitzer Bequest, 1917. The primary purpose of this engraving was to display the artist's mastery of the nude body in action. Pollaiuolo contributed more toward the solution of this problem than anyone else.

Medici family, and—although not in name—ruler of Florence. Pagan mythology and the gods of ancient Greece and Rome loomed large in this group's writings and conversation. The Florentine man in the street suspected the city's ruling circle of a "cult of paganism."

The patricians, poets, scholars, philosophers, and artists who made up the brilliant Medici circle were not pagans, but Christian Neo-Platonists. They did not abandon their religion to study and worship classical antiquity; they made religion broader and more specifically human. The focus of their thought was Man. Man was a little universe in himself, who, through his higher nature—his grasp of art and beauty—could reach to God and God's sublime realm. The basic aim of the Florentine Neo-Platonists was reconciliation of Christianity with the spiritual and cultural values of Greek and Roman art, philosophy, and religion.

The favorite painter of the Medici circle was Sandro Botticelli, whose famous *Birth of Venus* (colorplate 31) was painted around 1480. The time of year in this extraordinary work is spring. The goddess of love, whose pose is taken from a classical statue, rises from the sea. On the left, the West Winds fly toward her. On the right, the season Spring comes forward with a robe to throw about Venus's unclothed body the moment she touches shore.

The Venus here is the "celestial Venus." There is nothing earthly, human, or even material about her—she dwells in the "sphere of Mind." Like the Virgin Mary, she is a source of "divine love," the force in the universe

through which Man becomes linked to God and the sublime. When we are aware of this meaning, we are not astonished that the West Winds are so much like Christian angels. Spring, similarly, performs for Venus the same service that St. John the Baptist traditionally performs for the Saviour in the Baptism of Christ. Just as baptism signifies the rebirth of man, so does the birth of the celestial Venus. The painting, then, is a metaphor, a poetic statement of man's capacity to reach supreme heights. Finding a common denominator of spirituality in pagan myth and Christian religion, it proclaims the oneness of man's higher nature. And it announces that a new springtime has arrived—the "rebirth" from which the Renaissance took its name.

Botticelli's art represents the climax of the style of line and movement. As in Castagno's *David*, hair and drapery are windblown, and the forms are elegant and slim. The figures are not charged with energy, however; they are pale and delicate, wistful and solemn. They seem to float even when they touch the ground. The painting would be less suitable a carrier of its Neo-Platonic message if it were any less refined and ethereal.

A slightly later painting by Piero di Cosimo, *The Discovery of Honey* (colorplate 32), approaches classical mythology from a very different point of view. This picture is down-to-earth, gay, and colorful. Bacchus, looking a little tipsy, stands on the right with his wife Ariadne. Most of the satyrs are gathering about the old willow tree in the center of the picture. They bang pots and pans, for they have discovered a swarm of bees and hope that the noise will make the bees settle on a branch of the tree. The satyrs will then make mead, a kind of sweet beer, from the honey they collect. Piero di Cosimo describes the scene as though the god and his satyrs were simple country folk out for a good time. It would appear that the artist is out for a good time himself and is handling his subject matter

playfully, with a touch of comic irreverence. In actual fact, he has carefully adopted a light approach in order to avoid getting into trouble for what he is saying, for he is putting forward an idea that conflicts with the Biblical account of Creation. These are people—although he has disguised them as satyrs—who lived in mankind's early days, before history began. The discovery of honey must have been of great importance to those simple people, for it was a step toward civilization. So, at least, Piero di Cosimo believed. His idea of the birth of civilization, if less poetic than Botticelli's dream of mankind reborn, was considerably more realistic. His style, too, is more realistic. The fine airy landscape background of this picture would be inconceivable without the

179. Domenico Ghirlandaio. *An Old Man and His Grandson*. About 1480. Tempera on panel, 24½ × 18″. The Louvre, Paris. Ghirlandaio was Michelangelo's teacher in painting. He admired the detailed realism of the Flemish masters, but the human warmth and tenderness of this picture were beyond the reach of any Northern painter then living.

180. Luca Signorelli. *The Damned Cast into Hell*. 1499–1500. Fresco. San Brizio Chapel, Orvieto Cathedral. In this work, one of the crowning achievements of Early Renaissance painting, Signorelli fuses Piero della Francesca's discipline with Pollaiuolo's energy and scientific observation of anatomical structure. In contrast with Late Gothic artists (see colorplate 25 and figure 156), this Renaissance master does not rob the damned of their dignity as human beings. He depicts their fate as a tragedy, not as a horror story.

Flemish influence of *The Portinari Altarpiece* (compare figure 152). The landscape is not merely pleasant to look at, but helps to drive home the lesson of the picture. The rough, barren hill on the right stands for humanity's primitive early days; the little town and stee-

ple on the left tells us of the blessings of civilized living. The entire panel, thus, like Botticelli's *Birth of Venus*, reflects the confident outlook of the Early Renaissance.

So far, we have looked only at Florentine developments in examining Early Renaissance style. There has been justice in this, for Florence was not only the birthplace of the new style, but, throughout the fifteenth century, its greatest center of architecture and sculpture. The first impulse of the Florentine Renaissance, however, had an impact on the cities of Central and Northern Italy, which developed important painting styles of their own. Uccello, Castagno, and, above all, Donatello, carried the new style to Venice and its satellite town of Padua in the second quarter

181. Andrea Mantegna. *St. James Led to His Execution*. About 1455. Fresco. Ovetari Chapel, Church of the Eremitani, Padua (destroyed 1944)

of the fifteenth century. Before 1450, the seventeen-year-old Paduan Andrea Mantegna had emerged as an independent master. He became the most important painter of the Early Renaissance next to Masaccio. His mature style appeared about 1455 in the great fresco series in the Church of the Eremitani, Padua, before he was twenty-five. (They were destroyed by a bomb in one of the most painful cultural losses of World War II.) The *St. James Led to His Execution* (figure 181) was the most dramatic of the series because of its daring "worm's-eye" perspective, which is based on the observer's actual eye level (the principal vanishing point is below the bottom of the picture). The architectural setting thus looms large, as in Masaccio's *Trinity* fresco (see figure 174). Its main feature, a huge arch of triumph, is not a copy of any specific Roman monument, but looks so authentic in every detail that it might just as well be. Mantegna's devotion to the visible remains of antiquity is like an archaeologist's. No Florentine artist could have handed on such an attitude. Its source was the classical scholars of the University of Padua, who were

182. Andrea Mantegna. *St. James Led to His Execution*. About 1455. Pen drawing, 6½ × 9¼". Collection G. M. Gathorne-Hardy, Donnington Priory, Newbury, Berkshire, England

This fresco reveals the artist's tense, expressive style, as well as his passionate interest in Roman monuments. Compare figure 174 for the worm's-eye perspective. The sketch for this painting offers proof that Early Renaissance artists conceived their compositions in terms of nude figures.

just as reverent toward every word in ancient literature. The costumes of the Roman soldiers are also authentic; the artist even reproduces the "wet" drapery patterns originated by Classic Greek sculptors and handed on to the Romans. The tense, firmly constructed figures, however, were clearly inspired by Donatello. The picture tells us that the saint, on his way to martyrdom, blessed a paralytic and commanded him to walk; the bystanders —as we see by their glances and gestures— were so stirred by the miracle that one of them, on the far right, had to be forced back by a Roman guard. The excitement is echoed by the banner above, which curls energetically.

By rare good luck, a sketch for this fresco

has survived (figure 182) to show us how Early Renaissance painters worked out their conceptions. The composition is tentative and unsettled, and the forms are set down in a quick shorthand. The angle of vision, we notice, is almost normal—the dramatic worm's-eye perspective must have been constructed on the wall. The drawing, in addition, proves what we have already surmised—that Early Renaissance artists conceived their compositions in terms of nude figures. The men on the right are in the first, unclothed stage; the body outlines of other figures show through their costumes. But the drawing is much more than a document; it is a remarkable work of art in its own right. Its brief, sketchy strokes invest it with a speed, force, and immediacy necessarily lost in the fresco.

Mantegna's brother-in-law, Giovanni Bellini, was the foremost Early Renaissance painter of the city of Venice itself. His *St. Francis in Ecstasy* (colorplate 33), painted late in life, like all of his best works, is an early masterpiece of landscape painting. The saint has been made so small a detail that he seems incidental—or would seem incidental if his rapture at the view spread out before him did not key our own response to it. Like Giovanni Arnolfini (see colorplate 26), St. Francis has taken off his shoes (we see them in the right-hand corner) because he is standing on holy ground—that is, the ordinary visible world in all its beauty. The wonderfully atmospheric landscape, bathed in the radiance of late-afternoon sunlight, has sweeping breadth and close intimacy at the same time. Above it is a deep blue sky dotted with the softest of white clouds. This scene shows strong influence from the style of the Van Eycks (compare colorplate 25, left). Works of the great Flemish masters surely reached Venice before 1450. Bellini's contours are less crisp than Mantegna's, his colors softer, his light more glowing. He shares the tender regard of the great Flemings for every detail of nature. Unlike the Flemings, however, he locates every form in a clear, mathematically defined space, organizing the rock formations in the foreground according to the rules of scientific perspective.

The High Renaissance in Italy

The great masters of Italy at the dawn of the sixteenth century—Leonardo, Bramante, Michelangelo, Raphael, Giorgione, Titian— ushered the Renaissance into its classic age. To their contemporaries, these artists were a new race of giants with creative powers never known before. As men of genius, they were thought worthy of being called divine, immortal, and creative, for divine inspiration had animated their souls and guided their hands.

The High Renaissance style was, in some ways, the climax of Early Renaissance trends. Basically, however, it was a new departure. The founding fathers of the Early Renaissance had felt that art was governed by rules that had to be obeyed: the numerical ratios of musical harmony, the natural structure of the human body, the principles of scientific perspective. The leading figures of the High Renaissance, armed with faith in the divine origin of their inspiration, accepted such authority when it suited them, but, as need be, did not hesitate to shrug it off. They went where their inspiration took them. Freer aesthetic aims replaced the aim of strictly disciplined order as the High Renaissance sought visual drama and harmonious balance.

It was the briefest of periods and died with the great men who created it. By 1520, all of

183. Leonardo da Vinci. *Adoration of the Magi* (detail). 1481–82. Panel, size of area shown about 24 × 30″. Uffizi Gallery, Florence. These heads and hands are all part of a single pattern of light and shade, and the painting becomes more of a unity than previous examples, in which each form was self-contained and sculptural. This painting is on the threshold of the High Renaissance.

its key monuments had appeared, and four of the six masters we have listed were in the grave. At the same time, the bright image of a new era for mankind was fading. Italy was the cockpit for the armies of other countries as Europe sank into the confusion and bitterness of ferocious and never-ending war among religions, social classes, and nations.

The earliest High Renaissance master was Leonardo da Vinci, who came closer to universal genius than any other man in history. Regarding himself primarily as an artist, he was also a scientist whose studies have illuminated every field from aeronautics to zoology. Art, he thought, was the source of scientific understanding, for artists are the best observers; they grasp the fundamental nature of what they see and reveal their understanding to other men. He believed so strongly in the eye as the perfect instrument for exploring the natural world that seeing and knowing meant the same to him. Scientists today express their ideas, by and large, in words and in mathematical symbols. In Leonardo's day, a good picture was still worth thousands of words. His own drawings, the product of incredible industry, were so clear and full of life that when we look at them in his notebooks, we grasp his ideas even if we cannot read his notes.

Leonardo came from the tiny village of Vinci, near the city of Florence, and received his training from Verrocchio. But he had little

184. Leonardo da Vinci. *The Last Supper*. About 1495–98. Mural. Santa Maria delle Grazie, Milan. This painting has always been recognized as the first complete realization of the classic ideal of the High Renaissance.

interest in the remote and ideal intellectual realm of the Medici circle. In 1482, at the age of thirty, he went to Milan to work for the Duke, primarily as a military engineer, but also as a painter, sculptor, and architect. He left behind him, unfinished, a large altar panel of the *Adoration of the Magi*. A detail is shown in figure 183.

The most striking thing about this panel is the way it is painted, which is unlike anything we have seen. Botticelli's *Birth of Venus*, painted at the same time, had firm outlines bounding every shape. Leonardo's shapes are incomplete; when they are in shadow, the observer fills in the missing parts for himself. This painter does not think in outlines. He thinks of the way three-dimensional bodies intercept the light that falls upon them: the surfaces that catch the light and the surfaces that do not. And he creates a pattern of light and shade that the eye reads as a spatial form. In our example of this new method of model-

ing by light and shade, people and objects are seen all at once and together, not separately and one at a time; they are a pictorial unity. They emerge softly from one over-all realm of shadow, from which none of them is wholly detached. This is a painter's vision, not a sculptor's.

The *Adoration of the Magi*, original though it was, did not part company with the Early Renaissance. Leonardo's *Last Supper* (figure 184), later by at least a dozen years, was the first expression of a new and different style. Unhappily, he experimented with a new painting technique, for he was dissatisfied with the limitations of the traditional fresco method; the paint has not adhered to the wall properly. Enough of it remains, nonetheless, to let us imagine its original splendor.

Our first impression of this painting is utter balance and stability. Later we discover that the balance has been accomplished by an equilibrium of various demands upon our eyes. A comparison with Mantegna's *St. James Led to His Execution* (figure 181) may be instructive. The architecture painted by the Early Renaissance master struggles with the figures for our attention; Leonardo's does not. Mantegna conceived the architectural com-

position and the figure composition independently and then assembled them together. Leonardo, on the other hand, began with the figure composition and, from the start, kept the architecture in a supporting role. As design, the architecture could not be simpler and barer; it is hardly more than suggested. The vanishing point of the fast-converging perspective comes squarely between Christ's eyes, so that the whole space seems to radiate from his face. The one curved architectural shape, the pediment just above his head, does for a halo. The architecture, thus, is symbolic, and we see its perspective framework entirely in relation to the figures. This relationship is vital—how vital can be demonstrated by covering the top third of the picture. The composition then takes on the character of a frieze; the grouping of the disciples becomes less clear; and Christ's calm, triangular shape becomes a passive, geometric form rather than a dynamic focus of the action and emotion.

Christ, presumably, has just spoken the electrifying words, "One of you shall betray me," and the disciples are asking, "Lord, is it I?" Notice now that the disciples are all on the far side of the table, and that Leonardo has crowded them left and right into a space not big enough for all of them. No Early Renaissance painter would have done this. But Leonardo wanted to create dense, compact, impressive masses. He has made the painting spiritually compact also, presenting many levels of meaning at once. Christ, in spreading his hands and bowing his head, is making a

185. Peter Paul Rubens. *Drawing after Leonardo's cartoon for "The Battle of Anghiari."* About 1605. Chalk with pen and ink, 17¾ × 25¼". The Louvre, Paris. These horsemen fighting for the battle standard were the center of Leonardo's composition. The action is violent, yet Leonardo maintains harmony of form: the exploding energy of the figures remains firmly within the outline of the design. The fury of the men has also seized the animals, who are attacking each other.

186. Leonardo da Vinci. *Mona Lisa*. About 1503–5. Oil on panel, 30¼ × 21″. The Louvre, Paris. This painting has excited the imagination of countless beholders for almost five centuries.

gesture of submission to the Divine will and, in addition, is offering himself to the disciples —his main act at the Last Supper was to institute the Eucharist ("Jesus took bread . . . and gave it to the disciples, and said, Take and eat; this is my body. And he took the cup . . . saying, Drink ye all of it; for this is my blood . . ."). The disciples not only react to the words, but each reveals his own personality and his own relationship with the Saviour. Judas' dark, defiant profile sets him apart from all the others.

The highest and most difficult aim of painting, Leonardo wrote in one of his notebooks, was to depict "the intentions of man's soul." By this he meant not only men's temporary emotional states, but human psychology, individual and collective. Sketches (figure 185) for a big battle picture commissioned by the Republic of Florence four years after his return in 1503 reveal "the intention of man's soul" even more plainly than *The Last Supper*. The facial expressions of horses—as well as of men—are studied here. Leonardo was concerned with showing the savage fury that seizes men in battle as transmitted to their animals as well.

Leonardo never finished his battle scene, but during those same years in Florence he did his most famous painting, the *Mona Lisa* (figure 186). If we compare this with an earlier portrait (see figure 179), we see that Leonardo's sitter seems more rounded and complete than Ghirlandaio's. The elements of the painting—the three-quarter figure, the low wall behind her, and the distant landscape —are no longer independent from one another; as in *The Last Supper*, we are shown a unity higher than a combination of parts, the unity that we have already called balanced

harmony. Here Leonardo has not only composed the picture with an eye to harmony, but has also painted it as though everything were seen through a slight haze that swallows up small details, softens outlines, and blends the shapes and colors together. In this way, he leaves much to our imagination—and that is why the *Mona Lisa* seems so wonderfully alive. This is true both of the landscape, where the earth seems to grow out of the rocks and the water, and of the face, with its haunting smile. What is Donna Lisa thinking about? That depends on what we are thinking about when we look at her. Her features are too individual for Leonardo to have depicted an ideal type, but there is so much idealization that her character has not been set down once and for all. She embodies maternal tenderness, which to Leonardo was the essence of womanhood.

Michelangelo was Leonardo's opposite in many ways. He, too, was extremely versatile —sculptor, architect, poet, painter—but he took no interest in science. Leonardo could compare a man's face with a horse's or a lion's because human beings to him were a part of nature, but to Michelangelo, who was steeped in the Neo-Platonism of the Medici circle, man was unique and godlike. The artist was not a calmly observing scientist but a creator under whose hands dead material miraculously came to life. To accomplish this miracle, he needed more than a brilliant mind. He had to be inspired, with an inspiration that could come only from God—his competitor, in a sense. Michelangelo accepted the idea of his own genius, although it seemed to him sometimes a curse rather than a blessing. But he could acknowledge no higher authority, and believed profoundly in the rightness of every work that came from his hands. His forceful personality, always torn between hope and despair, filled the people around him with such awe that they were genuinely convinced that he was superhuman.

Unlike Leonardo, for whom painting was

the noblest of the arts because it embraced every visible aspect of the world, Michelangelo was a sculptor to the core. Painting, he believed, should imitate sculpture in the roundness of its forms, and architecture had to have the organic qualities of a human body.

Michelangelo eloquently described his process of creation as "liberating the figure from the marble that imprisons it." He tried to visualize his figure-to-be in the rough block that came from the quarry—we know that he liked to go to the marble quarry and pick out his stones on the spot. It seems reasonable to imagine that he did not envisage the figure-to-be too clearly. But it is not too much to assume that he could see isolated signs of life (to him, art was "the making of men"), a knee or an elbow that seemed to press against the surface. In order to get a firmer hold on this fluid, dimly perceived image, he was in the habit of making drawing after drawing—and sometimes small models in wax or clay—be-

left:
187. Michelangelo. *David*. 1501–4. Marble, height 18′. Academy, Florence. This huge statue by a twenty-six-year-old genius is the earliest statement of the heroic ideal of the High Renaissance in sculpture.

below:
188. Michelangelo. *Moses*. About 1513–15. Marble, height 8′ 4″. San Pietro in Vincoli, Rome. This superhuman figure was carved for the tomb of Julius II, which would have been Michelangelo's greatest masterpiece if it had been carried out as planned.

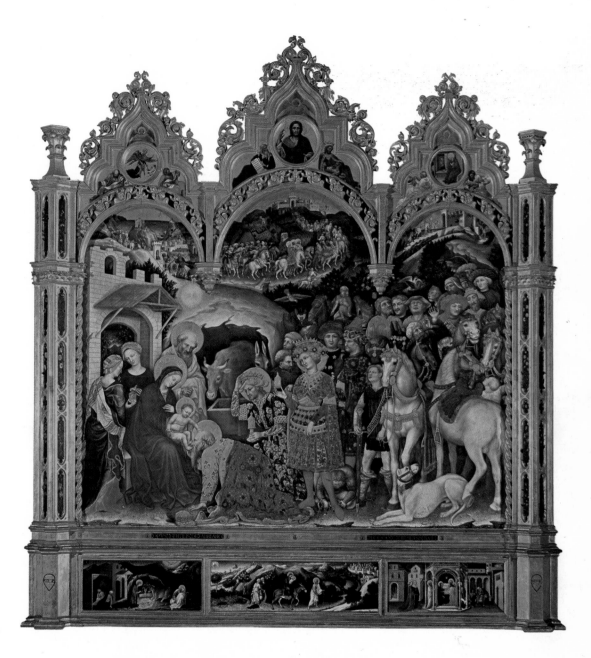

Colorplate 23. Gentile da Fabriano. *The Adoration of the Magi.* 1423. Tempera on panel, 9′ 10⅛″ × 9′ 3″. Uffizi Gallery, Florence

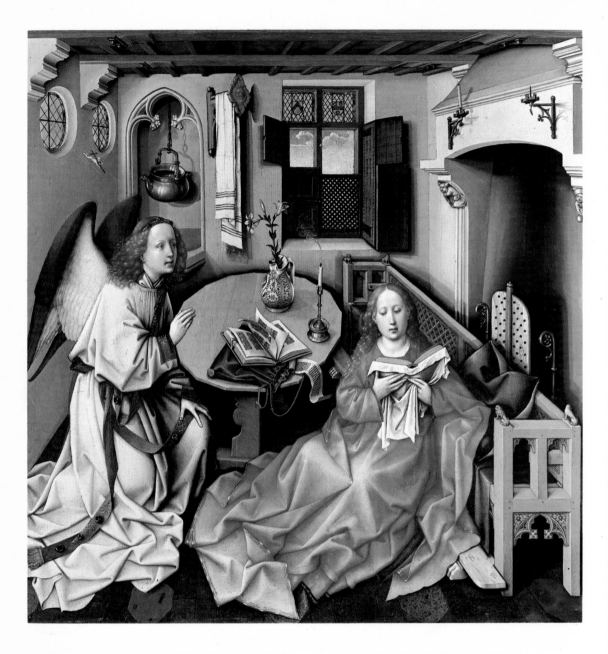

Colorplate 24. The Master of Flémalle. *Annunciation*, center panel of the *Merode Altarpiece*. About
1425–28. Oil on panel, 25¼ × 24⅞″. The Metropolitan Museum of Art, New York.
The Cloisters Collection, Purchase

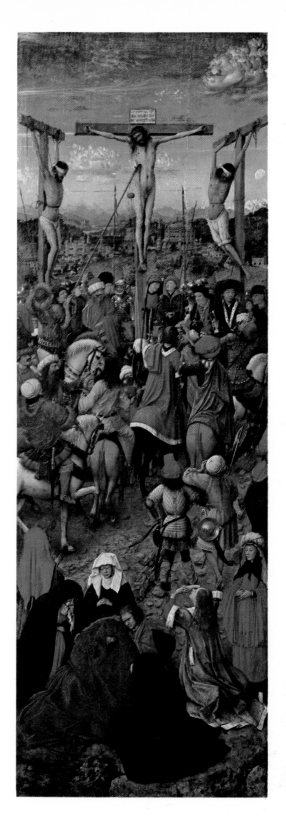
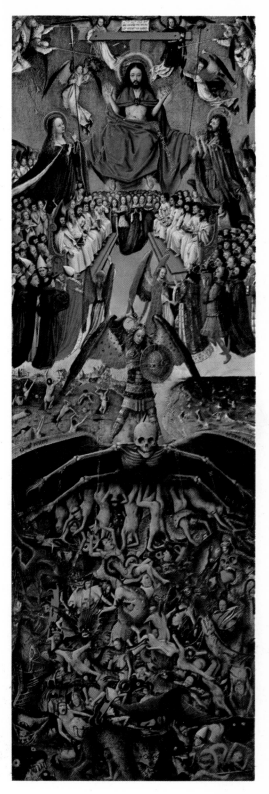

Colorplate 25. Hubert and Jan van Eyck. *Crucifixion; The Last Judgment*. About 1420–25.
Tempera and oil on canvas transferred from panel, each panel 22¼ × 7¾″. The
Metropolitan Museum of Art, New York. Fletcher Fund, 1933

Colorplate 26. Jan van Eyck. *Giovanni Arnolfini and His Bride*. 1434. Oil on panel, $33 \times 22\frac{1}{2}''$.
The National Gallery, London (see also figure 150)

Colorplate 27. Roger van der Weyden. *The Descent from the Cross*. About 1435. Oil on panel, 7'2⅝" × 8' 7⅛". The Prado, Madrid

Colorplate 28. Hieronymus Bosch. Center panel of *The Garden of Delights* (see figure 155)

Colorplate 29. Domenico Veneziano. *Madonna and Child with Saints*. About 1445. Tempera on
panel, 6′ 7½″ × 6′ 11⅞″. Uffizi Gallery, Florence

Colorplate 30. Paolo Uccello. *The Battle of San Romano*. About 1455. Tempera on panel, 6′ ×
10′ 5¾″. The National Gallery, London (Reproduced by courtesy of the Trustees).
This panel is one of a set commemorating a victory won by the Florentines in 1432.
Uccello shared Piero della Francesca's passion for scientific perspective, and has even
simplified the background hills into basic geometric shapes. The ground is covered
with a display of perspective studies—weapons, pieces of armor, a fallen soldier.
Uccello's single-minded enthusiasm for the mathematics of describing objects in
space gives his work a strangely frozen quality.

Colorplate 31. Sandro Botticelli. *The Birth of Venus*. About 1480. Tempera on canvas, 5′ 8⅞″ × 9′ 1⅞″.
Uffizi Gallery, Florence

Colorplate 32. Piero di Cosimo. *The Discovery of Honey*. About 1498. Oil on panel, 31¼ × 50⅝″.
Worcester Art Museum, Massachusetts

Colorplate 33. Giovanni Bellini. *St. Francis in Ecstasy*. About 1485. Oil on panel, 48½ × 55″.
The Frick Collection, New York (Copyright)

Colorplate 34. Raphael. *Pope Leo with His Nephews Cardinal Giulio de' Medici and Luigi de' Rossi.*
About 1518. Oil on panel, 60⅝ × 46⅞″. Uffizi Gallery, Florence

Colorplate 35. Giorgione. *The Tempest*. About 1505. Oil on canvas, 31¼ × 28¾". Academy, Venice

Colorplate 36. Titian. *Bacchanal*. About 1518. Oil on canvas, 5′ 8⅞″ × 6′ 4″. The Prado, Madrid

Colorplate 37. Rosso Fiorentino. *The Descent from the Cross*. 1521. Oil on panel, 11′ × 6′ 5″.
Pinacoteca, Volterra, Italy

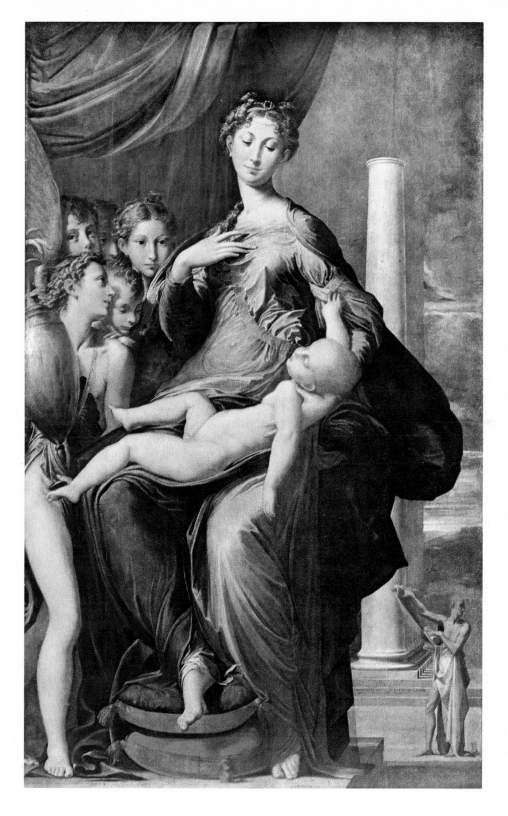

Colorplate 38. Parmigianino. *The Madonna with the Long Neck*. About 1535. Oil on panel,
7′1″ × 4′ 4″. Uffizi Gallery, Florence

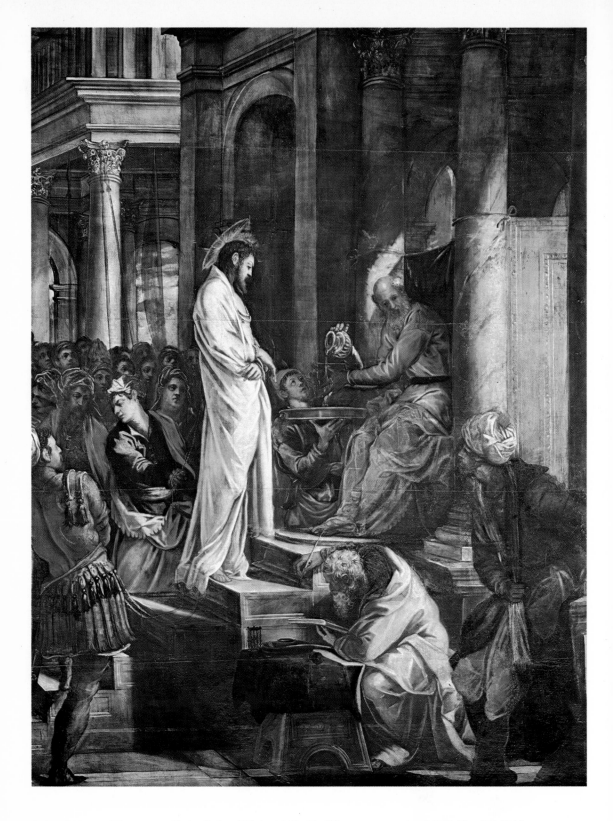

Colorplate 39. Tintoretto. *Christ Before Pilate*. 1566–67. Oil on canvas, about 18′ 1″ × 13′ 3½″.
Scuolo di San Rocco, Venice

fore his final assault on the marble prison. Once he started to carve, every chisel stroke committed him more and more to a specific conception of the figure imprisoned in the block; the marble permitted him to liberate the figure only if he had foreseen its shape correctly. Sometimes he had not; the stone then refused to give up some essential part of its prisoner, and Michelangelo, defeated, left the work unfinished.

In the same way that Michelangelo thought of his marble as the prison of his statues, he thought of the body of flesh and blood as the prison of the soul—the noblest of prisons, but a prison nevertheless. This Neo-Platonic idea is mirrored in his statues. Outwardly calm, smooth, and unbroken in contour, they seem like pressure vessels holding back tremendous force; the spirit inside the body struggles in vain to be released.

These qualities are fully present in the earliest monumental statue of the High Renaissance, Michelangelo's *David* (figure 187) commissioned in 1501, when the artist was twenty-six years old. Three times lifesize, the huge figure was intended for a place on the exterior of the Cathedral, high above the ground. The city fathers put it in front of the city hall instead. We can easily see why. David seems less a victorious hero—Goliath's head has been omitted—than the champion of a just cause, like Donatello's *St. George* (see figure 160). David's nudity links him to Donatello's bronze *David* as well (see figure 162). The style, however, is quite different. Michelangelo had just spent several years in Rome, where the emotion-charged, muscular bodies of Hellenistic sculpture had made a deep impression on him (compare figure 67). Their heroic scale, their superhuman beauty and power, and the swelling volume of their powerful forms became second nature to Michelangelo, and through him were given to Renaissance art in general. Yet the *David* could never be taken for an ancient statue.

The *David's* combination of outer calm and inner tension persists in the majestic *Moses* (figure 188) of a decade later. This statue was part of the vast program for the tomb of Pope Julius II, which would have been Michelangelo's greatest achievement had it been carried out as planned. Meant to be seen from below, the *Moses* has the force to which Michelangelo's contemporaries attached the name *terribilità*—in English, "awesomeness." The Pope interrupted Michelangelo's labors on the tomb at an early stage, half-forcing, half-cajoling the reluctant artist to fresco the ceiling of the Sistine Chapel instead (figure 189).

Michelangelo completed the entire ceiling in four years, 1508–12, producing a masterpiece of epochal importance. A detailed survey of the Sistine Ceiling would fill this whole book. Here we shall look at the scene that stirred Michelangelo's imagination most deeply: *The Creation of Adam* (figure 190). The artist shows us not the molding of Adam's body but the kindling of the Divine spark—the soul—which passes from God's fingertip to Adam's. The figure of God rushing through the sky is creative energy itself; Adam is almost part of the earth from which he was made. No other artist has ever equaled this vision of God and man. The drama grows when we realize that Adam strains not only toward his Creator but toward Eve, whom he sees, as yet unborn, in the shelter of the Lord's left arm.

When Michelangelo returned to the Sistine Chapel in 1534, over twenty years later, Germany was in religious revolt, and Rome, caught between the warring French and Spanish, had been brutally sacked; all Europe was in chaos. And we turn from the radiant vitality of Michelangelo's ceiling fresco to the somber vision of *The Last Judgment* on the end wall. A detail is shown in figure 191. The blessed and the damned alike huddle in tight clumps, pleading for mercy before a

above:

189. Interior of the Sistine Chapel showing Michelangelo's ceiling fresco and *Last Judgment*. The Vatican, Rome

at top right:

190. Michelangelo. *The Creation of Adam*, detail of the Sistine Ceiling. 1508–12

at bottom right:

191. Michelangelo. *The Last Judgment*, detail, with self-portrait. 1534–41

The drama of the *Creation* becomes even greater when we realize that Adam is straining not only toward his Creator but also toward the unborn Eve, who glances at him from the shelter of God's arm. A quarter-century and the crisis of the Reformation separate *The Last Judgment* from the paintings on the ceiling. The somber mood of the later painting is explained by the artist's advanced age and the general change in spiritual climate at least as much as by the difference in subject matter. Michelangelo had been greatly impressed by Signorelli's Last Judgment fresco (see figure 180).

192. Donato Bramante. The Tempietto. 1502. San Pietro in Montorio, Rome. This chapel is the first architectural monument of the High Renaissance. In its three-step platform and the pure, severe detail of its Doric colonnade, it recalls the classical temple with great directness.

masonry; these cavities are in rhythmic balance with the strongly projecting moldings and the hemisphere of the dome. The Tempietto, in consequence, has a solemn grandeur astonishing in a building so small.

The Tempietto was the earliest of the masterpieces that made Rome the capital of art as well as of religion in the first quarter of the sixteenth century. Most were ordered by Julius II, a man of limitless energy and ambition who wanted to unite all Italy under papal rule. He chose Bramante to carry out his plan of replacing Old St. Peter's by a church so magnificent that it would surpass the most famous structures of Roman antiquity. Bramante's design was indeed imperial in grandeur—as we see from the medal commemorating the start of construction (figure 193)—nine times the area of the Pantheon, a

wrathful God. Seated on a cloud just below the Lord is St. Bartholomew, holding a human skin to represent his martyrdom. The face on the skin is not the saint's, however, but Michelangelo's own.

Donato Bramante became the creator of High Renaissance architecture late in life. The style is fully formed in his sober and refined Tempietto (figure 192), built in Rome a little after 1500. This circular chapel originally was to be ringed by a colonnaded court replacing the court we see here. The three-step platform and severe Doric colonnade of the Tempietto recall classical architecture with great directness. The very sculptural treatment of the drum is equally striking. There, deep niches are scooped out of heavy

193. Caradosso. Medal with Bramante's design for St. Peter's. 1506. British Museum, London. This medal shows—even though roughly—how the front of St. Peter's would have looked if it had been carried out according to Bramante's great design. "I shall place the Pantheon on top of the Basilica of Constantine," the architect is reported to have said.

The High Renaissance in Italy 201

194. Michelangelo. View of St. Peter's, in Rome from the rear. 1546-64. Michelangelo simplified Bramante's plan for St. Peter's and introduced changes that gave the building a strong east-west axis even though the interior retained a central plan. He also re-designed the dome.

below:

195. Michelangelo. Plan for St. Peter's. Bramante had planned a hemi-spherical dome on a low drum. Michelangelo de-signed a high dome on a tall drum, continuing the upward impulse of the colossal order below.

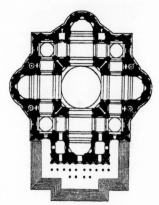

great central-plan church crowned by a hemi-spherical dome on a colonnaded drum, and with tall towers filling in the corners of the arms. Its forms, like the Tempietto's, were severely classical. Every demand laid down by Alberti for sacred architecture was fulfilled (see page 164)

Bramante died before very much of his de-sign was built. Other architects took his place during the next two centuries, and the building we know today is the work of a number of men over a long period of time. The biggest con-tribution was made by Michelangelo, who took over in 1546. His plan for St. Peter's

(figure 195) was central, as Bramante's had been, but he squared off the entrance front and placed a portico before it. In this way, the main axis was accented as strongly as in the traditional basilican plan. Michelangelo's en-trance front was never carried out. He built the rear part of St. Peter's, however; and the dome, which was finished after his death, follows his ideas in every important respect. Our exterior view (figure 194) shows Mi-chelangelo as an originator of architectural form. The exterior wall is strongly sculptural and features a colossal order—an order that rises through two or more stories, as in

Alberti's façade for Sant' Andrea (figure 172)
—thrusting upward toward the dome. The
dome is the dominant feature of the whole
structure. Like Brunelleschi's dome—which
Michelangelo revered—it is a high double
shell on a tall drum. The heavy lantern at the
top, the boldly projecting ribs of the cupola,
the paired columns of the drum, and the deep-
cut openings form a sculptural shape that
continues the upward impulse of the colossal
order below. Almost every important dome
thereafter, down to the beginning of our own
century, was influenced by this design.

If Michelangelo was the prime example of
the artist as solitary genius, Raphael was just
as surely the prime example of the artist as
man of the world. Acclaimed the prince of
painters, he lived like a prince and painted in
a courtly, formal style. He was less of an
innovator than Leonardo, Bramante, or Mi-
chelangelo. But he was the central painter of
the High Renaissance, and our conception of
the High Renaissance and its "grand manner"
rests more on Raphael's work than on any
other master's. Combining qualities of Leo-
nardo and Michelangelo with his own un-
rivaled grace and compositional skill, he
created an art that was lyrical and dramatic,
pictorially rich and sculpturally solid.

In 1504, after completing his apprentice-
ship in his native Central Italy, Raphael went
to Florence. He stayed there four years. One
of his Florentine works is the lovely *Madonna
del Granduca* (figure 196). The Virgin, grave
and tender, reminds us of the *Mona Lisa* in
her soft modeling and calm beauty, although
she has none of the mystery that makes
Leonardo so hard to understand.

Michelangelo's influence on Raphael came
later. At the time Michelangelo began to
paint the Sistine Ceiling, Julius II summoned
the younger artist to Rome to fresco a series
of rooms in the Vatican Palace. The most
famous of these murals is *The School of Athens*
(figure 197), long acknowledged as Raphael's

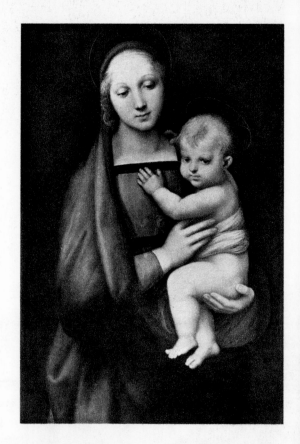

196. Raphael. *Madonna del Granduca*. About 1505.
Tempera on panel, 33 × 21½″. Pitti Palace,
Florence. In his first works in Florence, Raphael
absorbed the soft modeling and calm beauty
of Leonardo's recently completed *Mona Lisa*.

masterpiece and the perfect embodiment of
the classic spirit of the High Renaissance. Its
subject is the group of Greek philosophers
surrounding Plato and Aristotle. Raphael is
clearly indebted to Michelangelo for the ex-
pressive energy, physical power, and dramatic
grouping of these figures. He has not simply
borrowed Michelangelo's gestures and poses,
however; he has absorbed them into his own
style and thereby given them a different
meaning. We see a harmonious balance of
body and spirit, of action and emotion. Every
member of the great assembly plays his role
with magnificent, purposeful clarity. And al-
though the figure style owes so much to
Michelangelo, the total conception of this

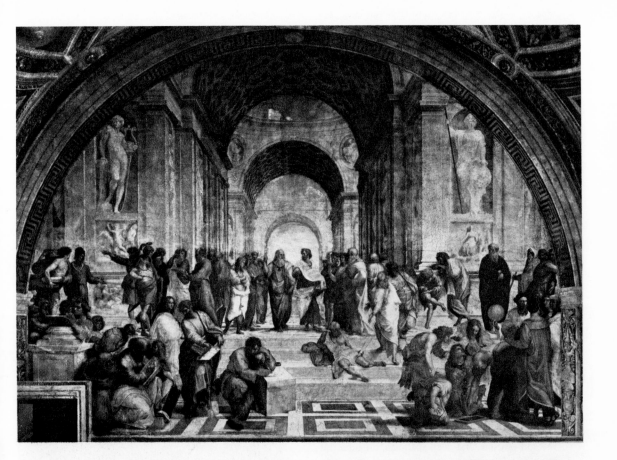

painting is closer in spirit to Leonardo's *Last Supper* than to the Sistine Ceiling. This is true of the way Raphael makes each philosopher reveal "the intention of his soul," and the way he sets apart individuals and masses groups, linking all together in an almost musical rhythm. The symmetrical design and symbolic use of architectural perspective—the vanishing point is between the heads of Plato and Aristotle, which are framed by a halo-arch—also remind us of Leonardo. Compared with the hall of the *Last Supper*, however, Raphael's structure—its lofty dome, barrel vault, colossal statues—has more importance in itself. Inspired by Bramante, it seems a preview of the new St. Peter's. Its geometric precision and spatial grandeur bring to a climax the tradition we have seen begun by Masaccio (see figure 174) and continued by Domenico Veneziano and Mantegna.

Raphael had a special talent for portraiture, successfully combining the realism of fifteenth-century portraits with the human ideal of the High Renaissance (which in the *Mona Lisa*

197. Raphael. *The School of Athens*. 1510–11. Fresco. Stanza della Segnatura, Vatican Palace, Rome. This fresco was painted on a wall of Pope Julius II's library. It shows a great assembly of Greek philosophers, each of them in a characteristic pose or activity, with Plato and Aristotle at left and right in the center. Raphael conveys the harmony of the classical world of ideas through the lofty architecture as well as through the lively yet highly disciplined grouping of figures.

almost dissolves the sitter's individuality). Surely, Pope Leo X (colorplate 34) is shown as no handsomer than he was in reality: his sullen, heavy-jowled features are recorded in almost Flemish detail. But the commanding presence and air of dignity and power come more from the man himself than from his exalted office. Raphael, we feel, has not falsified the sitter's personality but focused it, revealing Leo X in his finest hour. The two cardinals, who have been studied with as much care but not given the same balanced strength, heighten the majesty of the central figure

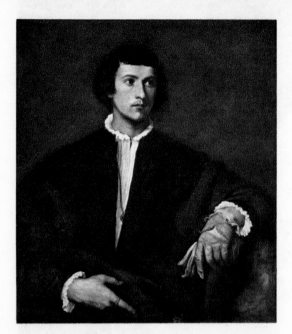

198. Titian. *The Man with the Glove*. About 1520. Oil on canvas, 39½ × 35″. The Louvre, Paris. The intimacy and dreaminess of this portrait, the soft outlines and deep shadows, all echo the style of Giorgione, who so influenced Titian's early work that for a time the two painters are often hard to tell apart.

through their less forceful personalities. Pictorially, too, Leo X is set off from his companions by more emphatic lighting, color, and texture.

After the terrible sack of Rome in 1527, the center of art shifted for a time to the rich seafaring and trading city of Venice, where a great new school of painting had been building on the foundation laid by Giovanni Bellini (see page 174). The first master of the Venetian High Renaissance was Giorgione, who died in 1510 while still in his early thirties. Yet he is ranked among the greatest painters in history. In the handful of works in his mature style we find, for the first time, all the qualities that made sixteenth-century Venice an artistic world very different from Florence and Rome—a world built out of light and color, close to nature, dreamily poetic, and appealing to our senses with the greatest directness.

The Tempest (colorplate 35), a picture almost magic in its charm, is so called because a flash of lightning streaks across a dark sky— this is the only action there is. Who are the people? A young soldier and a nude young mother and child—so much is obvious—but beyond this we just do not know. But our not knowing the story does not seem to make a great deal of difference to us. The charm of the picture, we feel, is in its mood, not in its action. Giorgione has created a piece of visual music—tranquil, melancholy, and intimate. Mood was more important to him than anything else; through his mastery of mood he created an ideal world, much as Michelangelo and Raphael had created an ideal world through mastery of form.

Giorgione's new way of painting was explored further by his friend and associate Titian, who outlived him by nearly seventy years and became the most brilliant and famous of all Venetian artists. Titian's *Bacchanal* of about 1518 (colorplate 36) is frankly pagan. The landscape background, with bluish distant hills and cloud-filled blue sky bathed in golden light, has all of Giorgione's poetry. The figures, however, are another breed. Active and muscular, impulsive yet controlled in their movements, they recall the figures of the High Renaissance in Rome. But they seem to be alive and breathing, to be made of flesh, to have a heartbeat—their heroic models, by comparison, were animated statues. Titian looked upon the realm of classical myths as belonging to nature. His forms, if not quite everyday reality, are idealized only to the point of persuading us that they belong to a lost golden age.

After Raphael's death, Titian became the most sought-after portrait painter in all Europe. We can see why in *The Man with the Glove* (figure 198). With quick, feathery strokes of the brush, the artist makes skin, cloth, and leather seem richer and more precious to us than they would ever be in real life.

199. Titian. *Christ Crowned with Thorns*. About 1570. Oil on canvas, 9′ 2″ × 6′. Pinakothek, Munich. Titian, during the final phase of his career, began to paint in an amazingly free and personal way, with broad, quick strokes of the brush. In this picture his style is carried to its furthest limits: there are no longer any solid, light-reflecting surfaces; the forms emerging from the darkness seem to glow from within.

The highlights are creamy; the darks are deep and clear. Touched with melancholy, intimate and dreamy, the picture recalls the poetic appeal of Giorgione's *Tempest*.

The new broad manner of *The Man with the Glove* is pushed to its limits in the *Christ Crowned with Thorns* (figure 199), a masterpiece of Titian's old age. Although paint has been brushed thickly and freely on the canvas, the surfaces do not seem in the least opaque. Glowing and shimmering, they have become a jewel-like translucent substance. Solid form has been dissolved in a symphonic harmony of light and color. Titian was the first painter to see the world as all light and color, the first to speak to the onlooker through an immediate impact upon the senses. This vision proved unquenchable. Passed on, developed, and transformed by many generations of artists, it became the backbone of modern painting.

Mannerism and Other Trends

The spiritual crisis of the sixteenth century had a deeply unsettling effect on Italian art. The younger artists rejected the harmonious balance of the High Renaissance, striking out along widely separated new paths.

The first signs of disquiet appeared around 1520 among young Florentines oppressed by a sense of doom. The High Renaissance faith in humanity's almost divine power had no meaning for them. Men, they felt, were in the grip of ominous forces too big for them to control. These young artists turned their backs on nature and the ancients, looking inside their own minds for dreams and visions.

They began to show the human figure in strange new ways. They twisted it into unnatural poses and pulled it out to unnatural height. In later centuries, disapproving critics labeled this restless new phase of Italian art Mannerism; it has remained for our twentieth century to rehabilitate the Mannerists and recognize them as serious and important artists. The willful, anticlassical art that followed on the heels of the High Renaissance has a special fascination for us today. Our time is also a time of anxiety; and we, too, have ceased to believe in fixed ideals in art.

Rosso Fiorentino, the earliest and most ec-

centric of the group, expressed the new attitude in his *Descent from the Cross* (colorplate 37). Nothing in past art prepares us for the shock of this latticework of spidery forms spread out against a dark sky. The angular figures, the forlorn gestures and expressions, the weird, unreal light—all these give the picture an eerie aspect that is not soon forgotten. The people whom we see do not perform actions; they are acted upon. Their bodies and their very garments have turned brittle.

200. Pontormo. *Study of a Young Girl.* About 1526. Red chalk drawing. Uffizi Gallery, Florence. Pontormo had a strange personality. Inward-looking and shy, he shut himself up in his quarters for weeks on end. The fragile, withdrawn look of the girl who sat for this sensitive portrait hints at the artist's own inner anxiety.

201. Agnolo Bronzino. *Eleanora of Toledo and Her Son Giovanni de' Medici.* About 1550. Oil on canvas, 45¼ × 37¾". Uffizi Gallery, Florence. This coldly elegant portrait shows the wife of Duke Cosimo I of Tuscany as completely unapproachable.

The most astonishing thing about Rosso's *Descent from the Cross*, perhaps, is the early date of its show of desolation and despair. In 1521, the great storms of the sixteenth century were gathering but had not yet released their fury; that was to happen a year or two later. Rosso Fiorentino and the men and women with whom he peopled his pictures felt the chill, it would seem, before the icy blasts swept Europe from one end to the other. Artists are remarkably sensitive to their surroundings. They often express what we all think and feel before we are aware of it.

Parmigianino's *Self-Portrait* (figure 202), painted a few years later, is not a nightmare image but an exploration of a corner of reality. All the same, it, too, represents a deliberate retreat from the stable, confident world of the High Renaissance. It shows this North Italian artist exactly as he saw himself in a round, convex mirror, his head perfectly normal, but his hand monstrously large, and the walls and

ceiling of the room bent into curves; Parmigianino even used a specially prepared convex panel. Why was he so fascinated with a view "through the looking glass"? Was he trying to say that there is no single, "correct" reality? That distortion is as real and as natural as "normal" appearances? Apparently he was, for what looks like scientific detachment here soon changed into what is obviously something else. *The Madonna with the Long Neck* (colorplate 38) is an image from Parmigianino's private world. The figures, with their ivory-smooth, unnaturally long limbs and bodies, represent an ideal of beauty as remote from nature as any Byzantine saint. The setting, too, is dreamlike: a row of gigantic columns, apparently without reason or purpose, soars above the tiny figure of a prophet. Parmigianino wants to prevent us from finding this scene in any way familiar and ordinary. He has given us a vision of unearthly perfection, a cold elegance as gripping as Rosso's nightmare world.

202. Parmigianino. *Self-Portrait*. 1524. Oil on panel, diameter 9⅝″. Kunsthistorisches Museum, Vienna. The anticlassical spirit of Mannerism is revealed in the artist's too complete acceptance of the distorted image he sees in the mirror. Before this work, only Northern art had produced such a "duplicate" of reality. Compare figure 150.

The elegant phase of Italian Mannerism appealed to such sophisticated art patrons as the Grand Duke of Tuscany and the King of France. It became the first international art style since the International Gothic (see page 129). Splendid portraits were produced, like Agnolo Bronzino's *Eleanora of Toledo* (figure 119). Here the sitter is revealed as a member of an exalted social caste, not as an individual personality. Congealed into immobility behind the barrier of her lavishly ornate costume, she seems more like Parmigianino's *Madonna* —compare the hands—than like ordinary flesh and blood.

Mannerism was late in making its appearance in Venice, but by the middle of the century was firmly established in the work of Tintoretto, the most important Venetian master after Titian. An artist of tremendous inventiveness and energy, Tintoretto brought the anticlassical and elegant phases of Mannerism together in one style. He wanted to "paint like Titian and design like Michelangelo," we are told. His huge canvas of *Christ Before Pilate* (colorplate 39) shows what he owed to Titian: bold brushwork, glowing colors, and electrifying lights and shadows (compare figure 199). But Tintoretto's picture is unmistakably Mannerist in its flickering, unreal light and the ghostly form of Christ, pencil-slim and motionless among the other figures, whose gestures are feverish and whose twisting poses recall the figures of Michelangelo (see figure 191).

Tintoretto's style of painting was in keeping with the new trend in the Catholic Church, which, in defense against the Reformation, had begun to stress the mystical and supernatural elements in religious experience. This Counter Reformation was at its strongest in Spain, where we find the last and most striking of the Mannerist painters. He is known today as El Greco, "the Greek," since he came from the island of Crete. Crete was a Venetian possession, and El Greco's painting style was

left:
203. Correggio. *The Assumption of the Virgin* (detail). About 1525. Fresco. Dome, Parma Cathedral. These ecstatic angels no longer belong to the High Renaissance, although Correggio's figure style may remind us of Leonardo, Michelangelo, and Raphael. Correggio's interest in perspective illusion comes from Mantegna, whose pupil he had been. Here he opens up the whole curved surface and transforms it into a vision of Heaven, peopled with figures freely soaring in space.

below:
204. Correggio. *Jupiter and Io*. About 1532. Oil on canvas, $64\frac{1}{2} \times 27\frac{3}{4}''$. Kunsthistorisches Museum, Vienna. For Correggio, there was little difference between spiritual and physical ecstasy, for this swooning maiden is a close kin of the angels in the *Assumption*.

formed in Venice under the influence of Tintoretto and other masters. He went to Spain as a mature artist and settled in Toledo, where he painted the enormous canvas of *The Burial of Count Orgaz* (colorplate 40) in 1586. The Count, a man so pious that St. Stephen and St. Augustine miraculously appeared at his funeral to lower his body into the grave, was buried in 1323; El Greco, however, shows us a sixteenth-century setting. The dazzling display of color and texture in the armor and vestments could hardly be surpassed by Titian himself. Directly above the earthly scene of the funeral, a heaven-bound angel carries a small, cloudlike figure—the Count's soul. The celestial assembly filling the upper half of the picture is painted quite differently from the lower half. All forms—clouds, draperies, limbs—are caught up in a sweeping, flamelike movement toward the far-distant figure of Christ. Here, even more than in Tintoretto's art, the various aspects of Mannerism fuse into a single ecstatic vision.

205. Girolamo Savoldo. *St. Matthew*. About 1535.
Oil on canvas, 36¾ × 49″. The Metropolitan
Museum of Art, New York. Marquand Fund,
1912. In the mid-sixteenth century a group of
painters in North Italy developed a style based
on Giorgione and Titian but far more realistic.
This night scene is remarkable for its dramatic
lamplight, which helps to convey religious
devotion.

Another trend that emerged around 1520,
with the maturing of the greatly gifted North
Italian painter Correggio, was almost a pre-
view of the Baroque style of the seventeenth
century. Correggio's fresco of *The Assumption
of the Virgin* (figure 203) on the underside of
the dome of the Cathedral of Parma is an
illusion, a masterpiece of eye-deceiving per-
spective. The surface of the dome has been
made to disappear as if by some miracle. It has
been replaced by what seems to be a vast,
luminous, celestial space filled with soaring
figures in free flight. In his own day, Correg-
gio was not regarded very highly. A century
later, however, many other painters took over
his sensational style, and for a long time he
was seen as the equal of Raphael and
Michelangelo.

A realistic trend developed side by side
with the style represented by Correggio. One
of the earliest North Italian Realists was
Savoldo, whose *St. Matthew* (figure 205) was

painted around the same time as Parmigia-
nino's *Madonna with the Long Neck*. His
broad, fluid painting technique reminds us of
Titian—but the great Venetian master would
never have placed the Evangelist in an envi-
ronment so lowly. The humble kitchen scene
in the right rear makes the presence of the
angel doubly miraculous. The dramatic light-
ing recalls such Late Gothic pictures as Geert-
gen tot Sint Jans's *Nativity* (see figure 153).
The main light source in Geertgen's panel
was the radiant form of the Christ Child;
Savoldo uses an ordinary oil lamp for a sim-
ilarly magical effect. Where the Mannerists
Rosso and Parmigianino were concerned to
take the real and make it supernatural, Savoldo
—like Correggio in another way—tried to
make the supernatural seem convincingly
real.

North Italian Realism took on the splendor
of a pageant in the work of Paolo Veronese.
Born and trained in Verona, he became, next
to Tintoretto, the most popular and important
painter in Venice. His *Christ in the House of
Levi* (figure 206) is a feast for the eye. The
rich, colorful costumes and the splendid archi-
tecture suggest a banquet in the palace of a
great Venetian family, rather than a Biblical
event. At first glance, this picture would ap-
pear to be a High Renaissance work born fifty
years after its time. But one High Renaissance
essential is missing: the elevated, ideal con-
ception of man. Veronese is not trying to show
us "the intention of man's soul." Significantly,
we are not sure what event in Christ's life
actually has been represented. The Inquisition
thought that Veronese was representing the
Last Supper, and summoned him to answer
charges that he had filled that sacred scene
with "buffoons, drunkards, Germans, dwarfs,
and similar vulgarities." Veronese, in his
wary defense against the charges, has given
us a good look into his artistic intentions. He
was basically unconcerned with subject matter
and was not in the least interested in spiritual

206. Paolo Veronese. *Christ in the House of Levi*. 1573. Oil on canvas, 18′ 2″ × 42′. Academy, Venice. Veronese was no mere decorator. He created a festive world that still enchants us today.

depth. His real obedience was to the surface richness of the world that brushed his senses. Only after the High Renaissance ideal had lost its force could a painter consciously hold such an attitude. And not until the nineteenth century could such an attitude gain wide public acceptance.

The later sixteenth century was far less an age of sculpture than of painting. The anti-classical Mannerist painting of Rosso and Pontormo had no sculptural counterpart, but the second, elegant phase appeared in countless sculptures both in Italy and abroad. The best-known representative of the style is Benvenuto Cellini, the Florentine goldsmith and sculptor famous for his colorful autobiography. The gold saltcellar for King Francis I of France (figure 207) is his only major work in precious metal to have escaped destruction. Holding condiments is the least important function of this luxurious conversation piece, which makes lavish use of the allegorical subject matter more usually employed in huge sculptural programs. On this tiny scale such a program becomes playful fancy; Cellini's major concern was to amaze his royal patron

207. Benvenuto Cellini. *The Saltcellar of Francis I*. 1539–43. Gold and enamel, 10¼ × 13⅛″. Kunsthistorisches Museum, Vienna. In this playful work, the goldsmith amazes us with his cleverness and skill and charms us with figures as elegant and elongated as Parmigianino's.

with a dazzling display of ingenuity and skill, and to charm him with the grace of his figures, which are as elegant, smooth, and elongated as Parmigianino's (see colorplate 38).

Mannerism became the dominant style in sixteenth-century France, and its influence penetrated far beyond the royal court. It reached a gifted young French sculptor, Jean de Boulogne, who went to Italy and, as Giovanni Bologna, became the most impor-

208. Giovanni Bologna. *The Abduction of the Sabine Woman*. Completed 1583. Marble, height 13'6". Loggia dei Lanzi, Florence. Like Cellini's saltcellar, this work is a showpiece. The artist demonstrates his ability to handle, in marble and on a great scale, a problem formerly restricted to small bronzes. The figures are engaged in a spiraling movement that demands their being seen from all sides.

Andrea Palladio—next to Michelangelo the most important architect of the period—is not easy to classify in this way. But it shares with the elegant phase of Mannerist painting and sculpture a polished, formal, and "correct" ideal. Palladio set out the highly detailed and systematic rules by which he designed in a treatise that became an international bible for architects. He distilled from the buildings of the ancients the qualities that he regarded as the very essence of classicism. His style, thus, if not truly classic in spirit, shows a conscious striving for classic qualities and very precise knowledge of the details of Roman buildings. We use the word "classicistic" both for his work and for his theoretical attitude.

The stately Villa Rotonda (figure 209), an aristocratic country house near Palladio's native North Italian town of Vicenza, is a perfect illustration of his scholarly classicism. A square-core building, crowned by a dome shaped like the Pantheon's (see figure 70), is faced on each of its four sides by a porch shaped

209. Andrea Palladio. Villa Rotonda, Vicenza. Begun 1550. Palladio was a scholarly theoretician who studied classical monuments and laid down a set of rules that he believed to be absolutely binding on architects. His own buildings, impressive for their dignity and clarity, represent a lofty, aristocratic phase of Mannerism.

tant sculptor in Florence during the last few decades of the century. Like Cellini's salt-cellar, his *Abduction of the Sabine Woman* (figure 208) is a demonstration of skill, for it was carved in order to silence critics who had cast doubts on his ability to create monumental sculpture in marble. Unlike the Cellini piece, however, it is well over lifesize. Bologna's self-imposed task was to carve, on a great scale, a sculptural composition to be seen not from one side but from all. Such a composition had been attempted before only on a smaller scale and only in bronze (see figures 167 and 168).

Although some late-sixteenth-century architecture is plainly Mannerist, the work of

above left:

210. Giacomo Vignola. Plan of Il Gesù, Rome. 1568

above right:

211. Giacomo della Porta. Façade of Il Gesù, Rome. About 1575–84. Mannerism here verges on the Baroque. Instead of appealing to a highly trained, aristocratic taste, like the architecture of Palladio, Il Gesù was more direct, dramatic, and popular in appeal.

like a temple front. The porches are beautifully tied in with the outside walls to create a neatly unified design and give this structure unusual grace and dignity.

A very different architectural style can be seen in the church of Il Gesù in Rome. This work was not scholarly and intellectual in design, for its purpose was direct involvement of the emotions. The importance of Il Gesù for later architecture cannot be exaggerated; it was the mother church of the Jesuit Order and was intended to express the spirit of the Counter Reformation. The Counter Reformation, as it took hold, used art more and more for influencing broad masses of the population, commoners and aristocrats alike.

The two architects who built the Gesù had assisted Michelangelo at St. Peter's. Vignola's plan (figure 210), a basilica with chapels in-stead of aisles, shows us a mighty nave like the auditorium of a theater. The entire congregation receives a clear view of the altar and pulpit, toward which attention is strongly directed. Since the nave is dimly lit, the light from the windows beneath the dome provides the interior with a dramatic focus at the eastern end.

The façade (figure 211) was designed by Giacomo della Porta, who was as free of classicistic scruples as his master Michelangelo. Its vertical center-line is accented by openings and very sculptural forms: the pedimented main doorway framed by columns paired with wall strips; a triangular pediment within a curved pediment; the high pedimented window of the second story; and the large pediment that crowns the façade as a whole. The pediments, the strongest forms, are a re-echoing series of similar shapes radiating from the main doorway, which projects in front of the rest of the building. The entrance thus is made a visual focus for people outside the building through the handling of elements of the façade, just as the altar and pulpit inside are made a visual focus through the organization of the interior light. We have not seen

so dramatic a concentration of elements at the entrance of a church since we looked at Gothic architecture. Nor have we seen such an effort to orchestrate the elements of a façade into an integrated design—achieved here through the rhythmic patterning of verticals and horizontals and the joining of the narrow second story to the wider first story by buttresses in the shape of scrolls. In its expressive energy, Il Gesù heralds the coming of the Baroque.

The Renaissance in the North

The artists of fifteenth-century Northern Europe largely ignored Italian forms and Italian ideas, looking to Flanders for leadership. But around 1500, the trickle of Italian influence became a flood. The Late Gothic style remained very much alive, nevertheless; and the Italian point of view prevailed only after a century-long tug of war. The paintings of Matthias Grünewald and Albrecht Dürer, the outstanding German masters of the sixteenth century, were battlegrounds of this war of styles.

Grünewald's imagination was Late Gothic. He was not untouched by the Italian Renaissance, for he had more knowledge of perspective than he could have learned from Late Gothic art alone, and many of his figures were solid and vigorous. But he used Italian ideas for the single purpose of giving his world of dreams and visions the greatest possible reality.

Grünewald's masterpiece, the *Isenheim Altarpiece*, is made up of four huge panels painted on both sides. When the altar is completely closed, we see the *Crucifixion* (colorplate 41), which is probably the most impressive Crucifixion ever painted. In one respect it is very medieval: Christ's unbearable agony and the desperate grief of the Virgin, John the Evangelist, and Mary Magdalene recall such older German works as the Bonn *Pietà* (see

212. Matthias Grünewald. *The Annunciation; Virgin and Child with Angels; The Resurrection*, second view of the *Isenheim Altarpiece*. About 1511–12. Tempera on panel, left wing 8′ 10″ × 4′ 8″; central scene 8′ 10″ × 11′ 2½″; right wing 8′ 10″ × 4′ 8¼″. Musée Unterlinden, Colmar, France. In contrast with the grim drama of the *Crucifixion* (colorplate 41) seen when the altar wings are closed, the opened altar overflows with scenes of joy—the glad tidings of the Annunciation, the Heavenly Concert, and the triumphant Risen Christ.

above:

213. Albrecht Dürer. *The Four Horsemen of the Apocalypse*. About 1497–98. Woodcut

above right:

214. Albrecht Dürer. *Knight, Death, and the Devil*. 1513. Engraving. Museum of Fine Arts, Boston

Dürer looked upon himself as an educator with the mission of spreading Italian discipline and learning among Northern artists. His influence was spread by his extraordinary woodcuts and copper engravings, which were admired all over Europe.

figure 133). But the pitiful body on the cross, with its rivulets of blood, its countless lacerations, and its twisted limbs, is heroic in size —far beyond human scale. Christ is thus revealed as God as well as man. The actions of the bystanders reflect his double nature: the figures on the left mourn Him as a man; on the right, St. John the Baptist proclaims Him as the Saviour.

When the outer panels are swung back, and the altar is in open position (figure 212), scenes overflowing with joy replace the dark and somber *Crucifixion*. The striking differ-

ence between these scenes and the Late Gothic paintings we have looked at before is the sense of movement that we find here—every form twists and turns as though it had a life of its own. The angel of the *Annunciation* panel on the extreme left enters the room like a gust of wind that blows the Virgin backward. The canopy over the angelic concert in the left-center panel writhes in response to the heavenly music. In the right-center panel, a great burst of light falls upon the clouds from which God the Father in all His glory gazes upon the young mother and her child. In this tender and poetic vision, heaven and earth become truly one. In the *Resurrection* panel on the extreme right, an even more awesome miracle takes place before our eyes: Christ leaves the earth and becomes God once more. He rockets upward, shining against the midnight sky with a light as brilliant as the sun. The guardians of the tomb—forces of death—grope along the ground in blind defeat. Here Grünewald's strange genius has created an unforgettable image.

left:
215. Albrecht Dürer. *Self-Portrait*. 1500. Oil on panel, 26¼ × 19¼″. Pinakothek, Munich. The deliberate resemblance to Christ reflects the Renaissance idea that artists of genius are endowed with God-given authority, since their creative power derives from the creative power of God.

above:
216. Albrecht Dürer. *Demonstration of Perspective*, from the artist's treatise on geometry. 1525. Woodcut. This print shows a mechanical device for constructing pictures in correct perspective. The string that goes from a point on the lute to a hook on the wall corresponds to a sight line. After locating a point where the sight line goes through the frame, the man on the right will transfer it to the piece of paper. After enough points have been located, a perspective projection of the lute will appear.

Italian ideas and forms had richer meaning for Dürer. At the age of twenty-three he crossed the Alps to visit Venice. There he found artists enjoying the same respect as scholars, philosophers, and scientists; in his native Germany, artists were still modest craftsmen. Dürer resolved to master not only Italian style but every branch of learning that went with the Italian conception of an artist. More, he felt called upon to spread his new knowledge among his fellow Northern artists. Their rule-of-thumb procedures, undisciplined by theoretical training, were to him a "wild, unpruned tree" in need of the rational ordering of the Italian Renaissance.

Dürer's mission to the artists was easier for him because he was already the foremost printmaker of his time. His woodcuts and copper engravings circulated everywhere, providing him with wide influence. *The Four Horsemen of the Apocalypse* (figure 213), a woodcut of the years following his return from Venice, is a grim, fantastic vision full of swirling movement and violent action. It

seems to return completely to Martin Schongauer's Late Gothic world (see figure 159). Yet the solidity and force of these figures is owed to Dürer's having studied engravings by Mantegna while he was in Venice. At this point of his life, Dürer's style had much in common with Grünewald's.

We find a shift toward a more Italian outlook in Dürer's *Self-Portrait* of 1500 (figure 215). The deliberate resemblance to Christ stems from the Italian humanist idea that the artist of genius is divinely inspired.

Dürer constructed the face of his self-portrait according to his theory of perfect

217. Albrecht Altdorfer. *The Battle of Issus.* 1529. Oil on panel, $62 \times 47''$. Pinakothek, Munich. Even though his work is full of Renaissance detail, Altdorfer never shared Dürer's enthusiasm for Italian monumentality. His fame rests on his poetic land-scapes, seen in the setting of this picture. The masses of tiny soldiers clashing in the foreground are less exciting than the cosmic drama of the sunrise defeating the moon.

proportions. In the engraving *Knight, Death, and the Devil* (figure 214), an outstanding print, the body of a horse is constructed in the same way. Knight and splendid mount are as confident and poised as a great equestrian statue. The knight is the Christian Soldier— a subject suggested by the writings of Erasmus, the Dutch humanist—who never swerves on his road to the Heavenly Jerusalem despite the hideous devil behind him or the terrifying horseman who tries to bar the way ahead.

Dürer spent his last years, which were full of illness and suffering, on messages to be handed down to posterity. He completed treatises on perspective and the proportions of natural forms. He made a bold attempt to forge a great new Protestant art, for his religious convictions had made him a follower of Martin Luther. No continuing tradition followed this beginning. The spiritual leaders of the Reformation were suspicious of art, in which they saw a menace of idolatry.

In 1526, Dürer presented a pair of panels, *The Four Apostles* (colorplate 42), to the city of Nuremberg, which had joined the Lutheran camp a year before. The apostles whom he chose to paint were basic to Protestantism: John and Paul in the foreground, Peter and Mark in the rear. German painting reached its high point in these two panels, whose figures have a severity and grandeur unmatched since Masaccio and Piero della Francesca.

In 1528, the year of Dürer's death, mobs were destroying works of art in Swiss and German cities. Hans Holbein the Younger, the last great German master of the sixteenth century, had returned to Basel from England, intending to stay. He changed his mind about staying and went back to England, where he became court painter to King Henry VIII. He left German art sinking into provincialism.

Holbein's best-known works are his portraits, which strike a happy balance between

218. Lucas Cranach the Elder. *The Judgment of Paris.* 1530. Oil on panel, 13½ × 8¾″. Staatliche Kunsthalle, Karlsruhe, Germany. Cranach's utterly unclassical pictures of mythological subjects are fairy-tale scenes of playful charm.

Northern European love of fine detail and Italian Renaissance dignity and solidity. His *Erasmus of Rotterdam* (figure 219), painted in Basel, gives us a memorable image of Renaissance man. Intimate yet monumental, this likeness of the famous humanist and author has great individuality and tremendous intellectual authority. Holbein's portrait of Henry VIII (colorplate 43) has the immobile pose, the unapproachability, and the precisely described dress and jewelry of Bronzino's *Eleanora of Toledo* (see figure 201). Both belong to the same world of court portraiture. The link between Bronzino's picture and Holbein's may be such French works as

219. Hans Holbein the Younger. *Erasmus of Rotterdam*. About 1523. Oil on panel, 16½ × 12½″. The Louvre, Paris. Holbein not only gives us a sensitive portrayal of character, but also endows the great humanist with an intellectual authority formerly reserved for the Evangelists or the Church Fathers.

Clouet's *Francis I* (figure 220), which Holbein could have seen on his travels. (See page 210 for Francis I as a patron of Italian Mannerists.) This type of portrait seems to have been invented in France and to have spread beyond French borders after 1525.

Although the history of the Low Countries in the sixteenth century was even more turbulent and painful than Germany's, art did not wither away. Sacred subjects, the mainstay of art in the Middle Ages, lost importance, and painters turned to nonreligious subjects for the basis of their art. We saw that the great German master Holbein concentrated on portraits. Pieter Bruegel the Elder, the great Flemish master, turned to a different type of secular subject. As pessimistic as Hieronymus Bosch, whose influence on his work is plain, he composed many visual fables of the vanity

of life and the shortcomings of the human race. *The Land of Cockayne* (colorplate 44), painted in 1567, shows us a fool's paradise where tables are forever laden with tasty dishes, houses are roofed with pies, and roast pigs, carving knives conveniently strapped to their backs, run around begging to be eaten. The men under the tree are not—as in the paintings of Bosch (compare colorplate 28)—powerless sinners in the grip of Satan. They have chosen to be slaves to their appetites and have given up all self-respect for the sake of animal satisfactions. They are fallen soldiers of the battle of the stomach: the knight has dropped his lance, the farmer his flail, and the scholar his books. "The fool's paradise," Bruegel seems to say, "is more dangerous than hell because people seek it of their own accord." He clearly

220. Jean Clouet. *Francis I*. About 1525–30. Oil on panel, 37¾ × 29″. The Louvre, Paris. The international court-portrait style (see figure 201 and colorplate 43) in London under Henry VIII and in Florence under Cosimo I may have existed even earlier in France, as this very polished example suggests.

thought this subject serious and important, for the composition, in the shape of a great wheel turned on its side, is as monumental as any Italian master's, and the forms are equally impressive in their gravity and weight.

The sweeping landscape of *The Return of the Hunters* (figure 222) belongs to a set of paintings depicting the months of the year. Series of this kind, we recall, began with med-

left:

221. Nicholas Hilliard. *A Young Man Among Roses.* About 1588. Tempera on parchment, $5\frac{3}{8} \times 2\frac{3}{4}''$. Victoria and Albert Museum, London. Miniature paintings were popular in Elizabethan England. The elegant young man probably ordered this picture as a keepsake for his ladylove.

below:

222. Pieter Bruegel the Elder. *The Return of the Hunters.* 1565. Tempera on panel, $46 \times 63\frac{3}{4}''$. Kunsthistorisches Museum, Vienna. The painting is part of a set that echoes the calendar landscapes in late medieval manuscripts (compare figure 144 and colorplate 22). The seasonal activities of man have become mere incidents within nature's great annual cycle of death and rebirth. The dead of winter can be sensed in the very air.

above:

223. Pierre Lescot. Square Court of the Louvre, Paris. Begun 1546. The medieval French château has been stripped of Gothic detail and reclothed in the classical orders. Despite the purity of the classical forms, we would never mistake this for an Italian structure. Verticals are heavily accented: the windows are very tall, and the roof has a steep pitch. The rich sculptural decoration, too, is un-Italian.

right:

224. Jean Goujon. Reliefs from the *Fountain of the Innocents*. 1548–49. Paris. These graceful figures recall the Mannerism of Benvenuto Cellini (see figure 207). Like Lescot's architecture, they combine classical details of astonishing purity with slender proportions, becoming uniquely French.

ieval calendar illustrations, and this winter scene shows its descent from the February page in the *Very Rich Book of Hours of the Duke of Berry* (see figure 144). In Bruegel's painting, however, the natural world is more than a setting for human activities; it is the main subject. The seasonal occupations of men are incidental to nature's majestic cycle of death and rebirth.

The Baroque in Italy, Flanders, and Spain

Like "Gothic" and "Mannerist," the word "Baroque" was once rather insulting. It originally meant "irregular, contorted, grotesque," and was used to compare the livelier and more exuberant styles of seventeenth-century art unfavorably with the cooler and quieter styles. Today we tend to use the word for the seventeenth century as a whole, even though the art of the time was extremely varied.

In many ways, the age of the Baroque was a summing-up of the previous two centuries. Much of the optimism of the Renaissance returned. The ideas and discoveries that had brought the Middle Ages to an end lost their earth-shaking newness. Daring explorers like Columbus were now being followed by colonists. England, Holland, France, and Spain had acquired important overseas territories and grew richer and more powerful, outstripping Italy and Germany. Mathematics and science became so technical and complex that it was hard for one man to be an artist, a humanist, and a scientist at the same time. Certainly there were no more universal geniuses like Leonardo and Dürer. Artists had already performed their main scientific contribution in showing scientists how to use their eyes; now other men were to describe the workings of nature in a deep and systematic way, men like Galileo and Newton, who summed up the behavior of moving bodies in a few simple laws that held good for the circling of the sun by the earth and for the fall of an apple from a tree. The scientists of the Baroque era laid the foundation for the technical marvels of our own day.

The struggle between the Reformation movement and the old faith had now reached a stalemate, and open conflict subsided. The Catholic Church, its strength revived by the Counter Reformation, felt secure again.

Churches and palaces multiplied, and were decorated in a new, confident, outgoing style. Rome once more was the mecca of artists from all Europe. They came to study the masterpieces of classical antiquity and the High Renaissance, but they also learned from their Italian contemporaries, who, in turn, learned from them. Seventeenth-century Rome was a melting pot in which North and South, past and present, mingled in an endless stream. Every visitor went away from Rome with his own set of impressions, yet the experience gave all visitors something in common—enough, certainly, to make us feel that the Baroque style was international no matter how much it varied from one place to the next.

The foreign artists who arrived in Rome toward 1600 found the city agog over a young North Italian painter named Caravaggio. His *Cardsharps* (figure 225) had little in common with Mannerism or the High Renaissance; its ancestry was the North Italian Realism of artists like Savoldo (see figure 205). Unlike Savoldo's work, however, it had nothing tender or elevated about it. Caravaggio's realism was so stark as to seem different in kind, not merely in degree, from the earlier outlook. We even employ a different word for it—naturalism.

The soldiers who play cards in this picture could have been met in any of Rome's taverns. The young scoundrel on the right has concealed a few extra cards behind his back; tipped off by an accomplice, he is about to play one of them. Will he get away with his cheating? Will there be a fight? Caravaggio does not tell us, and what is more, he does not care—although personally he was anything but averse to a good tavern brawl. Here is actuality, he is saying to us, without deception or pretense—the most wonderful thing in the world to look at and give oneself up to.

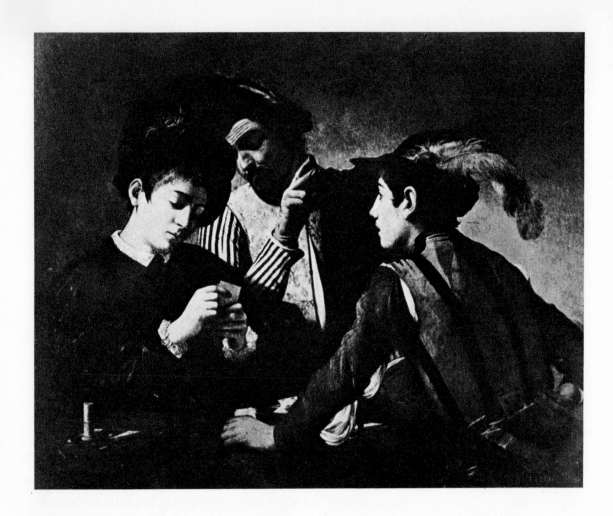

225. Caravaggio. *The Cardsharps*. About 1593. Oil on canvas, 39 × 51⅝″. Private collection. In Rome, where Caravaggio painted this picture soon after his arrival, people were struck by its bright colors and spoke of it as being "in the manner of Giorgione." Caravaggio must also have been impressed with the works of such North Italian artists as Savoldo, whose lighting was dramatic and whose *St. Matthew* (see figure 205) is placed as close to the beholder as these cardsharps.

The people of Rome felt that this subject was too coarse and vulgar for a large painting, but they were impressed by the way Caravaggio made his disreputable characters come alive. One of the things that impressed them most was the way Caravaggio had caught a fleeting moment in time; another was his dramatic use of light. Caravaggio was the first painter to spotlight his scenes like a stage director, contrasting brilliant highlights with sharply outlined deep shadows.

The Calling of St. Matthew (colorplate 45)

describes an event in the life of Christ in the setting of a seventeenth-century Roman street. The flashily dressed armed men seated around St. Matthew at a table outside a cheap tavern belong to the same disreputable class as the cardsharps of figure 225. St. Matthew points questioningly at himself as two poorly dressed, barefoot men approach from the right. They are Christ and a disciple. Why do we sense a religious spirit here? Surely not because of the halo, a thin gold band so inconspicuous that it is almost invisible. Our eyes fasten instead on Christ's commanding gesture—borrowed from the figure of Adam in Michelangelo's *Creation of Adam* (see figure 190). But the decisive factor is the beam of strong sunlight. It strikes the Saviour's face and hand and carries His call to Matthew. Without this light—so natural, yet so charged with symbolic meaning—this picture would have little power to make us aware of the Divine presence. Caravaggio's discovery of

right:

226. Annibale Carracci. Ceiling Fresco (detail). 1597–1601. Gallery, Palazzo Farnese, Rome. Shortly before 1600, two great anti-Mannerists appeared in Rome: the revolutionary realist Caravaggio and the cautious reformer Annibale Carracci. Both felt that art should become more natural, but Annibale approached this aim by studying Roman antiquity and such sixteenth-century masters as Raphael, Michelangelo, Correggio, and Titian.

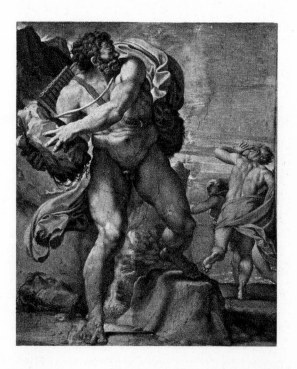

light as a force has enabled him to raise a tavern scene to the level of a sacred event.

Caravaggio's naturalism was of its time, in keeping with the new religious emphasis in Catholicism following the Counter Reformation. The mysteries of the faith were now to be grasped instinctively, through feelings and emotions common to all men, more than intellectually through conscious thought. But the very people for whom Caravaggio's religious works were intended rejected them with indignation. Painters and connoisseurs may have admired his art, but ordinary Italians, far from wanting to meet themselves in religious painting, thirsted for idealized and grandly operatic religious imagery. They got what they wanted from Annibale Carracci (see figures 226 and 227), another arrival from North Italy, and his host of pupils and follow-

below:

227. Annibale Carracci. *Landscape with the Flight into Egypt.* About 1603. Oil on canvas, 48¼ × 98½". Doria Gallery, Rome. Here Annibale has created a truly classical landscape: a view of nature idealized, composed, yet sharing the intimate pastoral mood of Venetian landscapes (compare colorplate 35).

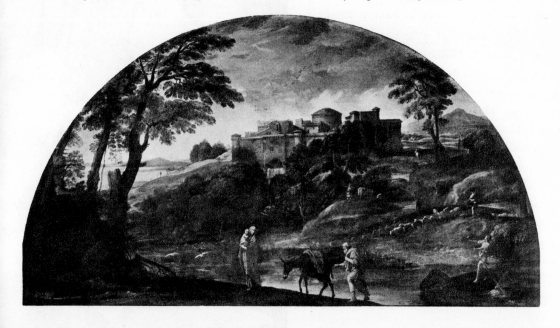

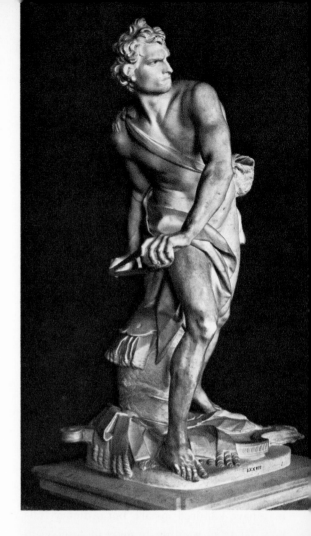

228. Gianlorenzo Bernini. *David*. 1623. Marble, lifesize. Borghese Gallery, Rome. The energy of Bernini's *David*, unlike that of Michelangelo's (compare figure 187), extends into the surrounding space.

ers. Caravaggio's naturalism, however, did not seem outrageous to visitors from beyond the Alps, for the human, everyday approach to religion had long been familiar to them. His deepest imprint was left on the art of Flanders, Holland, France, and Spain. His work appealed to Protestants no less than to Catholics, and had a profound—if indirect—influence on Rembrandt, the greatest religious artist of the Protestant North.

A decade after Caravaggio's death in 1610, another stupendous talent appeared in Rome. Gianlorenzo Bernini was the greatest sculptor-architect of the seventeenth century. His *David* (figure 228) invites comparison with two other famous works: Michelangelo's *David* (see figure 187) and the Hellenistic *Laocoön Group* (see figure 67). Bernini's *David* and the *Laocoön* share a oneness of body and spirit that Michelangelo deliberately rejected. Not that Bernini is more classical than Michelangelo: the two men, like the two eras to which they belonged, drew inspiration from different aspects of ancient art.

What new quality does Bernini's *David* possess? What makes its style Baroque? The simplest answer is Goliath's invisible presence. David has just hurled his stone with all his might, and now, teeth clenched, is watching its effect. Did Bernini, we wonder, plan a second statue to complete a group? No, for David's bodily action tells us where Goliath is and inveigles us into forming a mental picture of what goes on, just as the gestures and movements of an actor might. The energy generated by David's action is discharged into the space between him and his invisible antagonist; this energy-charged space becomes part of the design. If we step in front of David, our impulse is to get out of the line of fire

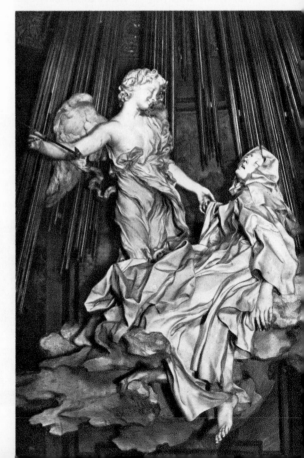

right away. By contrast, the energy of a figure by Michelangelo was never allowed to escape from the imprisoning form.

Baroque sculpture, then, is distinguished from Renaissance sculpture in the way it makes the space around it active. Before the seventeenth century, only painters had been able to create spatial illusion. Now the sharp distinction between painting and sculpture was being broken down. In Baroque art, sculpture and painting sometimes merged with architecture in such a way that it was hard to tell which was which. The effect was much like that of the theater, where the real space of a stage, the painted scenery, and costumed actors who move and speak create a compound illusion with the qualities of life itself.

Bernini, who was passionately devoted to the theater, was at his best when he could fuse the forms of architecture, sculpture, and painting into a unity. His masterpiece in this vein is the chapel containing the famous group *The Ecstasy of St. Theresa* (figure 229). Among the mystical experiences of this Saint of the Counter Reformation was the piercing of her heart by an arrow of divine love. Bernini has made this religious vision as sensuously real as Correggio's *Jupiter and Io* (see figure 204); in a work with a subject from classical mythology the angel would do just as well for Cupid, and St. Theresa's ecstasy is quite physical. Yet the two figures on their floating cloud are so illuminated from a source concealed above that their dazzling whiteness seems almost immaterial; we know that what we see is visionary. The space above the two

at left:
229. Gianlorenzo Bernini. *The Ecstasy of St. Theresa.* 1645–52. Marble, lifesize. Cornaro Chapel, Santa Maria della Vittoria, Rome. Bernini had a passionate interest in the theater and was at his best when he could merge architecture, sculpture, and painting into a compound illusion like that of the stage. This work is the focal part of his greatest masterpiece in this vein.

figures is charged with energy by the same mysterious force that carries them upward and causes their drapery to flutter. This force is suggested by golden rays originating high above the altar.

Bernini's imagination and daring are reflected again in the interior decoration of Il Gesù (figure 230). Giovanni Battista Gaulli, Bernini's protegé, painted the ceiling fresco. Antonio Raggi, his talented assistant, modeled the stucco sculptures. When we see the fresco spill over its frame and turn into sculpture, we sense the same spirit we have already met in *The Ecstasy of St. Theresa* and realize that the scheme must be Bernini's.

Bernini devoted much of his life to decorating St. Peter's, outside as well as in. He revived the forecourt of the torn-down Early Christian basilica (see figure 85) as the magnificent elliptical piazza (figure 231) framed by the mighty colonnades that he himself likened to the all-embracing motherly arms of the Church. So triumphant a molded open space linked to monumental enclosed structures had not been built since ancient times. In the Baroque era, architectural vision expanded to create a new form bigger in scale than the biggest of single buildings: the designed environment included buildings, statuary, and exterior space.

Bernini's great rival in architecture was Francesco Borromini. The two men brought the Roman Baroque style to its climax simultaneously. Opposites in personality—Bernini was a self-assured artist-prince, Borromini a brooding genius who died by his own hand—they were opposites in architectural thought and feeling. Bernini's colonnade design for the Piazza of St. Peter's was dramatically simple, the classic spirit in seventeenth-century dress. Borromini's design for the church of San Carlo alle Quattro Fontane is extravagantly complex and anticlassic, a new dress for the old Gothic spirit. Using classical columns, moldings, and pediments as design materials for

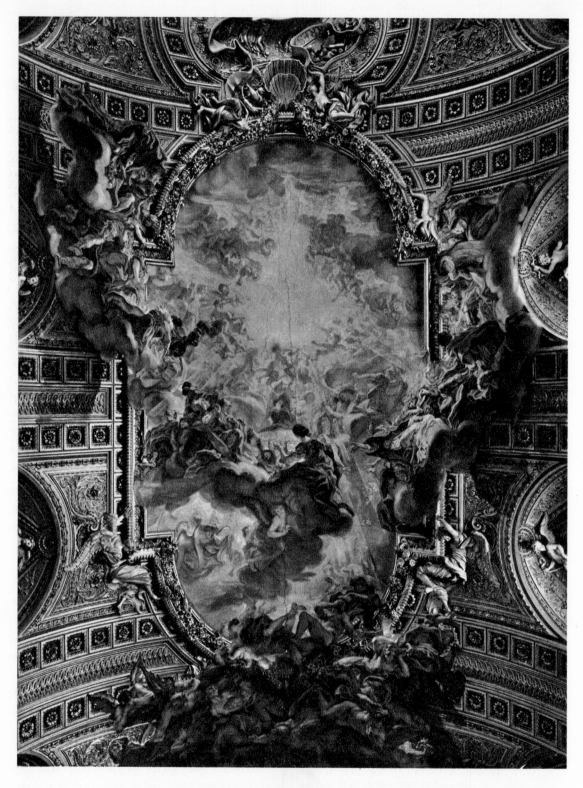

230. Giovanni Battista Gaulli. *Triumph of the Name of Jesus.* 1672–85. Ceiling fresco.
Il Gesù, Rome. This compound display of architecture, painting, and sculpture was
planned by Bernini and executed under his direction.

231. Aerial View of St. Peter's, Rome. Nave and façade by Carlo Maderno, 1607–15.
Piazza and colonnade by Gianlorenzo Bernini, designed 1657

the façade (figure 233), Borromini does violence to all traditional usage in the way he handles them. The ceaseless play of concave and convex forms suggests that the entire facade is of some elastic stuff in the grip of a giant force that has flexed it out of shape—relax it and it will snap back! The plan (figure 232) is in keeping: an equal-armed cross distended to a pinched ellipse. In this tense building, architecture and sculpture are fused in a way never attempted since Gothic times. "Nothing similar," wrote the head of the order for which San Carlo was built, "can be found anywhere in the world . . . we have been asked for [copies of the plan] by Germans,

Flemings, Frenchmen, Italians, Spaniards, and even Indians. . . ."

Spreading out from its birthplace in Rome, Baroque art became thoroughly international, breaking down the barriers of taste and style that had separated North and South. The man who more than any other helped to bring about this development was the Flemish painter Rubens, who spent eight years in Italy absorbing the Italian tradition as he studied the masterworks of the High Renaissance and the paintings of Caravaggio and Annibale Carracci.

On returning to his home in Antwerp in 1608, Rubens became court painter to the

below:

232. Francesco Borromini. Plan of San Carlo alle Quattro Fontane, Rome. Begun 1638

right:

233. Façade, San Carlo alle Quattro Fontane. 1665–67. In the irregularly curving plan and undulating façade of Borromini's masterpiece, the distinction between architecture and sculpture almost breaks down.

Spanish regent (Flanders remained under Spanish rule while Holland gained its independence) and a confidential adviser and diplomat besides. Diplomatic errands took him inside the royal households of England, France, and Spain, bringing him countless commissions and sales. With the aid of many assistants, he turned out a vast amount of work.

The wonderful *Raising of the Cross* (figure 234), the first big altarpiece Rubens produced after his return, reveals a great debt to the Italians. Here we find the strongly modeled,

muscular bodies of Michelangelo, the glowing color and confident brushwork of Titian, and the dramatic lighting of Caravaggio. The painting is heroic both in scale and in conception beyond any previous Northern work.

at right:

234. Peter Paul Rubens. *The Raising of the Cross.* 1609–10. Oil on panel, 15′ 2″ × 11′ 2″. Antwerp Cathedral, Belgium. The Baroque spirit reaches a high point in this scene of dramatic action. Rubens had absorbed the Italian tradition so thoroughly that, from now on, there were no more barriers of taste and style between North and South.

235. Peter Paul Rubens. *Marie de' Medici, Queen of France, Landing in Marseilles*. 1622–23. Oil on panel, 25 × 19¾". Pinakothek, Munich. Oil sketches such as this are small-scale models of large pictures. They are frequently more attractive, since they were done entirely by the master's hand in a quick, transparent technique that captures the full sweep of his inventive genius.

Rubens is a Northerner, however, a genuine Flemish realist, in such details as the foliage, the soldier's armor, and the curly-haired dog. The elements of the picture are widely scattered in origin, but Rubens has brought them into unity in so masterly a fashion that the only style of which we are conscious is his. The composition—a swaying pyramid of bodies that seem to travel on and out without even pausing at the frame—has tremendous force. For this master, nothing stands still. Energy leaps from form to form and builds up in a swirl of movement that sweeps through the picture like a high wind.

Rubens' dynamic style reached its climax in huge decorative schemes for churches and palaces. The most famous series glorified the career of Marie de' Medici, the Florentine-born Queen Mother of France. Figure 235 is a small oil sketch for one episode: the landing of the young Queen in Marseilles. Not a promising subject for drama, it could be said, but what a drama Rubens has made of it! The heavens, the seas, and the earth hail her safe arrival in a riot of blazing light and color. Fame soars on wings overhead, sounding a blast on two trumpets. Neptune and his mermaids rise to salute her. Everything flows together: motion and emotion, fantasy and reality, heaven and earth; even drawing and painting—for the two become one in this oil sketch. Rubens used such sketches when planning his compositions—his drawings were mostly studies of individual figures—for he thought of his pictures from the start in terms of light and color. He did not separate light and color in his mind from form, pattern, and space; he had a unitary vision. In this he was carrying forward the spirit and the aims of the great Venetians.

In 1628, Rubens went to Madrid for a visit of over a year. There he rediscovered Titian,

236. Peter Paul Rubens. *Landscape with the Château of Steen*. 1636. Oil on panel, 53 × 93″. The National Gallery, London. Rubens painted this picture just after his second marriage and his purchase of the Château of Steen, where he led the life of a country squire. In this masterly landscape, painted for himself alone, he creates a magnificent open sweep from the hunter and his prey in the foreground to the mist-veiled fields along the horizon.

left:

237. Anthony van Dyck. *James Stuart, Duke of Lennox.* About 1635. Oil on canvas, 85 × 50¼". The Metropolitan Museum of Art, New York. Gift of Henry G. Marquand, 1889. Van Dyck was Rubens' most brilliant pupil, but did not equal his master in vitality and inventiveness. This portrait, done after Van Dyck had settled in England as court painter to Charles I, breathes courtly elegance rather than human warmth.

above:

238. Diego Velázquez. *The Water Carrier of Seville.* About 1619. Oil on canvas, 41½ × 31½". Wellington Museum, London (Crown copyright reserved). Velázquez, twenty years old when he painted this canvas, may never have see an original painting by Caravaggio. Nevertheless, he had grasped every essential of Caravaggio's style.

whose finest works were owned by the Spanish monarch. Titian became Rubens' major source of inspiration in his late years, when his style changed from turbulence and drama to tenderness and serenity. In the poetic *Garden of Love* (colorplate 46), the artist himself appears on the left with his young second wife. Playful cupids mingle with the gay company so naturally that myth and reality are completely interwoven. Here Rubens pays perhaps his finest tribute to the joy of life.

In Madrid, Rubens formed a close personal friendship with his younger contemporary, Diego Velázquez, the court painter to the Spanish king. Velázquez was then working in his early style, which was strongly influenced by Caravaggio (see figure 238, *The Water Carrier of Seville*). Rubens and Velázquez

studied the Titians in the royal collections to-
gether, and, probably at Rubens' urging, the
King sent Velázquez on a picture-buying ex-
pedition to Italy. His experience thus broad-
ened, Velázquez developed a mature style
uniquely his own.

A better title for *The Maids of Honor* (fig-
ure 239) would be "The Artist in His Studio,"
for on the left we see Velázquez himselft a
work on a huge canvas. In the center is the
little Princess Margarita with her playmates
and maids of honor. Her royal parents have
just stepped into the room. We do not see
them, for the artist has put them and us in the
same place; in the mirror where we should see
our own faces we see theirs. We are being

239. Diego Velázquez. *The Maids of Honor.* 1656. Oil on canvas, 10′ 5″ × 9′.
The Prado, Madrid (see also colorplate 47). In this masterpiece of his
late years, Velázquez combines splendid portraiture with a poetry of light
and shade that shows his kinship with the best of the Dutch genre painters.

240. Frans Hals. *The Women Regents of the Old People's Home at Haarlem.* 1664. Oil on canvas, 67 × 98″. Frans Hals Museum, Haarlem. Hals was over eighty when he painted this magnificent group portrait. Unlike *The Jolly Toper* (color-plate 48), which is colorful and exciting, his last works are sober, revealing a depth of human insight matched only by Rembrandt.

shown, then, a king's-eye-view of the studio. No mere king, however, could have seen what Velázquez saw and now reveals to us.

As we look, we are challenged to discover and follow the almost limitless variety of the light. The light is alive. It changes from one part of the picture to the next—soft here, crisp there. Subtle changes of color keep company with the changing quality of the light. The paint has been applied more sketchily than we have ever seen it before, so that the detail is rather broad and open—look at color-

plate 47. Most of the paint has been built up in thin, transparent layers, rivaling the Venetians in richness of color. On top of this relatively smooth paint we see very bold, rough strokes. The Dutch painter Hals (see page 235) used somewhat similar brushstrokes at this same time and even earlier, but Velázquez' jabs, twists, and short slashes had a subtler intention: to catch light in motion.

In this canvas, Velázquez painted only what the eye could see at that particular moment, rather than what he knew. His love affair with the experience of seeing was matched by that of one painter of his century and one only: a great Dutchman, Jan Vermeer (see pages 240–41). The visual discoveries of these two men were ignored by the generation of painters who followed them. Not before the nineteenth century would their great importance be realized.

The Golden Age of Dutch Painting

Holland, proud of its hard-won freedom, became the commercial center of Europe early in the seventeenth century. The prospering nation of merchants, farmers, and seafarers quickly developed an appetite for paintings, which became as popular as movies or sports events today. There were more painters and more art collectors in Holland than in any other country.

The court of the Prince of Orange and the Dutch Reformed Church were not buyers of pictures, unlike the Regent's court and the Catholic Church in neighboring Flanders. Dutch art, therefore, was without official ties. It was private and middle-class. The faces, the surroundings, and the way of life of the Dutch people themselves—their visible world—were recorded lovingly and with great fidelity to nature. There were religious paintings, too, but these were mostly small pictures for private collectors, rather than altarpieces to be used for worship and prayer.

The boom in painting lasted only half a century or so—the Dutch merchants and farmers proved as fickle as any prince, and paid less for pictures. Even the greatest artists would suddenly find themselves out of favor and hard-pressed to make a living. But that half-century was one of the most important chapters in the history of painting.

It was not the custom for Dutch painters to go to Rome. There were those who went, in the early years of the century. They were mostly from Utrecht, a town with strong Catholic traditions. In Rome they fell under the spell of Caravaggio's naturalism, light, and timing, all of which they brought back to Holland. The new Italian ideas reached Frans Hals and other great Dutch masters in this way.

Hals was the leading portrait painter of Haarlem. The sitter of his *Jolly Toper* (color-plate 48), evidently, was quite willing to oblige Hals's wish for a more informal portrait than any artist had ever painted before. Hals is even suggesting here that the scene was unposed, that he caught this gay blade off guard. How happy he would have been with a modern camera! Everything here is keyed to a split second of time: the twinkle of the eyes, the half-opened mouth, the raised hand, the teetering of the wine glass, and—most important—the way the paint is laid on. Hals, like Velázquez (see colorplate 47), has worked in quick, slashing strokes. Each brushmark is so clearly visible that this "finished" work seems as immediate as the Rubens oil sketch of Marie de' Medici landing at Marseilles. Hals was not trying to catch the movements of light when he painted *The Jolly Toper*, but because he was showing instantaneous action, he wanted to suggest that the work had been done in the wink of an eye.

Rembrandt, the greatest genius of Dutch art, was also influenced by Caravaggio at second hand. *Tobit and Anna* (figure 241), painted when the artist was twenty and still living with his parents in Leyden, is typical of his early work: small, sharply lit, intensely realistic. This little panel, filled with homely details of peasant life, shows a new, Protestant attitude toward Old Testament scenes. Previous Christian art, from earliest times, had used Old Testament subjects for explaining Christian doctrine rather than for their own sake. (The Sacrifice of Isaac, for example, foreshadowed the sacrificial death of Christ.) Rembrandt is not using the story of Tobit in this way. He is telling us directly about God's ways with man. We can see how deeply he was moved by the touching relationship of Tobit and his wife.

The Blinding of Samson (figure 242), painted ten years later, after Rembrandt had

left:

241. Rembrandt. *Tobit and Anna with the Kid.* 1626. Oil on panel, 15½ × 11¾″. Collection Baroness Bentinck, Paris. From beginning to end, Rembrandt's art was charged with more human feeling than that of any previous painter. This painting is one of Rembrandt's earliest.

below:

242. Rembrandt. *The Blinding of Samson.* 1636. Oil on canvas, 93 × 119″. Staedel Institute, Frankfort. In the 1630s Rembrandt developed a full-blown High Baroque style of dramatic lighting and violent action.

at right:

243. Rembrandt. *The Polish Rider.* About 1655. Oil on canvas, 46 × 53″. The Frick Collection, New York (Copyright). Rembrandt's later works impress us by their subtle color and design. Everything seems to be in a state of transition here—the light, the mood, even the movement of the horse.

244. Rembrandt. *Self-Portrait*. About 1660. Oil on canvas, 45 × 38″. The Iveagh Bequest, Kenwood, London. Throughout his life, Rembrandt was his own favorite model. No other painter reveals himself so completely in self-portraits.

moved to the prospering capital of Amsterdam, comes close to the style of Rubens. It is High Baroque. The artist now sees the Old Testament as a world of oriental splendor and violence, cruel yet seductive. A sudden flood of brilliant light invades the dark tent and reveals the scene to us at its peak of drama. Rembrandt was an avid collector of Near Eastern clothes and knickknacks, which he used as props in his pictures.

As Rembrandt matured, he took less interest in violent action. He became concerned primarily with internal psychological states, with the drama of thoughts and feelings. *Jacob Blessing the Sons of Joseph* (colorplate 49) shows this new depth of feeling. His use of Jewish models shows his desire for authenticity—the people of the Hebrew Bible in a subject drawn from it. The golden light filtering into the scene from behind the curtain on the left is as gentle as the gestures and glances. A mood of tender silence so pervades the whole picture that we, the onlookers, permitted to watch from the foot of the bed, feel we are part of the scene.

In his later years, Rembrandt sometimes took compositions or ideas from the Northern Renaissance and adapted them to his own highly personal style. One instance is *The Polish Rider* (figure 243). We cannot be sure that the rider is Polish—the title was given to the picture many years after it was painted. All we know is that such costumes were worn in Eastern Europe by fighting men in countries then trying to stand off the Turks. Rembrandt, the greatest printmaker of the seventeenth century, must have known and admired the famous *Knight, Death, and the Devil* by Dürer, the greatest printmaker of the sixteenth (see figure 214). The Polish Rider is another Christian Soldier bravely riding through a perilous world. Rembrandt does not spell out the dangers and the goal, as Dürer did; he leaves them to our imagination. The forbidding landscape and the somber colors suggest that our horseman is not having an easy time; and his serious, alert glance tells

us of unseen dangers. But the determined set of his mouth makes us feel that he will face every difficulty with courage.

If *The Blinding of Samson* reminded us of Rubens, *The Polish Rider* reminds us of Giorgione and Titian. Like those two Venetian masters of the Renaissance, the mature Rembrandt is a maker of moods rather than of stories. And yet *The Polish Rider* remains a Baroque picture. Giorgione (see colorplate 35) respected the limits of his canvas; he

made all his forms stay within the frame. With Rembrandt, on the other hand, the frame does not hold things in place. His horseman is merely passing through, and will soon be out of sight. Since he moves in the direction along which the light in the picture falls, we feel that the light is a force that helps him along. The language of Rembrandt's late style, then, is not so different from that of Rubens after all; he says other things with it. And he joins the great company of Giorgione, Titian, Rubens, and Velázquez as a poet of light and color.

The pictures of Rembrandt's late style demanded an insight that was well beyond all but a few collectors. Most buyers of paintings in Holland preferred subjects as close as possible to their own experience—landscapes, seascapes, architectural views, still lifes, everyday scenes. We have already seen two of these types—landscapes and everyday

245. Rembrandt. *Christ Preaching*. About 1652. Etching. The Metropolitan Museum of Art, New York. Bequest of Mrs. H. O. Havemeyer, 1929. Rembrandt was one of the greatest printmakers who ever lived. The typical process of his day was etching. In this technique, a copper plate is coated, lines are scratched in the coating with a needle, and the plate is then bitten with acid. When inked, the plate will transfer the pattern of bitten lines to the paper.

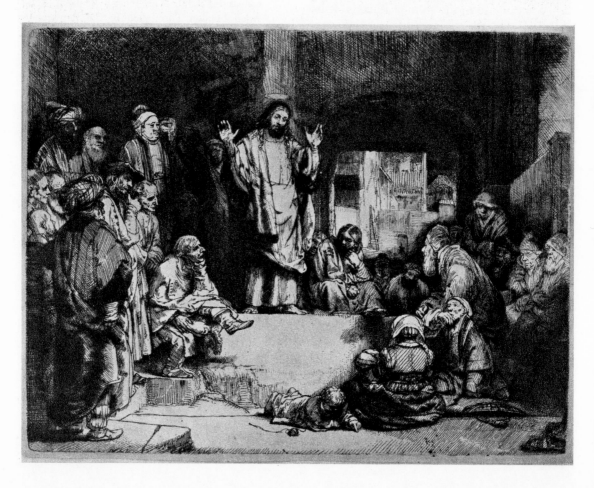

246. Jacob van Ruisdael. *The Jewish Graveyard.* About 1655. Oil on canvas, $32 \times 37\frac{1}{2}$". State Picture Gallery, Dresden. The landscape with ruins, with its melancholy awareness of the passage of time, is an invention of Baroque art.

scenes (see figures 217, 222, and 225)—begin to take on independent existence. In mid-seventeenth-century Holland, painters became specialists in one or another of these types, or even sub-types. Other countries followed Holland's example, and specialization grew.

The most famous seventeenth-century Dutch landscapist was Jacob van Ruisdael. The forces of nature are the theme of his *Jewish Graveyard* (figure 246), although the setting is imaginary. The thunderclouds passing over the wild and deserted countryside, the ruined building, the rushing stream that has forced its way between the ancient graves, all help create a mood of deepest gloom.

Nothing on earth endures, Ruisdael tells us. Time, water, and wind will wear all things down to pebbles and dust—not only the feeble works of man, but trees and rocks as well. He must have felt this way about his own life, for he signed the painting by placing his name on the nearest tombstone.

Willem Claesz. Heda's *Still Life* (figure 247) is a fine work by still another specialist in a single type. Earlier masters had been interested in still life, too, but only as part of

human subjects. Why, then, did Baroque painters regard pure still lifes as important enough to frame? And how did they decide what to put into such pictures? In Heda's painting, the silver dish and the great glass goblet are fine, expensive pieces interesting in themselves. The oysters go with the wine in the goblet; and the lemon goes with the oysters. Are we perhaps meant to wonder why this elegant lunch was left uneaten? The silver dish has been upset and one of the goblets is broken, but the whole arrangement is too tasteful and well balanced to fit any kind of story.

What really explains this still life is light

247. Willem Claesz. Heda. *Still Life*. 1634. Oil on panel, 17 × 22½″. Boymans-van Beuningen Museum, Rotterdam. Seventeenth-century Dutch artists were specialists in a tremendous variety of well-defined fields. Heda specialized in "breakfast" still lifes such as this.

—Heda's interest in light and in the way all these surfaces absorb it, pass it, and reflect it. The objects have been carefully chosen and as carefully arranged for their similarities and contrasts of shape, color, texture, and effect upon the light that strikes them.

We shall look next at two of the large and extremely varied class of pictures termed *genre*, which is to say, scenes from daily life.

The Eve of St. Nicholas (figure 248) shows a family at Christmas time. St. Nicholas has just visited the children and dealt out toys, sweets, and the traditional Dutch honey cake. Everybody is jolly except the bad boy on the left, who has received nothing but a birch rod. Steen tells this story with relish and embroiders it with a host of details.

In the genre scenes of Jan Vermeer there is hardly any narrative. Steen, the storyteller, had the sharp sense of timing we saw in Frans Hals. Vermeer, by contrast, shows us a world

without time. In *The Letter* (colorplate 50), the two women no more than exchange glances. They exist in a still-life world, calmed by some magic spell. The cool, clear light that filters in from the left is the picture's only active element, working its miracles upon all the objects in its path. As we look at *The Letter*, we feel that a veil has been lifted from our eyes: the everyday world shines with jewel-like freshness, beautiful as we have never seen it before. Not since Jan van Eyck has any painter *seen* so intensely. Vermeer completes what Van Eyck began, but he is also a discoverer in his own right. And he shows us seen reality not only as a perspective window, but also as a surface pattern made up of geometric forms, a field composed of fields. Rectangles predominate, carefully aligned with the picture surface; and there are no holes, no undefined empty areas. These interlocking shapes give Vermeer a unique and startlingly modern quality in the otherwise rather remote world of seventeenth-century art. How did he acquire this amazing vision? Almost all we know of him is that he was born in Delft in 1632 and died there 43 years later —nothing to explain the development of a

248. Jan Steen. *The Eve of St. Nicholas.* About 1660–65. Oil on canvas, 32¼ × 27¾″. Rijksmuseum, Amsterdam. Steen was an innkeeper because he could not support himself by his painting alone. This experience may explain his keen insight into human behavior.

style so beyond its time in its originality that Vermeer's genius was not even recognized until a century ago.

The Age of Versailles

France, in the middle of the seventeenth century, was the richest and most powerful country in Europe. The destiny of art fell into French hands, and Paris replaced Rome as Europe's cultural and artistic capital—a position Paris has maintained ever since. The French monarchy took command of cultural life, imposing a classical stamp on literature, architecture, sculpture, and painting. An antiquarian, noble, and heroic point of view was insisted upon. No other kind of art would do. The naturalism of Caravaggio and the sensuous appeal of Rubens and the Venetians fell into disgrace along with the luminous vision of Velázquez. We should not be surprised, then, to find that Georges de La Tour and Louis Le Nain, two astonishingly original French painters of the early seventeenth century, were forgotten until recent times. For both were inspired by Caravaggio, although in different ways. La Tour's *Joseph the Carpenter* (figure 249) could easily be taken for a genre painting, yet its religious spirit is as strong as that of Caravaggio's *Calling of St.*

left:

249. Georges de La Tour. *Joseph the Carpenter*. About
1645. Oil on canvas, 38½ × 25½″. The Louvre,
Paris. Like Vermeer, La Tour is far more
famous now than he was in his own day. His
pictures, which contain indirect echoes of
Caravaggio, combine clarity of form with
tenderness of feeling.

below:

250. Louis Le Nain. *Peasant Family*. About 1640. Oil
on canvas, 44½ × 62½″. The Louvre, Paris.
Although the impact of Caravaggio is plain here,
Le Nain has less in common with La Tour than
with the low-life scenes by the young Velázquez
(see figure 238). Two centuries later, the dig-
nity and humanity of Le Nain's poverty-stricken
peasants were to inspire Courbet and, indirectly,
Van Gogh (see figures 295 and 308).

251. Nicolas Poussin. *Landscape with the Burial of
Phocion.* 1648. Oil on canvas, 44⅞ × 68⅞".
The Louvre, Paris. This austerely beautiful
picture stems from the "classical landscape" of
Annibale Carracci (see figure 227). Poussin's
view of nature and of man's place therein was
a nostalgic vision of harmony and stability.

Matthew (see colorplate 45). The light from
the candle—La Tour's favorite device—held
by the boy Jesus gives the scene an intimacy
and tenderness that may remind us of Geert-
gen tot Sint Jans' *Nativity* (figure 153). Like
Geertgen before him, La Tour reduced his
forms to geometric simplicity. Le Nain's
Peasant Family (figure 250), unlike Steen's
genre pictures (see figure 248), has nothing
humorous or sentimental about it. It matches
Velázquez' commanding *Water Carrier of
Seville* (see figure 238) in human dignity.

The foundations of the classicistic French
Baroque were laid by Nicolas Poussin, the
greatest French painter of the seventeenth

century and the earliest French master to win
international fame. Poussin himself preferred
not to live in Paris. He spent most of his life
in Rome at a comfortable distance from the
pressures of the court. The French, even
today, are reluctant to use the word "Ba-
roque" for the style of Poussin and his succes-
sors. They see the Raphael in it, and call it
"classic." The Raphael in it came mostly by
way of Annibale Carracci, however, and
French classicistic art was very much a part
of its Baroque world.

In Poussin's *Abduction of the Sabine Women*
(figure 252), we see the elements of the vic-
torious classicism of the latter half of the cen-
tury. The subject is classical and literary, and
a noble or serious human action is represented.
The figures are generalized and heroic, not
individual and realistic. An intellectual ap-
proach is taken, not an appeal to the senses.
Form and composition are emphasized, and
color is of secondary importance. The story
of this picture comes from a legendary tale of

early Rome. The founders of the city, all of them men, got wives for themselves by trickery. Romulus, their leader, after inviting the Sabine tribe into the new settlement for a peaceful celebration, gave a signal to his followers, who then carried off the Sabine women by force. Although there are echoes of Rubens and Carracci here, the figures are frozen in action, like so many statues. Many were in fact taken from Hellenistic sculpture. The buildings shown behind them were believed by Poussin to be authentically Roman. The entire picture suggests that the artist knew his mind almost too well. Poussin's

252. Nicolas Poussin. *The Abduction of the Sabine Women*. About 1636–37. Oil on canvas, 61 × 82½″. The Metropolitan Museum of Art, New York. Dick Fund, 1946. Poussin was more at home in Italy than in France. He became the Baroque world's greatest guardian of the classical tradition, a tradition that stretched from Annibale Carracci back to Raphael and ancient Roman art.

style did not just grow; he constructed it by conscious effort. His goal was a stable, balanced art in which form and color, thought and feeling, truth and beauty, the ideal and the real, were all in harmony. In letters to his friends and patrons, he discussed his ideas at great length. Sometimes a single picture was explained, at other times his general theories about art. He believed that correct art obeyed eternal laws and was confident that these could be worked out by human reason, much as the mechanical laws of nature were being worked out by the great scientific minds of the century.

Poussin's genius speaks to us with full voice in the marvelously organized *Landscape with the Burial of Phocion* (figure 251), where structural clarity and mathematical discipline are sustained through every square inch of canvas. The theme is the burial of a Greek hero who died because he would not conceal the truth. The austerely beautiful landscape

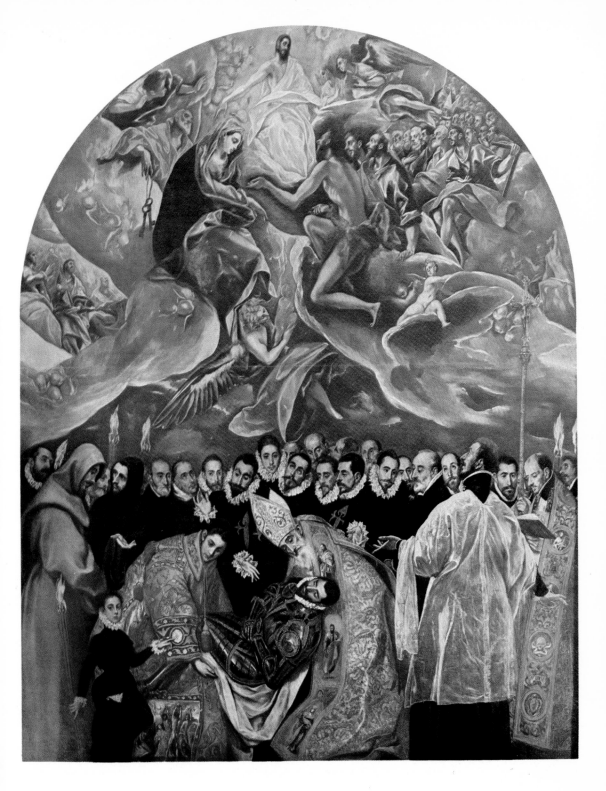

Colorplate 40. El Greco. *The Burial of Count Orgaz*. 1586. Oil on canvas, 16′ × 11′ 10″. Santo Tomé,
 Toledo, Spain

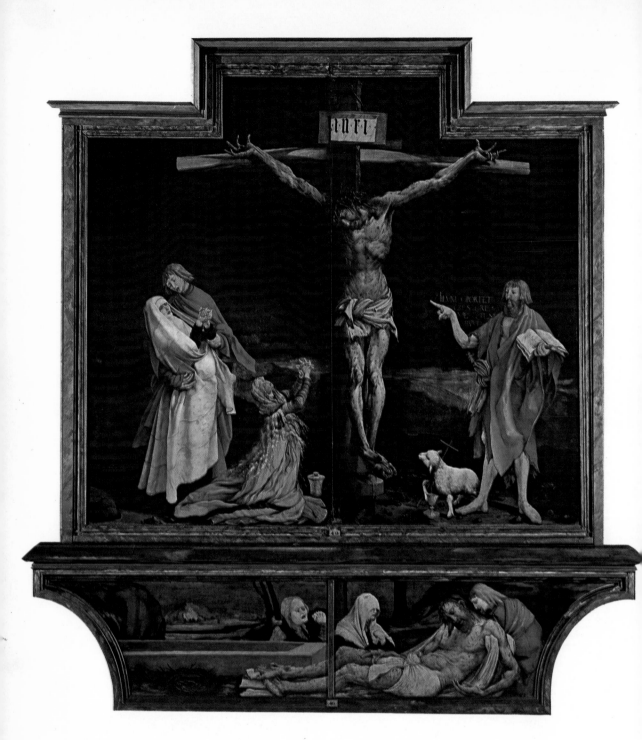

Colorplate 41. Matthias Grünewald. *Crucifixion*, from the *Isenheim Altarpiece* (closed). About 1511–12. Oil on panel, 8′ 10″ × 10′ 1″. Musée Unterlinden, Colmar, France (see also figure 212)

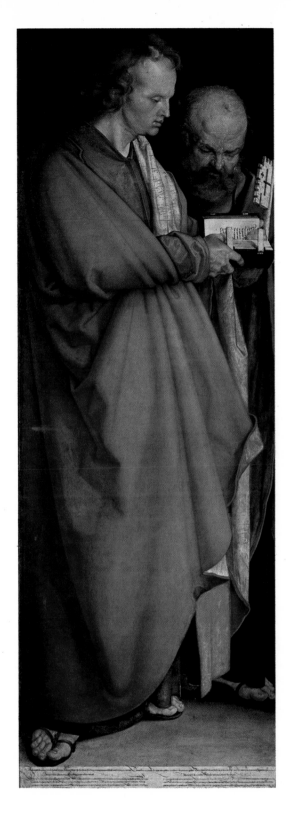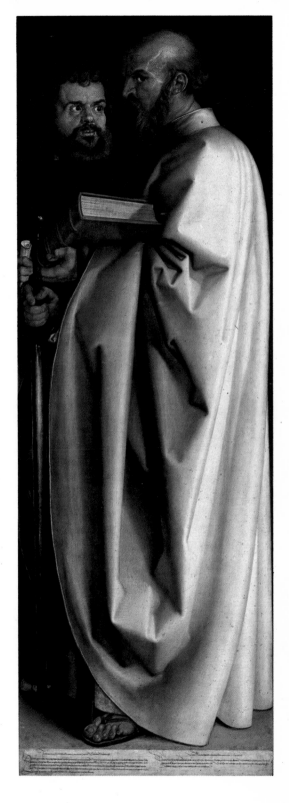

Colorplate 42. Albrecht Dürer. *The Four Apostles*. 1523–26. Oil on panels, each $85 \times 30''$.
Pinakothek, Munich

Colorplate 43. Hans Holbein the Younger. *Henry VIII*. 1540. Oil and tempera on panel, 32½ × 29″. National Gallery, Rome

Colorplate 44. Pieter Bruegel the Elder. *The Land of Cockayne*. 1567. Oil and tempera on panel, 20½ × 30¾″. Pinakothek, Munich

Colorplate 45. Caravaggio. *The Calling of St. Matthew*. About 1597–98. Oil on canvas, 11′ 1″ ×
11′ 5″. Contarelli Chapel, San Luigi dei Francesi, Rome

Colorplate 46. Peter Paul Rubens. *The Garden of Love*. About 1632–34. Oil on canvas, 6′6″×9′3½″. The Prado, Madrid

Colorplate 48. Frans Hals. *The Jolly Toper*. 1627. Oil on canvas, 31⅞ × 26¼″. Rijksmuseum,
 Amsterdam

Colorplate 49. Rembrandt. *Jacob Blessing the Sons of Joseph*. 1656. Oil on canvas, 5′ 8½″ × 6′ 11½″.
Gemäldegalerie, Kassel, Germany

Colorplate 50. Jan Vermeer van Delft. *The Letter*. 1666. Oil on canvas, 17¼ × 15¼". Rijksmuseum,
 Amsterdam

Colorplate 51. Balthasar Neumann. The Kaisersaal, Episcopal Palace, Würzburg. 1719–44

Colorplate 52. Antoine Watteau. *A Pilgrimage to Cythera*. 1717. Oil on canvas, 4′ 3″ × 6′ 4½″.
The Louvre, Paris

Colorplate 53. Jean-Baptiste Siméon Chardin. *Back from the Market*. 1739. Oil on canvas, 18½ × 14¾″. The Louvre, Paris

Colorplate 54. Jean-Honoré Fragonard. *Bathers*. About 1765. Oil on canvas, $25\frac{1}{4} \times 31\frac{1}{2}''$. The Louvre, Paris. In Watteau's most gifted successor we find both the virtues and shortcomings of the Rococo masters of the later eighteenth century : refined sensuousness but lack of emotional depth.

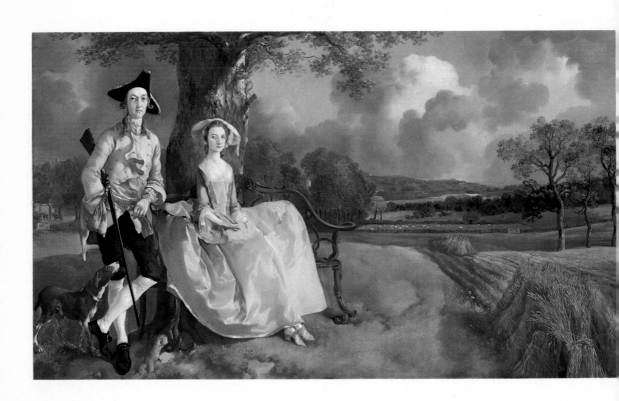

Colorplate 55. Thomas Gainsborough. *Robert Andrews and His Wife*. About 1748–50. Oil on canvas, 27½ × 47″. The National Gallery, London (Reproduced by courtesy of the Trustees)

of this picture is in keeping with the theme, a memorial to Stoic virtue.

The triumph of classicism became complete in 1661, when Louis XIV, the "Sun King" on whose will everything French depended, took over the reins of governmental power. In his system of government—expressed in his own words, "I am the State"—the task of the arts was to glorify the King. The King's "first painter," Charles Lebrun, who had been Poussin's pupil in Rome, was for all practical purposes the dictator of art in France. Under Lebrun, classicism became the official royal style. He imposed it on the artists of France through his directorship of the only institution allowed by law to educate them—the Royal Academy of Painting and Sculpture. In the Middle Ages and the Renaissance, young artists had been trained in the workshops of older men. By 1600, this kind of training was no longer enough; artists now had to have a good deal of formal education, including a knowledge of science and of art theory. Certain masters founded private academies, where these things were taught to young artists. At the Royal Academy, practice and theory were now combined in a course of instruction whose systematic rules gave students an obligatory standard of style and beauty. The teachers—following Poussin's example—took pictures apart as though they were rather complex machines. One teacher even prepared a scoreboard for all the great artists, marking each in drawing, color, and "expression." (Poor Caravaggio got a zero in expression; and the Venetians, Flemish, and Dutch—in that order—landed at the bottom of the list.) The Royal Academy was the model for all later academies. Its echoes still sound in the dogmatic attitudes of many art schools today. But the Academy produced not a single artist of Poussin's genius.

The issue of classicism versus the Italian Baroque was sharply drawn in 1665, when Bernini was invited to Paris to submit designs for completing the Palace of the Louvre. The open court on the east side of the palace needed to be closed off. Bernini submitted several majestic designs in the style that had served the Church so well. All were on a scale that would have dwarfed the rest of the palace. There was much opposition to Bernini and his ideas, and Louis XIV rejected the plans. The problem was turned over to a commission consisting of Lebrun, the royal architect Louis

253. Pierre Puget. *Milo of Crotona*. 1671–83. Marble, height 8′ 10½″. The Louvre, Paris. Puget, the greatest and most Baroque of seventeenth-century French sculptors, had no success at court until Lebrun's power was on the decline. This statue, his finest, would not be unworthy of Bernini.

above:

254. Claude Perrault. East Front of the Louvre,
 Paris. 1667–70. This work signaled the victory
 of French classicism over Italian Baroque as the
 royal style.

below:

255. Louis Le Vau and Jules Hardouin-Mansart.
 Garden Front, Palace of Versailles. 1669–85.
 The Garden Front, intended by Le Vau to be
 the principal view of the palace, was stretched
 out by Mansart to an enormous length without
 any change in the arrangement of architectural
 members. The whole center block contains one
 great hall.

256. Hardouin-Mansart, Lebrun, and Coysevox. Salon de la Guerre, Palace of Versailles. Begun 1678. Lebrun was a magnificent decorator and used the combined labors of architects, painters, sculptors, and craftsmen for interiors of unheard-of splendor. To subordinate all the arts to a single goal—here the glorification of Louis XIV, whom we see in the equestrian relief by the sculptor Coysevox in the center of the end wall—was a Baroque idea.

Le Vau, and the physician and architectural theorist Claude Perrault. Le Vau became occupied with the vast new enterprise of the Palace of Versailles, and Perrault was chiefly responsible for the final design (figure 254). Linking Louis XIV with the glory of the Caesars, this design marked the victory of the native French classicism over all other varieties of Baroque. The great central entrance section is a pedimented temple front with paired columns two stories high set above the ground floor. A free-standing colonnade stretches away on either side. Pure in detail, the East Front of the Louvre combines grandeur and elegance in a way that thoroughly justifies its fame.

Perrault's East Front was the cornerstone of French architectural classicism, but it was a little too pure for Louis XIV's personal taste. The first buildings of the huge palace and gardens covering the countryside at Versailles were far richer in Baroque decoration. The King was especially interested in gorgeous interiors that would make appropriate settings for himself and his glittering court. These interiors were entrusted to Lebrun, who proved himself to be a superb decorator as he utilized the combined labors of architects, sculptors, painters, and craftsmen for rooms of unheard-of splendor, for example, the Salon de la Guerre (figure 256). Construction of the main palace was begun in 1669 by Le Vau, who designed the Garden Front. He died within the year, and Jules

below:

257. Sir Christopher Wren. Façade, St. Paul's Cathedral, London. 1675–1710. English Baroque architecture was inspired by both Italian and French models. Wren's beautiful dome, which looks like a vastly enlarged version of Bramante's Tempietto, rises high above the rest of the structure and dominates even a close view of the facade.

Hardouin-Mansart took charge of the project, now greatly expanded. The Garden Front, intended by Le Vau to be the principal view of the palace, was stretched to an enormous length (figure 255). It is essentially a less severe version of the East Front of the Louvre.

English architecture of the seventeenth century followed the French pattern of classicism, as we see in St. Paul's Cathedral (figure 257) by the great English scientist and architect Sir Christopher Wren. Here the dome looks like a greatly enlarged version of Bramante's Tempietto (see figure 192). The free-standing paired columns of the entrance portico clearly reflect Perrault's design for the East Front of the Louvre (see figure 254)— Wren had visited Paris at the time of the dispute over the completion of the Louvre. In other respects, St. Paul's is thoroughly Baroque. Wren must have wanted St. Paul's to be the St. Peter's of the Church of England— soberer, not so large, but just as impressive.

Rococo

The dawn of the eighteenth century witnessed a major shift in French taste and manners. The stern grip of the Academy on the art of the nation relaxed after Lebrun's death in 1690. When Louis XIV died in 1715, to be succeeded by his great-grandson, it was as though the entire French court had decided to go on a holiday. The nobles deserted the Royal Palace of Versailles, where the King had forced them to live, and built themselves elegant town houses in Paris. For the aristocracy, at least, it was an age of diversions, of play acting, of pretending to live in a delightful world so free from care that all their time could be devoted to the pursuit of pleasure.

The new town houses were in the Rococo, or Louis XV style, which answered a demand for decoration more graceful and intimate than the stiff, formal interiors of the age of Louis XIV. Overwhelming grandeur was no longer desired. The Rococo was a refined, miniature version of the curving, elastic Baroque invented by Borromini (see pages 225, 227). The town house of the Prince de Soubise (figure 258), by Germain Boffrand, is one of the finest examples of Rococo style.

The Rococo style of Paris had a monumental counterpart in Austria and Germany, where the life of aristocratic society still revolved around royal and princely courts. The Austrian and German churches and palaces of the early eighteenth century, although they included some of the most imaginative structures ever built by man, were anything but playful. The term "Rococo" is not really appropriate for the huge, impressive structures east of the Rhine, which we call Late Baroque. In these, the Baroque style reached a dazzling climax.

Colorplate 51 shows us one of the most famous of German Late Baroque interiors, the breathtaking Kaisersaal of the Bishop's Palace in Würzburg. Balthasar Neumann, a supremely talented architect, designed it; the Venetian Giovanni Battista Tiepolo, the last and the most brilliant of perspective ceiling painters, did the ceiling decoration. This great oval hall in white, gold, and pastel tones— the favorite mid-eighteenth-century color scheme—seems as weightless as the nave of any Gothic cathedral. The underside of the vault looks as thin and taut as the surface of a balloon inflated to the bursting point. The white areas of walls and ceiling are traced over with the swirling, irregular ornamental patterns invented by Parisian decorators. Above the columns are painted the only dense groups of figures (figure 260). The ceiling around

258. Germain Boffrand. Salon de la Princesse, Hôtel de Soubise, Paris. Begun 1732. After the death of Louis XIV, the life of aristocratic society centered on the new town houses of Paris instead of the royal court of Versailles. The decoration of the town houses was intimate and playful, a miniature version of the dynamic Baroque style of Borromini.

settings in which are placed actors from the comic theater or sophisticated young aristocrats amusing themselves.

A Pilgrimage to Cythera is like a scene in the theater. The young people we see here have come to the island of Cythera to pay homage to Venus, whose flower-decked image appears on the far right. The enchanted day has drawn to a close, and now, accompanied by swarms of cupids, they troop to the gilded Rococo barge that will return them to the everyday world. This poetic scene recalls Rubens' *Garden of Love* (colorplate 46); and the easy, flowing brushwork and splendid color unmistakably come from Rubens. Watteau lacks the energy and sweep of the great Fleming. But his figures, delicate and slender,

and above them so frequently melts into a limitless depth of blue sky and sunlit clouds that we feel that we are out-of-doors. In the soaring, constantly expanding interior space of the Kaisersaal, we can sense the Gothic spirit reborn.

It should not surprise us that the hero of early eighteenth-century easel painters was no longer Poussin but Rubens, who stood for everything the Academy had frowned upon: light, color, movement, and joy. The first painter of the Rococo era, and by far the most gifted, was Antoine Watteau, who came from the northern border of France, close to Flanders. In 1717, Watteau was admitted to the Academy on the strength of his *Pilgrimage to Cythera* (colorplate 52). This picture was not only thoroughly unacademic, but was impossible to pigeonhole according to the classes of painting that the Academy recognized and accepted. The Academy was by now very obliging, however, and invented for Watteau the new class of *fête galante* (elegant party). Wattean's *fêtes galantes* have park-like

259. Jakob Prandtauer. The Monastery of Melk, Austria. Begun 1702. The buildings of Melk form a tightly knit unit that centers on the dome and towers of the monastery church. Occupying the crest of a huge rock, Melk rises above the Danube like a vision of heavenly glory.

at left:
260. Giovanni Battista Tiepolo. Ceiling Fresco of the Kaisersaal (detail). 1751. Episcopal Palace, Würzburg, Bavaria. The Würzburg frescoes (compare colorplate 51) climax the astonishing interior architecture of Balthasar Neumann's palace for the Bishop of Würzburg. Gay, opulent, and facile, Tiepolo's masterpiece celebrates the final triumph of the Baroque imagination.

half gay, half sad, move with the assurance of superb actors who know how to touch our emotions.

There was more to eighteenth-century French society than the amusements of aristocrats, and more to eighteenth-century French painting than *fêtes galantes*. We see this other side in the work of Jean-Baptiste Siméon Chardin, whose *Back from the Market* (colorplate 53) shows a middle-class Parisian household. There is so great a feeling here for the beauty of the commonplace, and so clear a sense of spatial order, that we can compare Chardin to Vermeer. Chardin's remarkable technique, however, is unlike any Dutch artist's. The well-placed, creamy brushstrokes describe the light on colored surfaces with poetic sensitivity.

Chardin was as remarkable a still-life painter as he was a genre painter. In figure 262 we see simple, modest objects: earthenware jugs, a copper pot, uncooked meat, chicken, fish, and two eggs. Heda (compare figure 247) was concerned to show us oysters and lemons, fine silver and glass—costly foods and proud possessions. But not Chardin—the objects he shows us are workaday and unpretentious. He tells us about them in his artist's language of light, color, texture, form, and space. His respect for these simple things borders on reverence. They symbolize the life of the common man, who may some day take power away from king and noble and begin to govern himself.

Frenchmen who shared Chardin's reverence for the common man envied and admired the English, who in the eighteenth century were the leaders of Europe's political and intellectual life. The people of England had some voice in how they would be governed. They had carried out a revolution in the seventeenth century, and the English king now shared his powers with Parliament. The English colonies prospered, and the English navy and merchant fleet ruled the seas. And England, once again, was playing an important part in the visual arts.

Except for portraiture, there had been little painting in England since the Reformation. The leading portraitists, moreover, had been foreigners: Holbein in the sixteenth century, Van Dyck in the seventeenth. Even in the eighteenth century, when native English artists came to the fore, only portraits provided

261. Étienne-Maurice Falconet. *Equestrian Monument of Peter the Great*. 1766–82. Bronze, over lifesize. Leningrad. Most eighteenth-century French sculpture was small and coquettish, and commissions for monumental pieces were few and far between. But this statue of Peter the Great created for Catherine II shows that Falconet was capable of recapturing Baroque grandeur.

above:

262. Jean-Baptiste Siméon Chardin. *Kitchen Still Life.* About 1730–35. Oil on canvas, 12½ × 15¼". Ashmolean Museum, Oxford. Chardin is clearly influenced by Dutch still lifes (compare figure 247). But instead of objects that are interesting in themselves he shows us common household things, beautiful because of the way they are grouped and painted.

below:

263. William Hogarth. *The Orgy*, Scene III from *The Rake's Progress.* About 1734. Oil on canvas, 24½ × 29½". Sir John Soane's Museum, London. Hogarth's sermon is so full of the spice of life that we can enjoy it without taking its lesson at face value. Greuze (compare figure 268) has often been called "the French Hogarth." Greuze was unworthy of the compliment, despite his debt to the inventor of these pictorial morality plays.

painters with a steady living. But many painted other subjects as important sidelines, so that genre scenes and landscapes also found a home in England. William Hogarth was such a painter. He was a great portraitist, but his interest lay in realistic scenes from daily life, much like those of Dutch genre painters of the previous century. Hogarth gave a sharp satirical twist to his genre scenes and strung them together into long series that told a connected story picture by picture. He thought of them as wordless plays; he wished to be judged as a dramatist, he said, even though his actors could only "exhibit a dumb show." His narrative series all taught the solid middle-class virtues by dramatizing the dreadful consequences of giving in to fleshly temptations. *The Orgy* (figure 263) is Scene III from the

below left:

264. Thomas Gainsborough. *Mrs. Siddons.* 1785. Oil on canvas, 49½ × 39″. The National Gallery, London

below:

265. Sir Joshua Reynolds. *Mrs. Siddons as the Tragic Muse.* 1784. Oil on canvas, 93 × 57½″. Henry E. Huntington Library and Art Gallery, San Marino, California

Gainsborough shows the great London actress as a coolly elegant lady of fashion. Reynolds, the history painter in the "grand manner" and formulator of art theories resembling those of Lebrun a hundred years before, finds it necessary to "ennoble" his portrait with allegories, props, and disguises. Reynolds almost succeeded in making painting respectable in England (he received an honorary doctorate from Oxford) but at great cost to English art. He was generous enough to give praise to Gainsborough, whose talent he must have envied.

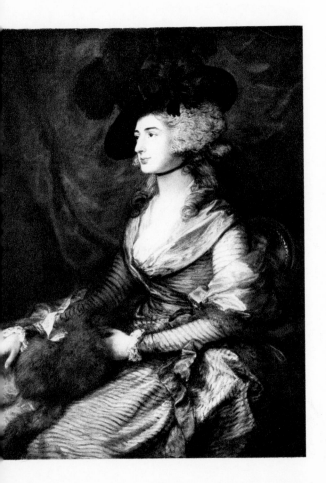

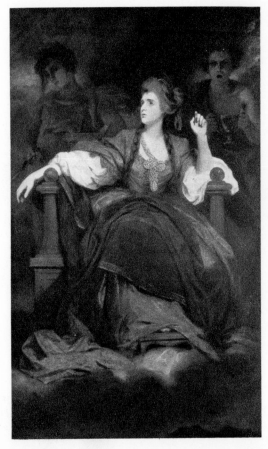

series *The Rake's Progress*. Here a young man of weak moral fiber is giving in to the temptations of wine and women; in the last picture of the series he will meet a miserable end. Hogarth combines something of Watteau's sparkle with an enthusiasm as hearty as Jan Steen's (see figure 248). Few other painters have had so observant an eye, and none so salty a sense of humor.

The new English portrait style departed from Continental traditions. England's greatest portrait painter was Thomas Gainsborough, who was her greatest landscapist as well—as we see in the portrait of *Robert Andrews and His Wife* (colorplate 55). The casual charm of this work is not often found in Gainsborough's later pictures. The landscape,

although derived from Ruisdael, is very English in its sunny, hospitable mood. The relaxed and natural poses of the country gentleman and his lady are also characteristically English.

Gainsborough's portrait of Mrs. Siddons, the great actress (figure 264), was painted much later and has different virtues: a cool elegance and brilliantly fluid technique based on Van Dyck (compare figure 237). This picture was painted for the deliberate purpose of inviting comparison with his great rival Sir Joshua Reynolds, the first president of England's Royal Academy, who had painted Mrs. Siddons as the Tragic Muse (figure 265) a year before. Few modern viewers find the comparison favorable to Sir Joshua.

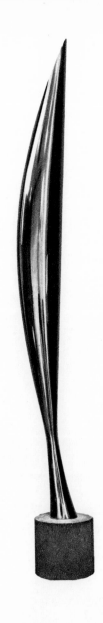

PART FOUR

The Modern World

Revolution and Revivals

When religion and kingship ceased to command the allegiance of Western peoples, the end was near for the Renaissance-Baroque era. Political revolutions in America and France soon launched a new age of rapid and violent change, eventually producing our own modern world of science, mass industry, giant cities, and faster-than-sound travel. The ideas and feelings that shaped Renaissance-Baroque art have little strength today, so little that almost every important painter or sculptor has abandoned Renaissance habits of representation. The picture surface has ceased to be a window into space. Painted and sculptured images have ceased to be convincing likenesses of the people and things in the world around us. Artists have cast off the framework of tradi-

tional authority; they choose their own messages and invent their own styles. No limits are imposed upon them. This utter freedom exhilarates them—but it frightens them, too.

In our time, stylistic changes come so fast that what is new today is old tomorrow. Styles by the dozen, old and new, exist together. During the first century of the modern era, change came more slowly. There was a great clashing of styles, each with its set of dedicated champions. The styles were not exactly new, for eighteenth-century style was continued and earlier styles were revived (revival of past style was an important characteristic of the earlier modern period). But they were not the same old styles, either, for they were filled with the new spirit we call Romanticism.

The Romantic Movement

Romanticism is a state of mind. The Romantic attitude arose as an emotional reaction against the established order in all its aspects, but especially religion and politics. It could be defined, perhaps, as religious feeling become secular.

The most influential minds of the later eighteenth century held that life had become too formal, too artificial, too far removed from its base in nature. A cult of the natural took shape, its heroes the nonconformist who was his individual self and defied social convention; the "noble savage," who lived in dignity and freedom in a "state of nature"; the

poor man, simple, good, and honest—the polar opposite of the immoral and effete aristocrat. As Romanticism grew, not only were nature and freedom worshiped, but also the wild, the strange, the marvelous, the melancholy, and the world remote in space or time: Classic Greece, the Middle Ages, the forests of America, the kingdoms of the East. One after the other, such styles of the past as Roman, Gothic, Greek, Renaissance, Baroque, and Romanesque were resurrected by artists who felt in tune with them.

The first stirrings of Romanticism were a matter of content, not style. We see them in

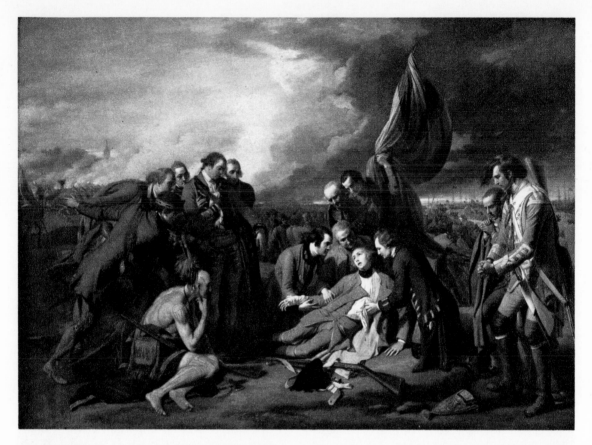

266. Benjamin West. *The Death of General Wolfe.* 1770. Oil on canvas, 59½ × 84". National Gallery of Canada, Ottawa. West created a sensation when he arrived in Rome in 1760, since no American painter had ever appeared in Europe before. He became a founder-member of the Royal Academy and, after Reynolds' death, its president. His career thus was European rather than American, but he always took pride in his New World background and trained many American painters who went to London to study under him.

the work of two Americans of the late eighteenth century. By then the English colonies in America were old enough to have fine painters of their own.

Both artists, Benjamin West of Pennsylvania and John Singleton Copley of Boston, went to London not long before the American Revolution. There they had such success that they stayed for good. West even became president of the British Royal Academy. After the Revolution an entire generation of American painters traveled to London to study under him.

West's *Death of General Wolfe at Quebec* (figure 266), placed in the New World for us by the prominent figure of an Indian brave, brings to our mind the "grand manner" of Poussin, for the action is "noble and serious," and the attitudes and expressions are heroic. The subject of this painting is not religious, but the composition echoes an ancient and hallowed religious theme: the lamentation over the dead Christ (see colorplate 19). We are, then, present at the transfer of emotional allegiance from religion to national patriotism. No wonder this picture had an army of successors in the nineteenth century.

A new spirit is plainer, perhaps, in Copley's *Watson and the Shark* (figure 267). Brook Watson, as a young man swimming in Havana harbor, was attacked by a huge shark. Years later, he commissioned Copley to describe that terrifying experience, in which he had lost a leg. Copley turned Watson's story into

a vivid picture. Following West's example, he made the details as authentic as he knew how (the Negro here places the scene in the New World just as the Indian did in West's *Death of General Wolfe*). For this painting Copley dipped freely into his inherited Baroque stockpile of movement, glance, and gesture in order to enlist our emotions and make us part of the event. Caravaggio himself could not have timed the action better. The psychological tension here is very great. The shark has become a monstrous embodiment of evil. The man fending it off with a boat hook is almost an Archangel Michael fighting Satan. The naked youth flounders between contending forces of salvation and doom; and even though the sailors are pulling him out of the water, not throwing him in, the parallel with the story of Jonah and the Whale seems clear

enough. This painting is Romantic in its New World setting, in its fascination with terrifying experience, in the way it endows a personal, private adventure with the symbolic significance formerly reserved for Bible stories and classical myths.

Romanticism, born in England, found its natural home on the Continent. The melodramatic *Village Bride* (figure 268) by the Frenchman Jean-Baptiste Greuze created a

267. John Singleton Copley. *Watson and the Shark*. 1778. Oil on canvas, 72½ × 90¼″. Museum of Fine Arts, Boston. Copley painted this picture in the hope of gaining full membership in the Royal Academy. Far more than a show piece, it recreates Mr. Watson's ordeal with such passion that it becomes a modern equivalent of the heroic tales of the ancients and an inspiration to many later artists.

sensation when unveiled in 1761. In keeping with the advanced opinion of the day, it was a pious rebuke to the immorality of the pleasure-loving aristocracy and a hymn of praise to the honesty and virtue of simple country people. Its dumb-show narrative, borrowed from Hogarth (compare figure 263), has none of Hogarth's keen satirical wit; Greuze's social message is delivered head-on. Without the saving grace of humor, the painting becomes a sentimental caricature by present-day standards: the bride seems altogether too bashful, the mother too tear-stained, the grandfather too venerable. But *The Village Bride* was promptly declared a masterpiece by the French philosophers of the Enlightenment. They were delighted to find a painter who addressed himself wholeheartedly to his viewers' moral sense, and they overlooked what we tend to regard as artistic shortcomings. They admired Greuze less, however, when after a while an even more sternly moralizing and immeasurably more gifted painter appeared. This was Jacques Louis David.

David's work was the highest expression of the anti-Rococo revolt, in both content and style. The classicism of *The Death of Socrates* (figure 269) out-Poussins Poussin himself, for the figures are all parallel with the picture surface, as in ancient reliefs. Sharply lit and minutely realistic in detail, they seem as firm and solid as statues, and just as still. Socrates,

268. Jean-Baptiste Greuze. *The Village Bride*. 1761. Oil on canvas, 36 × 46½". The Louvre, Paris. It is hard for us today to understand why Greuze was hailed as the apostle of a return to nature, for the theatricality of his works makes us suspect that he actually cared very little about how people behave and feel.

above:

269. Jacques Louis David. *The Death of Socrates.* 1787. Oil on canvas, The Metropolitan Museum of Art, New York. Wolfe Fund, 1931. This picture marks a return to the severe ideals of Poussin. Its heroic theme and relief-like Neoclassic design are a protest against the sensuous, pleasure-centered art fostered by Rococo society.

about to drain the poison cup, is shown not only as a virtuous and heroic defender of freedom in ancient Athens, but, in addition, as the actual founder of the religion of Reason. He is a Christlike figure—there are twelve disciples in this scene. This picture breathes the political ideals of the French Revolution, for which it is helping to pave the way. Even its severity of style is a rebuke to the followers of Watteau, now looked upon as mere pleasure seekers with nothing worthwhile to say.

Because David and his followers went so much further than Poussin in admiring and imitating ancient art, we speak of this first revival style of the Romantic era as Neoclassic.

270. Jacques Louis David. *The Death of Marat.* 1793. Oil on canvas, $65 \times 50\frac{1}{2}''$. Royal Museum of Fine Arts, Brussels. This picture, painted to "avenge the murder of Marat," was placed in the meeting hall of the Deputies during the French Revolution. A 1795 decree forbidding the public display of any portrait whose subject had not been dead for ten years forced its removal. The painting followed David to Brussels, where the artist took refuge after Napoleon's downfall.

271. Antoine-Jean Gros. *Napoleon at Arcole.* 1796. Oil on canvas, 29½ × 23″. The Louvre, Paris. This splendid, frankly hero-worshiping portrait was painted when Gros was twenty-five and Napoleon twenty-seven. A tide of emotion has swept away David's Neoclassic doctrine, replacing it with the color and drama derived from the Baroque.

Neoclassicism to David was the very spirit of the Revolution, in which he took an active part. He became its official painter (see *The Death of Marat*, figure 270) and a figure of authority as great, almost, as Lebrun had been a hundred years before. His attitude toward any deviation from Neoclassicism was uncompromising. Neoclassicism was the official style approved by the government during the First Republic, the Empire, and the restored monarchy that followed. But the impulses of the period were too many and various to be contained by Neoclassicism alone, and a contending style arose.

David's favorite pupil, Antoine-Jean Gros, outshone him as a painter of the Napoleonic myth. Figure 271 shows us Gros's hero-worshiping portrait of Napoleon as a twenty-seven-year-old general leading his troops during a battle in Italy. The painting conveys Napoleon's magic as a man of destiny with a rush of emotion that David could never match. Much as Gros respected his teacher's doctrines, an inner drive turned him toward the Baroque. The true Romantic was sustained by emotion more than by food and drink. Neoclassic style, which was tight and controlled, had a built-in resistance to emotional flow. The Baroque, with its color, drama, and force, provided outlets for it.

Most distinguished Romantic painters belonged to the neo-Baroque trend, including the one artist of the age who was unquestionably a genius: the Spaniard Francisco Goya. Goya's first works were in a delightful Rococo vein, which he abandoned later for a style based on Velázquez and Rembrandt. Goya was chief painter to the royal court when he painted *The Family of Charles IV* (figure 272) in 1800. This group portrait is a variation on the theme of Velázquez' *Maids of Honor* (see figure 239 and colorplate 47). The entire royal clan has come to visit the artist, who is working in one of the picture galleries of the palace. As in Velázquez' painting, shadowed canvases hang in the background; light pours in from the side; and the brushwork sparkles and glows. Was Goya burying himself in the admired past? Not at all. He was turning seventeenth-century style upside down and making it nineteenth-century and revolutionary. This court painter is most unlike the court painters of previous centuries. Obviously no royalist, he has not used the polite conventions of his profession to shield his high-born subjects from exposure of their human frailty. Their souls have been laid bare without mercy. What a collection of ghosts! Frightened children, a bloated vulture of a king, a grotesquely vulgar queen posed—in a master stroke of savage humor—exactly like the radiant little Princess Margarita in the center of *The Maids of Honor*. How could the royal family have tolerated this portrayal?

above:

272. Francisco Goya. *The Family of Charles IV*. 1800. Oil on canvas, 9′ 2″ × 11′. The Prado, Madrid. Goya echoes the courtly portraiture and luminous realism of Velázquez—but, in paying homage to his great predecessor, he portrays his royal patrons with uncompromising directness.

left:

273. Francisco Goya. *Bobabilicon*, from *Los Proverbios*, No. 4. About 1818. Etching. The Metropolitan Museum of Art, New York. Dick Fund, 1931. Goya found the repressive atmosphere of Spain under the restored monarchy intolerable, and toward the end of his life withdrew into a private world of nightmarish visions. Many of these defy analysis even though, as here, they were based on proverbs and popular superstitions.

at left:

274. Théodore Géricault. *Mounted Officer of the Imperial Guard*. 1812. Oil on canvas, 9' 7" × 6' 4". The Louvre, Paris. Here we see an ideal image of the Napoleonic soldier, alive with all the color and excitement of violent action. Goya had grown up within the Baroque tradition; Géricault revived it as the style best suited to his own temper.

Were they so dazzled by the splendid painting of their costumes that they failed to realize what Goya had done to them?

When Charles IV abdicated in favor of Napoleon, his military ally against England, Goya and many other Spaniards hoped for the liberal reforms that backward Spain so badly needed. But the savage behavior of the French troops in Spain crushed those hopes and produced a popular Spanish resistance just as savage. *The Third of May, 1808* (colorplate 56) shows the shooting of a group of citizens of Madrid who had rioted against French soldiers the day before. The blazing color, the broad, fluid brushwork, and the dramatic lighting are emphatically neo-Baroque. The picture has all the emotional intensity of a martyrdom scene in religious art, but these martyrs are dying for independence from foreign domination, not for the Kingdom of Heaven. Their executioners are so many machines, impervious to their victims' despair and defiance. Goya thus has painted a memorial to shattered hopes—and to countless other shattered hopes in the years to come. The scene has been repeated since Goya's time in so many lands and with so many different casts of characters that it has become a terrifying symbol of our era of revolutions and counterrevolutions.

Let us now turn back to France and to the *Mounted Officer of the Imperial Guard* (figure 274), a lifesize painting by the extraordinarily talented Théodore Géricault, who carried on the trend begun by Gros. Only twenty-one years old when he created this ideal vision of

275. Théodore Géricault. *The Madman*. 1821–24. Oil on canvas, 24 × 20". Museum of Fine Arts, Ghent. A sympathetic interest in the mentally ill grew out of Romantic fascination with the world of the emotions.

a Napoleonic soldier, Géricault was born more than forty years after David and Goya. And he had a very different viewpoint from either. Politics, for him, no longer had the force of religious faith. What he saw in Napoleon's military campaigns was the color and excitement of violent action. The spirit we see in this painting is the Romantic religion of excitement, of danger, of Life with a capital L. Géricault explored extremes of the human condition scarcely touched by earlier artists. He visited the morgue and the insane asylum of Paris. There he became a friend of Dr. Georget, a pioneer of psychiatry, for whom he painted a series of portraits of inmates to illustrate various types of mental illness. Figure 275 shows us one from this series, marvelous for its immediacy and freshness of handling, and even more so for the artist's deep sympathy toward his subject. This capacity to see the victims of mental illness as fellow human beings rather than as outcasts, accursed or

276. Eugène Delacroix. *Frédéric Chopin*. 1838. Oil on canvas, 18 × 15". The Louvre, Paris. Here is the Romantic conception of the artist-hero. A blend of Gros's Napoleon and Géricault's madman, the great composer is agonized, rebellious, and burning with the fever of genius.

277. Jean-Auguste Dominique Ingres. *Louis Bertin*. 1832. Oil on canvas, 46 × 37½". The Louvre, Paris. Ingres was the finest portraitist of his day. He observed with detachment and precision and revealed character with great force.

bewitched, was one of the noblest fruits of the Romantic movement.

Géricault's untimely death at thirty-three established Eugène Delacroix as the foremost neo-Baroque Romantic painter in France. He and Jean-Auguste Dominique Ingres, David's pupil and successor, were to be the two opposite poles of French painting—professional enemies, as it were—until well past 1850. Ingres, the great conservative and champion of Neoclassic orthodoxy, received all the honors and prizes at first, although Delacroix caught up with him in the end. Figure 276, Delacroix's portrait of Frédéric Chopin, and figure 277, Ingres' portrait of Louis Bertin, provide us with an instructive comparison between the styles of the two perennial antagonists. Delacroix rarely accepted commissions to paint portraits. His best were of his

personal friends, fellow victims of the "Romantic agony." Here we see the image of the Romantic hero at its purest; a cross between Gros's *Napoleon* and Géricault's *Madman*, he is consumed by the fires of genius. Ingres shows us a solid, wealthy newspaper publisher, so carefully detailed and accurately described that we seem to be looking at some kind of superphotograph. And he has endowed his subject with a force of personality so massive and intense as to make him truly formidable. Only Ingres could be at once so physically accurate and so psychologically penetrating. His followers concentrated on physical accuracy alone, competing vainly with the camera, which was invented around this time. Portraits by the neo-Baroque Romantics tended to be records of the artist's private emotional relationship with the sitter;

they are often interesting and moving, but hardly portraits in the old documentary sense.

Few artists have exceeded Delacroix in sheer splendor of painting—in which he was a fair match for the great Rubens himself—or for thrilling, violent action. Several of his boldest works were inspired by the Greek war of independence against the Turks, which stirred the sympathies of Western Europe. One of the severest blows suffered by the Greeks was the fall of the fortress of Missolonghi in 1826. The following year Delacroix painted his highly imaginative *Greece Expiring on the Ruins of Missolonghi* (colorplate 57). The defenseless maiden is as appealing as a martyred saint. Beside her, a dead Greek fighter lies crushed under marble blocks. Far to the rear, a turbaned Moor triumphantly drives his pennant into the crest of a hill. Creamy whites and smooth flesh tones set off by deep blues and reds show Delacroix to be a colorist of the first order. Contemporary beholders, remembering that Lord Byron had died at Missolonghi, must surely have found a special pathos in this picture.

Ingres, a faithful believer in David's theories, regarded himself as a draftsman and designer before everything else. Since he thought that color and light were far less important than form, he carefully avoided the broad, flowing brushwork of Baroque masters. Yet he was much more of a painter's painter than he thought. His *Odalisque* (colorplate 58) shows an extraordinary color sense. The limbs of this Oriental Venus ("odalisque" is a Turkish word for a harem slave girl) are petal-smooth, and the whole picture is a dazzling arrangement of rich tones and textures. The foreign subject, perfumed with the musky enchantment of *The Thousand and One Nights*, could hardly be more typical of the Romantic movement—although until recently the word "Romantic" was not applied to artists who professed the Neoclassic faith.

Nor, despite Ingres' theoretical worship of Raphael, can we see a classical ideal of beauty here. The strange mixture of the cool and the voluptuous exhibited by this nude, her long proportions and languid grace, remind us more of Parmigianino (see colorplate 38).

Neither in Delacroix nor in Ingres can we find a hint of the greatest force transforming their contemporary world. The one great French Romantic artist who did not shrink from contemporary reality, Honoré Daumier, was well known as a biting political cartoonist, but not until late in his life as an important painter. His *Third-Class Carriage* (figure 278) describes the strange loneliness of modern life: these people are crowded together in one railway car but have nothing else in common. Each is occupied with his own thoughts, and they take no notice of one another. Daumier explores the dignity of the poor with a breadth of human sympathy worthy of Rembrandt, whose work he revered. Painted very freely, this work must have seemed raw and "unfinished" even by Delacroix's standards. Yet its power comes from this very freedom.

Other paintings by Daumier have subjects more typical of Romanticism. Many drawings and paintings of the adventures of Don Quixote show his fascination with Cervantes' sixteenth-century novel. The lanky knight-errant, vainly trying to live out his dreams of noble deeds, and Sancho Panza, the dumpy materialist, seemed to Daumier to embody a tragic conflict within human nature, the war between soul and body, between ideal aspiration and harsh reality. In *Don Quixote and Sancho Panza* (figure 279), the mock hero dashes off toward his unrealistic goal while Sancho wrings his hands in helpless despair. We marvel at the strength, the sculptured simplicity, of Daumier's shapes and the expressive power of his brushwork.

Like the Daumier of *The Third-Class Carriage*, Camille Corot was closer than other

above:

278. Honoré Daumier. *The Third-Class Carriage.*
About 1862. Oil on canvas, 26 × 35½″. The
Metropolitan Museum of Art, New York.
H. O. Havemeyer Collection, Bequest of Mrs.
H. O. Havemeyer, 1929. Daumier's subject
here is the central dilemma of modern city life:
the loneliness of people in a crowd.

below:

279. Honoré Daumier. *Don Quixote and Sancho
Panza.* About 1866. Oil sketch, 15⅞ × 25¼″.
The National Gallery, London. Daumier is one of
the Romantic painters not only in his broad, ex-
pressive technique and dramatic composition,
but also in his use of various literary themes.

above:

280: Camille Corot. *Papigno*. 1826. Oil on canvas, 13 × 15¾″. Collection Dr. Fritz Nathan, Zurich. Corot's early works have a morning-bright freshness. But he was the heir to the landscape style of Poussin, too; and in the solidity and balance of this view there is a classical serenity very different from Constable's ever-changing moods (see figure 282).

Romantics to sober reality. The misty and poetic landscapes of his later style were once greatly prized. Today we have more admiration for his earlier work, which had key importance for the development of landscape painting. His *Papigno* (figure 280), a small Italian hill town, is not an ideal vision. The particular quality of a particular place at a particular time has been made into a painting

281. Alexander Cozens. *Landscape*, from *A New Method of Assisting the Invention in Drawing Original Compositions of Landscape*. 1784–86. Aquatint. The Metropolitan Museum of Art, New York. Rogers Fund, 1906. Leonardo noted around 1500 that we sometimes read images into accidental blots. Cozens created a method of working up landscapes from a series of blots dropped on the paper more or less by chance. This idea earned him much ridicule at the time, but has proved of great value to modern artists (see figure 344).

282. John Constable. *Hampstead Heath*. 1821. Oil sketch, 10 × 12″. City Art Galleries, Manchester, England. When Constable's landscapes were shown in Paris for the first time in 1824, their freshness and vibrant color made a deep impression on Delacroix.

—a small canvas done on the spot in an hour or two. The picture thus has great immediacy. It also has the sparkle and architectural clarity of a well-cut diamond.

Before the nineteenth century, no landscapists had painted on the spot in the open air. They had only made drawings, which they had then worked up indoors at their leisure. Among the first to paint out-of-doors was a great Englishman, John Constable. In 1824 one of his landscapes was exhibited in Paris, where it had an immediate effect upon Delacroix's backgrounds. What Rubens was to French neo-Baroque Romantics, the Dutch Baroque landscape painters were to Constable, who found in them his own feeling for the

majesty of nature and the comparative insignificance of man. *Hampstead Heath* (figure 282) is one of the countless oil sketches Constable did of this district, which today is a suburb of London. He was so fascinated by nature's ever-changing moods that they became far more important to him than those aspects which remained the same. In our sketch, he has caught a particularly splendid moment—a great sky drama of wind, sunlight, and clouds covering a vast sweep of fresh countryside.

Meanwhile, William Turner, the other great English landscapist of the day, arrived at a style that Constable characterized as "airy visions, painted with tinted steam." *The Slave Ship* (colorplate 59) was based partly on a passage from James Thomson's poem *The Seasons*, describing how sharks follow a slave ship in a storm, "lured by the scent of steaming crowds, of rank disease, and death," and partly on an actual event: the

captain of a slave ship had dumped his human cargo into the sea when disease had broken out below decks. This picture unites the poet's storm and the slaver's monstrous crime in a spectacular vision of violence, natural and human. It awes us, but not because we respond to it today with the emotions that the artist strove so mightily to evoke. We are impressed by its atmospheric splendor and blazing color.

In Germany, as in England, landscape painting was the finest flower of the Romantic movement. Caspar David Friedrich's *Polar Sea* (figure 283) was inspired by the end of an ill-fated expedition in the Bering Strait. The theme of man's defeat by the forces of nature was always dear to the Romantics. This picture's infinite loneliness is a haunting reflection of the artist's own melancholy. He

intrudes upon us in no other way, however; there is hardly a trace of brushwork to show us the movements of his hand. We look right through the picture surface, as it were, to what seems to be photographic reality. This technique, painstaking and impersonal, came out of Neoclassicism. The Germans, who had not produced any important Baroque painters, were not much concerned with the surface of a painting as a value in itself.

283. Caspar David Friedrich. *The Polar Sea*. 1824. Oil on canvas, $38\frac{1}{2} \times 50\frac{1}{2}''$. Kunsthalle, Hamburg. This picture was inspired by the account of an expedition in the Bering Strait. The theme of man's defeat by the forces of nature held great appeal for the Romantic imagination.

284. George Caleb Bingham. *Fur Traders on the Missouri*. About 1845. Oil on canvas, 29 × 36″. The Metropolitan Museum of Art, New York. Morris K. Jesup Fund, 1933. Scenes such as this show that Americans were becoming aware of themselves as a nation molded by the conditions of the Middle and Far West rather than by those of the Atlantic seaboard alone.

The New World, too, had its Romantic landscape artists, and German landscape had an influence upon them, as in George Caleb Bingham's *Fur Traders on the Missouri* (figure 284). Two trappers glide downstream in the sun-shot mist, a black fox chained to the prow of their dugout canoe. They remind us of how much Romantic adventurousness went into the westward expansion of the United States.

Painting was the characteristic art of Romanticism, but in architecture the Roman-

tic impulse lasted longer and produced a wider variety of revival styles. No sooner had the classic revival got under way in architecture and interior decoration than it was joined by the Gothic revival and then by revivals of other historic styles: Egyptian, Romanesque, Renaissance, and so on.

The classic revival in architecture, during its beginnings around 1750, was not much more than a reaction against the complexity of Baroque-Rococo style, a renewed insistence on flat surfaces and simple, precise, geometric shapes. Jacques Soufflot's domed and temple-fronted Panthéon (figure 285) belongs to this early phase of the classic revival, and is a counterpart in stone of David's Neoclassic painting. The surfaces are severely plain, completely without windows and almost without ornament.

After 1750, the classic revival became in-

above:

285. Jacques-Germain Soufflot. The Panthéon (Sainte-Geneviève), Paris. 1755–92. Toward the end of the eighteenth century, architecture became smooth and severe in sharp contrast with the more decorative style of a generation before.

below:

286. Thomas Jefferson. Monticello, Charlottesville, Virginia. 1770–84; 1796–1806. Neoclassicism spread from England to the American colonies, where—executed in brick with wood trim—it became known as "Georgian." Monticello is a most distinguished example.

287. Karl Langhans. The Brandenburg Gate, Berlin. 1788–91. This structure is derived from the Propylaea in Athens (see figure 55). Here is Neoclassicism in its most uncompromising, or Greek Doric, phase.

creasingly archaeological. The ancient world caught everyone's imagination. Greek art—unknown in the West for a thousand years—was rediscovered. Excavations at Herculaneum and Pompeii revealed, for the first time, the surroundings and daily life of ancient Romans. Ancient structures were reproduced rather than imitated, usually just in detail but sometimes in a building as a whole. The Greek orders became part of the architectural scene, and Greek structures sometimes furnished direct models for Neoclassic buildings. The Brandenburg Gate in Berlin (figure 287) was almost a reconstruction of the Propylaea of the Acropolis of Athens (see figure 55).

Neoclassic style dominated Romantic architecture until the early nineteenth century, when Gothic came to be preferred. Nationalist sentiment, extremely intense during the Napoleonic wars, helped create this prefer-

ence, for the English, French, and Germans all tended to believe that Gothic expressed their own national genius. Certain theorists, notably John Ruskin, regarded Gothic as the superior style for ethical and religious reasons: its elegantly precise structural systems were "honest"; its rapt spirit was "Christian."

The largest building of the Gothic revival was the Houses of Parliament, London, designed by Sir Charles Barry and A. Welby Pugin (figure 288). This seat of a vast governmental apparatus and focus of patriotic feeling is a rather curious mixture: relentless symmetry and endless repetition of standardized forms govern the main body of the huge structure, but the skyline is irregular and picturesque.

By mid-century, the Renaissance and the Baroque had returned to favor. The revival movement had now come full circle: the neo-Renaissance and the neo-Baroque replaced the Neoclassic and the neo-Gothic. This final phase of Romantic architecture dominated the years 1850–75 and lasted until well after 1900.

It lingers even now, but almost never produces a building of artistic merit.

The Paris Opéra (figure 289), designed by Charles Garnier, shows us the neo-Baroque at its moment of triumph, Baroque more in its lush profusion of sculpture and carved ornament than in the way major architectural forms have been handled. Overdressed by the standards of today, the Opéra reflects the naïve, untutored taste of the group of men ushered into wealth, prominence, and power by the Industrial Revolution. The new rich saw themselves as successors to the old nobility. As self-made aristocrats, they found more appeal in prerevolutionary style than in neo-Gothic or Neoclassic.

In limiting their vision to the styles of the past, Romantic architects lost touch with their own present. By the time of the Opéra, the

288. Sir Charles Barry and A. Welby Pugin. The Houses of Parliament, London. Begun 1836. After 1800, neo-Gothic architecture came to be preferred to Neoclassic. The Houses of Parliament were the largest monument of the Gothic revival.

gap was very great. The Opéra gives us no hint of belonging to an age of astonishing technical and industrial achievement. In buildings of practical utility—factories, warehouses, stores, and apartment houses—new materials and building methods had been introduced decades before. The most important new building material was iron. Iron structural members became standard for the support systems used in roofing large interior spaces in railroad stations and other places where people congregated. A famous early **example is the reading room of Henri Labrouste's Bibliothèque Sainte-Geneviève, Paris (figure 290). Here two curved ceilings rest on cast-iron arches supported by a row of cast-iron columns as thin as pencils.** The architect could have sheathed this structural skeleton with stone to match his Renaissance-revival decoration. But wishing to be "honest" in Ruskin's sense, he had the courage to leave it bare. It cannot be said that he produced a unified design—pioneers seldom do. But the airy spacing of columns and the delicate scrollwork perforating the exposed iron

above:
289. Charles Garnier. The Opéra, Paris. 1861–74.
When Baroque style was revived in the mid-
nineteenth century, the revival movement had
come full circle.

below:
290. Henri Labrouste. Reading Room. Bibliothèque
Sainte-Geneviève, Paris. 1843–50. Within the
cocoon of the revival styles—here the Renais-
sance revival—modern architecture has begun
to grow through the introduction of new materi-
als such as cast iron.

members have a special appeal of their own. Unified design based on novel materials and techniques would come only at the end of the century.

The Romantic era was a time of difficulty for sculptors. At its outset, every respected critic was paying reverence to mechanical Roman copies of undistinguished Hellenistic pieces—supposedly the supreme artistic achievement of the human race, they were the models that *had* to be followed. (Goethe, seeing the newly discovered Late Archaic sculpture from Aegina—see figure 59—pronounced it clumsy and inferior.) How could an artist rise above such works if they were perfection itself?

Neoclassic sculptors were at their best in portraits. The finest were by Jean Antoine Houdon, who had a sharp sense of individual character. Invited to America to portray George Washington, Houdon made two portrait statues of the great Virginian. One wears a Roman toga, the other (figure 291) an up-to-date costume. Even this second statue has a classical pose and displays the fasces, a bundle of rods symbolizing union.

Washington—while he lived, at least—escaped glorification as a heroic marble nude. Some of his younger contemporaries did not, for certain sculptors—Antonio Canova, for example—were more deeply committed than Houdon to Neoclassic ideology. Canova produced a colossal nude of Napoleon echoing statues of divine rulers of the Hellenistic age. Not to be outdone, Napoleon's sister Pauline Borghese had Canova portray her in marble as a reclining Venus (figure 292). From the neck down she is an idealized form copied from ancient statues rather than studied from life. We recognize this pallid Venus as a more classical-looking forerunner of Ingres's *Odalisque*.

With the neo-Baroque phase of Romanticism, the pulse of sculpture took on a stronger beat. The rather operatic *Marseillaise* (figure 293) on the Arc de Triomphe in Paris, by

291. Jean Antoine Houdon. *George Washington·* 1788–92. Marble, height 74″. State Capitol, Richmond, Virginia. The finest portrait sculptor of his era, Houdon does not allow individual character to disappear in his portrayal of America's national hero.

292. Antonio Canova. *Pauline Borghese as Venus.* 1808. Marble, about lifesize. Borghese Gallery, Rome. This idealized portrait of Napoleon's sister, although carved in the round, is treated as though in relief.

at left:
293. François Rude. *La Marseillaise*. 1833–36. Stone,
about 42 × 26'. Arc de Triomphe, Paris. The
artist recaptures the warmth and excitement
of French Baroque sculpture.

François Rude, is genuinely a masterpiece.
The soldiers, volunteers of 1792 rallying to
defend the Republic, are in classical disguise,
but the Genius of Liberty above imparts her
rush of forward movement to the entire group.
She would not have been unworthy of Puget
(see figure 253).

Rude's successor in architectural sculpture
was Jean-Baptiste Carpeaux, whose famous
Dance for the Paris Opéra may be seen in the
bottom right of figure 289. Figure 294 shows
us the plaster model for the group. It is both
livelier and more precise than the final version.
A perfect match for Garnier's architecture, it
is very Rococo in feeling, gay and coquettish.
Yet the figures look undressed rather than
nude, so photographically realistic in detail
that they seem like real people acting out a
Rococo scene rather than fanciful beings
sprung from the realm of myth.

294. Jean-Baptiste Carpeaux. *The Dance*. 1867–69.
Plaster model, about 15' × 8' 6". Musée de
l'Opéra, Paris. This work is a perfect match
for Garnier's neo-Baroque architecture. This
plaster model is both livelier and more precise
than the final version in stone.

Realism and Impressionism

We hardly realize today how thoroughly
factories, steamboats, and railroads unsettled
the lives of our great-great-grandfathers.
Automobiles, aviation, electronics, and nu-
clear power have unsettled ours much less.
The mid-nineteenth century marveled at the
flood of low-priced goods that poured out of
the new machines; but the same machines also
produced a shocking amount of human misery.
The craftsmen of previous days were dis-
placed by masses of industrial workers, un-
skilled, poorly paid, and huddled together in
dreary slums. The machines were a curse as
well as a blessing. Unrest was the order of
the day. Workers pressed demands for a more
human existence and a more democratic soci-
ety; and terrified governments moved to
suppress their organizations. In 1848 revolu-
tionary violence broke out in Paris and spread
to Vienna and Berlin.

How did these events affect the artists?
The Romantic painters, architects, and sculp-
tors, we have seen, put freedom of feeling and
imagination ahead of every other considera-
tion, ignoring the lackluster world around
them. But there were those who thought that

295. Gustave Courbet. *The Stone Breakers*. 1849. Oil on canvas, 63 × 102″. Formerly State Picture Gallery, Dresden (destroyed 1945). Courbet's monumental treatment of workingmen aroused a storm of criticism in the 1850s. The artist thrived on controversy; boisterous, forthright, proud of his provincial background, he enjoyed defying officialdom and the custodians of respectability.

such artists were taking an easy escape from the problems of their time. The French poet and art critic Charles Baudelaire in 1846 called for paintings that expressed "the heroism of modern life." And one painter and friend of Baudelaire's was willing to turn this challenge into an artistic creed: Gustave Courbet.

Courbet began as a neo-Baroque Romantic in the early 1840s. He was a man of the people in origin and a socialist in politics. After the Revolution of 1848 he launched the anti-Romantic movement that he called Realism. It was the duty of modern artists, he announced, to rely on their direct experience: "I cannot paint an angel because I have never

seen one." "Realism" is not a precise word. What Courbet meant by it was something like the "naturalism" of Velázquez' *Water Carrier of Seville* (see figure 238).

Courbet's painting was roundly denounced for its "vulgarity" and lack of "spiritual values." The storm broke in 1849, when he exhibited *The Stone Breakers* (figure 295), the first picture to embody his Realistic creed. He had seen two men working on a road and had asked them to pose for him in his studio. There he painted them lifesize, solidly and unsentimentally. One is too old for such heavy work, the other too young, but they do not turn to us for sympathy, for their backs are turned and the artist has not let us see their faces. We learn little about them as persons, then, but it was not Courbet's intention to dwell upon their individuality. He wanted to paint something that would be at once a "slice of life" and a symbol of social injustice.

Courbet was more interested in the new things he wanted to say than in finding a new way to say them. The new way was worked

out by another great Frenchman, Édouard Manet. Manet shared Courbet's idea that one should paint only what the eye actually sees. In order to do this, he felt, it was necessary to rethink the whole language of painting. The kind of visual language used by Courbet had been taken over by the camera, which did a better job of documenting the world than a painter could. Courbet's realism, therefore, would no longer do. Manet tried to find out everything he could about the proper language of painting; for years, his major activity was copying the old masters and making experimental studies based on what he was learning.

In *The Fifer* (colorplate 60) we see the new visual language Manet constructed in the 1860s. Since the late Middle Ages, when pictures first became windows, painters had relied on modeling and shading to make their forms look round and solid and the surrounding spaces empty and hollow. Manet seems to have decided that form and space can be conveyed through contrasts of color, without modeling and shading. In his *Fifer*, the light hits the forms head-on, so that we find hardly any shadows and no modeling at all. The whole picture is made up of separate flat patches of color placed side by side on the canvas. And every patch, whether it stands for something solid or just for empty space, has a clear-cut shape—its own shape.

What does all this mean? Simply this: for Manet the picture has become more important than the things it represents; the canvas is a little world with its own laws. Brushstrokes and patches of color—not the things they stand for—are the artist's primary reality.

Among the old masters, Vermeer and Velázquez came the closest to Manet's ideal of "pure" painting. But Manet turned their Baroque triumph of light into a triumph of color. In doing so, he made the picture surface something to be looked *at*, not *through*. He knew his style was revolutionary—that was his intention. He did not know that it marked

a turning point in art history: the beginning of the great shift from Renaissance vision to ours.

Younger artists carried Manet's revolution further. *The River* (colorplate 61), painted on the spot by Claude Monet, is an outdoor scene flooded with sunlight so bright that hostile critics complained that it hurt their eyes. In this flickering network of color patches, the reflections of light on the water are as "real" as the seated young woman and the trees, grass, and earth of the banks of the Seine. Form has been broken up into colored light. There are no blacks. Color is everywhere, especially in the shadows (if we can call them shadows).

Conservative critics called Monet's new style Impressionism. Such pictures were no more than quick impressions to these critics, half-finished sketches unworthy of serious attention. Monet and his friends accepted the name and wore it like a banner. Manet refused to do so; and certainly the word was better suited to Monet's work than to his.

Scenes from the world of entertainment—dance halls, cafés, concerts, the theater—were favorite subjects for Impressionist painters. Auguste Renoir filled his canvases with the joyousness of a singularly happy temperament. The flirting couples in *Le Moulin de la Galette* (figure 296), under the dappled pattern of sunlight and shadow, radiate a human warmth that is nothing less than entrancing, even though the artist permits us no more than a fleeting glance at any of them.

By way of contrast, Edgar Degas makes us look steadily at the defeated couple in his café scene *The Glass of Absinthe* (figure 297), but out of the corner of our eye, so to speak. The design of this picture, at first glance, seems as unstudied as a snapshot. As we continue to look, however, we see more and more calculation—an interlocking pattern dovetailed with the utmost precision. The zigzagging tabletops deepen the mood of brooding loneli-

above:

296. Auguste Renoir. *Le Moulin de la Galette*. 1876.
Oil on canvas, $51\frac{1}{2} \times 69''$. The Louvre, Paris.
Café life and other forms of amusement were
favorite subjects of the Impressionists, but
Renoir knew best how to capture the human
warmth of such scenes. Here the gay, flirting
couples dappled by light and shadow radiate
happiness.

left:

297. Edgar Degas. *The Glass of Absinthe*. 1876. Oil
on canvas, $36 \times 27''$. The Louvre, Paris. Degas'
disenchanted pair present a typically Impres-
sionist slice of life. Their brooding loneliness,
behind the zigzag of empty tables, is as memo-
rable as Renoir's sunlit charm.

at right:

298. Edgar Degas. *The Tub*. 1886. Pastel, $23\frac{1}{2} \times$
$32\frac{1}{2}''$. The Louvre, Paris. In the 1880s, Degas'
work showed a change in the Impressionist
treatment of nature. The design emphasizes
pattern over natural form; and the perspective
has become so sharply angled that the viewer
is not sure whether he is seeing forms on the
surface or in depth.

ness. "No art," Degas once said, "was ever less spontaneous than mine."

Compositions such as this set Degas apart from his fellow Impressionists. So did his preoccupation with nighttime and the indoors. He was a peerless draftsman, and his finest works were often in pastel (powdered pigments molded into sticks), a medium that he loved because it enabled him to draw and paint at the same time. The *Café Concert* (colorplate 62) shows us an unforgettable view of Parisian night life. Here the bright costumes, the dramatic lighting, and the contrasted realms of reality and make-believe are woven into a wonderfully rich and vivid pattern of shifting light and color. Again we are given what looks like a chance view, as though the artist had sketched this animated scene in a few brief moments while passing through the crowded hall. But that view took an enormous amount of planning. Notice how the string of lanterns draws our eye to the singer's outstretched arm, how the neck of the bass fiddle projecting from the orchestra pit makes us aware of the distance between the spectators and the performers beyond. The picture has been put together with the care of an old master, an old master with updated ways of seeing.

Degas' *The Tub* (figure 298) was done ten years later, in the 1880s. His vision seems to have altered in the course of those ten years. The perspective of the *Café Concert*, although accurate, was surprising; the perspective of *The Tub* is far more so. The shelf on the right is so sharply tilted that it almost shares the plane of the picture, yet on this shelf Degas has placed two pitchers that are hardly foreshortened at all, so that we are no longer sure where we, the beholders, stand in relation to these objects. Degas used linear strokes as accents in the *Café Concert*, particularly in the foreground. On the stage, however—the heart

right:

299. Auguste Renoir. *Study for "The Bathers."* About 1885. Drawing, 43½ × 49½". Fogg Art Museum, Harvard University, Cambridge, Mass. Maurice Wertheim Collection. In the 1880s Renoir, began to depart from the Impressionism of the 1870s. This drawing, with its firm, simple outlines and strongly modeled forms, was made after a trip to Italy had helped him to rediscover the classical tradition.

of the picture—there were no hard edges and form was thoroughly broken up into a fused pattern of colored light. In *The Tub*, all the forms are firmly and vigorously outlined. We read these forms as a person and as things, yes, but we read them just as strongly as a severely geometric pattern: woman and tub become a circle in a square, the shelf an almost-rectangle patterned with bold shapes. If we continue to look, we may see the picture even more strongly in its aspect of geometric pattern, for we tend to alternate between the one way of seeing and the other.

What has changed decisively in ten years is the artist's treatment of nature—of space especially. Not very much is left of the Renaissance conception of the picture surface as a window. In its shimmer of bright color, *The Tub* is still Impressionist. Its other qualities, however, belong more to post-Impressionism (see the next section), which began in the 1880s. The spatial outlook of *The Tub* also reminds us a little of the art of the late Middle Ages (see figure 138 and colorplate 25). In going out, it would appear, Renaissance vision resembled itself coming in.

Courbet, during his later years—he died in 1877—enjoyed considerable influence and fame abroad. Winning international recognition was understandably slower for the Impressionists. Americans—often more hospitable than Europeans themselves to new European art—were their first patrons and collectors. American painters were among the earliest followers of Manet and his circle.

below:

300. Claude Monet. *Water Lilies, Giverny.* 1907. Oil on canvas, 36½ × 29". Collection Mr. and Mrs. David T. Schiff, New York. Only Monet, among the major figures of the movement, remained faithful to the Impressionist view of nature after 1880. He became more and more concerned with the way light and color change with the time of day. His pictures now began to look like shimmering weightless screens.

James McNeill Whistler came to Paris to
study in 1855, moving to London four years
later. He stayed in London for the rest of his
life, but visited Paris in the 1860s and was in
close touch with the rising Impressionist
movement. His best-known picture is *Ar-
rangement in Black and Gray: The Artist's
Mother* (figure 301), which reflects Manet's
influence in its emphasis on flat areas. Its rise
to fame as a sentimental cliché would have dis-
mayed Whistler; he wanted this canvas to be
appreciated exclusively for its qualities of
space, form, and rhythmic pattern.

A witty and sharp-tongued advocate of Art
for Art's Sake (the name applied to the whole
movement in the arts that included not only

301. James A. McNeill Whistler. *Arrangement in
Black and Gray: The Artist's Mother*. 1871.
Oil on canvas, $57 \times 64\frac{1}{2}''$. The Louvre, Paris.
The title proclaims Whistler's belief in "Art
for Art's sake." Art, he said, meant formal
qualities—shapes and colors, not sentiment.
The idea of art for art's sake became important
for the artistic and literary practice of the 1890s.

Impressionist painting but corresponding de-
velopments in literature and music as well),
Whistler thought of his pictures as akin to
music and often called them symphonies or
nocturnes. The boldest of these was *Nocturne
in Black and Gold: The Falling Rocket* (figure
302). No French painter had yet dared to pro-
duce a picture so nonrepresentational, so like

Cozens' "blotscapes" and Turner's "tinetd steam" (see figure 281 and colorplate 59). This canvas provoked John Ruskin into accusing Whistler of "flinging a pot of paint in the public's face." Ruskin, since he had used nothing but superlatives for *The Slave Ship*, must have liked Turner for his Romantic sen-

at left:

302. James A. McNeill Whistler. *Nocturne in Black and Gold: The Falling Rocket.* 1874. Oil on canvas, 23¾ × 18⅜". The Detroit Institute of Arts. No French artist at this time had dared to produce a picture so nearly abstract as this work.

below:

303. Winslow Homer. *The Morning Bell.* About 1866. Oil on canvas, 24 × 38". Yale University Art Gallery, New Haven, Connecticut. Bequest of Stephen C. Clark. Homer was a passionate believer in out-of-doors subjects, relishing the brilliance of sunlight.

timent, not for his tinted steam. Whistler sued Ruskin for libel in a famous case. In court he stated his aim as "divesting the picture from any outside sort of interest . . . It is an arrangement of line, form, and color, first . . ." He was speaking not only for himself but for most artists of the next hundred years.

Winslow Homer, Whistler's gifted contemporary, also went to Paris as a young man. He returned to America too soon to absorb the full influence of Impressionism. *The Morning Bell* (figure 303), a fresh and delicate sunlit scene, might be called "pre-Impressionist." It seems halfway between Corot and Monet (compare figure 280 and colorplate 61). Its design is extremely subtle: the upward-slanting footpath becomes a seesaw, while the descending line of treetops keeps the picture in balance.

Thomas Eakins arrived in Paris from Philadelphia about the time Homer painted *The*

304. Thomas Eakins. *The Gross Clinic*. 1875. Oil on canvas, 96 × 78″. Jefferson Medical College, Philadelphia. Eakins was an austere passionate realist who believed that to improve upon nature was unacceptable distortion.

Morning Bell. His *Gross Clinic* (figure 304) is the most imposing work in all nineteenth-century American painting. Powerfully realistic, it is a lifesize view of an operation in progress, with no unpleasant detail glossed over. It was denounced by conservative critics as a "degradation of art," but to us it seems a splendid fulfillment of Baudelaire's demand for pictures expressing "the heroism of modern life."

During the 1860s, the decade in which Manet's experiments began, sculpture took the same new turn as painting. The man who led sculpture into the realm of Art for Art's Sake was Auguste Rodin, the first sculptor of genius since Bernini. Rodin's step into the future was visible in the first piece he tried to exhibit (as we might expect, it was rejected), *The Man with the Broken Nose* (figure 305). Its vigorously creased bronze surface produces an ever-changing pattern of reflections. Was this effect borrowed from Impressionist paintings? No, for there were no Impressionist paintings as yet. Form, moreover, was not being dissolved. No matter what the conditions under which we view this piece, its fiercely molded shapes pulsate with sculptural energy. Rodin was not trying to capture elusive optical effects. Modeling in wax or clay, he tried to emphasize the process of the growth of the artistic image—the miracle in which dead matter comes to life under the artist's hands. The malleable lumps from which he built his forms were his primary reality, just as patches of color were to Manet and Monet. Like Impressionist paintings, *The Man with the Broken Nose* is "unfinished." Rodin made unfinishedness an important principle of artistic creation. It governed not only the way he handled surfaces but the over-all shape of the work. For the work is not a bust; it is a fragment, a head broken off at the neck. The fragment is the whole.

The sculptural revolution that the twenty-four-year-old Rodin proclaimed so boldly in

305. Auguste Rodin. *The Man with the Broken Nose.* 1864. Bronze, height 9½″. Rodin Museum, Philadelphia Museum of Art

306. Auguste Rodin. *The Thinker.* 1879–89. Bronze, height 27½″. The Metropolitan Museum of Art, New York. Gift of Thomas F. Ryan, 1910

Rodin built his forms out of small lumps of clay—the counterpart in sculpture of the color patches out of which the Impressionists built their paintings. Cast in bronze, Rodin's forms catch the light in ever-changing patterns of reflection.

the 1860s arrived at full force in the 1870s, when he was commissioned to do a doorway for the Museum of Decorative Arts in Paris. *The Gates of Hell*, as he called his program for that assignment, was never finished, but a number of details planned for it were later converted into independent works. The most famous is *The Thinker* (figure 306). This figure was originally to have been above the entrance, looking down upon a sea of misery below. Here the pent-up, unreleased energy

of Michelangelo's superhuman bodies (see figures 187 and 188) and the tension of Puget's *Milo* (compare the feet especially with figure 253) have been added to the dynamic surface pattern of *The Man with the Broken Nose*. Who is *The Thinker*? Rodin, wisely, has not identified him. But unlike Carpeaux's naked figures pretending to be nudes (compare figure 294), he is as genuinely a nude as the nudes of Michelangelo. In Rodin's new image of man, form and meaning are one.

Post-Impressionism

Paul Cézanne, a gruff young man from Aix, in southern France, was one of the earliest admirers of Manet. After mastering the new language of *The Fifer* (see colorplate 60), Cézanne went on to paint brilliantly sunlit outdoor scenes. But he never tried to capture the world's fleeting, momentary aspects. "I want," he said, "to make of Impressionism something solid and durable, like the art of the museums."

Toward 1880, Cézanne found his "solid and durable" art. We see it in his *Fruit Bowl, Glass, and Apples* (colorplate 63). Never since Chardin had simple, everyday objects taken on such importance. And never before had so much discipline been united to so much life. As solid and ordered as a Poussin, this picture is as harmonious and lively in color as a Rubens. The brushstrokes, the building blocks of its pictorial architecture, have a rhythmic pattern that gives it its shimmering texture. The play of color sends chords of warm and cool tones reverberating through the canvas. The shapes of objects are outlined with dark contours and simplified almost to geometry. By the standards of the Renaissance tradition, they are out of perspective and out of drawing: the horizontal surfaces seem to tilt upward, and the bowl not only seems tilted but also

warped out of shape. But the longer we study this picture, the more we realize the absolute rightness of these deliberate distortions. When Cézanne took liberties with nature, his purpose was to reveal fundamental shape and movement hidden by the accidents of appearances. All nature, he said, was based on "the cone, the sphere, and the cylinder." The bowl's warped shape and off-center stem are responses to a suggested pressure exerted by the objects on the right. Even nature—of tremendous artistic importance to Cézanne—had to submit to the demands of the composition as a whole.

It is not surprising that Cézanne's greatest triumphs in his new style were first achieved in still lifes. Of all living things, apples, oranges, peaches, pears, and grapes are not only the closest in shape to the regular figures of solid geometry, but they are also the purest in color, and their surfaces provide the richest interplay with light. To achieve landscapes as triumphant as the *Fruit Bowl* became the greatest challenge of Cézanne's career. From 1882 on, he lived in seclusion near the town of Aix, exploring the countryside of southern France. He became obsessed, almost, by the distinctive shape of one mountain, Mont Sainte-Victoire. Its craggy profile looms

against the blue Mediterranean sky in a long series of canvases. Figure 307 is a late example. In this impressive work we see no men, houses, or roads—nature's geometry is enough. Above a forbidding wall of rocky cliffs, the mountain rises in utter clarity. It is remote, yet as solid and as present to our senses as the shapes in the foreground. The scene, for all its architectural stability, pulses with movement; but the forces at work here have been brought into balance, subdued by the greater power of the artist's will.

In arriving at his new style, Cézanne became the first of the Post-Impressionists—a label that gives very few clues to style. At least, however, it suggests that the men who began new movements in the 1880s and 90s were not anti-Impressionists. All, on the con-

307. Paul Cézanne. *Mont Sainte-Victoire Seen from Bibemus Quarry.* About 1898–1900. Oil on canvas, 25½ × 32″. The Baltimore Museum of Art. The Cone Collection. The pictures of Cézanne's old age have a new energy and strength of feeling. Here the great mountain near Aix-en-Provence looms majestically above its base of rocks and trees. The artist has erased houses and roads—the traces of man's presence —so that the lonely grandeur of this view will not be disturbed.

trary, preserved the Manet revolution and, in their different ways, carried it a step further.

Georges Seurat shared Cézanne's aim of making Impressionism over into something "solid and durable" but went about it in another way. Like Masaccio, Giorgione, and Géricault, he had a brief career crowned by glorious achievement. He left a handful of

major works, but more than a thousand draw-
ings and studies for them, for he worked
slowly and systematically. *A Sunday After-
noon on the Grande Jatte* (colorplate 64) shows
a subject popular among the Impressionists:
a gay crowd enjoying a fine summer day on an
island near Paris. Seurat spent two years paint-
ing it. The colors have the rainbow brightness
of Monet's *River* (see colorplate 61), but the
picture is the opposite of a quick impression:
the simple, firm contours and the relaxed,
still figures create a timeless scene that recalls
Piero della Francesca (compare figure 175).
Seurat's passion for permanence and order
shows even in his brushwork. Cézanne's
brushstrokes, although pattern-like, were
strongly personal. With Seurat, every stroke
has become an impersonal, uniform dot of
pure color, a precise and tiny building block
in the structure of the picture. This technique,
known as Pointillism, was based on scientific
studies of color perception. The tone of a
color undergoes apparent change when a dif-
ferent color is placed beside it; this principle
can be utilized in color mixing. Seurat, in-
stead of mixing the tone of an area directly
on the palette, tried to make the observer's
eye do much of the work—that is why he
made his dots so small. Colors mixed by the
eye, he believed, would appear more luminous
and brilliant. Yet his colors do not fuse com-
pletely inside the eye; at normal viewing
distances we are aware of individual dots.
The *Grande Jatte*, thus, is mosaic-like in
structure; and the vibrations of the color dots
give the whole canvas the quality of a shim-
mering screen.

Vincent van Gogh transformed the color
patches of Impressionism into swirling rib-
bons of pure color. His aim in art was to give
vent to his own turbulent inner feelings. For
this reason, he is sometimes called an Expres-
sionist. The first great Dutch master since
the seventeenth century, Van Gogh did not
start out as an artist at all. His main early

interest was religion; he worked as a lay
preacher among the very poor, sharing their
life. His painting career was even shorter
than Seurat's: he turned to art in 1880 and
died ten years later. His greatest works were
all painted during the last three years of his
short life.

In Paris, where his brother Theo worked
in an art gallery, Van Gogh met Degas,
Seurat, and other leading French painters in
1886. The effect on him was electrifying. His
pictures, formerly dark and somber, now
blazed with color. He experimented with
Seurat's Pointillist technique. Paris opened
his eyes to the beauties of the visible world
and taught him the language of the color
patch, but did not provide him with his
sought-for opportunity to give full vent to
his surging emotions. He therefore left Paris
and went to southern France, hoping to find
the right surroundings. There, between 1888
and 1890, he poured out masterpieces. In
the sun-drenched Mediterranean countryside,
where Cézanne saw permanence and archi-
tectural stability, Van Gogh saw ecstatic
movement. In *Wheat Field and Cypress Trees*
(colorplate 65), the field is like a stormy sea;
the trees spring flamelike from the ground;
and the hills and clouds heave with the same
surge of motion. Every stroke stands out
boldly in a long ribbon of strong, unmixed
color. Color was even more important to Van
Gogh than his personal "handwriting." The
colors of this painting speak to us of that
"kingdom of light" he found in southern
France; they also speak of his mystic faith in
the creative forces within nature. This is a
religious painting. Van Gogh was seeking
union with the essence of all things.

The self-portrait illustrated in figure 309
shows us two burning eyes staring out of an
emaciated face centered in a whirlpool of
darkness. "I want to paint men and women,"
Van Gogh had written his brother Theo,
"with that something of the eternal which the

Colorplate 56. Francisco Goya. *The Third of May, 1808*. 1814–15. Oil on canvas, 8′ 9″ × 13′ 4″.
The Prado, Madrid

Colorplate 57. Eugène Delacroix. *Greece Expiring on the Ruins of Missolonghi*. 1827. Oil on canvas,
6′ 11½″ × 4′ 8¼″. Museum of Fine Arts, Bordeaux, France

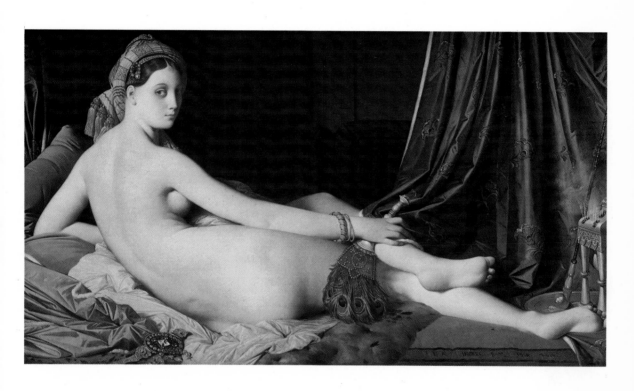

Colorplate 58. Jean-Auguste Dominique Ingres. *Odalisque*. 1814. Oil on canvas, 35¼ × 63¾″.
The Louvre, Paris

Colorplate 59. Joseph Mallord William Turner. *The Slave Ship*. 1839. Oil on canvas, 35¾ × 48″.
Museum of Fine Arts, Boston

Colorplate 60. Édouard Manet. *The Fifer*. 1866. Oil on canvas, 63 × 38¼″.
The Louvre, Paris

Colorplate 61. Claude Monet. *The River*. 1868. Oil on canvas, $32 \times 39\frac{1}{2}''$. The Art Institute of Chicago.
Potter Palmer Collection

Colorplate 62. Edgar Degas. *Café Concert. At Les Ambassadeurs.* 1876–77. Pastel, 14¾ × 10¾″.
Musée de Lyons, France

Colorplate 63. Paul Cézanne. *Fruit Bowl, Glass, and Apples*. 1879–82. Oil on canvas, $18 \times 21\frac{1}{2}''$.
Collection René Lecomte, Paris

Colorplate 64. Georges Seurat. *A Sunday Afternoon on the Grande Jatte*. 1884–86. Oil on canvas, 6′ 9¼″ × 10′. The Art Institute of Chicago. Helen Birch Bartlett Memorial Collection

Colorplate 65. Vincent van Gogh. *Wheat Field and Cypress Trees.* 1889. Oil on canvas, $28\frac{1}{2} \times 36''$.
The National Gallery, London (Reproduced by courtesy of the Trustees)

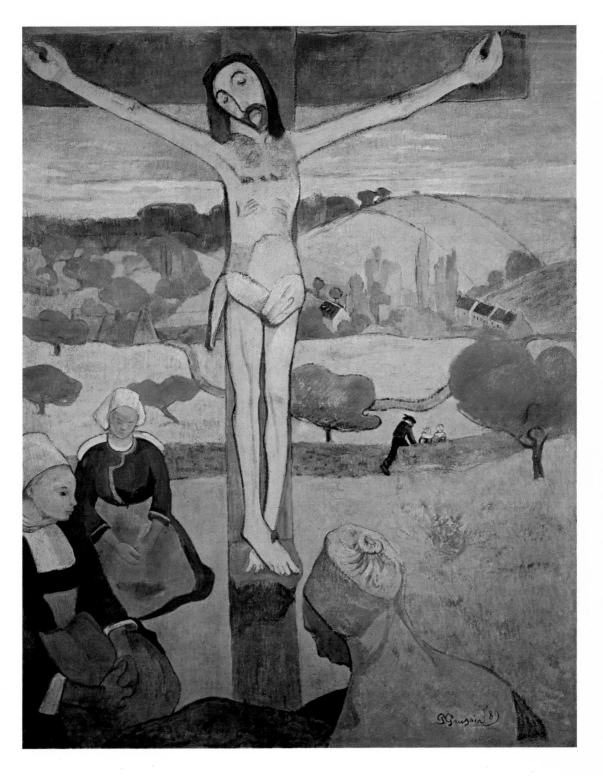

Colorplate 66. Paul Gauguin. *The Yellow Christ*. 1889. Oil on canvas, 36⅜ × 28¾″. Albright-Knox Art Gallery, Buffalo, New York

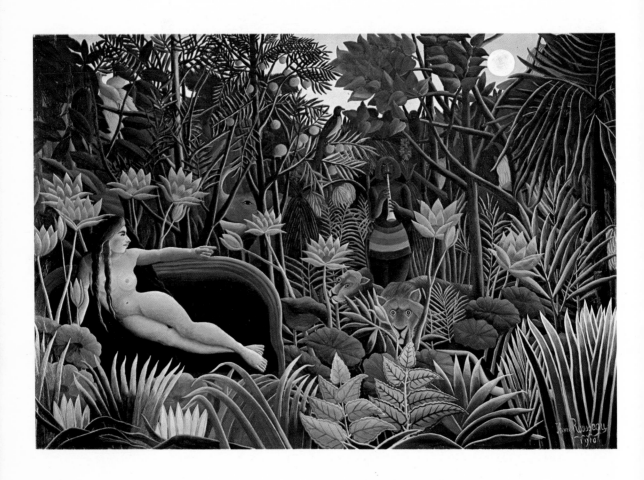

Colorplate 67. Henri Rousseau. *The Dream*. 1910. Oil on canvas, 6′ 8½″ × 9′ 9½″. The Museum of Modern Art, New York. Gift of Nelson A. Rockefeller

308. Vincent van Gogh. *Peasant of the Camargue*. 1888. Pen drawing. Fogg Art Museum, Harvard University, Cambridge, Mass. Had none of Van Gogh's paintings survived, his powerful drawings would still be enough to safeguard his place among the great masters of modern times.

309. Vincent van Gogh. *Self-Portrait*. 1889. Oil on canvas, 22½ × 17″. Collection Mr. and Mrs. John Hay Whitney, New York. About a year before his death, Van Gogh began to paint in long, wavy strokes, and his work acquired a new rhythm and flow. In this picture, the whirling brushwork of the background creates a pool of darkness against which the flamelike head stands out with great force.

halo used to symbolize." The former Christian missionary has become the prophet of a new personal faith.

At the time of this portrait, Van Gogh had already begun to suffer attacks of a mental illness that made it difficult for him to paint. Only art could make life worth living for this tormented man, and despairing of a cure, he committed suicide a year later.

The search for religion also played an important part in the work of Paul Gauguin, another great Post-Impressionist. Gauguin was a stockbroker who painted on Sundays and collected modern pictures (he once owned Cézanne's *Fruit Bowl, Glass, and Apples*). In 1883, at the age of thirty-five, he abandoned his business career, separated from his family, and began to paint every day of

the week. Six years later, he founded a movement he called Symbolism. His style at that time, though less intensely personal than Van Gogh's, was in some ways an even bolder advance across the frontier of Impressionism. Feeling that industrial society had robbed the modern city dweller of his essential humanity, Gauguin went to live among the peasants of Brittany, in western France. He hoped, by this means, to recover a lost world of pure feeling. He was particularly impressed by the part still played by religion in the everyday life of those country people, and in his *Yellow Christ* (colorplate 66) tried to express their simple, direct faith. Here, at last, is what no Romantic painter ever achieved: a style based on pre-Renaissance sources. The Christ is Late Gothic in type, simple and flat, on the level of folk art—for that is the way the three peasant women in the foreground think of Him. The other forms, too, have been simplified and flattened, to show that they are imagined, not observed from nature. The brilliant colors, heavily outlined in black in the manner of medieval stained glass, are

310. Paul Gauguin. *Offerings of Gratitude*. About 1891–93. Woodcut. In their stark black-and-white patterns and studied, simple technique, Gauguin's woodcuts of Tahiti suggest primitiveness more effectively than do his paintings.

equally contrary to nature. The style is meant to re-create both the imagined reality of the vision and the actual trancelike rapture of the peasant women. Yet it is clear that the artist was an outsider still. He longed to share the religious experience of the Breton peasantry, but could only describe it.

Two years later, Gauguin's restless search for the unspoiled life led him even farther from the centers of urban civilization. He bed to the island of Tahiti in the South Pacific, going as a pilgrim, not as a missionary; he wanted to learn from the natives, not teach them. He stayed in the South Seas until his death in 1903. Not finding in the tropics what he looked for there, he supplied it from his own world of dreams. The huge idol in the woodcut *Offerings of Gratitude* (figure 310) had no counterpart in Tahitian life. But the stark black-and-white patterns and studied simplicity of this splendid print convey the idea of primitive faith to us with great effectiveness. None of Gauguin's South Sea paintings were as daring as *The Yellow Christ*, but his woodcuts opened up a new era in the history of printmaking.

The renewal of Western civilization, Gauguin believed, had to come from "the Primitives." He advised his fellow Symbolists to abandon the European tradition that began in Greece 2,500 years before, and turn instead to Persia, the Far East, and ancient Egypt. This idea was not new. It stemmed from the Romantic myth of the noble savage; it had a deeper source in the age-old tradition of an earthly paradise where Man had once lived— and might live again—in a state of innocence. Few men had gone so far as Gauguin to put the doctrine of primitivism into practice. But his pilgrimage to the South Pacific had more than a private meaning. The colonial expansion that in four centuries had brought the entire globe under Western domination was coming to an end. The "white man's burden" so cheerfully and ruthlessly shouldered by the empire builders had become unbearable.

At the close of the nineteenth century, Gauguin's feeling that the world was sick haunted the literary and artistic community. Even those who could see no hope for improvement analyzed their predicament in fascinated horror. In mood, at least, Henri de Toulouse-Lautrec's view of the interior of the Moulin Rouge, the well-known Parisian night club (figure 311), is no Impressionist "slice of life." It has much in common with Degas' *Café Concert* (compare colorplate 62). We see the same sudden leap from foreground to background, the same sharp lighting, the same interest in the performers' poses and gestures, the same combination of drawing and painting. But Toulouse-Lautrec cuts right through the gay surface of the scene to expose both performers and customers as depraved and decadent—himself included (he is the dwarfed and bearded figure next to the tall man in the very back of the room). The atmosphere of *At the Moulin Rouge* is so joyless and oppressive that we can only regard it as a place of evil.

In the work of the Belgian painter James Ensor, this bitter view of contemporary humanity became almost an obsession. *Intrigue* (figure 312) shows us a carnival with masked merrymakers. But the masks are not masks. As we look, we become aware that these are humanity's true faces; the artist has revealed the depravity that we are accustomed to hide behind our real masks, the faces we wear every day. The demon-ridden world of Bosch has come back to life in modern guise (compare figure 156). Toulouse-Lautrec's pessimism, Gauguin's primitivism, and Van Gogh's expressive handwriting become a single, concentrated nightmare image in *The Scream* (figure 313), by the important Norwegian artist Edvard Munch. The long, wavy lines carry the echo of the scream into every corner of the picture, making of earth and sky one great sounding board of fear.

at top left:

311. Henri de Toulouse-Lautrec. *At the Moulin Rouge*. 1892. Oil on canvas, 48⅜ × 55¾". The Art Institute of Chicago. Helen Birch Bartlett Memorial Collection. This scene, despite its surface gaiety, is oddly joyless. The stony, masklike faces, the off-key color scheme, and the combination of large, flat areas and exaggerated perspective produce a disquieting, nightmarish effect.

at bottom left:

312. James Ensor. *Intrigue*. 1890. Oil on canvas, 35½ × 59". Royal Museum of Fine Arts, Antwerp. Like Van Gogh, this great Belgian painter was moved to anguish by the shallow optimism of his time, and was concerned with expression rather than with form. His art is bitterly mocking, full of demoniacal laughter.

top right:

313. Edvard Munch. *The Scream*. 1893. Oil on canvas, 36 × 29". National Gallery, Oslo. "I want to paint pictures," Munch wrote, "that will make people take off their hats in awe, the way they do in church."

bottom right:

314. Pablo Picasso. *The Old Guitarist*. 1903. Oil on canvas, 47¾ × 32½". The Art Institute of Chicago. Helen Birch Bartlett Memorial Collection. Picasso painted this melancholy picture in his native Barcelona, where he had been forced to return after a miserable winter in Paris. He went back to Paris in 1904, and has lived in France ever since.

A young Spaniard who arrived in Paris in 1900 came under the same spell that had shaped Munch's style. Picasso's Blue Period —blue in the tonality of his canvases as well as in the mood that they evoke—was given over to pictures of beggars, derelicts, and outcasts of society. The pathos of *The Old Guitarist* (figure 314) reflects the artist's own sense of isolation. But this is not an angry painting. The aged musician accepts his fate with a resignation that seems almost saintly, and the elongated grace of his limbs reminds us of El Greco.

A few years later, Picasso and his friends

315. Aristide Maillol. *Seated Woman (Méditerranée)*. About 1901. Height 41″. Collection Dr. Oskar Reinhardt, Winterthur, Switzerland. Maillol, the greatest sculptor of the early twentieth century, turned for inspiration to Late Archaic and Early Classic Greek sculpture. He rejected all later phases of Greek art.

discovered a painter who until then had attracted no attention. This was Henri Rousseau, a retired customs collector who, at the age of forty, had begun to paint. A completely untrained folk artist, Rousseau was also—astonishingly—a man of genius. How otherwise could he have painted *The Dream* (colorplate 67)? No explanation is possible for what is happening in the enchanted world of this canvas, but none is needed. Here at last is that innocent directness of feeling which Gauguin had thought so necessary for the age and had traveled so far to find. Picasso and his circle recognized this quality in Rousseau and

revered him as the godfather of twentieth-century painting.

Tendencies paralleling Post-Impressionism in painting appeared in sculpture around 1900, when younger men schooled by Rodin were ready to travel their own ways. The finest sculptor of this generation was Aristide Maillol. A Symbolist painter at first, Maillol was less thoroughgoing than Gauguin in rejecting the European tradition. He took the early fifth century B.C. for his cutoff point, for he admired the simplified strength of the Archaic and Severe styles of Greek sculpture (see pages 60–65). The *Seated Woman* (figure 315) evokes memories of early Greece. In its solidity, weight, and clearly defined volumes, it recalls Cézanne's statement that all natural forms are based on the cone, the sphere, and the cylinder. Maillol's ideas were the exact opposite of Rodin's. A statue, he believed, should be self-contained and at rest. No out-

above:
316. Ernst Barlach. *Man Drawing a Sword*. 1911. Wood, height 31″. Museum, Cranbrook Academy of Art, Bloomfield Hills, Michigan. Barlach, another great sculptor of the early twentieth century, rediscovered the intensely emotional world of German Gothic art.

side force should be able to disturb its harmonious repose.

If we were to call Maillol a Greek primitivist, the German sculptor Ernst Barlach, by the same token, was a Gothic primitivist. Some years before World War I, Barlach went to Russia, finding there what Gauguin had found in Brittany and the South Seas: the simple humanity of a world not yet industrialized. His figures, such as *Man Drawing a Sword* (figure 316), embody the basic emotions—fear, anger, grief. They are gripped by forces too big for them to understand or control. Most of his figures do not fully emerge from the material substance of which they are made (here, a massive block of wood); their clothing is a solid casing in which the body is lost, as in medieval sculpture. Barlach's art is not wide-ranging, yet its mute intensity is not easily forgotten.

317. Wilhelm Lehmbruck. *Standing Youth*. 1913. Cast stone, height 7′ 8″. The Museum of Modern Art, New York. Gift of Mrs. John D. Rockefeller, Jr. A fine balance derived from Maillol, something of Rodin's expressive energy, and the elongation and poetic melancholy of Picasso's Blue Period are combined in a monumental figure of surpassing grace.

Art in Our Time

The chapters on the Renaissance acquainted us with "schools" of art: each country and each important city had its own way of doing things. Often, a glance will tell us where a fifteenth- or sixteenth-century painting or statue came from. We found such differences in the Baroque era still, but we also found more international give-and-take. Today, however, when men travel faster than sound, and images and ideas travel with the speed of light, no movement remains local very long. Ideas that catch on anywhere catch on everywhere. "Isms" have dethroned "schools."

Even in the nineteenth century, artistic trends became international quickly, and we ran across many "isms"—Romanticism, Realism, Impressionism, Pointillism, Symbolism, and more. No one has counted all the "isms" of our own twentieth century.

"Isms" can be stumbling blocks to understanding. Many people feel that they cannot come to terms with modern art without getting mired down in a swamp of far-out doctrines. But "isms" need not scare us; they are no more than convenient labels that can help us to keep things in their proper place. There are three main currents in modern painting and sculpture, and within each current the approach taken by an artist can be realistic, nonrepresentational, or anywhere in between. The "ism" label we give him helps us pinpoint his style somewhere within this body of possibilities.

The three currents of modern art—Expression, Abstraction, and Fantasy—all began among the Post-Impressionists and underwent further development in this century. The "isms" that we group under Expression put great stress on the artist's emotional attitude, toward the world and toward himself. Those we group under Abstraction put stress on structure, on the organization of line, form, space, and color. And those we group under Fantasy put stress on the workings of the imagination. We should not forget, however, that feeling, structure, and imagination are present in every work of art. Without feeling, it could not move us; without some degree of structure, it would be chaotic; and without imagination, it would be boring.

EXPRESSIONISM

The opening years of the twentieth century saw the first public showings of Van Gogh, Gauguin, and Cézanne. Their works were a revelation to the young painters of Paris, a number of whom struck out freely along the new lines suggested by those nineteenth-century masters. In no time at all, they had outdistanced their models, developing a radical new Expressionist style full of violent color and bold distortion. They made their own first public appearance in 1905.

"Fauves (wild beasts)!" screamed the conservative critics. The artists did not mind in the least. They were, in fact, delighted. Accepting the label, they wore it with pride.

The leading member of the "wild beasts" was Henri Matisse, now recognized as one of the old masters of modern art. His large canvas *The Joy of Life* (figure 318), perhaps the most important picture of his long career, was the chief target of the outraged critics. More than any other one work, it sums up the whole spirit of Fauvism. Its flat, strong colors, dark, wavy contours, and "primitive" flavor come from Gauguin (see colorplate 66). The subject, too, suggests Gauguin's dream of man unspoiled—but the suggestion is misleading. We must look elsewhere for a source. These figures are not "noble savages" in a "state of nature." They are part of a classical,

318. Henri Matisse. *The Joy of Life.* 1905–6. Oil on canvas, 68½ × 93¾″. Barnes Foundation, Merion, Pennsylvania. Matisse's achievement is best summed up in his own words: "What I am after, above all, is expression . . . [But] . . . expression does not consist of the passion mirrored upon a human face . . . The whole arrangement of my picture is expressive. The placement of figures or objects, the empty spaces around them, the proportions—everything plays a part."

pagan scene, like Titian's *Bacchanal* (see colorplate 36). The figure poses are classical. The careless-looking draftsmanship is anything but careless: it shows a profound knowledge of the structure and workings of the human body.

What is revolutionary about this picture? Mainly, its extreme simplicity. Everything that an artist could leave out of a description of nature and still *be* describing nature has been left out. Space and form have been reduced to their essentials: a decorative pattern, an arrangement of lines and colors. "Expression," Matisse said, "does not consist of the passion mirrored upon a human face . . . The whole arrangement of my picture is expressive." But what does *The Joy of Life* express? The joy of life. Matisse was head over heels in love with the act of painting, and wanted the viewer to share in his own pleasure.

In *Harmony in Red* (colorplate 68), Matisse's interplay of flatness and depth becomes an astonishing drama. Here, the horizontal tablecloth and the vertical wall have the same flat blue-on-red pattern, but the artist distinguishes between what is vertical and what is horizontal all the same. Just as bold and just as readable is the window view of a tree-studded garden. The bright pink of the distant house is an echo of the bright pink in-

319. Georges Rouault. *Head of Christ*. 1905. Oil on paper (mounted on canvas), 45 × 31″. Collection Walter P. Chrysler, Jr., New York. Here the artist reveals himself as the true heir of Van Gogh and Gauguin in his anguish over the corrupt state of the world. He hoped for regeneration through a revitalized Catholic faith.

320. Georges Rouault. *The Old Clown*. 1917. Oil on canvas, 40 × 29¾″. Collection Mr. and Mrs. Stavros Niarchos, Paris. The defeated expression of this face recalls Daumier and Rembrandt; the bold, black outlines and flat areas of color suggest medieval stained glass.

side the red room. The blue of the sky, the green tones of grass and shrubbery, the bright yellow dots (for flowers), are also echoes of shapes and colors in the foreground. Matisse's genius for omission is again at work. By reducing the colors to a few clear, strong tones, he makes them important in themselves, frees them from the job of describing nature. The colors are so important in *Harmony in Red* that a black-and-white reproduction of it would carry little meaning.

For another member of the Fauves, Georges Rouault, expression still meant "the passion mirrored upon a human face," as we see in his *Head of Christ* (figure 319). But the ex-

pressiveness of this picture is not a matter of facial expression alone. The savage, slashing strokes of the brush are outward testimony of the artist's anger and compassion. Rouault, like Van Gogh and Gauguin before him, was deeply troubled over the corrupt state of the world. He had hopes for the renewal of society through a rebirth of the Christian spirit of the Middle Ages. Trained in his youth as a worker in stained glass, he was better prepared than the other Fauves to accept Gauguin's enthusiasm for medieval art. Rouault's late paintings, for example *The Old Clown* (figure 320), are made up of areas of glowing color outlined by heavy black borders in the

manner of Gothic stained-glass windows (compare figure 137). Here the mood of resignation and inner suffering reminds us of Rembrandt and Daumier.

The new style of the Fauves had a particularly strong echo in Germany and Austria, where it touched off a similar movement: German Expressionism. Max Beckmann, the most powerful of the German Expressionists, was also the latest. World War I left him with

a deep sense of despair for the future of the world, a despair mirrored in his pictures. *The Dream* (figure 323) is a mocking nightmare, a tilted, zigzag world crammed with puppet-like figures. As disturbing as Bosch's *Hell* (see figure 156), it is equally hard to understand. But Beckmann, unlike Bosch, created his own private symbols.

The most daring Expressionist advance beyond Fauvism was taken by Wassily

321. Chaim Soutine. *Dead Fowl*. About 1926. Oil on canvas, 38½ × 24½″. The Art Institute of Chicago. Joseph Winterbotham Collection. The only artist in Paris to follow Rouault's lead was Chaim Soutine, an immigrant from Eastern Europe. Although the picture is a still life, the dead bird, through its resemblance to a human shape, is a terrifying symbol of death. For sheer anguish and tempestuous brushwork this artist has few equals.

322. Oskar Kokoschka. *Self-Portrait*. 1913. Oil on canvas, 32 × 19½″. The Museum of Modern Art, New York. Purchase. The most memorable works of this Austrian Expressionist are the portraits painted before World War I. This self-portrait shows us the artist as a seer, a witness to the truth of his own inner visions (compare figure 309).

323. Max Beckmann. *The Dream*. 1921. Oil on canvas, 71 × 35″.
Collection Morton D. May, St. Louis, Missouri. Beckmann
saw the present-day world as a nightmare. For him, these
grotesque and sinister images from his dreams represented
the true nature of modern man.

than his forms, for example, *Sketch I for "Composition VII"* (colorplate 69). Not everyone can respond to such works naturally and easily, and no one can be certain about what they express. But the excitement and freshness of colorplate 69 does not fail to make a powerful impression upon us.

ABSTRACTION

Kandinsky's nonrepresentational art joins Expression to Abstraction, the second of our three currents. The painting we have just seen is abstract in a special sense, however, for nature disappears altogether. We usually use the word "abstract" to mean that natural forms have been reduced to basic, fundamental shapes—for example, to Cézanne's "cone, sphere, and cylinder." Some abstraction, of course, goes into the making of any work of art, whether or not the artist is aware of it. The ancient Egyptian muralist who drew the little stick men of figure 17 did not realize that he was abstracting, nor did the Greek potter who made the Geometric vase in figure 45. Artists began to abstract in a controlled and self-conscious way only during the Renaissance. Renaissance artists found that the shapes of nature were easier for the eye to grasp when translated into the simple, regular shapes of geometry (see figures 175 and 176). Cézanne and Seurat went even further than Renaissance painters in simplifying nature to geometry, becoming the founding fathers of modern Abstraction.

Toward 1906, Picasso turned away from the poetic, melancholy style of his Blue Period and began to work more in the manner of Cézanne. Within a year, he had taken a great leap beyond Cézanne, and a style called Cubism burst upon a startled world. *Demoiselles d'Avignon* (figure 325) was so challenging that it shocked even Matisse. It is a composition of one still life and five nudes. And what

324. José Clemente Orozco. *Victims* (detail from a mural cycle). 1936. University of Guadalajara, Mexico. During the 1920s and 30s, the center of Expressionism in the New World was Mexico. Orozco's art, shaped by the Mexican Revolution, springs from a deep sympathy with the silent, suffering masses.

Kandinsky, a Russian working in Germany. Beginning in 1910, Kandinsky threw representation overboard. Using the full-strength colors and free, bold brushwork of the Fauves, he created shapes and patterns that resembled nothing in nature, charging form and color with (as he put it) a purely spiritual meaning. Whistler, too, had spoken of "divesting the picture from any outside sort of interest." The liberating influence of the Fauves enabled Kandinsky to put this theoretical principle into actual practice. Kandinsky's titles for his pictures had no more connection with nature

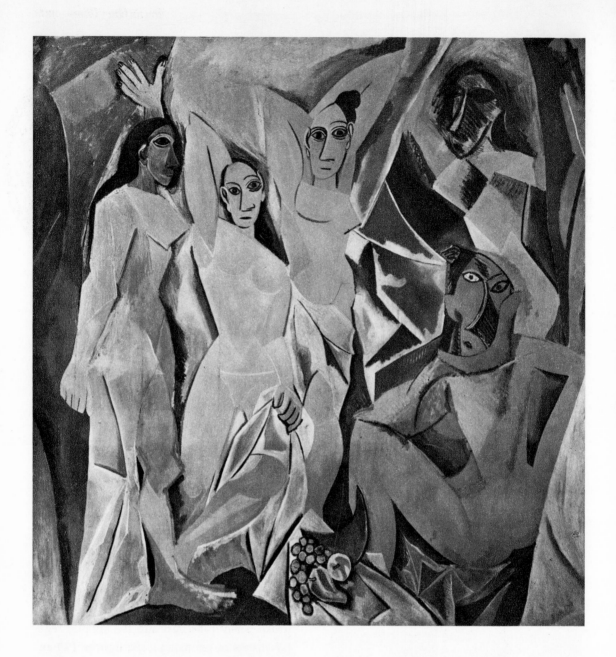

325. Pablo Picasso. *Demoiselles d'Avignon*. 1906–7. Oil on canvas, $96 \times 92''$. The Museum of Modern Art, New York. Acquired through the Lillie P. Bliss Bequest. This work marked a great breakthrough in modern art. Announcing the arrival of Cubism, it proclaimed the end of the Renaissance tradition.

nudes! The three on the left are angular distortions of classical figures. The two on the right are violently dislocated in feature and body; they have the barbaric qualities of primitive art (compare figures 9–16). The Fauves, following Gauguin's lead, had discovered the aesthetic appeal of African sculpture and had introduced Picasso to it. But Picasso, not the Fauves, used primitive art as a battering ram against classical ideas of beauty. Not only are the proportions of the human body violated here, but its unity and its structural connections; the canvas (as one critic aptly said) "resembles a field of broken glass." Picasso, then, was destroying a great deal. Was he also creating something to take its place? Once we recover from our first shock, we begin to see that he was. Everything—figures and setting —is broken up into angular wedges or facets.

They are not flat, but shaded in a way that makes them somehow three-dimensional. We are not always sure whether they are concave or convex; some look like chunks of frozen space, others like fragments of transparent forms. They seem to be made of a new kind of matter, and they enter into combinations that make the canvas connected and unified in a new way. We do not read the *Demoiselles* as an image of the world outside us. We read it as a new world, something like ours but constructed along different lines.

By 1910, Cubism was well established as a sister style to Fauvism. Notable among the artists who took up Cubism was Georges

327. Pablo Picasso. *Still Life with Chair Caning.* 1911–12. Oil on canvas and collage, 10½ × 13¾". Collection the Artist. Here we witness the beginnings of another breakthrough, heralding the end of facet Cubism. The canvas is about to become a tray on which the still life is "served" to us.

Braque, who worked so closely with Picasso during the next few years that the output of the two men is hard to tell apart. Picasso abandoned the violence of the *Demoiselles* and began to explore his new-found land calmly and systematically; Braque worked side by side with him at the same task. Now, around 1912, they brought Cubism to its second stage, which was even bolder than the first.

We see the beginnings of the second stage of Cubism in Picasso's *Still Life with Chair Caning* (figure 327). Here everything is broken up into angles and planes except the three letters of the alphabet (whose forms cannot be made any more abstract than they are to begin with). But how do we explain the piece of imitation chair caning pasted into the picture? Why the oval shape, and why the piece of rope instead of a frame? Picasso apparently wished to make this painting look like a tray on which the still life is served to us, as it were. He had the rather witty notion of putting painted abstract shapes of things on

326. Pablo Picasso. *Nude.* 1910. Charcoal drawing. Collection Alfred Stieglitz Estate. The violence of the *Demoiselles d'Avignon* has given way to calm and methodical exploration of the new structural devices of Cubism.

right:

328. Georges Braque. *Le Courrier*. 1913. Collage, 20 × 22½″. The Philadelphia Museum of Art. A. E. Gallatin Collection. Such paste-ups, of which both Picasso and Braque did many in 1913 and 1914, demonstrate the importance of the "tray" idea met in figure 327.

below:

329. Pablo Picasso. *Three Musicians*. 1921. Oil on canvas, 79 × 87¾″. The Museum of Modern Art, New York. Mrs. Simon Guggenheim Fund. Here traditional figures of the comedy stage are put into the language of collage Cubism. Their human presence is felt behind the patchwork of costumes and masks.

top of real things, such as canvas, chair caning, and rope. And whether or not he realized it there and then, he had begun to invent a new visual language.

The next step in the developing new language can be seen in Braque's still life *Le Courrier* (figure 328). Here the main parts of the picture are pasted together out of odd bits of paper and other materials, with only a few drawn lines added to complete the design. We see strips of imitation wood graining, part of a tobacco wrapper with a contrasting stamp, half the masthead of a newspaper, and a bit of newsprint made over into a playing card—the ace of hearts. This technique came to be known as *collage*—which is the French word for "paste-up."

Why did Picasso and Braque all of a sudden prefer the contents of the wastebasket to brush and paint? Wanting to explore the new idea of the picture-as-a-tray, they found putting real things on the "tray" the best way of doing it. The elements of a collage play two parts at the same time. Put together and then drawn or painted on, they describe something, creating a new identity. At the same time, they keep their old identity as tobacco wrappers and scraps of newsprint. What is real in such a work, and what is a representation? Each is the other. The real and the represented are interwoven in an extraordinary way. The collage, thus, is far more a world in itself than a first-stage, facet-Cubist work can ever be.

The difference between the first and second stages of Cubism has another aspect. The two stages belong to different realms of space. Facet Cubism retained a certain amount of depth. The painted surface was still something of a window through which we could see bits and pieces of the familiar perspective space of the Renaissance. In collage Cubism, on the other hand, the picture surface is the *back* of the picture space. Space is not created by modeling, foreshortening, mathematical perspective, and similar devices. It is a nonperspec-tive space, created by the overlapping and interweaving of layers of actual material. Collage Cubism, then, gives us a new basic space concept, the first since Masaccio. It is a true landmark in the history of painting.

Soon Picasso and Braque took the final step in their new language. They created the new pictorial space without using pasted materials, painting as though they were making collages. Picasso's *Three Musicians* (figure 329) shows us this technique, which is carried through with absolute consistency. This painting is one of the great masterpieces of modern times. It has both the size and the feeling of a big mural; its precisely "cut" shapes are fitted together as firmly as building blocks. The artist's major concern was not pattern—if it had been, we would be looking at a patchwork quilt—but the image of the three seated, masked figures, whose human presence we sense behind the costumes and the masks. If we now turn back to Manet's *Fifer* of color-plate 60, does not this musician of 1866 strike us as the true ancestor of Picasso's three musicians of 1921? He should; such shadow-less paintings touched off the revolution of the color patch, which had its final triumph in collage Cubism.

For a man like Picasso there could be no standing still. Once he and Braque had worked out collage Cubism, he returned to representation. By 1920 he was working in two separate styles at one and the same time. The "Neoclassic" *Mother and Child* of figure 330 was done in the same year as *Three Musicians*. Here the bodies are as rounded and heavy as carved stone, but they belong to the warm, human world of the Blue Period (see figure 314). To many of Picasso's admirers, such paintings seemed almost a betrayal, but the artist, chafing at the limitations of collage Cubism, felt the need of renewing his contact with "the art of the museums." A few years later the two tracks of his style merged. *Three Dancers* (colorplate 70) of 1925 shows

330. Pablo Picasso. *Mother and Child*. 1921–22. Oil on canvas, 38 × 28″. The Alex Hillman Corporation, New York. Picasso's revived interest in representation during and after World War I here reaches its "Neoclassic" climax.

how he accomplished this seemingly impossible feat.

In structure, *Three Dancers* is pure collage Cubism. We see painted imitations of patterned wallpaper and various fabrics cut out with pinking shears. The figures present a wildly fantastic version of a classical scheme (compare the dancers in Matisse's *Joy of Life*). They are an even more violent assault on convention than the figures of *Demoiselles d'Avignon*. Human anatomy here is simply raw material for Picasso's incredibly nimble imagination. Limbs, breasts, and faces get the same high-handed treatment as the tobacco wrapper and scraps of newsprint in Braque's *Le Courrier*. Their original identity hardly matters: breasts turn into eyes; profiles merge with frontal views; shadow becomes

substance, and substance, shadow. The flow of surprise transformations is endless. We are given visual puns with a remarkable range of expressive power: they can be humorous, grotesque, sinister, even tragic.

The new style announced in *Three Dancers* rose to grandeur in Picasso's *Guernica* (figure 331), painted in 1937. Unconcerned with politics before the 1930s, Picasso took the part of the Loyalists during the Spanish Civil War. His mural, painted for the pavilion of the Spanish Republic at the Paris International Exposition, was inspired by the terror bombing of Guernica, the ancient capital of the

331. Pablo Picasso. *Guernica*. 1937. Oil on canvas, 11′ 6″ × 25′ 8″. The Museum of Modern Art, New York. On indefinite loan from the Artist. Images of the agony of total war in the cut-out forms of black, white, and gray collage Cubism.

Basques in Northern Spain. It does not describe the event itself, but in a series of powerful images evokes the agony of total war. The destruction of Guernica was the first saturation bombing of a civilian population center, a preview of the huge-scale saturation bombings of World War II. *Guernica* was thus a prophetic vision of doom—the doom that hangs over us more ominously still in this age of nuclear warfare. Some of *Guernica's* symbolism is obscure, but not all: the mother lamenting her dead child is a descendant of the Pietà (see figure 133); the woman with the lamp recalls the Statue of Liberty; the warrior clutching a broken sword in one hand is a familar symbol of heroic resistance. The woman in flames speaks for herself. The menacing bull surely represents the powers of darkness and evil. The agonized horse—is it

Spain?—is dying, but a bird, ancient symbol of the soul and immortality (see figure 10 and page 16), issues from its open mouth. These figures owe their terrifying eloquence to what they are, not to what they refer to. Everything that seemed so willful and fantastic in *Three Dancers*—distortions, dislocations, transformations, and fragmentations—now expresses a stark reality: unbearable pain. In Picasso's hands, flat "cutouts" of black, white, and gray can carry overpowering emotion.

Meanwhile, Cubism had spread its influence far and wide, not only in painting, but also in sculpture, the decorative arts, and architecture. To many painters, Cubism seemed to be in tune with science and engineering—the only style for putting the new surroundings of the modern era down on

right:

332. Joseph Stella. *Brooklyn Bridge*. 1917. Oil on
canvas, 84 × 76″. Yale University Art Gallery,
New Haven, Connecticut. Collection of the
Société Anonyme. A maze of cables compacted
into a rousing vision of the dynamic modern
world by an Italian-American linked with
Futurism.

below right:

333. Charles Demuth. *My Egypt*. About 1927. Oil
on composition board, 35¾ × 30″. Whitney
Museum of American Art, New York. Demuth,
like talented young artists from many coun-
tries, went to Paris before World War I. His
personal response to Cubism took shape some
years later.

canvas. The short-lived Italian Futurist
movement made almost a religion of this at-
titude. Its founders issued a manifesto in
1910, rejecting the past in violent terms and
exalting war, speed, and the beauty of ma-
chines. Echoes of Futurism appear in *Brooklyn
Bridge* (figure 332) by Joseph Stella, an
American painter born in Italy. With its
glowing maze of cables, vigorous diagonal
thrusts, and crystalline "cells" of space, this
painting is a hymn to the dynamic environ-
ment of the modern city. Another American,
Charles Demuth, paid tribute to the American
industrial landscape in *My Egypt* (figure
333). Demuth sought to bring out the force
and majesty of factories and silos. He saw
them as the pyramids of modern times. *The
City* (figure 334), by the Frenchman Fernand
Léger, shows us a beautifully controlled in-
dustrial landscape, full of the poetry the artist
found in the clean, geometric shapes of modern
engineering. Its optimism and pleasurable
excitement conjure up a smoothly whirring
mechanized heaven.

Cubism as dynamic as Joseph Stella's can
be seen in the early work of the German
painter and printmaker George Grosz. At
the end of World War I, Grosz developed a
bitter, savagely satiric style to express the
disillusionment of his generation. In *Germany,*

above:

334. Fernand Léger. *The City*. 1919. Oil
on canvas, 91 × 117½". The Phila-
delphia Museum of Art. A. E. Gal-
latin Collection. Léger's Cubism pro-
claims his love of the clean geometric
shapes of modern machines and en-
gineering. *The City* is a vivid kalei-
doscopic image of our mechanical
civilization, full of optimism and
pleasurable excitement—stable and
controlled in spite of the crowding
and the broken forms.

left:

335. George Grosz. *Germany, a Winter's
Tale*. 1918. Oil on canvas. Formerly
Collection Garvens, Hanover, Ger-
many. A savage criticism of German
society expressed in the visual lan-
guage of Cubism.

336. Piet Mondrian. *Broadway Boogie-Woogie.*
1941–42. Oil on canvas, 50 × 50″. The Museum
of Modern Art, New York. A picture full of
life and movement in spite of its severely re-
stricted vocabulary of shapes. The tingling
staccato rhythm of the design captures the very
qualities suggested by the musical title.

a Winter's Tale (figure 335), the city of
Berlin becomes a helter-skelter background
for a number of large figures imposed upon
it like the pasted cutouts of a collage: the
marionette-like Berlin citizen at the center,

and, below, the sinister forces that have made
him what he is—a hypocritical clergyman, a
ramrod of a general, a brutal schoolmaster.

The dean of Abstraction in our time was a
Dutchman nine years Picasso's senior, Piet
Mondrian, who painted *Broadway Boogie-
Woogie* (figure 336) shortly before his death
in this country. Mondrian was the strictest
and most architectural of all the abstraction-
ists. His pictures are composed entirely of
vertical and horizontal lines and solid squares
and rectangles. It might be thought that a

language with so limited a vocabulary would not enable its user to say very much. In fact, however, *Broadway Boogie-Woogie* has a spine-tingling liveliness unmatched by any other painting in this book. The entire design moves to the pulse beat of the big city—its grid of streets and winking traffic lights, flashing neon signs, and stop-and-go traffic.

FANTASY

The one thing all painters of fantasy have in common is the belief that seeing with "the inner eye" of the imagination is more impor-

tant than observing the world. A minor current in nineteenth-century painting—we saw it taking shape in the art of Goya (see figure 273)—private fantasy is of major importance today.

Private art, by definition, is not public. An artist's way of telling us about his inner world has to be personal and unique. How *can* he tell us about his own world of daydreams and nightmares? Why should he want to? And how can what he has to say about it mean anything to us? Aren't our private worlds bound to be different from his?

The more we learn about the deep workings

337. Giorgio de Chirico. *Mystery and Melancholy of a Street.* 1914. Oil on canvas, 33½ × 27¼". Collection Mr. and Mrs. Stanley R. Resor, New Canaan, Connecticut. In De Chirico's ominous dream world every object is a disquieting portent of the unknown.

338. Marc Chagall. *I and the Village*. 1911. Oil on canvas, 75½ × 59½".
The Museum of Modern Art, New York. Mrs. Simon Guggenheim
Fund. In pictures such as this, done soon after his arrival in Paris,
the young Russian-Jewish artist used the devices of Cubism to build
a personal world of dream and memory images.

of the human mind, the clearer it becomes that we are all cut on the same mental pattern. Our imaginations and memories work in much the same way. They belong to the unconscious part of the mind; our experiences are stored there. We cannot control the unconscious part of us at will; but when we are lying in bed, or when we are thinking of nothing in particular, experiences come back to us, and we seem to live through them again. They do not necessarily come back the way they actually happened; the unconscious

likes to disguise them as dream images—in this form they are less vivid and can be lived with more easily.

We are always interested in learning about imaginary things, especially when the person who tells us about them knows how to make them seem real. Put in the language of the daily newspaper, what happens in a fairy tale would seem absurd. Told in an opera or ballet as it should be told, it enchants us. This is just as true in painting, as witness Rousseau's *Dream* (colorplate 67).

Mystery and Melancholy of a Street (figure 337), by the Italian painter Giorgio de Chirico, comes close to the imaginary reality of *The Dream*. In a deserted moonlit square with endlessly diminishing arcades, a child rolls her hoop toward a shadow in the distance. The scene is poetic, but strangely sinister. The unknown is lying in wait.

If De Chirico's painting is troubled by hidden fears, Marc Chagall's *I and the Village* (figure 338) is enchantingly gay. In this Cubist fairy tale, dreamlike memories of Russian folk stories and the Russian countryside are woven into a glowing vision. Chagall here relives childhood experiences so important to him that his imagination shaped and reshaped them year after year.

The fairy tales of the Swiss painter Paul Klee may strike us as rather childlike. Let us not deceive ourselves, however—in all history, very few works of art have been quite so controlled and purposeful. Deriving equal inspiration from Cubist painting, primitive art, comic strips, and the drawings of small children, Klee created a deft new language of his own. The few simple lines in *Twittering Machine* (figure 339) build a wispy device that imitates the sound of birds when a crank is turned. Is this little contraption an innocent toy? Not too innocent. The resemblance of the heads of the four sham birds to the lures that fisherman use is unmistakable. These birds are decoys! Quietly, gently, this subtlest of artists

has condensed a world of ideas into one striking invention, a witty model of machine-age civilization. He mocks our faith in technical miracles and exposes the love we profess for nature's miracles—birdsong, for example— as sentimental hypocrisy and the kiss of death. The simplicity, precision, and seeming innocence with which he does this are nothing short of miraculous.

Toward the end of his life, Klee buried himself in the study of hieroglyphs, hex signs, and the mysterious markings in prehistoric caves—all boiled-down images that appealed to him because they had the very qualities he himself strove for. Just as a lyric poet sums up a wealth of feeling in a few words of the

339. Paul Klee. *Twittering Machine.* 1922. Watercolor, pen and ink, 16¼ × 12″. The Museum of Modern Art, New York. Purchase. The laughter here may be directed against our sentimental attachment to birdnotes in song and story as well as against our faith in mechanical inventions.

plainest kind, Klee, in colorplate 71, *Park near L(ucerne)*, uses a few deceptively simple signs to sum up the freshness of all spring and the manicured order of a city park in Switzerland. Only one other painter, the American Mark Tobey, has developed a picture-writing style like Klee's. Tobey's personal signs are more like Chinese writing; in *1951* (figure 340), these signs are suspended in space, like stars against the night sky.

The Bride (figure 341) is a work of fantasy painted on the eve of World War I by the Frenchman Marcel Duchamp. Its dynamic facet-Cubist style reminds us of Joseph Stella's Futurism—but Duchamp is denouncing the machine, not glorifying it. The bride he shows us bears no resemblance to a human being; she—or it—is a complicated piece of plumbing. Beautifully engineered and serving no purpose whatever, this apparatus is the exact opposite of Klee's twittering machine. Our civilization, Duchamp is saying, robs us of humanity and turns us into busy, purposeless, chrome-plated nothings.

It is hardly surprising that the mechanized butchery of World War I filled Duchamp with black despair. Halfway through the war he joined with other artists—neutrals and men from both warring camps alike— to form the Dada movement. Dada was a great cry of protest. Its message: all historic European values were now empty of meaning. Its art: spur-of-the moment gestures intended to defy all accepted principles of taste and reason. Duchamp would add his signature and an impudent title to a ready-made object and exhibit it as a work of art: a snow shovel, a handsomely mustached reproduction of Leonardo's *Mona Lisa*. Not even modern art was safe; one Dadaist exhibited a toy monkey inside a frame and called it "Portrait of Cézanne." On the other hand, the Dadaists took over modern-art techniques when it served their purpose. Max Ernst, a German and Duchamp's associate, made bitter use of collage Cubism in *1 Copper Plate 1 Zinc Plate 1 Rubber Cloth 2 Calipers 1 Drainpipe Telescope 1 Piping Man* (figure 342). Pasting together snips of illustrations of machinery and other technical equipment, he invented a nightmarish couple. They stare at us blindly through their huge goggles, demanding recognition as true images of modern man.

340. Mark Tobey. *1951*. 1951. Oil on canvas, 43¾ × 27¾". Collection Joseph R. Shapiro, Oak Park, Illinois. Mark Tobey, an American, is the only painter who has developed a picture-writing style comparable to Klee's.

to set his imagination going by seeing images in "blotscapes," and then adding missing details so that other men could see them, too (compare figure 1). The Surrealists now made similar use of chance effects, and many of their pictures have the strange, irrational quality of dreams.

Max Ernst was the most inventive member of the group. Ernst often combined collage with rubbings from pressed flowers and pieces of wood—we all know the process, because all of us as children have rubbed a pencil point over a piece of paper placed on top of a coin. In *Totem and Taboo* (figure 343), Ernst applied oil paint to various materials and then

below:

342. Max Ernst. *1 Copper Plate 1 Zinc Plate 1 Rubber Cloth 2 Calipers 1 Drainpipe Telescope 1 Piping Man.* 1920. Collage, 12 × 9″. Collection Mme. Arp-Hagenbach, Meudon, France. The bitterness of this Dadaist invention is summed up in the title. The artist probably intended to add the woman to his list but ran out of space.

above:

341. Marcel Duchamp. *The Bride.* 1912. Oil on canvas, 34¾ × 21½″. The Philadelphia Museum of Art. Louise and Walter Arensberg Collection. This complicated and beautifully engineered apparatus that serves no purpose is, like Klee's *Twittering Machine* (figure 339), a mocking commentary on the machine age, which, the artist says, robs us of our humanity.

But the Dada movement was not all negative. It gave artists who wished it the opportunity to explore new realms of the human mind. A new movement, Surrealism, succeeded Dada in 1924. Its leading spirits sought to give the imagination free rein through bypassing the conscious reasoning part of the mind and letting the instinctive, unconscious part take over. In the late eighteenth century the English Romantic artist Alexander Cozens (see figure 281) had tried

right:

343. Max Ernst. *Totem and Taboo*. 1941. Oil on canvas, 28 × 36″. Private collection. Ernst has been the leading spirit of the Surrealist movement. A luxuriant, sinister world of plant and animal life seems to grow before our eyes, born of accidental effects similar to Alexander Cozens' ink blots (see figure 281) but far more imaginatively handled.

transferred the paint to his canvas by rubbing, obtaining fascinating shapes and textures. He then completed images he had found on the canvas, letting his imagination run riot. Salvador Dali employed Ernst's technique with great skill in the drawing *Return of Ulysses* (figure 344), where he fastened upon chance effects and made them over into an imaginary reality.

Surrealism has a more boldly imaginative branch as well, led by the Spanish painter Joan Miró, who painted the striking *Composition* (figure 345). Its fluid and curving forms are like living creatures. They seem to

below:

344. Salvador Dali. *Return of Ulysses*. 1936. Ink blots, brush, and pen drawing, 9⅜ × 14½″. Private collection, New York. Dali shows us how our unconscious fastens upon the accidents of technique and transforms them into imaginary reality. Such drawings have an appeal missing in his paintings, where he covers his tracks so thoroughly that we cannot follow his creative process.

345. Joan Miró. *Composition*. 1933. Oil on canvas,
51¼ × 63½". Wadsworth Atheneum, Hartford,
Connecticut. Here the artist presents us with a
strange interior world full of forms that float,
wave, and wriggle in delightful unreason.

346. Jackson Pollock. *One*. 1950. Oil on canvas,
8'10" × 17' 5⅝". Collection Mr. and Mrs. Ben
Heller, New York (see also colorplate 72). Ab-
stract Expressionism was the dominant style of
the 1950s, and Jackson Pollock was its foremost
exponent. In works like this he achieved surfaces
of unprecedented life and richness.

change before our eyes, expanding and con-
tracting like the wriggling things we see
under a microscope. But they look almost
human, too, and even take on individual
personalities. Miró's mysterious interior
world is serene in spirit and designed with
painstaking care. The artist had been one of
the most disciplined of Cubists before he
discovered this new realm of fantasy.

NEWER TRENDS

From the end of World War II to the early
1960s, painting was dominated by the style
often labeled Abstract Expressionism. This
style is abstract only in the special sense of
Kandinsky's art: it is nonrepresentational.
One of its originators, the American Jackson
Pollock, did the huge painting entitled *One*
(figure 346, colorplate 72) mainly by pouring
and spattering colors instead of applying them
with a brush. The result reminds us not only
of Kandinsky's nonrepresentational Expres-
sionism, but also of Max Ernst's Surrealist
chance effects. These sources, however, do not

account for Pollock's revolutionary technique nor for the emotional appeal of his work. Why did he "fling a pot of paint in the public's face"—to use the words that Ruskin flung at Whistler?

Pollock thought of paint as energy to be released, not as inert material to be worked and handled. He did not work the paint; he aimed it and let it go. The result depended on the nature of his process and materials: the thickness of the paint, the direction in which he threw it, the speed with which it hit the canvas, the way it acted on the paint already there. The surface Pollock created in this way was amazingly alive, rich, and appealing to the senses.

Pollock did not leave everything to chance. He was inside the process from beginning to end. He himself was the energy source for the forces he released, and he rode them the way a cowboy rides a bucking bronco. He did not always stay in the saddle, but he found the exhilaration of that exacting contest well worth its cost. No painter before Pollock was so thoroughly committed to the *act* of painting. Pollock's enormous canvases allowed him to paint not merely with hand and arm action but with the motion of his whole body. "Action Painting," the term coined for this style in the 1950s, is a far more meaningful label than "Abstract Expressionism."

In the 1960s, Action Painting was joined by newer trends. The most important was "Pop Art," an example of which we see in Roy Lichtenstein's *Girl at Piano* (figure 347, colorplate 73). This work is like a tremendously enlarged single frame from a comic strip. The artist painstakingly imitates the coarse dots of the engraving process used in printing comic books. Far from proclaiming the virtues of mass-level graphic art, Lichtenstein is really looking with disenchantment at all modern mass communication, not only comic strips but also consumer advertisements, packaging, and television. "Pop" may

347. Roy Lichtenstein. *Girl at Piano*. 1963. Magna on canvas, 68 × 48″. Harry N. Abrams Family Collection, New York (see also colorplate 73). In its concern with "low-brow" commercial art, hitherto spurned as vulgar by "high-brow" culture, sophisticated Pop Artists such as Lichtenstein acknowledge the importance of our everyday visual environment as the raw material of aesthetic experience.

be a convenient label for such work, but there is nothing naïve or simple about Lichtenstein and other Pop artists. A crisis of representational art exists today, and Pop Art asks important questions: what is the meaning of representation? where does it begin and end? is there value to representational pictures that throw out traditional concepts of form and color? In grappling with these issues, Pop artists may well have opened up interesting lines of development for art in the future.

SCULPTURE

The sculptors of the twentieth century developed along much the same lines as the painters. Of the three currents we have traced, Expressionism had the least importance for sculpture. It is hard to say why this should have been so, for the enthusiasm of the Fauves for primitive sculpture might be expected to have aroused even greater enthusiasm among sculptors. One important sculptor turned his gaze on primitive art: Constantin Brancusi, a Rumanian who came to Paris in 1904. The savage expressiveness of primitive carvings, however, interested Brancusi far less than their simplicity and directness. His *Kiss* (figure 348) is compact and self-sufficient beyond anything even dreamed of by Maillol (compare figure 315). The basic shape of the stone block has been disturbed as little as possible, and the embracing lovers have been distinguished from each other only enough so that we can identify them as man and woman. Rather than primitive, this work looks primeval, as though it came from the first age of creation.

Brancusi's "primevalism" was the starting point of a sculptural tradition still going on. It has appealed to English sculptors particularly, as we may see in Henry Moore's *Recumbent Figure* (figure 349). More abstract than *The Kiss* and more subtly shaped, Moore's statue also is more human and more individual. And it seems, almost, to have been produced through the wearing away of stone by the winds and waters of the centuries, rather than by human tools and muscle power. Its design flows along in perfect harmony with the ridges and grooves of the natural layers of the stone.

Long before Moore carved this majestic and mysterious figure, Brancusi had taken his second daring step. Keeping his primeval style for works in wood or rough stone, he had begun to produce nonrepresentational pieces

348. Constantin Brancusi. *The Kiss*. 1908. Height 22¾″. The Philadelphia Museum of Art. Louise and Walter Arensberg Collection. Brancusi has a genius of omission not unlike Matisse's. The description of human form is reduced to terms that will not interfere with the artist's conception of a monument as a slab—upright, symmetrical, immobile.

in metal or polished marble. They were even simpler in shape than *The Kiss*. *Bird in Space* (figure 350) is not an abstract image of a bird. It is the trace of a bird moving through space —flight made visible.

The metal of which Brancusi made this shape has a mirror polish, so that the surface reflects its surroundings. The entire object loses all suggestion of solidity and substance,

349. Henry Moore. *Recumbent Figure*. 1938. Green Horton stone, length about 54". The Tate Gallery, London. Brancusi's primevalism was the starting point of the tradition to which this work belongs. It seems almost to have been produced by a process of nature.

and we see it as a gleaming piece of shaped space set inside the free space that surrounds us also.

Toward the end of World War I, a group of Russian artists, who came to be known as Constructivists, tackled the problems of Cubist sculpture. Antoine Pevsner's *Torso* (figure 351) is a kind of three-dimensional collage made of cutouts of sheet copper and clear celluloid, first bent and curved and then put together. The machine-like precision of its shapes reminds us of Marcel Duchamp, for whom Pevsner had great admiration. In this

work, the figure of a woman has been broken up into airy, unsubstantial volumes bounded by curving surfaces and separated one from another by transparent celluloid partitions. Note how the artist has twisted three-dimensional space the way we often see flat sheets twisted: he has erased the usual distinction between convex and concave. In Pevsner's new sculptural language, as in that of Picasso's *Demoiselles d'Avignon*, a swelling is interchangeable with a cavity; both have the same meaning.

The influence of Dada and Surrealism on sculpture is clear in Ready-Mades (see pages 346–49)—or assemblages, as they are now called. We saw such a work in Picasso's *Bull's Head* (figure 2). Sculptors can use found objects as springboards for the imagination—if they have the imagination—but it is not very

Colorplate 68. Henri Matisse. *Harmony in Red (Red Room)*. 1908–9. Oil on canvas, 71¼ × 96⅞".
The Hermitage Museum, Leningrad

Colorplate 69. Wassily Kandinsky. *Sketch I for "Composition VII."* 1913. Oil on canvas, 30¾ × 39⅜".
Collection Felix Klee, Bern

Colorplate 70. Pablo Picasso. *Three Dancers*. 1925. Oil on canvas, 84½ × 56¼". Collection the
Artist

Colorplate 71. Paul Klee. *Park near L(ucerne)*. 1938. Oil on canvas, 39½ × 27½". Klee Foundation, Bern

Colorplate 72. Jackson Pollock. *One* (detail of figure 346)

Colorplate 73. Roy Lichtenstein. *Girl at Piano* (detail, actual size, of figure 347)

Colorplate 74. Alexander Calder. *Lobster Trap and Fish Tail*. 1939. Mobile; steel wire and sheet aluminum, more about 8′ 6″ × 9′ 6″. The Museum of Modern Art, New York. Gift of the Advisory Committee. Calder's contact with Surrealism helped him to realize the poetic possibilities of free movement as against controlled movement. The organic-looking forms stem from Joan Miró.

left:

350. Constantin Brancusi. *Bird in Space.* 1919. Bronze, height 54″. The Museum of Modern Art, New York. Anonymous Gift. No sculptor before Brancusi had set himself the task of shaping an image of space itself. Brancusi makes this shape look immaterial by giving it a mirror-like surface that denies its solidity.

below:

351. Antoine Pevsner. *Torso.* 1924–26. Plastic and copper, height 29½″. The Museum of Modern Art, New York. Katherine S. Dreier Bequest. The machine-like precision of these Cubist shapes suggests the influence of Futurism.

easy for them to come across chance effects when they use their own two hands to give shape to materials. The Swiss sculptor Alberto Giacometti has somehow managed to do this, however, in *The Palace at 4 A.M.* (figure 352), an eerie miniature world made of wood, wire, glass, and string. The space Giacometti defines here has strange properties: it has eaten away the forms till only skeletons have been left. These too, we feel, will soon disappear.

One of the triumphs of twentieth-century vision is sculpture that adds the extra dimension of time to an art that formerly had only three dimensions. Mobiles, as such works are called, were first created in the 1930s by the American Alexander Calder, and bear the same relation to previous sculptures as motion pictures to still photographs. Calder's *Lobster Trap and Fish Tail* (colorplate 74) is a huge construction of sheet-metal shapes suspended on wires. The shapes remind us unmistakably of Joan Miró's strange, poetic creatures. This work, despite its great size, is so delicately balanced that it sails gracefully round and round with the slightest breath of air—unpredictable, ever-changing, shifting from one pattern to another with the natural, fluid movement of leaves in the wind or marine animals floating in the sea. Though manmade, it seems alive.

TWENTIETH-CENTURY ARCHITECTURE

Of all the arts in our day, architecture displays the most optimism and confidence. For more than a century, most painters and sculptors have found it hard to accept their own civilization. The rhythms of the machine are not the rhythms of people. The arrival of mechanized industry and mass production seemed to turn men into machines: it imposed a machine-like regularity upon their comings and goings; it turned the making of things into repetitious drudgery. Factory chimneys

352. Alberto Giacometti. *The Palace at 4 A.M.* 1932–33. Construction in wood, glass, wire, and string, height 25″. The Museum of Modern Art, New York. Purchase. This airy cage is the three-dimensional equivalent of a Surrealist picture.

polluted the air; and slums grew faster than avenues and parks. Painters and sculptors were offended by the ugliness with which humanity surrounded itself, and they feared the loss of their own human identity—more precious to the creative personality than to any other. Architects came to terms with the industrial era perforce. To provide man-made surroundings for men's activities was their profession, and they had to use the new techniques and materials placed at their disposal by engineers and manufacturers. Forward-looking architects could see the positive side of machine civilization: its potential of a better life for men, its opportunities for new visual poetry.

We saw the first stirrings of a new architectural vision in the pioneering work of Henri Labrouste (see page 291). In the 1880s, Henry Hobson Richardson, an American architect who had worked for Labrouste in Paris during the 1860s, moved from Boston to Chicago, then the most rapidly developing metropolis in either hemisphere. Richardson

built commercial buildings of unprecedented dignity, simplicity, and strength. In style, they were still attached to the past. But they also looked forward to the future; and in 1890 a new architectural tradition was born, in Chicago, on the drawing board of Richardson's great pupil Louis Sullivan—the first modern architect.

The Wainwright Building in St. Louis (figure 353) was Sullivan's first skyscraper and an embodiment of his famous creed, "Form follows function." The beautifully organized exterior, here, expresses the structure of the steel cage it sheaths: rows of windows have opened up the walls almost completely; between the windows, tall vertical strips rise from the third story almost to the top.

Sullivan's brilliant disciple Frank Lloyd Wright invented a remarkable "Cubist" architectural style between 1900 and 1910— even earlier than Picasso's development of Cubist painting in Paris. Wright's main activity in those years was the design of suburban houses in the Chicago area. These were known as Prairie Houses, because their low, horizontal lines were intended to blend with the flat Illinois landscape. The last and most masterful of the series was the Robie House (figures 354 and 355). The Cubism of the

353. Louis Sullivan. Wainwright Building, St. Louis, Missouri. 1890–91. This building embodies Sullivan's famous credo, "form follows function." The building is shaped by its purpose, and makes full and frank use of modern materials and construction methods.

Robie House is a matter not merely of the clean-cut rectangles of which the building is composed, but also—and particularly—of Wright's handling of space. Blocks of space are wrapped around a central core of stairs and fireplace. Some of the blocks of space are open; some are closed. All are precisely defined. Thus the large space that the architect has broken into smaller spaces includes balconies, terrace, court, and garden, as well as the house itself. Exterior spaces and interior spaces flow together. Wright's aim was to design a complete environment. He even took command of the details of the interior, designing stained glass, fabrics, and furniture. Wright was firmly convinced that houses profoundly influence the people who live in

them. The architect, he believed, molded humanity.

Wright's Prairie Style attracted even more attention in Europe than in America, inspiring Dutch architecture as early as 1914 and becoming the basis of the International Style of all Europe in the 1920s. The largest and most complex group of buildings in the International Style was the Bauhaus, a famous school of art and design in Dessau, Germany. Walter Gropius, the architect of the Bauhaus, was also the founder and director of the school. In the 1930s Gropius came to the United States, where he was a practicing architect and architectural educator until his death. The most dramatic building of the Bauhaus group is the shop block (figure 356),

right:
354. Frank Lloyd Wright. Plan of Robie House, Chicago. 1909

below:
355. Robie House. Wright's brilliant early style became the basis for advanced architectural design everywhere between 1920 and 1950.

356. Walter Gropius. Shop Block, the Bauhaus, Dessau, Germany. 1925–26. The first use of the glass window wall, which makes the space inside and outside a building continuous.

a square box with continuous surfaces of glass. Here the architect frankly acknowledges that in modern architecture the wall is no longer structural: it is only a barrier to climate; if maximum daylight is needed or wanted, the wall can be completely of glass.

A quarter-century later, the same principle was used on a much larger scale for the two main faces of the great building slab of the Secretariat of the United Nations (figure 357), which was designed by an international team of architects. The effect here is surprising. Such walls can reflect light as well as pass it; and the glass surface of the building often shows us mirror images of clouds drifting across the sky. Late in the day the lights go on, and we see the brilliantly lit interior. The building responds to any change of lighting conditions within and without, and thus takes on life in a strange and interesting way. The mirror-like finish of Brancusi's *Bird in Space* (figure 350) had a similar artistic purpose, although on a tiny scale.

The most distinguished International Style architect in France was the Swiss-born Le Corbusier. In the 1920s Le Corbusier designed private houses as important as Wright's Prairie Houses of twenty years before. Le Corbusier called them "machines for living" —a term meant to convey his admiration for the clean, precise shapes of machinery; he was not calling for mechanized living. Moreover, he wanted to suggest a difference between his

357. Wallace K. Harrison and an International Advisory Committee of Architects (Le Corbusier, Oscar Niemeyer, and others). United Nations, New York. 1949–51. Here the window wall is put to dramatic use: during the day it reflects clouds and sky; at night artificial light makes the whole interior visible from the outside.

358. Le Corbusier. Savoye House, Poissy-sur-Seine, France. 1929-30. Europe's most famous private house in the International Style.

houses and the conventional variety—a Le Corbusier house was an entirely new species. The famous Savoye House at Poissy-sur-Seine *was* a new species at the time it was built. The exterior view (figure 358) shows us a low box on stilts. The stilts are cylinders of reinforced concrete that form part of the structural skeleton of the ground floor. Long horizontal bands of strip windows open up the walls of the second story. Beyond these walls is a sheltered environment in which interior and exterior space—opened-up rooms

and closed-off garden—flow together in a manner only prophesied by the Robie House.

After the 1930s, Le Corbusier's work became more and more sculptural and free. His church of Notre-Dame-du-Haut at Ronchamp (figures 359 and 360), which rises like a medieval fortress from the crest of a mountain, is the most extraordinary building of our time. The massive walls seem to obey an unseen force that makes them slant and curl like paper. The overhanging roof suggests a pair of boats hanging alongside the prow of a

left:
359. Le Corbusier. Notre-Dame-du-Haut, Ronchamp,
France. 1950–55. Interior

below:
360. Notre-Dame-du-Haut, Ronchamp

After World War II Le Corbusier abandoned
the International Style and its precise, cubic
shapes. Ronchamp marks a return to ancestral
forms: the interior is a cave, the exterior a
memory of Egyptian pyramids and Mesopota-
mian ziggurats.

great ship. Ronchamp has the primeval quality of Henry Moore's sculpture. Its evocation of a dim, prehistoric past was absolutely intentional. The architect saw himself as the direct successor of the builders of the Great Circle at Stonehenge, the pyramids of Egypt, and the ziggurats of Mesopotamia. The interior is an ancestral form—a cave. The doors to the interior are concealed; we must seek them out. Only when we are inside this secret and sacred cave do we realize we are in a Christian building. Filtered through stained-glass windows, the light cuts ever-widening paths through the thickness of the wall. The openings are pinpricks on the exterior and large squarish shapes inside. As in the churches of the Middle Ages, the light thus becomes the visible counterpart of the Light Divine. There is true magic in Ronchamp's interior, but a disquieting presence also, a yearning for the old certainties of a religious faith no longer beyond question. Ronchamp, then, mirrors the spiritual condition of modern man—a measure of its greatness as a work of art.

Maps

Europe, The Near East, and India Before 1400

Europe After 1400

Europe, The Near East, and India Before 1400

SCALE OF MILES

0 50 100 200 300

Cividale

Milan Brescia
 Verona Padua
 Po River Venice
 Fidenza
 Bologna Ravenna
Genoa Classe
 Prato
 Florence
 Pisa Arno Arezzo
 Siena
 Chiusi Perugia
 Orvieto
 Vulci
 Tarquinia Veii Tivoli
 Cerveteri Praeneste
 Ostia Rome
 Fossanova
 Herculaneum
 Naples Boscoreale
 Ischia Pompeii
 Paestum

ITALY

ADRIATIC SEA

CASPIAN SEA

KHURASAN

BACTRIA

Teheran

PARTHIA

Kostromskaya

BLACK SEA

Erzurum

ARMENIA

Lake Van Lake Urmia

Constantinople
Bogazköy

Tigris River

SAMOTHRACE

Salonica
▲ Mt. Olympus
Peparethus

Troy
Pergamum

ANATOLIA

Dur Sharrukin
Nineveh ASSYRIA
 Nimrud
 Assur

LURISTAN

PERSIA

Larissa
LYDIA
Ephesus
Tralles

Çatal Hüyük

Euphrates River

MESOPOTAMIA

Samarra

GREECE

Miletus
Halicarnassus
Cnidus

RHODES

Issus
Antioch

Palmyra

Dura-
Europos

Baghdad Tell Asmar
AKKAD CHALDAEA
Babylon

Susa

Dur-Untash

Knossos

CRETE

CYPRUS

SYRIA

Damascus

Baalbek

BABYLONIA Lagash
SUMER
Uruk

Naksh-i-Rustam

ELAM

Persepolis

AEGEAN SEA

Jericho
Jerusalem
Bethlehem

Mshatta

Ur ANCIENT
 COASTLINE

Alexandria

LOWER EGYPT

Giza Cairo
Saqqara

ARABIA

GANDHĀRA

TIBET

Harappa

Indus River

Delhi

The Faiyum

EGYPT

Beni Hasan

Mohenjo-Daro

Agra

Mathurā

Sarnath Ganges River

Tell el Amarna

UPPER EGYPT

Deir el-Bahari Karnak
Thebes Luxor
Hierakonpolis

RED SEA

ARABIAN SEA

INDIA

Ajantā
Elūrā

Sānchī

BAY OF BENGAL

Nile River

Mecca

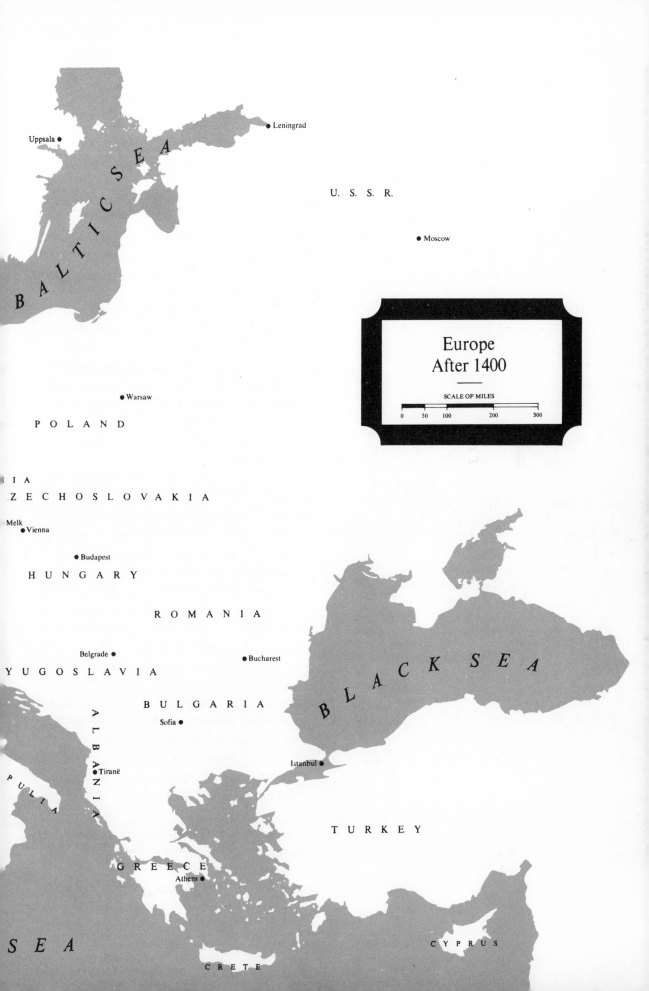

GLOSSARY OF TERMS

Cross reference are indicated by words in SMALL CAPITALS.

ABSTRACT. Having little or no reference to the appearance of natural objects; pertaining to the non-representational art styles of the twentieth century.

AMBULATORY. A passageway, especially around the CHANCEL of a church. An ambulatory may also be outside a church.

AMPHORA. A Greek vase having an egg-shaped body, a narrow cylindrical neck, and two curving handles joined to the body at the shoulder and neck.

APSE. A large niche facing the nave of a church. See BASILICA.

ARCADE. A series of ARCHES and their supports.

ARCH. A structural member, often semicircular, used to span an opening; it requires support from walls, piers, or columns, and BUTTRESSING at the sides.

ARCHAIC. A relatively early style, as Greek sculpture of the seventh and sixth centuries B.C.; or any style adopting characteristics of an earlier period.

ARCHITRAVE. The main horizontal beam, and the lowest part of an ENTABLATURE.

ATMOSPHERIC PERSPECTIVE. A means of showing distance or depth in a painting by changing the tone of objects that are far away from the picture plane, especially by reducing in gradual stages the contrast between lights and darks.

BARREL VAULT. A semi-cylindrical VAULT.

BASE. The lowest element of a COLUMN, wall, DOME, etc.

BASILICA. In the Roman period, the word refers to the function of the building—a large meeting hall—rather than to its

form, which may vary according to its use; as an official public building, the Roman basilica had certain religious overtones. The term was used by the Early Christians to refer to their churches. An Early Christian basilica had an oblong plan, flat timber ceiling, trussed roof, and an APSE. The entrance was on one short side and the apse projected from the opposite side, at the farther end of the building.

BAYS. Compartments into which a building may be subdivided, usually formed by the space between consecutive architectural supports.

BLACK-FIGURED. A type of Greek vase painting, practiced in the seventh and sixth centuries B.C., in which the design was painted mainly in black against a lighter-colored background, usually the natural clay.

BOOK OF HOURS. A book for individual private devotion with prayers for different hours of the day; often elaborately ILLUMINATED.

BUTTRESS, BUTTRESSING. A masonry support that counteracts the THRUST exerted by an ARCH or a VAULT. See FLYING BUTTRESS, PIER BUTTRESS.

CAPITAL. The crowning member of a COLUMN, PIER, or PILASTER, on which the lowest element of the ENTABLATURE rests. See DORIC COLUMN, IONIC COLUMN, CORINTHIAN COLUMN.

CARTOON. A preliminary SKETCH or DRAWING made to be transferred to a wall, a panel, or canvas as a guide in painting a finished work.

CASTING. A method of reproducing a three-dimensional object or RELIEF. Casting in bronze or other metal is often the final stage in the creation of a piece of sculpture; casting in plaster is a convenient and inexpensive way of making a copy of an original. See SCULPTURE.

CHANCEL. In a church, the space reserved for the clergy and CHOIR, set off from the NAVE by steps, and occasionally by a screen.

CHAPEL. A compartment in a church containing an altar dedicated to a saint.

CHOIR. See CHANCEL.

CLASSIC. Used specifically to refer to Greek art of the fifth century B.C.

CLASSICAL. Used generally to refer to the art of the Greeks and the Romans.

CLERESTORY. A row of windows in a wall that rises above the adjoining roof.

COLLAGE. A composition made by pasting cut-up textured materials, such as newsprint, wallpaper, etc., to form all or part of a work of art; may be combined with painting or drawing or with three-dimensional objects.

COLONNADE. A series of COLUMNS placed at regular intervals.

COLOR. The choice and treatment of the hues in a painting.

COLUMN. A vertical architectural support, usually consisting of a BASE, a rounded SHAFT, and a CAPITAL.

COMPOSITION. The arrangement of FORM, COLOR, LINE, etc., in any given work of art.

COMPOUND PIER. A PIER with COLUMNS, PILASTERS, or SHAFTS attached.

CORINTHIAN COLUMN. First appeared in fifth-century Greece, apparently as a variation of the IONIC. The CAPITAL differentiates the two: the Corinthian capital has an inverted bell shape, decorated with acanthus leaves, stalks, and volute scrolls. The Corinthian ORDER was widely used by the Romans.

CORNICE. The crowning, projecting architectural feature, especially the uppermost part of an ENTABLATURE.

COUNTERPOISE. The disposition of the parts of the body so that the weight-bearing leg, or engaged leg, is distinguished from the raised leg, or free leg, resulting in a shift

in the axis between the hips and shoulders. Used by the Greek sculptors as a means of showing movement in a figure.

CROSSING. In a cross-shaped church, the area where the NAVE and the TRANSEPT intersect.

CUPOLA. A rounded, domed roof or ceiling.

DOME. A large CUPOLA supported by a circular wall or DRUM.

DORIC COLUMN. The Doric COLUMN stands without a BASE directly on the top of the stepped platform of a temple. Its SHAFT has shallow FLUTES.

DRAWING. A sketch, design, or representation by lines. Drawings are usually made on paper with pen, pencil, charcoal, pastel, chalk, etc.

DRUM. One of several sections composing the SHAFT of a COLUMN; also a cylindrical wall supporting a DOME.

ENCAUSTIC. A method of painting in colors mixed with wax and applied with a brush, generally while the mixture is hot. The technique was practiced in ancient times and in the Early Christian period, and has been revived by some modern painters.

ENGAGED COLUMN. A COLUMN that is part of a wall and projects somewhat from it. Such a column often has no structural purpose.

ENGRAVING. A design incised in reverse on a copper plate; this is coated with printer's ink, which remains in the incised lines when the plate is wiped off. Damp paper is placed on the plate, and both are put into a press; the paper soaks up the ink and produces a print of the original.

ENTABLATURE. The upper part of an architectural ORDER.

ETCHING. Like ENGRAVING, etching is an incising process. However, the design is drawn in reverse with a needle on a plate thinly coated with wax or resin. The plate is placed in a bath of nitric acid; the etched lines are produced on the plate by the coating. The coating is then removed, and the prints are made as in engraving.

FAÇADE. The front of a building.

FLUTE, FLUTES. Vertical channels on a column SHAFT; see DORIC COLUMN, IONIC COLUMN.

FLYING BUTTRESS. An ARCH that springs from the upper part of the PIER BUTTRESS of a Gothic church, spans the aisle roof, and abuts the upper NAVE wall to receive the THRUST from the nave VAULTS; it transmits this thrust to the solid pier buttresses.

FORESHORTENING. A method of representing objects as if seen at an angle and receding or projecting into space; not in a frontal or profile view.

FORM. The external shape or appearance of a representation, considered apart from its color or material.

FREE-STANDING. Used to refer to a work of SCULPTURE in the round, that is, in full three-dimensionality; not attached to architecture and not in RELIEF.

FRESCO. A technique of wall painting known since antiquity; the PIGMENT is mixed with water and applied to a freshly plastered area of a wall. The result is a particularly permanent form of painted decoration.

FRIEZE. In classical architecture an architectural element that rests on the ARCHITRAVE and is immediately below the CORNICE; also, any horizontal band decorated with moldings, RELIEF sculpture, or painting.

GABLE. The triangular part of a wall, enclosed by the lines of a sloping roof. See PEDIMENT.

GALLERY. A roofed promenade. See AMBULATORY, COLONNADE.

GOSPELS, GOSPEL BOOK. Contains the four Gospels of the New Testament that tell the life of Christ, attributed to the Evangelists Matthew, Mark, Luke, and John. Often elaborately illustrated.

GROIN. The sharp edge formed by the intersection of two VAULTS.

GROIN VAULTS. A VAULT formed by the intersection at right angles of two BARREL VAULTS of equal height and diameter, so that the GROINS form a diagonal cross.

GROUND PLAN. See PLAN.

HIEROGLYPHICS. The characters and picture-writing used by the ancient Egyptians.

ICON. A panel painting of Christ, the Virgin, or saints regarded as sacred, especially by Eastern Christians.

ILLUMINATION. A term used generally for manuscript paintings. Illuminated manuscripts may contain separate ornamental pages, marginal illustrations, ornament within the text, entire MINIATURE paintings, or any combination of these.

ILLUSIONISM, ILLUSIONISTIC. The effort of an artist to represent the visual world with deceptive reality.

ILLUSTRATION. The representation of an idea, scene, or text by artistic means.

IONIC COLUMN. The Ionic COLUMN stands on a molded BASE. The SHAFT normally has FLUTES more deeply cut than Doric flutes. The Ionic CAPITAL is identified by its pair of spiral scroll-like ornaments.

JAMB. The side of a doorway or window frame.

KORE. An ARCHAIC Greek statue of a draped maiden.

KOUROS. An ARCHAIC Greek statue of a standing nude youth.

LINE. A mark made by a moving tool such as a pen or pencil; more generally, an outline, contour, or silhouette.

LINEAR PERSPECTIVE. A mathematical system for representing three-dimensional objects and space on a two-dimensional surface. All objects are represented as seen from a single viewpoint.

MASS. The expanse of COLOR that defines a painted shape; the three-dimensional volume of a sculptured or architectural form.

MEDIUM. The material with which an artist works, such as marble, TERRA COTTA, OIL PAINT, WATERCOLOR, etc.

METOPE. An oblong panel between the TRIGLYPHS on the ENTABLATURE of the Doric ORDER.

MINIATURE. A painting or drawing in an ILLUMINATED manuscript; also a very small portrait, frequently painted on ivory.

MOBILE. A type of sculpture made of movable parts that can be set in motion by the movement of air currents.

MODELING. See SCULPTURE. In painting or drawing, the means by which the three-dimensionality of a form is suggested on a two-dimensional surface, usually through variations of COLOR and the play of lights and darks.

MONUMENTAL. Frequently used to describe works that are larger than lifesize; also used to describe works giving the impression of great size, whatever their actual dimensions.

MOSAIC. A design formed by embedding small pieces of colored stone or glass in cement. In antiquity, large mosaics were used chiefly on floors; from the Early Christian period on, mosaic decoration was increasingly used on walls and vaulted surfaces.

MOTIF. A distinctive and recurrent feature of theme, shape, or figure in a work of art.

MURAL. A wall painting. See FRESCO.

NAVE. The central aisle of a BASILICAN church, as distinguished from the side aisles; the part of a church between the main entrance and the CHANCEL.

OIL PAINTING. Though known to the Romans,

it was not systematically used until the fifteenth century. In the oil technique of early Flemish painters, PIGMENTS were mixed with drying oils and fused while hot with hard resins; the mixture was then diluted with other oils.

ORDER. In architecture, a CLASSICAL system of proportion and interrelated parts. These include a COLUMN, usually with BASE, SHAFT, and CAPITAL, and an ENTABLATURE with ARCHITRAVE, FRIEZE, and CORNICE.

PAINTING MEDIUMS: see ENCAUSTIC, FRESCO, OIL PAINTING, TEMPERA, WATERCOLOR.

PASTEL. Powdered PIGMENTS mixed with gum and molded into sticks for drawing; also a picture or sketch made with this type of crayon.

PEDIMENT. In CLASSICAL architecture, the triangular part of the front or back wall that rises above the ENTABLATURE. The pediments at either end of a temple often contained sculpture, in high RELIEF or FREE-STANDING.

PERISTYLE. A COLONNADE (or ARCADE) around a building or open court.

PERSPECTIVE. See ATMOSPHERIC PERSPECTIVE, LINEAR PERSPECTIVE.

PIER. A vertical architectural element, usually rectangular in section; if used with an ORDER, often has a BASE and CAPITAL of the same design.

PIER BUTTRESS. An exterior pier in Romanesque and Gothic architecture, buttressing the THRUST of the VAULTS within.

PIETÀ. In painting or sculpture, a representation of the Virgin Mary mourning the dead Christ whom she holds.

PIGMENT. Dry, powdered substances which, when mixed with a suitable liquid, or vehicle, give color to paint. See OIL PAINTING, FRESCO, ENCAUSTIC, TEMPERA, WATERCOLOR.

PILASTER. A flat vertical element having a CAPITAL and BASE, engaged in a wall from which it projects. Has a decorative rather than a structural purpose.

PLAN. The schematic representation of a three-dimensional structure, such as a building or monument, on a two-dimensional plane. A GROUND PLAN shows the outline shape at the ground level of a given building and the location of its various interior parts.

PORTAL. An imposing doorway with elaborate ornamentation in Romanesque and Gothic churches.

POST AND BEAM. A system or unit of construction consisting solely of vertical and horizontal elements.

PROPORTION, PROPORTIONS. The relation of the size of any part of a figure or object to the size of the whole. For architecture, see ORDER.

PYLON. In Egyptian architecture, the entranceway set between two broad oblong towers with sloping sides.

READY-MADE. A manufactured object exhibited as being aesthetically pleasing. When two or more accidentally "found" objects are placed together as a construction, the piece is called an assemblage.

RED-FIGURED. A type of Greek vase painting in which the design was outlined in black and the background painted in black, leaving the figures the reddish color of the baked clay after firing. This style replaced the BLACK-FIGURED style toward the end of the sixth century B.C.

RELIEF. Forms in SCULPTURE that project from the background, to which they remain attached. Relief may be carved or modeled shallowly to produce low relief, or deeply to produce high relief; in very high relief, portions may be entirely detached from the background.

REPRESENTATIONAL. As opposed to ABSTRACT, means a portrayal of an object in recognizable form.

RHYTHM. The regular repetition of a particular form; also, the suggestion of motion by recurrent forms.

RIB. An ARCH or a projecting arched member of a VAULT.

RIBBED VAULT. A compound masonry VAULT, the GROINS of which are marked by projecting stone ribs.

SARCOPHAGUS. A coffin made of stone, marble, terra cotta (less frequently, of metal). Sarcophagi are often decorated with paintings or RELIEF.

SCALE. Generally, the relative size of any object in a work of art, often used with reference to normal human scale.

SCULPTURE. The creation of a three-dimensional form, usually in a solid material. Traditionally, two basic techniques have been used: carving in a hard material, and modeling in a soft material such as clay, wax, etc. For types of sculpture, see FREE-STANDING and RELIEF.

SHAFT. A cylindrical form; in architecture, the part of a COLUMN or PIER intervening between the BASE and the CAPITAL. Also, a vertical enclosed space.

SKETCH. A rough drawing representing the main features of a composition; often used as a preliminary study.

STAINED GLASS. The technique of filling architectural openings with glass colored by fused metallic oxides; pieces of this glass are held in a design by strips of lead.

STILL LIFE. A painting or drawing of an arrangement of inanimate objects.

TEMPERA. A painting process in which PIGMENT is mixed with an emulsion of egg yolk and water or egg and oil. Tempera, the basic technique of medieval and Early Renaissance painters, dries quickly, permitting almost immediate application of the next layer of paint.

TERRA COTTA. Clay, modeled or molded, and baked until very hard. Used in architecture for functional and decorative parts, as well as for pottery and SCULPTURE. Terra cotta may have a painted or glazed surface.

THRUST. The downward and outward pressure exerted by an ARCH or VAULT, and requiring BUTTRESSING.

TRANSEPT. In a cross-shaped church, an arm forming a right angle with the NAVE, usually inserted between the latter and the CHANCEL or APSE.

TRIGLYPH. A vertical block with V-cut channels, placed between METOPES on the ENTABLATURE of the Doric ORDER.

TYMPANUM. The space above the beam and enclosed by the ARCH of a medieval PORTAL or doorway; a church tympanum frequently contains RELIEF sculpture.

VAULT. An arched roof or covering, made of brick, stone, or concrete. See BARREL VAULT, GROIN VAULT, RIBBED VAULT.

VELLUM. Thin, bleached calfskin, a type of parchment on which manuscripts are printed.

WATERCOLOR. PIGMENTS mixed with water instead of oil or other mediums, or a picture painted with watercolor, often on paper.

WOODCUT. A printing process in which a design or lettering is carved in relief on a wooden block; the areas intended not to print off are hollowed out.

ZIGGURAT. An elevated platform, varying in height from several feet to the size of an artificial mountain, built by the Sumerians to support their shrines.

SYNOPTIC TABLES

SYNOPTIC TABLE I

	POLITICAL HISTORY	RELIGION, LITERATURE	SCIENCE, TECHNOLOGY
B.C. 4000	Sumerians settle in lower Mesopotamia	Pictographic writing, Sumer, c. 3500	Wheeled carts, Sumer, c. 3500–3000 Sailboats in Egypt after c. 3500 Use of potter's wheel, Sumer, c. 3250
3000	Old Kingdom, Egypt (Dynasties I–VI), c. 3100–2185 Early dynastic period, Sumer, c. 3000–2340; Akkadian kings 2340–2180	Hieroglyphic writing, Egypt, c. 3000 Divine kingship of the Pharaoh	First bronze tools and weapons, Sumer
2000	Middle Kingdom, Egypt, 2133–1786 Hammurabi founds Babylonian dynasty c. 1760 Flowering of Minoan civilization c. 1700–1500 New Kingdom, Egypt, c. 1580–1085	Code of Hammurabi c. 1760 Monotheism of Akhenaten (r. 1372–1358)	Bronze tools and weapons in Egypt Canal from Nile to Red Sea Mathematics and astronomy flourish in Babylon under Hammurabi Hyksos bring horses and wheeled vehicles to Egypt c. 1725
1000	Jerusalem capital of Palestine; rule of David; of Solomon (died 926) Assyrian Empire c. 1000–612 Persians conquer Babylon 539; Egypt 525 Romans revolt against Etruscans, set up republic 509	Hebrews accept monotheism Phoenicians develop alphabetic writing c. 1000; Greeks adopt it c. 800 First Olympic games 776 Homer (fl. c. 750–700) Zoroaster (born c. 660)	Coinage invented in Lydia (Asia Minor) c. 700–650; soon adopted by Greeks Pythagoras (fl. c. 520)
500	Persian Wars 499–478 Periclean Age in Athens c. 460–429 Peloponnesian War 431–404 Alexander the Great (356–323) occupies Egypt 333; defeats Persia 331; conquers Near East	Sophocles (496–406) Socrates (died 399) Plato (427–347); founds Academy 386 Aristotle (384–322)	Travels of Herodotus c. 460–440 Hippocrates (born 469) Euclid (fl. c. 300–280) Archimedes (287–212)
200	Rome dominates Asia Minor and Egypt 147		Invention of paper, China
100	Julius Caesar dictator of Rome 49–44 Emperor Augustus (r. 27 B.C.–A.D. 14)	Golden Age of Roman literature: Cicero, Catullus, Vergil, Horace, Ovid	Vitruvius' *De architectura*
A.D. 1	Jewish rebellion against Rome 66–70; destruction of Jerusalem	Crucifixion of Jesus c. 30 Paul (died c. 65) spreads Christianity to Asia Minor and Greece	Pliny the Elder, *Natural History*
100	Emperor Marcus Aurelius (r. 161–180)		Ptolemy, astronomer (died 160)
200	Shapur I (r. 242–272), Sassanian king of Persia Emperor Diocletian stops decline of Rome	Persecution of Christians in Roman Empire 250–302	

SYNOPTIC TABLE II

300	Emperor Constantine the Great (r. 324–337) Roman Empire split into eastern and western branches 395	Christianity legalized by Edict of Milan 313; state religion 395 St. Augustine, St. Jerome	

NOTE:

Figure numbers of black-and-white illustrations are in (italics). Colorplate numbers are in **(bold face)**. *Duration of papacy or reign is indicated by the abbreviation* r.

ARCHITECTURE	SCULPTURE	PAINTING	
"White Temple" and ziggurat, Uruk (*31*)		Mural, Hierakonpolis (*17*)	B.C. 4000
Step pyramid and funerary district of Zoser, Saqqara, by Imhotep (*18*) Pyramids at Giza (*21*)	Statues from Abu temple, Tell Asmar (*33*) *Rahotep and Nofret* (**1**) Harp and offering stand from Ur (*34*, **3**)		3000
Palace of Minos, Knossos, Crete (*41*) Stonehenge (*7, 8*) Temple of Amun, Luxor (*29, 30*)	Stele of Hammurabi (*35*) Vaphio Cups (*44*) Heads of Akhenaten and Nofretete (*27, 28*) Tomb of Tutankhamen (**2**) Lion Gate, Mycenae (*42*)	Tomb of Khnum-hotep, Beni Hasan (*24*) *"Toreador Fresco"* (**4**)	2000
Citadel of Sargon II, Dur Sharrukin (*36*) Ishtar Gate, Babylon (*38*) "Basilica," Paestum (*51*)	Reliefs from Nimrud (*37*) Kouros (*56*) *"Hera"* from Samos (*57*) Kore from Chios (**6**)	Funerary vase (*45*) Black-figured amphora by Psiax (*46*, **5**)	1000
Palace, Persepolis (*39*) "Temple of Poseidon," Paestum (*51*) Parthenon, Acropolis, Athens (*54*) Temple of Athena Nike, Acropolis, Athens (*55*)	East pediment from Aegina (*58, 59*) Pediment, Olympia (*60*) Sculpture from the Parthenon (*62, 63*) *Hermes* by Praxiteles (*64*) *Dying Gaul* (*65*)	*Lapith and Centaur*, red-figured ware (*47*) Tomb of Lionesses, Tarquinia (**8**) White-ground ware (*48*) *Battle of Issus* (*50*)	500
	Nike of Samothrace (*66*) *Laocoön Group* (*67*)		200
"Temple of the Sibyl," Tivoli (*69*)	Portrait head from Delos (**7**) *Augustus of Primaporta* (*76*)	Painting by Alexandros of Athens (*49*) Villa of Livia, Primaporta (*81*)	100
Pont du Gard, Nîmes (*72*) Colosseum, Rome (*73, 74*)	Arch of Titus (*77*)		A.D. 1
Pantheon, Rome (*70*)	Equestrian statue of Marcus Aurelius (*78*)	Portrait of a boy, Faiyum (**10**)	100
			200
Old St. Peter's, Rome (*85*) St. Paul's Outside the Walls, Rome (*86*)	Sarcophagus of Junius Bassus (*97*)	Catacomb of SS. Peter and Marcellinus, Rome (*84*)	300

	POLITICAL HISTORY	RELIGION, LITERATURE	SCIENCE, TECHNOLOGY
400	Rome sacked by Visigoths 410 Fall of Western Roman Empire 476 "Golden Age" of Justinian 527–565	Split between eastern and western Churches begins 451 St. Patrick (died c. 461) founds Celtic Church in Ireland	Silk cultivation brought to eastern Mediterranean from China
600	Mohammed (570–632) Byzantium loses Near Eastern and African provinces to Moslems 632–732; to Seljuk Turks 1071 Moslems invade Spain 711–718; defeated by Franks, battle of Tours, 732 Independent Moslem state established in Spain 756	Isidore of Seville (died 636) *Beowulf* epic Iconoclastic controversy 726–843	Paper-making introduced into Near East from China Stirrup introduced into Western Europe
800	Charlemagne (r. 768–814) crowned Emperor of Romans by Pope 800 Alfred the Great (r. 871–899?), Anglo-Saxon king of England	Carolingian revival of Latin classics	Earliest documented church organ, Aachen, 822 Horse collar adopted in Western Europe, makes horses efficient draft animals
900	Otto I (the Great) crowned emperor by Pope 962 Otto II (r. 973–983) defeated by Moslems in southern Italy	Monastic order of Cluny founded 910 Conversion of Russia to Orthodox Church c. 990	Earliest application of water power to industry
1000	Normans arrive in Italy 1016 Reconquest of Spain from Moslems begins William the Conqueror defeats Harold at Battle of Hastings 1066 First Crusade 1095–96	College of Cardinals formed to elect pope 1059 Cistercian Order founded 1098	Leif Ericson sails to North America 1002
1100	Frederick Barbarossa (r. 1155–90) titles his realm "Holy Roman Empire," tries to assert his authority in Italy King Henry II founds Plantagenet line in England	Rise of universities (Bologna, Paris, Oxford) based on faculties of law, medicine, theology Peter Abelard (1079–1142) First flowering of vernacular literature; age of the troubadours	Earliest manufacture of paper in Europe, by Moslems in Spain Earliest use of magnetic compass for navigation
1200	Fourth Crusade (1202–4) conquers Constantinople Latin empire in Constantinople 1204–61 Magna Carta limits power of English kings 1215 Louis IX (St. Louis, r. 1226–70), king of France Philip IV (the Fair, r. 1285–1314), king of France, humiliates Pope Boniface VIII 1303	St. Dominic (1170–1221) founds Dominican order; Inquisition established to combat heresy St. Francis of Assisi (died 1226) St. Thomas Aquinas (died 1274) Dante Alighieri (1265–1321)	Marco Polo travels to China and India c. 1275–93
1300	Exile of papacy at Avignon 1309–76 Hundred Years' War between England and France begins 1337	*Canterbury Tales* by Chaucer c. 1387	First large-scale production of paper in Italy and Germany First large-scale production of gunpowder; earliest known use of cannon 1326 Earliest cast iron in Europe
1400	Great Papal Schism (since 1378) settled 1417; Pope returns to Rome	Jan Hus burned at stake for heresy 1415	Gutenberg invents printing with movable type 1446–50

ARCHITECTURE	SCULPTURE	PAINTING	
Hagia Sophia, Istanbul (*91–93*) S. Apollinare in Classe, Ravenna (*87*)	*Archangel Michael*, diptych (*98*)	*Vatican Vergil* (*89*) Mosaics, Sta. Maria Maggiore, Rome (*88*) *Vienna Genesis* (*90*) Mosaics, S. Apollinare in Classe and S. Vitale, Ravenna (*94*, **11**, **12**)	400
	Sutton Hoo ship-burial treasure (*100*)	*Madonna*, Sta. Francesca Romana, Rome (*99*) *Echternach Gospels* (**14**)	600
Palace Chapel of Charlemagne, Aachen (*106*)	Oseberg ship-burial (*101*)	*Gospel Book of Charlemagne* (*104*) *Gospel Book of Ebbo of Reims* (*105*)	800
			900
St. Michael's, Hildesheim (*107*) Pisa Cathedral (*115*) Baptistery, Florence (*116*) St.-Étienne, Caen (*113*) St.-Sernin, Toulouse (*109–11*) Durham Cathedral (*114*)	Bronze doors of Bernward, Hildesheim (*108*) Apostle, St.-Sernin, Toulouse (*117*)	*Gospel Book of Otto III* (**15**) Mosaics, Daphnē (*95*)	1000
Notre-Dame, Paris (*121–24*)	South portal, Moissac (*118*) *Last Judgment* tympanum, Autun (*119*) West portals, Chartres Cathedral (*129*)	Nave vault murals, St.-Savin-sur-Gartempe (*120*) *Gospel Book of Wedricus* (**16**)	1100
Amiens Cathedral (*125*) Salisbury Cathedral (*126*) Florence Cathedral (*128*)	West portals, Reims Cathedral (*130*) Choir screen, Naumburg Cathedral (*132*)	Nave, Chartres Cathedral (**18**) Stained glass, nave clerestory, Bourges Cathedral (*137*) *Madonna Enthroned*, icon (**13**) *Prayer Book of Philip the Fair*, by Master Honoré (*138*)	1200
Choir, Gloucester Cathedral (*127*) Louvre of Charles V, Paris (**22**)	*Virgin of Paris*, Notre-Dame (*131*) *Pietà*, Bonn (*133*) *Moses Well*, by Claus Sluter (*135*)	Arena Chapel frescoes, Padua, by Giotto (**19**) *Maestà* altar, Siena, by Duccio (*139*) *Good and Bad Government* frescoes, Siena, by Ambrogio Lorenzetti (*141*, *142*) Altar wings, Dijon, by Broederlam (*143*)	1300
	Trial relief for Baptistery doors, Florence, by Ghiberti (*136*)	*Very Rich Book of Hours of the Duke of Berry*, by Limbourg Brothers (*144*, **22**) *Adoration of the Magi* altar, by Gentile da Fabriano (*145*, **23**)	1400

SYNOPTIC TABLE III

	POLITICAL HISTORY	RELIGION, LITERATURE	SCIENCE, TECHNOLOGY
1300		Petrarch, first humanist (1304–74) Boccaccio (1313–75)	
1400		Leonardo Bruni (c. 1374–1444) Leone Battista Alberti (1404–72) Council of Florence attempts to reunite Catholic and Orthodox faiths 1439	Prince Henry the Navigator of Portugal (1394–1460) promotes geographic exploration
1450	End of Hundred Years' War 1453; Joan of Arc Ferdinand and Isabella unite Spain 1469 Spain and Portugal divide New World 1493–94 Charles VIII of France invades Italy 1494–99	Marsilio Ficino (1433–99) Sebastian Brant's *Ship of Fools* 1494 Savonarola burned at the stake for heresy in Florence 1498	Diaz rounds Cape of Good Hope 1486 Columbus discovers America 1492 Vasco da Gama reaches India, returns to Lisbon 1497–99
1500	Charles V elected Holy Roman Emperor 1519 Cortés wins Aztec empire in Mexico for Spain 1519 Henry VIII of England (r. 1509–47) founds Anglican Church 1534 Wars of Lutheran vs. Catholic princes in Germany; Peace of Augsburg (1555) lets each sovereign decide religion of his subjects	Erasmus of Rotterdam's *Praise of Folly* 1511 Thomas More's *Utopia* 1516 Martin Luther (1483–1546) posts theses 1517; excommunicated and outlawed 1521 Castiglione's *The Courtier* 1528 Ignatius of Loyola founds Jesuit Order 1534	Balboa sights Pacific Ocean 1513 First circumnavigation of the globe by Magellan and crew 1520–22
1550	Elizabeth I of England (r. 1558–1603) Netherlands revolt against Spain 1568 Spanish Armada defeated by English 1588 Lutheranism becomes state religion in Denmark 1560, in Sweden 1593	Council of Trent 1545–63 St. Theresa of Avila (1515–82) Cervantes (1547–1616) William Shakespeare (1564–1616)	

ARCHITECTURE	SCULPTURE	PAINTING	
			1300
Brunelleschi begins career as architect 1419; Florence Cathedral dome (*128*); S. Lorenzo (*169, 170*) Michelozzo, Palazzo Medici-Riccardi (*171*)	Donatello, *St. George* (*160*) Donatello, *Zuccone* (*161*) Donatello, *David* (*162*) Ghiberti, "*Gates of Paradise*" (*164*) Donatello, *Gattamelata* (*163*)	Masaccio, *Trinity* fresco (*174*) Master of Flémalle, *Merode Altar* (**24**) Jan van Eyck, *Ghent Altar* (*146–48*); *Arnolfini and Bride* (*150*, **26**) Roger van der Weyden, *Descent from the Cross* (**27**) Witz, Geneva altar (*157*) Domenico Veneziano, *Madonna and Saints* (**29**)	1400
Alberti, S. Andrea, Mantua (*172*) Giuliano da Sangallo, Sta. Maria delle Carceri, Prato (*173*)	Antonio Rossellino, *Giovanni Chellini* (*166*) Luca della Robbia, *Madonna and Angels* (*165*) Verrocchio, *Putto* (*168*) Pollaiuolo, *Hercules and Antaeus* (*167*)	Mantegna, Ovetari Chapel frescoes (*181*) Piero della Francesca, Arezzo frescoes (*175*) Pollaiuolo, *Battle of Ten Naked Men*, engraving (*178*) Hugo van der Goes, *Portinari Altar* (*152*) Schongauer, *Temptation of St. Anthony*, engraving (*159*) Botticelli, *Birth of Venus* (**31**) Leonardo, *Adoration of the Magi* (*183*) Giovanni Bellini, *St. Francis* (**33**) Leonardo, *Last Supper* (*184*) Dürer, *Four Horsemen of the Apocalypse*, woodcut (*213*)	1450
Bramante, Tempietto, Rome (*192*) Michelangelo becomes architect of St. Peter's 1546 (*194, 195*) Lescot, Louvre court (*223*)	Michelangelo, *David* (*187*) Michelangelo, *Moses* (*188*) Cellini, Saltcellar of Francis I (*207*) Goujon, *Fountain of the Innocents* (*224*)	Bosch, *Garden of Delights* (*155, 156*, **28**) Leonardo, *Mona Lisa* (*186*) Giorgione, *Tempest* (**35**) Michelangelo, Sistine ceiling (*190*) Raphael, *School of Athens* (*197*) Grünewald, *Isenheim Altar* (*212*, **41**) Titian, *Bacchanal* (**36**) Rosso, *Descent from the Cross* (**37**) Dürer, *Four Apostles* (**42**) Correggio, *Assumption of the Virgin* (*203*) Altdorfer, *Battle of Issus* (*217*) Parmigianino, *Madonna with Long Neck* (**38**) Michelangelo, *Last Judgment* (*189, 191*) Holbein, *Henry VIII* (**43**)	1500
Palladio, Villa Rotonda, Vicenza (*209*) Vignola, plan of Il Gesù, Rome (*210*); façade by Della Porta (*211*)	Giovanni Bologna, *Rape of Sabine* (*208*)	Bruegel, *Land of Cockayne* (**44**) Veronese, *Christ in the House of Levi* (*206*) El Greco, *Burial of Count Orgaz* (**40**) Caravaggio, *Calling of St. Matthew* (**45**) Annibale Carracci, Farnese Gallery ceiling (*226*)	1550

POLITICAL HISTORY	RELIGION, LITERATURE	SCIENCE, TECHNOLOGY
1600 Jamestown, Virginia, founded 1607; Plymouth, Mass., 1620 Cardinal Mazarin governs France during minority of Louis XIV 1643–61 (civil war 1648–53) Charles I of England beheaded 1649; Commonwealth under Cromwell 1649–53	King James Bible 1611 René Descartes (1596–1650)	Harvey describes circulation of blood 1628 Galileo (1564–1642)
1650 Parliament passes Habeas Corpus Act 1679 Louis XIV absolute ruler of France (r. 1661–1715)	Molière (1622–73) Pascal (1623–62) Racine (1639–99) Milton's *Paradise Lost* 1667 Bunyan's *Pilgrim's Progress* 1678	Isaac Newton (1642–1727)
1700 Peter the Great (r. 1682–1725) westernizes Russia, defeats Sweden	Defoe's *Robinson Crusoe* 1719 Swift's *Gulliver's Travels* 1726 Wesley brothers found Methodism 1738 Voltaire (1694–1778)	
1750 Seven Years' War (1756–63): called French and Indian War in U.S.		

SYNOPTIC TABLE IV

POLITICAL HISTORY	RELIGION, LITERATURE	SCIENCE, TECHNOLOGY
1750	Gray's *Elegy* 1750 Diderot's *Encyclopedia* 1751–72 Johnson's *Dictionary* 1755 Edmund Burke (1729–97)	Watt perfects steam engine 1765–76 Priestley discovers oxygen 1774 Coke-fed blast furnaces for iron smelting perfected c. 1760–75
1775 American Revolution 1775–85; Constitution adopted 1789 French Revolution 1789–97; Reign of Terror under Robespierre 1793 Consulate of Napoleon 1799	Gibbon's *Decline and Fall* 1776–87 Paine's *The Rights of Man* 1790 Wordsworth and Coleridge, *Lyrical Ballads*, 1798	Power loom 1785; cotton gin 1792 Jenner's smallpox vaccine c. 1798
1800 Louisiana Purchase 1803 Napoleon crowns himself emperor 1804; exiled to St. Helena 1815 Greeks declare independence 1822	Goethe's *Faust* (part I) 1808 Byron's *Childe Harold's Pilgrimage* 1812–18 Keats (1795–1821) Shelley (1792–1822) Sir Walter Scott (1771–1832)	First voyage of Fulton's steamship 1807; first Atlantic crossing 1819 Stephenson's first locomotive 1814 Faraday discovers principle of electric dynamo 1821
1825 Revolution of 1830 in France Queen Victoria crowned 1837 U.S. treaty with China opens ports 1844 U.S. annexes western land areas 1845–60 Revolution of 1848: fails in Germany, Hungary, Austria, Italy; France sets up Second Republic (Louis Napoleon)	Pushkin (1799–1837) Victor Hugo (1802–85) Dickens' *Oliver Twist* 1838 Thackeray's *Vanity Fair* 1847 *Communist Manifesto* 1848 Edgar Allan Poe (1809–49)	Erie Canal opened 1825 First railway completed (England) 1825 McCormick invents reaper 1831 Daguerrotype process of photography introduced 1839 Morse perfects telegraph 1844
1850 Louis Napoleon takes title of emperor 1852 Perry's visit ends Japan's isolation 1854 Russia abolishes serfdom 1861 U.S. Civil War (1861–65) ends slavery Franco-Prussian War 1870–71 Disraeli British prime minister 1874–80	Melville's *Moby Dick* 1851 Whitman's *Leaves of Grass* 1855 Baudelaire (1821–67) Tolstoy's *War and Peace* 1864–69 Dostoyevsky's *Crime and Punishment* 1867 Marx's *Das Kapital* 1867–94	Darwin publishes *Origin of Species* 1859 Bessemer patents tilting converter for turning iron into steel 1860 Pasteur develops germ theory 1864 Mendel publishes first experiments in genetics 1865 Nobel invents dynamite 1867 First transcontinental railroad completed in America 1869 Suez Canal opened 1869

ARCHITECTURE	SCULPTURE	PAINTING	
Maderno, nave and façade of St. Peter's (*231*); Bernini's colonnade (*231*) Borromini, S. Carlo alle Quattro Fontane, Rome, plan (*232*)	Bernini, *David* (*228*) Bernini, Cornaro Chapel (*229*)	Rubens, *Raising of the Cross* (*234*) Hals, *Jolly Toper* (**48**) Rembrandt, *Blinding of Samson* (*242*) Poussin, *Burial of Phocion* (*251*)	1600
Borromini, S. Carlo alle Quattro Fontane, Rome, façade (*233*) Perrault, east front of Louvre (*254*) Le Vau and Hardouin-Mansart, Versailles (*255*) Wren, St. Paul's, London (*257*)	Puget, *Milo of Crotona* (*253*)	Ruisdael, *Jewish Graveyard* (*246*) Velázquez, *Maids of Honor* (*239*, **47**) Rembrandt, *Jacob Blessing* (**49**) Vermeer, *The Letter* (**50**)	1650
Prandtauer, Melk, Austria (*259*) Neumann, Episcopal Palace, Würzburg (**51**) Boffrand, Hôtel de Soubise (*258*)		Watteau, *Pilgrimage to Cythera* (**52**) Hogarth, *Rake's Progress* (*263*) Chardin, *Back from the Market* (**53**) Gainsborough, *Mr. and Mrs. Andrews* (**55**)	1700
	Falconet, Equestrian monument of Peter the Great (*261*)	Tiepolo, Würzburg ceiling fresco (*260*) Fragonard, *Bathers* (**54**)	1750
Soufflot, Panthéon, Paris (*285*)		Greuze, *Village Bride* (*268*) West, *Death of Wolfe* (*266*)	1750
Jefferson, Monticello (*286*) Langhans, Brandenburg Gate, Berlin (*287*)	Houdon, *Washington* (*291*)	Copley, *Watson and the Shark* (*267*) Cozens, *A New Method . . .* (*281*) David, *Death of Socrates* (*269*) David, *Death of Marat* (*270*) Gros, *Napoleon at Arcole* (*271*)	1775
	Canova, *Pauline Borghese* (*292*)	Goya, *Family of Charles IV* (*272*) Géricault, *Mounted Officer* (*274*) Ingres, *Odalisque* (**58**) Goya, *Third of May . . .* (**56**) Friedrich, *Polar Sea* (*283*)	1800
Barry and Pugin, Houses of Parliament (*288*) Labrouste, Bibliothèque Ste.-Geneviève, Paris (*290*)	Rude, *La Marseillaise* (*293*)	Corot, *Papigno* (*280*) Ingres, *Bertin* (*277*) Turner, *Slave Ship* (**59**) Bingham, *Fur Traders* (*284*) Courbet, *Stone Breakers* (*295*)	1825
Garnier, Opéra, Paris (*289*)	Rodin, *Man with Broken Nose* (*305*) Carpeaux, *The Dance* (*294*)	Daumier, *Third-Class Carriage* (*278*) Homer, *Morning Bell* (*303*) Monet, *The River* (**61**) Whistler, *The Artist's Mother* (*301*)	1850

POLITICAL HISTORY	RELIGION, LITERATURE	SCIENCE, TECHNOLOGY
1875 Spanish-American War 1898; U.S. gains Philippines, Guam, Puerto Rico, annexes Hawaii	Mark Twain's *Tom Sawyer* 1876 Ibsen (1828–1906) Zola (1840–1902) Oscar Wilde (1854–1900) Henry James (1843–1916) G. B. Shaw (1856–1950)	Bell patents the telephone 1876 Edison invents phonograph 1877 Edison invents electric light bulb 1879 First internal combustion engines for gasoline 1885 Roentgen discovers X-rays 1895 Marconi invents wireless telegraphy 1895 Edison invents motion picture 1896 The Curies discover radium 1898
1900 T. Roosevelt (1901–9) proclaims Open Door policy; Panama Canal (opened 1914) Internal strife, reforms in Russia 1905 Revolution in China, republic set up 1911 First World War 1914–18; U.S. enters 1917 Bolshevik Revolution 1917; Russia signs separate peace with Germany 1918 Gandhi agitates for Indian independence after First World War Irish Free State established 1921 Mussolini's Fascists seize Italian government 1922 Turkey becomes republic 1923	Marcel Proust (1871–1922) W. B. Yeats (1865–1939) André Gide (1869–1951) T. S. Eliot (1888–1964) James Joyce (1882–1941) Eugene O'Neill (1888–1953) D. H. Lawrence (1885–1930)	Planck formulates quantum theory 1900 Freud's *Interpretation of Dreams* 1900 Pavlov's first experiments with conditioned reflexes 1900 Wright brothers' first flight with power-driven airplane 1903 Einstein's theory of relativity 1905 Ford begins assembly-line automobile production 1909 First radio station begins regularly scheduled broadcasts 1920
1925 Stalin starts Five-Year Plan 1928 Hitler seizes power in Germany 1933 Roosevelt proclaims New Deal 1933 Mussolini conquers Ethiopia 1936 Spanish Civil War 1936–39; won by Franco Hitler annexes Austria 1938 Second World War 1939–45 Atomic bomb dropped on Hiroshima 1945 United Nations Charter signed 1945 Israel becomes independent 1948 Communists under Mao win in China 1949	Sinclair Lewis (1885–1951) William Faulkner (1897–1962) Ernest Hemingway (1898–1961) Thomas Wolfe (1900–1938) Berthold Brecht (1898–1956) André Malraux (born 1895) Jean Paul Sartre (born 1905) Albert Camus (1913–60)	First regularly scheduled TV broadcasts in U.S. 1928, in England 1936 Atomic fission demonstrated on laboratory scale 1942 Penicillin discovered 1943 Computer technology developed 1944
1950 Korean War 1950–53 U.S. Supreme Court outlaws racial segregation in public schools 1954 Common Market established in Europe 1957 African colonies gain independence after 1957 John F. Kennedy assassinated 1963 Johnson begins massive U.S. intervention in Vietnam 1965 Martin Luther King assassinated 1968	Samuel Beckett (born 1906) Eugene Ionesco (born 1912) Jean Genet (born 1910) Lawrence Durrell (born 1912)	Genetic code cracked 1953 First hydrogen bomb (atomic fusion) exploded 1954 Sputnik, first satellite, launched 1957 First manned space flight 1961 First manned landing on the moon 1969

ARCHITECTURE	SCULPTURE	PAINTING	
Sullivan, Wainwright Building (*353*)	Rodin, *The Thinker* (*306*)	Eakins, *Gross Clinic* (*304*) Renoir, *Moulin de la Galette* (*296*) Degas, *Glass of Absinthe* (*297*) Cézanne, *Fruit Bowl, Glass, and Apples* (**63**) Van Gogh, *Wheat Field and Cypress Trees* (**65**) Toulouse-Lautrec, *Moulin Rouge* (*311*) Munch, *The Scream* (*313*)	1875
Wright, Robie House (*354*, *355*)	Maillol, *Méditerranée* (*315*) Brancusi, *The Kiss* (*348*) Barlach, *Man Drawing Sword* (*316*) Lehmbruck, *Standing Youth* (*317*) Brancusi, *Bird in Space* (*350*) Pevsner, *Torso* (*351*)	Picasso, *Old Guitarist* (*314*) Rouault, *Head of Christ* (*319*) Matisse, *Joy of Life* (*318*) Picasso, *Demoiselles d'Avignon* (*325*) Rousseau, *The Dream* (**67**) Chagall, *I and the Village* (*338*) Duchamp, *The Bride* (*341*) Braque, *Le Courrier* (*328*) Kandinsky, *Sketch I for "Composition VII"* (**69**) De Chirico, *Mystery and Melancholy . . .* (*337*) Stella, *Brooklyn Bridge* (*332*) Léger, *The City* (*334*) Ernst, *1 Copper Plate . . .* (*342*) Picasso, *Mother and Child* (*330*) Klee, *Twittering Machine* (*339*)	1900
Gropius, Bauhaus (*356*) Le Corbusier, Savoye House (*358*) Harrison and advisors, U.N. Buildings (*357*)	Giacometti, *Palace at 4 A.M.* (*352*) Moore, *Recumbent Figure* (*349*) Calder, *Lobster Trap and Fish Tail* (**74**) Picasso, *Bull's Head* (*2*)	Picasso, *Three Dancers* (**70**) Miró, *Composition* (*345*) Picasso, *Guernica* (*331*)	1925
Le Corbusier, Notre-Dame, Ronchamp (*359*, *360*)		Pollock, *One* (*346*, **72**) Lichtenstein, *Girl at Piano* (*347*, **73**)	1950

BOOKS FOR FURTHER READING

Asterisks () indicate that titles are available in paperback.*

PART ONE: HOW ART BEGAN

Adam, Sheila, *The Technique of Greek Sculpture in the Archaic and Classical Periods*, Thames & Hudson, London, 1967

Arias, Paolo E., and Hirmer, Max, *A History of 1000 Years of Greek Vase Painting*, Abrams, New York, 1963

Beazley, Sir John D., and Ashmole, Bernard, *Greek Sculpture and Painting to the End of the Hellenistic Period*, Cambridge University Press, 1966

*Boas, Franz, *Primitive Art*, new ed., Dover, New York, 1955

*Burkitt, Miles C., *The Old Stone Age*, 3rd ed., New York University Press, 1956

*Carcopino, J., *Daily Life in Ancient Rome*, Yale University Press, 1940

*Carpenter, Rhys, *The Esthetic Basis of Greek Art of the Fifth and Fourth Centuries B.C.*, rev. ed., Indiana University Press, Bloomington, 1965

Demargne, Pierre, *Aegean Art: The Origins of Greek Art*, tr. by Stuart Gilbert and James Emmons, Golden Press, New York, 1964

Fakhry, Ahmed, *The Pyramids*, University of Chicago Press, 1962

*Frankfort, Henri, *The Birth of Civilization in the Near East*, Williams & Norgate, London, 1951

Groenewegen-Frankfort, H. A., *Arrest and*

Movement, University of Chicago Press, 1951

*———, and Ashmole, Bernard, *The Ancient World*, New American Library, New York, 1967

Hanfmann, George M. A., *Roman Art*, New York Graphic Society, Greenwich, Conn., 1964

*Higgins, Reynold, *Minoan and Mycenaean Art*, Praeger, New York, 1967

Kraay, Colin M., and Hirmer, Max, *Greek Coins*, Abrams, New York, 1966

Lange, Kurt, and Hirmer, Max, *Egypt*, Phaidon, London, 1956

Lommel, Andreas, *Shamanism, the Beginnings of Art*, McGraw-Hill, New York, 1967

Lullies, Reinhard, and Hirmer, Max, *Greek Sculpture*, Abrams, New York, 1960

Maiuri, Amedeo, *Roman Painting*, Skira, New York, 1953

Marinatos, Spyridon, and Hirmer, Max, *Crete and Mycenae*, Abrams, New York, 1960

*Mellaart, James, *Earliest Civilizations of the Near East*, McGraw-Hill, New York, 1965

Pallottino, Massimo, *Etruscan Painting*, Skira, New York, 1953

Parrot, André, *The Arts of Assyria*, tr. by Stuart Gilbert and James Emmons, Golden Press, New York, 1961

———, *Nineveh and Babylon*, Thames & Hudson, London, 1960

———, *Sumer: The Dawn of Art*, tr. by Stuart Gilbert and James Emmons, Golden Press, New York, 1961

Pfuhl, Ernst, *Masterpieces of Greek Drawing and Painting*, tr. by Sir John Beazley, latest ed., Macmillan, New York, 1955

*Pollitt, J. J., *The Art of Greece*, Sources and Documents in the History of Art, Prentice-Hall, Englewood Cliffs, N. J., 1965

*———, *The Art of Rome and Late Antiquity*, Sources and Documents in the History of Art, Prentice-Hall, Englewood Cliffs, N. J., 1966

*Powell, T. G., *Prehistoric Art*, Praeger, New York, 1966

Richardson, Emeline, *The Etruscans: Their Art and Civilization*, University of Chicago Press, 1964

Richter, Gisela M. A., *The Sculpture and Sculptors of the Greeks*, new rev. ed., Yale University Press, 1950

*Saggs, H. W. F., *The Greatness That Was Babylon*, New American Library, New York, 1968

Strommenger, Eva, and Hirmer, Max, *5000 Years of the Art of Mesopotamia*, tr. by Christina Haglund, Abrams, New York, 1964

*Wheeler, Sir R. E. Mortimer, *Roman Art and Architecture*, Praeger, New York, 1964

Wingert, Paul S., *The Sculpture of Negro Africa*, Columbia University Press, 1959

PART TWO: THE MIDDLE AGES

Aubert, Marcel, *The Art of the High Gothic Era*, Crown, New York, 1964

*Beckwith, John, *Early Medieval Art*, Praeger, New York, 1964

*Cennini, Cennino, *The Craftsman's Handbook (Il Libro dell'arte)*, tr. by Daniel V. Thompson, Jr., Dover, New York, 1954

Crichton, George H., *Romanesque Sculpture in Italy*, Routledge & Kegan Paul, London, 1954

Dupont, J., and Gnudi, C., *Gothic Painting*, Skira, New York, 1954

*Focillon, Henri, *The Art of the West in the Middle Ages*, ed. by Jean Bony, tr. by Donald King, 2 vols., Phaidon, New York, 1963

Grabar, André, *The Beginnings of Christian Art, 200–395*, tr. by Stuart Gilbert and James Emmons, Thames & Hudson, London, 1967

————, *The Golden Age of Justinian, from the Death of Theodosius to the Rise of Islam*, tr. by Stuart Gilbert and James Emmons, Odyssey Press, New York, 1967

————, *Romanesque Painting from the Eleventh to the Thirteenth Century*, tr. by Stuart Gilbert, Skira, New York, 1958

————, and Nordenfalk, Carl, *Early Medieval Painting*, Skira, New York, 1957

*Jantzen, Hans, *High Gothic: The Classic Cathedrals of Chartres, Reims, Amiens*, tr. by James Palmes, Pantheon Books, New York, 1962

*Katzenellenbogen, Adolf, *The Sculptural Programs of Chartres Cathedral*, Johns Hopkins Press, Baltimore, 1959

*Kitzinger, Ernst, *Early Medieval Art in the British Museum*, Indiana University Press, Bloomington, 1964

Mâle, Émile, *The Gothic Image: Religious Art in France of the Thirteenth Century*, tr. by Dora Nussey, Harper, New York, 1958

*Pevsner, Nikolaus, *An Outline of European Architecture*, 6th (Jubilee) ed., Penguin Books, Baltimore, 1960

Pope-Hennessy, John, *Italian Gothic Sculpture*, Phaidon, London, 1955

Porcher, Jean, *Medieval French Miniatures*, tr. by Julian Brown, Abrams, New York, 1960

*Rice, David Talbot, *Art of the Byzantine Era*, Praeger, New York, 1963

*Simson, Otto G. von, *The Gothic Cathedral*, Pantheon Books, New York, 1956

Stoddard, Whitney S., *Monastery and Cathedrals in France*, Wesleyan University Press, Middletown, Conn., 1966

Swarzenski, Hanns, *Monuments of Romanesque Art: The Church Treasures in North-Western Europe*, 2nd ed., University of Chicago Press, 1967

Volbach, Wolfgang F., and Hirmer, Max, *Early Christian Art*, Abrams, New York, 1961

PART THREE: THE RENAISSANCE

Ackerman, James S., *The Architecture of Michelangelo*, 2 vols., Viking, New York, 1961

*Alberti, Leon Battista, *On Painting*, tr. by J. R. Spencer, Yale University Press, 1956

Antal, Frederick, *Hogarth*, Routledge & Kegan Paul, London, 1962

Baldass, Ludwig, *Jan van Eyck*, Phaidon, New York, 1952

Bellori, Giovanni Pietro, *The Lives of Annibale and Agostino Carracci*, tr. by Catherine Enggass, Pennsylvania State University Press, University Park, 1968

*Benesch, Otto, *The Art of the Renaissance in Northern Europe*, rev. ed., Phaidon, London, 1965

————, *German Painting, from Dürer to Holbein*, tr. by H. S. B. Harrison, Skira, Geneva, 1966

*Berenson, Bernard, *Italian Painters of the Renaissance*, rev. ed., Phaidon, London, 1957

————, *Italian Pictures of the Renaissance: Central and North Italian Schools*, 3 vols., Phaidon, London, 1968

————, *Italian Pictures of the Renaissance: Florentine School*, 2 vols., Phaidon, London, 1963

*Blunt, Sir Anthony, *Artistic Theory in Italy*, Clarendon Press, Oxford, 1940

Borsook, Eve, *The Mural Painters of Tuscany*, Phaidon, London, 1960

*Burckhardt, Jakob C., *The Civilization of the Renaissance in Italy*, tr. by S. G. C. Middlemore, 3rd rev. ed., Phaidon, London, 1950

*Clark, Sir Kenneth, *Leonardo da Vinci*, Macmillan, New York, 1939

————, *Piero della Francesca*, Phaidon, London, 1951

Cuttler, Charles D., *Northern Painting: From Pucelle to Bruegel*, Holt, Rinehart, Winston, New York, 1968

*Friedländer, Max J., *Early Netherlandish Painting from Van Eyck to Bruegel*, Phaidon, London, 1956

*Friedlaender, Walter F., *Mannerism and Anti-Mannerism in Italian Painting*, Columbia University Press, 1957

——, *Nicolas Poussin, A New Approach*, Abrams, New York, 1966

Hartt, Frederick, *History of Italian Renaissance Art*, Abrams, New York, 1969

——, *Michelangelo: The Complete Sculpture*, Abrams, New York, 1969

*Hind, Arthur M., *History of Engraving and Etching*, 3rd rev. ed., Houghton Mifflin, Boston, 1927

*——, *An Introduction to a History of Woodcut*, Houghton Mifflin, Boston, 1935

Hinks, Roger P., *Michelangelo Merisi da Caravaggio: His Life . . . , His Legend . . . , His Works*, Faber & Faber, London, 1953

*Ivins, William M., Jr., *How Prints Look*, Metropolitan Museum of Art, New York, 1943

Kimball, Sidney Fiske, *The Creation of the Rococo*, Philadelphia Museum of Art, 1943

*Klein, Robert, and Zerner, Henri, *Italian Art 1500–1600*, Sources and Documents in the History of Art, Prentice-Hall, Englewood Cliffs, N.J., 1966

Landolt, Hanspeter, *German Painting: The Late Middle Ages: 1350–1500*, Skira, New York, 1968

Leymarie, Jean, *Dutch Painting*, tr. by Stuart Gilbert, Skira, New York, 1956

*Murray, Peter, *The Architecture of the Italian Renaissance*, Schocken Books, New York, 1966

*Panofsky, Erwin, *Albrecht Dürer*, 3rd ed., 2 vols., Princeton University Press, 1948

Pope-Hennessy, John, *Italian High Renaissance and Baroque Sculpture*, 3 vols., Phaidon, London, 1963

——, *Italian Renaissance Sculpture*, Phaidon, London, 1958

Reynolds, Sir Joshua, *Discourses on Art*, ed.

Robert R. Wark, Huntington Library, San Marino, Cal., 1959

Ring, Grete, *A Century of French Painting*, Phaidon, London, 1949

*Rosenberg, Jakob, *Rembrandt*, 2 vols., Harvard University Press, 1948

*Seznec, Jean, *The Survival of the Pagan Gods*, tr. by Barbara F. Sessions, Bollingen Foundation and Pantheon Books, New York, 1953

*Shearman, John K. G., *Mannerism*, Penguin Books, Baltimore, 1967

Stechow, Wolfgang, *Dutch Landscape Painting of the Seventeenth Century*, Phaidon, London, 1966

*——, *Northern Renaissance Art*, Sources and Documents in the History of Art, Prentice-Hall, Englewood Cliffs, N.J., 1966

Trapier, Elizabeth, *Velázquez*, Hispanic Society of America, New York, 1948

*Vasari, Giorgio, *The Lives of the Painters, Sculptors, and Architects*, tr. by A. B. Hind, 4 vols., Dutton, New York, 1927

Venturi, Lionello, *Italian Painting*, 3 vols., Skira, New York, 1950–52

Waterhouse, Ellis K., *Italian Baroque Painting*, Phaidon, London, 1962

*Wittkower, Rudolf, *Architectural Principles in the Age of Humanism*, Random House, New York, 1965

——, *Gian Lorenzo Bernini, The Sculptor of the Roman Baroque*, 2nd ed., Phaidon, London, 1966

PART FOUR: THE MODERN WORLD

Arnason, H. H., *History of Modern Art*, Abrams, New York, 1968

Barker, Virgil, *American Painting, History and Interpretation*, Macmillan, New York, 1953

*Battcock, Gregory, ed., *Minimal Art: A Critical Anthology*, Dutton, New York, 1968

*————, *The New Art: A Critical Anthology*, Dutton, New York, 1966

*Brown, Milton, *American Painting from the Armory Show to the Depression*, Princeton University Press, 1955

Chipp, Herschel B., *Theories of Modern Art*, University of California Press, 1968

*Clark, Sir Kenneth, *The Gothic Revival*, Scribner's, New York, 1929

Collins, Peter, *Changing Ideals in Modern Architecture, 1750–1950*, Faber & Faber, London, 1965

Elsen, Albert Edward, *Rodin*, Doubleday, Garden City, N.Y., for The Museum of Modern Art, New York, 1963

*Finch, Christopher, *Pop Art: The Object and the Image*, Dutton, New York, 1968

Fitch, James Marsden, *American Building*, Houghton Mifflin, Boston, 1948

Fleming, Gordon H., *Rossetti and the Pre-Raphaelite Brotherhood*, Hart-Davies, London, 1967

*Friedlaender, Walter F., *From David to Delacroix*, Harvard University Press, 1952

Gernsheim, Helmut and Alison, *The History of Photography from the Camera Obscura to the Beginning of the Modern Era*, Thames & Hudson, London, 1969

Golding, John, *Cubism: A History and an Analysis, 1907–1914*, Wittenborn, New York, 1959

*Goldwater, Robert J., *Primitivism in Modern Art*, rev. ed., Vintage Books, New York, 1967

————, and Treves, Marco, *Artists on Art*, Pantheon Books, New York, 1945

Gray, Camilla, *The Great Experiment: Russian Art 1863–1922*, Abrams, New York, 1962

*Haftmann, Werner, *Painting in the Twentieth Century*, 2 vols., Praeger, New York, 1961

Hamilton, George Heard, *Manet and His Critics*, Yale University Press, 1954

*Herbert, Robert L., ed., *Modern Artists on Art*, Prentice-Hall, Englewood Cliffs, N.J., 1965

Hitchcock, Henry-Russell, and Johnson, Philip, *The International Style*, Norton, New York, 1966

Hofmann, Werner, *The Earthly Paradise; Art in the Nineteenth Century*, tr. by Brian Battershaw, Braziller, New York, 1961

*Honour, Hugh, *Neo-Classicism*, Penguin Books, Harmondsworth, England, 1968

Jaffé, Hans L. C., *De Stijl, 1917–1931; The Dutch Contribution to Modern Art*, Meulenhoff, Amsterdam, 1956

Klingender, Francis D., *Art and the Industrial Revolution*, rev. and enl. ed., Evelyn, Adams & Mackay, London, 1968

Larkin, Oliver, *Art and Life in America*, Rinehart, New York, 1949

Licht, Fred S., *Sculpture of the 19th and 20th Centuries*, New York Graphic Society, Greenwich, Conn., 1967

*Lippard, Lucy R., *Pop Art*, Praeger, New York, 1966

*Madsen, Stephan T., *Art Nouveau*, McGraw-Hill, New York, 1967

Martin, Marianne W., *Futurist Art and Theory, 1909–1915*, Clarendon Press, Oxford, 1968

*McCoubrey, John, *American Art, 1700–1960*, Sources and Documents in the History of Art, Prentice-Hall, Englewood Cliffs, N.J., 1965

Motherwell, Robert, *The Dada Painters and Poets*, Wittenborn, Schultz, N. Y., 1951

*Nochlin, Linda, *Impressionism and Post-Impressionism, 1874–1904*, Sources and Documents in the History of Art, Prentice-Hall, Englewood Cliffs, N.J., 1966

*————, *Realism and Tradition in Art, 1848–1900*, Sources and Documents in the History of Art, Prentice-Hall, Englewood Cliffs, N.J., 1966

*Pevsner, Nikolaus, *Pioneers of Modern Design*, 2nd ed., Museum of Modern Art, New York, 1949

Popper, Frank, *Origins and Development of Kinetic Art*, tr. by S. Bann, New York Graphic Society, Greenwich, Conn., 1968

Rewald, John, *History of Impressionism*, rev. and enl. ed., Museum of Modern Art, New York, 1961

————, *Post-Impressionism from Van Gogh to Gauguin*, Museum of Modern Art, New York, 1956

Reynolds, Graham, *Victorian Painting*, Studio Vista, London, 1966

Rheims, Maurice, *The Flowering of Art Nouveau*, tr. by Patrick Evans, Abrams, New York, 1966

Rickey, George, *Constructivism; Origins and Evolution*, Braziller, New York, 1967

Roh, Franz, *German Art in the 20th Century*, New York Graphic Society, Greenwich, Conn., 1968

Rosenberg, Harold, *The Anxious Object: Art Today and Its Audience*, Horizon, New York, 1964

*Rosenblum, Robert, *Cubism and Twentieth-Century Art*, Abrams, New York, 1961

————, *Jean-Auguste-Dominique Ingres*, Abrams, New York, 1967

Rubin, William, *Dada and Surrealist Art*, Abrams, New York, 1969

Selz, Peter, *German Expressionist Painting*, University of California Press, 1957

Tunnard, Christopher, *The City of Man*, Scribner's, New York, 1953

INDEX

LIST OF CREDITS

The authors and publisher wish to thank the libraries, museums, and private collectors for permitting the reproduction in black-and-white of paintings, prints, and drawings in their collections. *Photographs have been supplied by the owners or custodians of the works of art except for the following, whose courtesy is gratefully acknowledged:*

Alinari (including Anderson and Brogi), Florence (49, 50, 65, 69, 76–78, 81, 83, 88, 94, 96, 116, 128, 134, 136, 140, 141, 145, 160–63, 165, 167–69, 171, 173, 175, 179–81, 183, 184, 187–91, 196–98, 201, 203, 206, 208, 211, 227, 229, 233, 253, 292); Andrews, Wayne, Grosse Pointe, Mich. (258, 286); Copyright Archives Centrales Iconographiques, Brussels (146–48, 234); Archives Photographiques, Paris (3, 6, 35, 118, 137, 219, 250, 251, 255, 256, 268, 274, 294, 298); Arts Council of Great Britain (300); Copyright The Barnes Foundation, Merion, Pa. (318); Bildarchiv Oesterr. Nationalbibliothek, Vienna (90, 123); Brassaï, Paris (2); Bruckmann, F., Munich (202, 212); Bulloz, Paris (119, 186, 224, 225, 275, 293, 294); Burckhardt, Rudolph, New York (347); Burstein, Barney, Boston, Mass. (319); Commissione Pontificale d'Archeologia Sacra (84); Cooper, A. C., Ltd., London (282); Deutsche Fotothek, Dresden (295); Deutscher Kunstverlag, Munich (106); Dingjan, A., The Hague (240); Ethnographic Collection of the University, Zurich (11, Copyright Hugo P. Herdeg's Erben, Zurich); Fleming, R. B. and Co., Ltd., London (300); Fotocielo, Rome (73, 87, 231); Fototeca Unione, Rome (68, 70, 194); Foto Vitullo, Rome (86); Frantz, Alison, Athens (42, 54, 55); Freeman, John, London (182); Gabinetto Fotografico, Florence (174); Gabinetto Fotografico Nazionale, Rome (99, 192, 226, 228, 230); German Archaeological Institute, Rome (75, 82); Giraudon, Paris (144, 185, 220, 254, 271, 276, 277, 289, 297, 301); Green Studio, Dublin (102); Photo-Verlag Gundermann, Würzburg (260); Hahn, E., Berlin (13); Hervé, Lucien, Paris (358–60); Hirmer Fotoarchiv, Munich (18–22, 28, 29, 41, 48, 57, 59–61, 64, 66, 67, 79, 92, 97); Hürliman, Martin, Zurich (261); Istituto Centrale del Restauro, Rome (139); Kersting, A. F., London (114, 127, 285); Kidder-Smith, G. E., New York (51, 74, 91, 115, 123); Knoedler, M., New York (299); Kühn, H., Mainz (4); Lomeli, Juan Arauz, Guadalajara (324, courtesy of Professor Laurence Schmeckebier, Syracuse, N.Y.); Copyright London County Council (244); Foto-Marburg, Marburg/Lahn (44, 131, 132, 290); A. and R. Mas, Barcelona (239, 272); McKenna, Rollie, New York (172, 209); Ministry of Works, London, Crown Copyright (8); National Monuments Record, London (288); Nickel, Richard, Park Ridge, Ill. (353); Oriental Institute, University of Chicago (24, 33, 36, 39); Powell, Josephine, Rome (95, 142); Rabin, Nathan, New York (343); Rheinisches Bildarchiv, Cologne (133); Roubier, Jean, Paris (72, 111–13, 121, 130); St. Joseph, Dr. J. K. (7); Schmidt-Glassner, Helga, Stuttgart (259); Smith, Edwin, London (126); Sunami, S., New York (10, 327, 333, 337–39, 346, 350, 352); Virginia Chamber of Commerce, Richmond (291); Vizzavona, Paris (235); Ward, Clarence, Oberlin, Ohio (125); Wehmeyer, Hermann, Hildesheim (108); Yan Photo Reportage, Toulouse (110, 117); Photohaus Gebrüder Zumbühl, St. Gall, Switzerland (103).